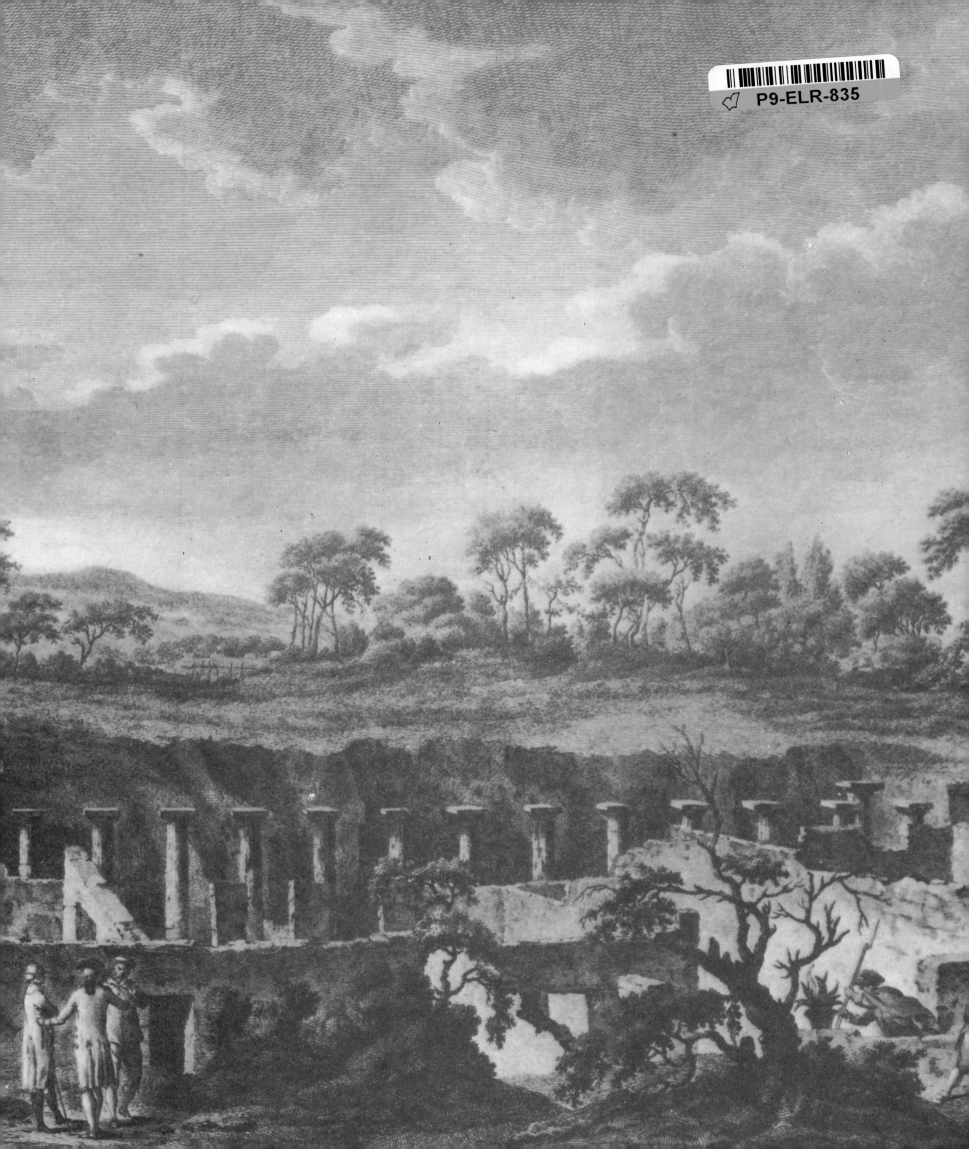

Pompeii and Herculaneum

Pompeii and Herculaneum

The Living Cities of the Dead

Text by Theodor Kraus
Photographs by Leonard von Matt

Translated by Robert Erich Wolf

Harry N. Abrams, Inc., Publishers, New York

Library of Congress Cataloging in Publication Data

Kraus, Theodor, 1919-
 Pompeii and Herculaneum.: the living cities of the dead.

 Translation of Pompeji und Herculaneum.
 Includes bibliographical references and index.
 1. Art, Greco—Roman—Pompeii. 2. Art—Pompeii.
 3. Art, Greco-Roman—Herculaneum. 4. Art—Herculaneum.
I. Title.
N5769.K7213 913.37'7 74–19453
ISBN 0–8109–0418–7
Library of Congress Catalogue Card Number: 74–19453
Published by Harry N. Abrams, Incorporated, New York, 1975
All rights reserved. No part of the contents of this book may be reproduced
without the written permission of the publishers.
Copyright 1973 in West Germany by Verlag M. DuMont Schauberg, Cologne
Printed and bound in Yugoslavia

All photographs were taken especially for this book by
Leonard von Matt, with the exception of the following:
plates 14, 290, Deutsches Archaeologisches Institut, Rome;
plates 173, 267, Soprintendenze alle Antichità, Naples;
and plates 50, 136, 192, 200, 262, 268, Fratelli Alinari, Florence.

CONTENTS

POMPEII

POMPEII BEFORE THE ROMANS

One of the farthest spurs of Mount Vesuvius toward the southeast is a hill of lava 131 feet above sea level in the north dropping to a mere 26 feet in the south. It was on this steeply sloping plateau looming above the lower course and mouth of the Sarno River that, certainly as early as the eighth century B.C., an Italic people laid down the nucleus of what was to become Pompeii. Strabo confirmed the fact that they were Oscans, and Pliny the Elder, too, was aware of the Oscans as the first of many populations that held sway in Campania in the course of the centuries.

Almost nothing is known of that earliest settlement, and as far as architecture is concerned it can scarcely have been more than modest. But the site may at least owe its name to that humble first beginning: the root of the word Pompeii would appear to be the Oscan word for the number five, *pompe*, which suggests that either the community consisted of five hamlets or, perhaps, was settled by a family group (*gens Pompeia*), whose name derived from that number in the same way as the Latin Quintii. It may be, too, that it was those first inhabitants who laid down the network of streets which centuries later, when Rome had become an empire and the master of Pompeii, still clearly marked off the urban nucleus of Pompeii from the newer quarters. Looking at an aerial photograph or a map (plate 1), one is struck by the fact that the southwestern part of the town is delimited by streets laid out irregularly and seemingly without any overall plan. Not only does this section have a different orientation from the rest but it also has smaller, tighter blocks of houses—*insulae*—than the regular oblongs of the newer neighborhoods. Its streets and the lanes between them meander in a way entirely unlike the geometrically regular courses pursued elsewhere in the city. The only large open area of Pompeii lay not in the precise middle, as one might expect, but a little to the west, in what would later become the central portion of the Roman Forum.

By the sixth century B.C. at the latest, the tiny town—its twenty-three acres could scarcely have accommodated more than two thousand persons, at best another fifty—must have come under the influence of the Greek coastal towns, especially the important colony of Cumae, north of present-day Naples. As Strabo indicated, Pompeii functioned as a port town, with a two-way traffic of goods between the gulf and the towns upriver along the Sarno. In ancient times the coastline ran much deeper inland, some two-fifths to one-half of a mile west and southwest of the hill on which the town itself sat. For the Greeks, who were superior to the people of Campania both culturally and economically, Pompeii undoubtedly was not without its importance, since it was there that goods for the towns in the hinterland, Nola and Nuceria (the present Nocera Inferiore) in particular, were transshipped.

There is impressive evidence of the Greek hegemony in the Doric temple (plate 3) built about the middle of the sixth century B.C. on the spur of land southeast of the old town, where it served as a landmark for sailors approaching the mouth of the Sarno. Moreover, it seems that it was Greeks from Cumae who introduced into the locality the cult of Apollo, whose seat was in a temple west of the Forum, a sanctuary rebuilt many times but surviving into the Roman era and, indeed, to the last days of Pompeii.

In the late sixth century B.C., the Etruscans extended their dominion into Campania. Dionysius of Halicarnassus reported that in 524 B.C. the Etruscans ventured an attack on Cumae, having formed an alliance with the Italic populations of the hinterland. Although failing to seize the powerful Greek colony, they were nevertheless able to maintain power in southern Campania for another fifty years, until 474 B.C., when their fleet was defeated by Hieron of Syracuse in the waters off Cumae. It was then that the Etruscans relinquished their control of the bay of Naples once and for all.

The Etruscan presence in Campania is attested to in Pompeii by graffiti on shards of bucchero vases found in the precinct of the Temple of Apollo. Nevertheless, this does not mean that Pompeii was ever an Etruscan town. While some proper names among its inhabitants indicate Etruscan origins, and a column incorporated into the wall of one of the houses has long been identified as Etruscan, this evidence is not sufficient to prove that there was ever an Etruscan settlement of any importance. Citizens with such names could just as well have come in at a later period; they may have been among the new population element represented by the Roman colonists. The column certainly has nothing to do with Etruscan art, if indeed it is really archaic. All in all, then, Pompeii appears at best to have been no more than in the Etruscan sphere of influence, much as it was in that of the Greeks before 524 and after 474 B.C. Even after the Greeks had definitively driven off their own and Pompeii's Etruscan adversary, they left no more imprint on Pompeii in this second period of their domination of Campania than they had before. Once again it is chiefly the earlier Doric temple that indicates a Greek presence: its terra-cotta decoration (plate 2) was redone about the middle of the fifth century B.C.

A new epoch, one in which the town was to flourish as never before, began for Pompeii in the late fifth century B.C. It was then that the Samnites began to emerge from their domain in the mountainous interior of the Abruzzi and to take over all of Campania with amazing rapidity. In 423 Capua fell to them, in 420 Cumae was theirs, and it was then that Pompeii, too, must have succumbed to these new masters, though we can neither point to a particular year nor say how it came about, nor even if it was attended by a blood bath such as Livy tells us was Capua's lot.

Whatever the particulars were, the Samnites enlarged the city beyond its old borders to about seven times its former area, so we can assume there was a correspondingly large increase in population. The new districts to the north and east took on a look quite unlike that of the old town. Just as in many modern cities where the medieval nucleus comes to be surrounded by new and more spaciously planned quarters, so, too, in Pompeii new houses took their places in regular blocks of buildings marked off on all four sides by straight streets. There were unmistakable Greek influences, probably thanks to Neapolis, the most important city on the gulf. The newly enlarged city was surrounded by a wall which, in the course of time, was frequently rebuilt and improved until its final phase, when defensive towers were added and it had to endure the victorious Roman onslaught.

Archaeologists call the earlier Samnitic time the Limestone Period, a reference to the most often used building material; this period is not as clearly understood as the so-called Tufa Period, the last century before the Romans took over, when houses were built in a brown tufa stone from Nuceria. It was in this latter period that Hellenistic influence reached its apogee in the Samnite city. Doric colonnades now surrounded the open place where the venerable Greek temple still stood (plate 4), a theater rose on the slope northeast of it, and the first public baths were laid out. The main square of the city, the Forum, was extended to the south and surrounded by colonnaded porticoes, on the west a grandiose new basilica opened onto it, and at the north end it was crowned by a forerunner of the great temple on the Capitol in Rome dedicated to the three gods, Jupiter, Juno, and Minerva. Other religious buildings, among them the Temple of

Zeus Meilichios and perhaps even at such an early date those of Isis and of Venus, took their places alongside the earlier one.

However, it is the homes that provide us with the best evidence of the prosperity of the time. Scarcely ever again were houses of greater elegance and opulence built in Pompeii, and we shall have much to say about their wall decorations and splendid mosaic floors. Even before one sets foot in them, these sumptuous houses call attention to themselves by their long fronts. The gateposts are crowned by stuccoed capitals artfully carved from soft tufa stone. Sometimes these capitals are embellished with figures (plates 5, 6), and their Greek-influenced forms and motifs distinguish them from so many humbler carvings executed contemporaneously by locally trained native craftsmen.

Although Pompeii was indebted to the Greeks for their artistic achievements, it remained nevertheless an Italic city or a Campanian one, if by that term we understand the linkage of Samnitic elements with the Hellenistic culture holding sway in that period. The language used was Samnitic, and indeed even the Oscans, who founded the town, belonged to that people. All the official documents use that language and are written in the Oscan alphabet, and it is they that we look to most to learn how the community was organized and governed. At the apex of the community stood the *meddix*, who was also responsible for meting out justice, while the *kvaisstur* administered the public funds. Two individuals occupied the post of *aidilis*, which meant that they were in charge of all construction. Legal measures as well as expenditures of public monies required the authorization of the *kumbennion*, an assembly whose role must have been much like that of a present-day city council, although unfortunately we have no information as to the number of its members.

Pompeii belonged to a federation of Samnitic towns whose capital was Nuceria. The highest authority of that league was the *meddix tuvtiks [tuticus]*, and it tells us something of the prestige enjoyed by Pompeian families that their members, too, at times filled this position, notably one from the *gens Popidia*. It was probably because of its membership in that federation that Pompeii, unlike Nuceria, had no need to mint its own coins, although the large number of foreign coins found there attests to its role as a commercial center, with connections as far west as Massilia (Marseilles) and the Baleares.

Toward the middle of the fourth century B.C., two great rivals confronted each other in Italy. Rome, which had quickly recovered from its devastation by the Gauls, had been able to extend its territory to the northern borders of Campania and could stand up to any and all comers. Southeast of its sphere of influence, the Samnitic tribes of the interior had assembled the Caudines and the Hirpini into the Samnite League with the aim of controlling all of the fertile Campanian plain. But there, too, war broke out: in 343 B.C. Capua called on Rome for help, and this gave rise to the First Samnite War. Although that war concluded two years later with the Samnites yielding in Campania and with an alliance between Capua and Rome, the second of those wars brought Rome to a harsh crisis: in 321 its army was defeated at the Furculae Caudinae, the narrow pass known as the Caudine Forks, and was sent home to Rome stripped of its weapons and under the yoke. After a peace lasting from 321 to 315, Rome was more fortunate in a second phase of the war, and by the end of hostilities Nola and Nuceria, in the vicinity of Pompeii, had become Roman confederates.

Virtually nothing is known of Pompeii during this period nor during the Third Samnite War of 298–290. Certainly it must have been on the side of Nuceria which, as Diodorus reports, allied with the Samnite League under the pressure of a pro-Samnite party. Only once is there word of Pompeii, in 310, when according to Livy the Roman fleet under Publius Cornelius attempted to move against Nuceria and suffered a dire defeat, though Pompeii itself does not seem to have been involved in this campaign.

Nevertheless, there was good reason for Pompeii to reinforce its walls and build them higher, for in the following century the Second Punic War (218–201) raged over all of Italy, with Hannibal administering crushing defeats to the Romans at the Trebbia River, on Lake Trasimene, and at Cannae. In Campania, Capua deserted Rome, but other cities put up a bitter resistance to the Carthaginian invader, among them Nola, which was defended by Marcellus. Pompeii also seems to have taken the side of Rome, and it was not until about 100 B.C. that it openly opposed the great city.

It was at that time that a considerable number of the Italic peoples rose up against Rome, most particularly the inhabitants of the Abruzzi in Central Italy, along with the Samnites, Lucanians, and Bruttians. Rome had refused all of them the citizenship they coveted, and the confederates came to recognize that the burdens they had to bear for Rome were quite disproportionate to the rights Rome conceded them. The outcome was a new confederation and a new war. The command of the Roman troops assigned to suppress the rebellion in the south was given to Lucius Cornelius Sulla by the Senate in the spring of 89 B.C. At Pompeii he found a city excellently equipped for its defense. The wall had once again—for the last time—been renovated and provided with towers which projected at a right angle to the exterior so as to loom over and protect the defensive parapet. The north side, where the land lay highest behind the city and therefore offered the best vantage point for attackers, was particularly fortified. In case of peril from outside, the inhabitants were instructed to report to particular sectors of the fortifications, as we know from a few Oscan-Samnitic inscriptions which were written in red on house walls and which also name the commander for that sector. Thus one on a pilaster of the House of Pansa reads: *eksuk amvianud eit(uns) anter tiurri XII ini veru sarinu puf faamat mr aadiriis v* (the men of this block of streets are to report between Tower XII and the Sarina Gate, where Maras Adirius, the son of Vibius, is in command). The expression "amvianud," translated here as "block of streets," refers to the group of streets surrounding a block of houses on all four sides. In this manner all those able to bear arms were assigned places for defense, and on the basis of such inscriptions it appears that Pompeii was divided into five defensive sectors under the high command of Lucius Popidius.

Armed and ready, the city awaited the troops of Sulla, who attacked from the north. The deep holes made by the stone missiles launched by the enemy's war engines can still be seen. But the city was not so quickly taken. How long the siege lasted, how long Pompeii was able to withstand the Roman forces is simply not known, and scholars have proposed a great number of entirely contradictory answers. All we do know is that the Samnitic allies sent relief troops under Lucius Cluentius in the hope of rescuing the threatened city from the clutches of Sulla, but their expedition came to nought. By 87 B.C. Sulla was busy warring against King Mithridates VI of Pontus, and it seems most improbable that the Pompeians would still be holding off the Romans at that date. What is certain, however, is that about 80 B.C., after his return from the East, Sulla established Pompeii as a colony for the veterans of his campaigns and placed his nephew Publius Cornelius Sulla at its head. It was then, at the

latest, that the Samnite population of Pompeii was granted Roman citizenship.

COLONIA VENERIA CORNELIA POMPEIANORUM

Generally the Roman colonies assumed the family name of their founder. At Pompeii, however, Lucius Cornelius Sulla interpolated the name of the goddess he especially venerated and to whose protection he entrusted his fate: Venus. Henceforth, as Venus Pompeiana, the goddess of love was to play a great role among the various cults of the city. Whether she was already prominent among the tutelary gods of Pompeii before the time of Sulla will only be known when the extensive precinct of her temple west of the Basilica will have been studied and its findings interpreted with proper scientific care.

The official designation of the city—in which the second and third words were at times interchanged and the last word even omitted—can be read on wax tablets found in the House of Lucius Caecilius Jucundus that date to shortly before the great earthquake of A.D. 62 (plate 185). Nevertheless, the full name is not met with very often in the inscriptions and documents, and for the most part, especially in literature, the now familiar short form—Pompeii—was adopted.

It is possible that the Pompeians had already surrendered and thereby acquired Roman citizenship well before 80 B.C., and if so, during those years the city would have existed as a *municipium*, a community not ranked as high as a colony. But we have no proof of this, nor do we have any idea how the newcome Roman colonists initially got along with the long-established Samnite population. Tensions between the Roman veterans and the Samnite patrician families would seem to have been unavoidable, representing as they did different national origins and different social classes. A hint of this crops up in Cicero's oration in defense of Publius Cornelius Sulla, who was accused by Lucius Manlius Torquatus and others of having led the Pompeians to take part in the Cataline conspiracy, thereby adding fuel to their conflicts with the *coloni*. Cicero admits quite openly that disunity was the result in the city but says, "*omnis Pompeianorum colonorumque dissensio delata ad patronos est, cum iam inveterasset ac multos annos esset agitata*" (*Pro Sulla* lx). Thus every conflict between Pompeians and colonists which went on for any appreciable length of time was first brought before the *patroni*, distinguished Romans who represented the city in Rome itself and, in these cases, performed the function of arbitrator.

No doubt it must have taken years before the old and the new populations fused into a true community with equal rights and status for Samnites and Romans. It is certain that in the Roman period the native aristocracy still had an important voice in determining the fate and fortune of the city. Numerous inscriptions and graffiti bear the names of members of such prominent Samnite families as the Epidii or the Popidii, either as functionaries in office or as candidates for the posts of *duoviri iure dicundo* and *aediles*, the topmost positions in the city government.

Already in its first years as a colony the city took steps to improve its appearance with new public buildings. Alongside the large theater a smaller one was built, which was roofed over and therefore designated as a *theatrum tectum* in its dedication inscription. The southeast corner of the city was utilized for an amphitheater in which to present the favorite Roman sports of gladiatorial fights and animal baiting, entertainments whose preparation, conduct, and outcome were followed with passionate attention by Pompeians new and old. Although modernized at that time, the baths built by the Samnites obviously could no longer suffice an expanding community, and a second bath sector was laid out in the vicinity of the Forum and equipped with all the latest technical improvements and conveniences. The influence of the Roman capital was making itself felt more and more throughout the Empire, and not least in this southern colony. The Forum was paved with limestone tiles, and the first Roman statues honoring worthy citizens were set up on the main public piazza.

Private dwellings did not lag behind public undertakings. Many wealthy citizens redecorated their houses to be more modern, with wall decorations in the style then fashionable in late Republican Rome. Around the city sprang up a ring of villas, though their owners were not the local upper classes. The magnificent gulf of Naples and the fertile terrain attracted wealthy Romans to build country houses there. The southeast slope of Vesuvius became the preferred site for *villae rusticae*, those with some sort of farm attached, whereas the choice location for elegant *villae urbanae*, intended solely as residences for the wealthy, was just outside the city gates. The most famous owner of one of these suburban villas at the time was Cicero. His letters often mention his "Pompeianum"; in one addressed in June of 60 B.C. to Titus Pomponius Atticus he says, "*Tusculanum et Pompeianum valde me delectant*," from which we know that his properties in Tusculum and Pompeii afforded him much pleasure—though, as he goes on to explain, he could ill afford the debts they incurred.

During the rule of Augustus, the emperor's son-in-law, Marcus Vipsanius Agrippa, built a villa near the present Boscotrecase which, upon his death, passed to his son, Agrippa Postumus. Its paintings were unearthed in excellent condition and have been the key evidence of the new Augustan style. In A.D. 20, Drusus, the son of the future emperor Claudius, choked to death on a pear while at play in a villa in Pompeii. It has been supposed that the accident occurred in the Villa of Boscotrecase, which reverted to the emperor after Agrippa Postumus was driven into exile, but this is not certain, and the misadventure may have taken place in someone else's country house. Yet other threads connect Pompeii with the Julian-Claudian imperial house: Lollia Paulina, the third wife of Caligula, was related to a Pompeian family, which may be why the emperor consented to be named honorary duovir of Pompeii in A.D. 34 and 40. The family of Poppaea Sabina, the second wife of Nero, also appears to have originated in the city on the Sarno; at any rate, she acquired property there by inheritance.

It would be wrong, however, to conclude from all this that Pompeii was of any great importance. With no more than fifteen to twenty thousand inhabitants, it was at best a prosperous provincial town which at no time under the Romans played any historical role. None of its sons ever became great or famous. As a port town it survived chiefly through commerce, though its farm products, such as wine and oil, and even its textiles found customers beyond its walls. Its most important article of export was quite certainly a fish sauce known as *garum*, which Pliny tells us was one of the most appreciated in the entire Empire.

When Rome turned imperial there was a change in building technique. Pompeian masons took to the *opus reticulatum*, the technique in which the core of the wall was composed of mortar and rubble amalgamated into concrete and faced with cubic stones laid on their points, diamond-fashion, to make a netlike pattern. This was anticipated, however, even in the first phase of the colony, in a "quasi-reticulate" technique

midway between the earlier *opus incertum*, where the concrete wall was faced with irregularly shaped stones, and the *opus reticulatum*. Under Roman influence marble began to be used for building, though not to a great extent. Even in the capital it was not until Augustan times that the emperor could boast that he had found a Rome of brick and was leaving behind him a Rome of marble. In Pompeii it was adopted for columns and entablatures as well as for facing the wall of the cella in the Temple of Fortuna Augusta. The costly material was used also in parts of the new buildings that went up around the Forum, most notably in the Macellum, which was the central market of the city, and in the edifice erected by the priestess Eumachia and dedicated by her to the Concordia Augusta and to Pietas, but which served as business headquarters for the clothmakers' corporation. On the other hand, the porticoes of the Forum itself were redone only in travertine, but they were at the same time extended farther. The major effort at modernization, however, was a new system of conduits to supply homes with water from central mains rather than from the old wells and fountains.

With peace, the fortifications lost their importance. In the western part of the town, near and outside the walls, there were now sumptuous dwellings with a splendid view of the gulf. Peace and prosperity made life in Pompeii so uneventful that the only occurrence of sufficient importance to have found its way into historians' accounts was a purely local one: in the year 59, during the games in the Amphitheater, a bloody brawl flared up between the Pompeians and their guests from nearby Nuceria, which created such a reaction that Nero ordered the Amphitheater to be shut down for a full ten years. Three years later, however, the placidly unprepared city was to experience something far worse, a true catastrophe.

THE GREAT EARTHQUAKE

"We have heard that Pompeii, the very lively city in Campania where the shores of Surrentum and Stabiae and that of Herculaneum meet and hem in a lovely, gently retreating inlet from the open sea, has been destroyed by an earthquake which also struck the entire vicinity. This occurred in winter, a time which our forefathers always held to be free from such perils. It was on the fifth of February in the year of the consuls Regulus and Verginius that this earthquake came to pass, ravaging Campania with dire effect. This region had never before been visited by a calamity of such extent, having always escaped unharmed from such occurrences and having therefore lost all fear of them. Part of the city of Herculaneum caved in; the houses still standing are in ruinous condition. The colony of Nuceria was not heavily affected but nonetheless appears distressed. Neapolis was considerably less affected by the catastrophe: much private but no public property was damaged. Country villas, too, were wrecked, though many only felt the tremor without being harmed. To this can be added that a herd of six hundred sheep was wiped out, statues were smashed, people wholly lost their heads and wandered about completely out of their senses."

This is how Seneca begins the sixth book, the one devoted to earthquakes, of his *Naturales Quaestiones*. His depiction is both more extensive and more impressive than that of Tacitus, who merely concludes his account of the events of the year 62 with the remark, "besides these, an earthquake devastated the larger part of the bustling city of Pompeii in Campania." The historian's brevity should not be held against him since this was but one misfortune among many others, and he was writing at a distance of many years. Seneca, however, wrote as a contemporary and as one familiar with the place. It may well be that his book *De Terrae Motu* was written under the distressing impact of the catastrophe, which is often mentioned in it.

No wonder, then, that in at least one detail, the only one in which he differs from Tacitus, Seneca was for a long time generally accepted as the authority: the date itself. It so happens that Regulus and Verginius, whom Seneca names, held their consulships in the year 63. But there are decisive grounds that speak for the date of A.D. 62 as handed on by Tacitus. The point has been endlessly debated, but there are two especially convincing bits of evidence. The series of small wax tablets on which the banker Lucius Caecilius Jucundus noted down his transactions, and which after the earthquake were stowed away on the upper story of the rear part of his house, break off at a date corresponding to January 11, 62. Evidently a decisive event put a sudden stop to the successful business of the financier, and what more likely one than the catastrophe which, if we follow Tacitus, took place a month later? Also, in the year 60 a comet was seen which, according to Seneca himself, was two years before the Campanian earthquake. So in all probability the year was indeed A.D. 62 and not 63.

Pompeii must have been very close to the epicenter of the quake. Geologists are inclined to view it as an unsuccessful attempt on the part of Vesuvius, a rehearsal for the disaster which, seventeen years later, was to put an end forever to the life of the city. Judged to be of an intensity of nine on the Mercalli scale, it was literally devastating. The number of dead is nowhere mentioned and will probably never be known, but collapsing roofs and walls must surely have buried many under them. Only a few of the public edifices were spared. All the buildings around the Forum were damaged to some degree, and the Temple of Apollo and the Basilica caved in. With its statues thrown off their pedestals and the colonnaded porticoes reduced to rubble, the main plaza of the city must have offered a picture of desolation. Among the religious edifices in other districts, only the Temple of Zeus Meilichios seems to have escaped with minor damage. The Theater lost the upper tier of its broad seating area (*summa cavea*) and its stage building, while on the Triangular Forum nearby the elegant colonnades which had stood since Samnitic times fell in. The vaults of the Amphitheater seem to have stood up better, but the two public bathhouses—the Forum and the Stabian Thermae—were severely damaged. To cap it all, the network of the city water supply became inoperative, the main distributing installation at the Vesuvius Gate was affected, and the conduits were smashed at various places.

Nor did the houses, shops, workshops, public houses, and inns fare any better. Some escaped with slight damage, others were virtually destroyed. Struck to its vitals, the city faced a desperate situation demanding immediate action if something was to be saved.

RECONSTRUCTION AND DESTRUCTION

Scarcely any written sources tell us what went on in Pompeii after the great earthquake. To date, only a single inscription has been found which

even mentions it, one expressly describing the Temple of Isis as *terrae motu conlapsa* (caved in). Only the archaeological finds give us any information about the damages and reconstruction, though in most cases they do speak clearly and vividly.

Unlike Herculaneum, where Vespasian saw to rebuilding the Temple of the Mater Deum, the great Mother of Gods, there is no evidence of any such royal intervention in Pompeii. Vespasian stirred himself no more than to dispatch the tribune Titus Suedius Clemens with plenipotentiary authority to repossess for the state whatever public property may have illegally gotten into the hands of private individuals during the initial confusion after the earthquake. Nothing more in the way of aid was provided Pompeii, and it found itself faced with depending on its own means and resources to rebuild the razed city.

The seventeen years still granted the unlucky city did not suffice to heal all its wounds. Not every public building could be put back into order. There is not the slightest trace of any restoration in the temple of the Capitoline triad on the Forum, though perhaps there was a plan to build an entirely new one in connection with the new plan for the Forum. Apparently the temple was never used again, because terra-cotta statues replacing those destroyed were found in the Temple of Zeus Meilichios (plate 10) which, it can be assumed, took over the function of the Capitoline temple. The only building on the Forum to be given an almost total restoration was the Temple of Apollo. The other ruined buildings there were for the most part replaced by entirely new ones, as was the great Temple of Venus Pompeiana. Probably the first of the religious edifices of the city to be reconstructed was the Temple of Isis, and the dedication inscription advises that it was carried out at the personal expense of Numerius Popidius Celsinus. It is no accident that private initiative served a foreign divinity and a mystery cult. It was in precisely those years that the Eastern gods, with their promises of salvation, began to challenge the old Roman deities, whose austere rites held out to the individual believer neither promise nor hope of an afterlife.

When disaster struck a second, final time, the imposing and time-honored Basilica already lay in ruins, unreconstructed after the earthquake. Nearby, however, on the south side of the Forum, an all-out effort had been made to build new quarters for the magistrates and very likely also the city archives, because only the uninterrupted functioning of those institutions could guarantee the orderly administration so necessary in times of such general distress. Certainly objects of diligent attention were the Building of Eumachia and the Macellum, the city market, though neither was completed, and it is a moot question if they were really ever able to resume operation on the old scale, even though both were essential for the provision of the city and for commerce and export.

Between them rose two new temples. One was dedicated to the veneration of the emperor and was begun in the reign of Vespasian. The titulary of the other temple has so far not been identified with certainty, but the likeliest proposal is that it served the cult of the *Lares publici*, the tutelary divinities of the city venerated together with the genius, or spirit, of the emperor. To build a temple to these less prepossessing powers after the earthquake and bring them thank offerings or expiatory gifts was all the more necessary since none of the great gods still possessed a sanctuary intact enough for use.

But not only religious edifices were built anew. While the Stabian and Forum bathhouses were being reconstructed—the latter so rapidly that the men's section was soon reopened—in the final years before the eruption of Vesuvius, work had been begun on the so-called Central Thermae

at the intersection of the main arteries leading respectively to the Nola and Stabiae gates. This was the largest building Pompeii was capable of erecting at that time, and for it the masons used the new technique of facing the rubble walls with well-formed bricks. The new baths rose on the ruins of private homes and covered a full insula. They included a large swimming pool (*piscina*) and an extensive area set aside for gymnastics and games (*palaestra*) together with rooms which, thanks to much larger windows, were more cheerfully lighted than the gloomy chambers of the old bathhouses. The establishment was beyond question the most modern and the handsomest in the city, though in the fatal year of A.D. 79 only its rough structure had been brought to completion.

Of the places of public entertainment it was the Amphitheater which was first to open its doors after the earthquake, the damage being for the most part repairable by simply interposing supporting arches. Now, however, the gladiators took up their quarters behind the theater in the large four-sided portico formerly used as a promenade or lounge during intermissions. At the large theater the stage proscenium was rebuilt, but its marble facing seems not to have been completed. Nothing very much was done to the upper tiers, so that the theater now afforded considerably fewer seats—if, indeed, performances were ever resumed in it.

The vital water system was restored in part at least, as evidenced by the elaborate fountains in the houses of Loreius Tiburtinus, Trebius Valens, the Vettii, and other wealthy citizens. Much, however, was still under way, and even such important installations as the Stabian Thermae or the piscina of the large palaestra alongside the Amphitheater had not as yet been connected with the system. Work seems to have been in progress on the water tower near the Vesuvius Gate at the time of the eruption.

If public undertakings stretched over so many years, it is understandable that restoration of many private homes lagged very much behind. Families like the Vettii or Holconii were able to have their houses in perfect order in no time at all, but they were wealthy. In other houses the walls were still undecorated and the floors not yet laid, or the workmen's material still cluttered up a court or some room where everything was in readiness for their trowels and brushes. That a good number of the unfinished houses belonged to the old patricians shows how hard the long-established aristocracy was hit by the catastrophe. Often rooms in the houses of such distinguished citizens had to be rented out as shops or cook-shops (*thermopolia*), though these were only the rooms directly on the street and well apart from the living quarters. A typical case is that of Julia Felix, the owner of a large tract on the Via dell'Abbondanza who, having fallen on difficult days, was now obliged to rent out part of her villa as an inn and a bathhouse open to the public.

Often craftsmen and proprietors of small businesses were back at work more quickly than the aristocrats. Indeed, they had no choice. But, by and large, at the time of its destruction in A.D. 79, Pompeii had not been restored to its former economic activity and capacity. Despite great and certainly admirable efforts, including the concentration of all available forces and resources in the task of rebuilding the city, a newcomer in those last days before Vesuvius exploded might well have taken it for one large building site.

No one could have thought that the mountain would ever spew forth fire. Never, as long as Pompeii had stood, had it ever stirred. What happened on August 24, 79 A.D., caught the city entirely unprepared. About one o'clock in the afternoon, the commander of the Roman fleet at Misenum, Pliny the Elder, was informed that a gigantic pine-shaped cloud of smoke was rising above Mount Vesuvius. The author of *Naturalis Historia*,

he wanted to set out immediately to observe this natural phenomenon at closer range. But a desperate call for help reached him from a woman named Rectina, whose villa lay at the base of the volcano with no escape except by boat. Pliny promptly mobilized a rescue expedition, but under a rain of ash and brimstone, and with the harbor made shallow and obstructed by the flow of lava, a landing was no longer possible. So Pliny drove his ship on to Stabiae, where his friend Pomponianus was already prepared for flight. Unfortunately a northwest wind kept the ship prisoner in the bay, and the admiral could only offer his terrified friends words of encouragement in the face of the flames searing down from Vesuvius. Soon the rain of ashes grew more menacing and violent earth tremors shook the house, so the company finally agreed to go down to the shore in the hope of being able to embark. It was then, on the morning of August 25, when flames and sulfurous fumes drove the panic-stricken Stabians to hopeless flight, that Pliny, a longtime sufferer from asthma, met death through suffocation.

This is the story as we have it from his nephew Pliny the Younger in a letter he wrote more than twenty-five years later to Tacitus. He himself had remained in Misenum, where he saw the daylight sky darken over, endured the thick showers of ashes, and felt the earth tremble beneath him. But neither he nor his uncle set foot in Pompeii, and no one lived to recount what happened there. All we can know of the city's agony has had to be reconstructed by comparing what has been dug up with the sequence of events as narrated in Pliny's letter, though the details have remained a matter of keen interest for both archaeologists and volcanologists, especially when similar cataclysms have occurred in modern times, as at Mount Pelée in 1902.

As early as ten o'clock in the morning the plug of lava bottling up the cone must have been blown skyward by the monstrous pressure of the gas within. Small fragments of solidified lava or lapilli fell on Pompeii from the sky. Molten magma was at the same time catapulted a mile upward and transformed in flight into pumice stones to hail down on the doomed city. Strata of such stones still visible (plate 13) are several yards high and range in color from white to grayish green. In this phase the upper crater of the volcano evacuated itself. The pressure of gas had decreased, but magma in small bits continued to be expelled and, in their course, they stirred up the dust around the rim of the crater to create a rain of ashes that fell over the entire area. As more and more rocks came loose and plummeted into the upper part of the crater, they repeatedly blocked the free release of the gases, which were forced to break through ever more violently. This meant, too, that repeated waves of lapilli fell on the city. In addition, the eruption shook the very depths of the mountain and, in consequence, was accompanied by a series of earthquakes the volcanologists judge must have been most severe on the morning of August 25, when the eruption itself was at its climax. On that day the wind, which was carrying lapilli and ashes far beyond Pompeii, must have veered, because it was then that the younger Pliny, as far away as Misenum, witnessed the rain of ashes which blacked out the sun, a phenomenon which persisted until August 28, when the furious elements finally came to rest. Pompeii, however, was dead by then. It died on the very first day. Around the time that Pliny the Elder sailed past it on his way to Stabiae there could have been no soul still breathing there. Hours later Herculaneum, too, was buried under a flood of slime compounded mostly of ashes and water.

Terror and panic had swept through Pompeii at the first signs of eruption. Death leveled all men, in the atria of the rich as in the hovels of the poor, in the bustling Forum as in the stillness of a garden. How easy it is to grasp the feeling of the Jew who, in this inferno of destruction, could still scrawl on a house front (IX, 1, 26) the two words, *Sodoma Gomora*. Many sought refuge in their own homes, in deep cellars, or in inside chambers. The process by which human bodies were cast like bronze statues in the mass of lava that poured over them has preserved forever the lineaments and gestures of ultimate horror. Those who hoped to escape the unchained hell outside by hiding in their own houses did no more than meet death at home. The entire family of the owner of the Villa of Diomedes was wiped out in the underground passage (*cryptoporticus*), where they must have expected to find sure protection: the master of the house with key still in hand, his wife and children, and all the servants and slaves. The persons who had fled to another underground shelter in the House of the Cryptoporticus found themselves suffocating there, broke their way out, only to have death seek them out in the garden, choking them in a shroud of ashes. In a last impulse of despair, a young girl hid her head in her mother's lap.

Even more terrible was the fate of those who could not flee—slaves in chains, or two gladiators locked in irons, whom no one thought to release from their confinement in the barracks, where another sixty or more perished along with them. Dogs, too, died chained to a wall. Most gruesome of all was a scene in the House of the Vestals, where a hound devoured its master.

Some risked their lives for their treasures. When the roof of the tablinum collapsed in the House of the Faun, the mistress of the house met her death bravely, or foolishly, trapped with all her jewels, armbands, hairpins, earrings, and gold coins. Quite unlike her, Publius Cornelius Teges stopped only long enough to have the lovely bronze statue of an ephebe in his garden covered over with cloths and then took to his heels. The inhabitants of the House of Pansa tried to take with them their bronze statue of Bacchus and a Satyr but were forced to abandon it in a vase in the garden and flee unhindered.

But who could flee? It was difficult to leave the city and perilous to be out in the open, exposed not only to the hail of pumice stones and rain of ashes but also to the falling stones of collapsing buildings. In the Forum many were killed when the columns fell. Flight to the north was impossible, because it was from that direction that the fiery hell was steaming, and many met death on the road in front of the Herculaneum Gate, where they vainly sought shelter in the tombs. Only the streets leading south still offered some hope, but even there many only rushed to their end, like the thirteen persons whose corpses were found in the vicinity of the gate to Nuceria (plate 12). If anyone succeeded in leaving the city behind him, his life was still in peril, since the calamity did not stop at the city walls. Of those who hoped to escape by sea, many never got as far as the shore.

That there were so many more deaths in Pompeii than in Herculaneum is explained by the fact that in the latter, from the beginning, it was clear that the only escape lay in flight before the river of slime but that there was not a moment to lose, the road to Naples still being usable but only so long as the northwest wind held. The number of Pompeians who lost their lives on August 24, 79 A.D. has been estimated as over two thousand, some ten to thirteen percent of the population. But Pompeii itself was literally swallowed up by the earth, and only a few bits of ruin emerged here and there from the lava and detritus to mark the spot where, a few days before, there had been a city brimming with life but which was now condemned to be buried out of men's sight for more than seventeen centuries.

Grief and horror greeted the news of the calamity wherever it reached. "Will future centuries, when new seed will have covered over the waste, believe that entire cities and their inhabitants lie under their feet, and that the fields of their ancestors were drowned in a sea of flames?" wrote the poet Statius (*Silvae* iv. 4). And Martial, in the year 88, commemorated in a poem (iv. 44) the destruction of the region around Vesuvius which "Bacchus loved more than the hill of Nysa" and where Venus cared more to sojourn than in Lacedaemon.

The catastrophe took place during the reign of Titus (79–81), and the emperor tried to do what he could. Suetonius reports in his biography of Titus (viii. 9) that "out of the body of ex-consuls he chose by lot a commission to organize relief for Campania, and whatever property had been owned by people who died without heirs in the eruption of Vesuvius he allotted to the stricken cities to be used for their rebuilding." But there was nothing to rebuild in Pompeii and Herculaneum, and their survivors had no choice but to settle elsewhere.

As soon as it was possible, the Pompeians attempted to salvage their buried possessions. They burrowed down into their houses, whose positions could still be determined by the occasional landmark of some ruin or other, and they broke through the walls to get from one room to another. Much returned safely to the hands of the owners, much however was stolen, as one would expect. A number of wall inscriptions testify to the activity of these first excavators, rightful or not. Thus in the House of Popidius Priscus (VII, 2, *20*), there is this laconic notice in Greek letters as warning that the house had been burrowed and tunneled: *Dummos [domus] pertusa*. Along with other inscriptions in the House of the Golden Cupids one finds: *quinquaginta ubi erant exinde iacent* (since the day of the catastrophe, fifty still lie here), referring, it would seem, to the numerous inhabitants of this house.

Then, after a while, Pompeii became silent. Only occasionally was there passing mention of it by Roman writers. With time the place itself lost its name. People in the vicinity simply referred to it as "Civitas"—they remembered only that once there had been a city there—and, in its Italian form of *civita* (city), the name was retained through the centuries until the forgotten place began to be dug out of oblivion.

But that was a matter of centuries and centuries. The Middle Ages no longer knew or cared about the buried cities. In the literature of the Renaissance the name cropped up here and there, in 1488 in the *Cornucopia* of Niccolò Perotti, in 1504 in the *Arcadia* of Jacopo Sannazaro. In 1551, in his *Descrittione di tutta Italia*, Leandro Alberti described the eruption of Vesuvius in the year 79 and also mentioned the destruction of the two cities: "*brusciò detto fuogo due Città quiui vicine, cioè lo Herculanio & Pompeij.*" Yet at no time did anyone give any serious thought to pinning down just where the lost cities were located. And when this did finally happen, thanks to Lucas Holstenius, an erudite scholar of Hamburg residing in Rome who arrived at the correct conclusions, the information did not fall on fertile ground. On the basis of firsthand acquaintance with the district, Holstenius came to the conclusion that Pompeii must have been at the site then known as Civita, though when he published this opinion in his *Annotationes* in 1637 he met with considerable opposition, the scholars of the time being inclined much more to identify that spot with the ancient Stabiae.

Meanwhile, a part of Pompeii had in fact been excavated without anyone realizing it. In 1592 Count Tuttavilla had had an underground canal constructed to bring water from the Sarno to Torre Annunziata. In charge of the project was no less than Domenico Fontana, the Roman architect whose name is associated with the erection of the obelisk in front of St. Peter's and who began the Palazzo Reale in Naples. His subterranean gallery led past the Amphitheater and the Temple of Isis and across the Forum, and the workers turned up inscriptions and coins without anyone understanding that they were in nothing less than the mysterious city of Pompeii itself.

Much the same happened in 1709 when the Austrian Prince D'Elboeuf began to dig a well on the site where Herculaneum was buried and came upon what he took to be a Temple of Hercules. He managed to bring a number of statues to light, three of which he presented to Prince Eugene of Savoy, among them the two female figures still known to archaeology as the Large and the Small Herculaneum Females. After the death of Prince Eugene in 1736, the statues entered the collection of the Prince Elector August of Saxony in Dresden. There they were seen by August's daughter, Princess Maria Amalia Christina, a passionate enthusiast of art who, in 1738, was to become the wife of the man under whose rule the first planned and orderly excavations would be undertaken: Charles III, son of Philip V of Spain, who in 1735 at the age of nineteen had acceded to the throne of the Kingdom of Naples and Sicily, then known as the Kingdom of the Two Sicilies. Even before his marriage the plot of land in Portici formerly owned by Prince D'Elboeuf had caught his eye when he was looking for a place close to his capital where he could hunt and fish. So it was with special interest that he saw what the former owner had dug out of the ground. The couple shared a passion for just such Antique treasures as the site appeared to afford, so on October 22, 1738, shortly after their marriage, Charles III ordered the excavations resumed at Herculaneum, at the point where D'Elboeuf himself had dug.

The terrain at Herculaneum posed special problems. The city lay under fifty to sixty-five feet of volcanic slime which had cooled down to become hard as stone. Moreover, the modern town of Resina had grown up on the site and could too easily be endangered by rash operations. The only possibility was to dig the same sort of underground galleries as in mines, and in his notes on his travels in Italy Goethe remarked that it was "a thousand pities that the excavation had not been carried out in an orderly manner by German miners, since without doubt, in the course of a haphazard predatory grubbing about, many noble antiquities were wastefully dispersed." As head of the undertaking, the king appointed the Spanish colonel Rocque Joaquin de Alcubierre, who, as commander of the engineer corps in Naples, was technically well equipped for the operation but had not a glimmer of understanding of art and Antiquity. J. J. Winckelmann condemned him in no uncertain terms: "This man, who had as little to do with antiquities as the moon with crabs (to cite the Italian proverb), was guilty of much damage and the loss of many beautiful things because of his inexperience." However, Charles III did give Alcubierre a mentor in the person of his own erudite librarian, Marquis Marcello Venuti from Cortona, who, as early as 1749, wrote the first book on the discoveries at Herculaneum.

It was on December 11, 1738, that the excavators first learned with certainty what they were uncovering: fragments of the building inscription of the Herculaneum theater came to light. But no one at the time could have thought of an excavation in modern historical-topographical terms, and what they were after were primarily art works to enrich the monarch's collection, so whatever was unearthed was promptly carted off to the royal villa at Portici.

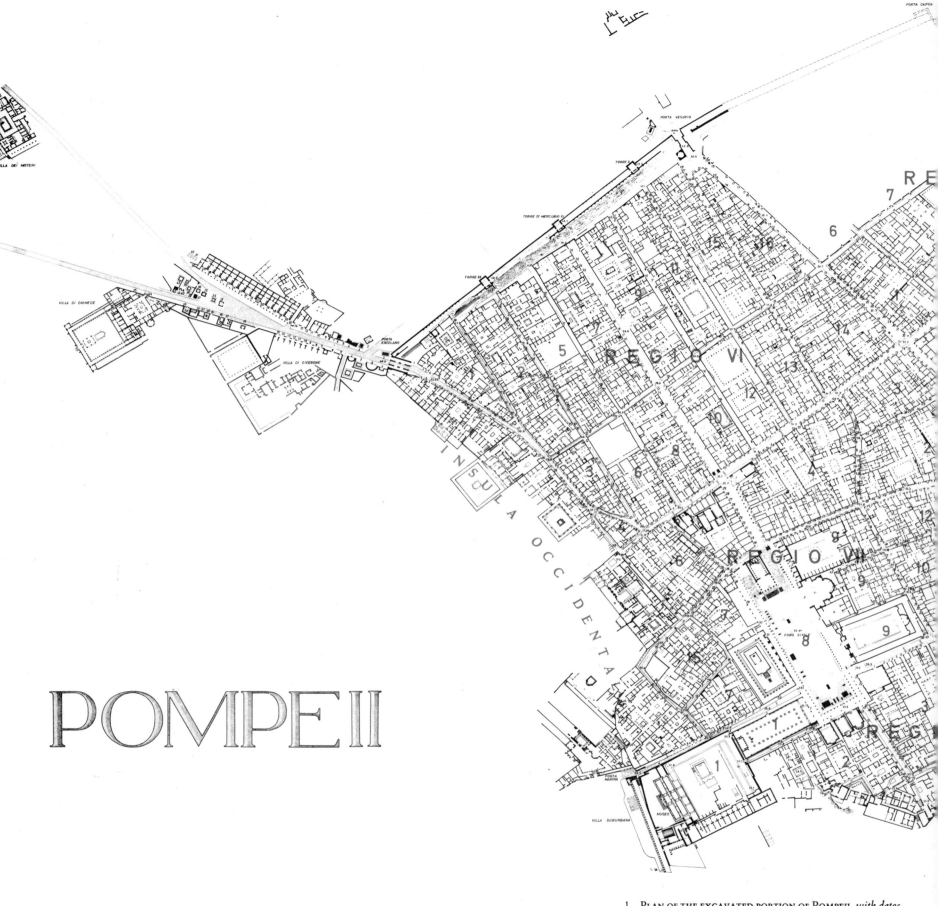

1 PLAN OF THE EXCAVATED PORTION OF POMPEII, *with dates of the unearthing of the more important buildings and ensembles. 1748:* area of the Amphitheater. *1755–57:* Villa of Julia Felix (regio II, insula 4, entrance *3.*) *1763–70:* Herculaneum Gate and the first tombs on the Via dei Sepolcri northwest of the city, plus parts of the insula occidentalis (work there continuing to 1808). *1764–66:* Temple of Isis (VIII, 7, *28*). *1766–94:* area of the Theaters (VIII, 7). *1771–*

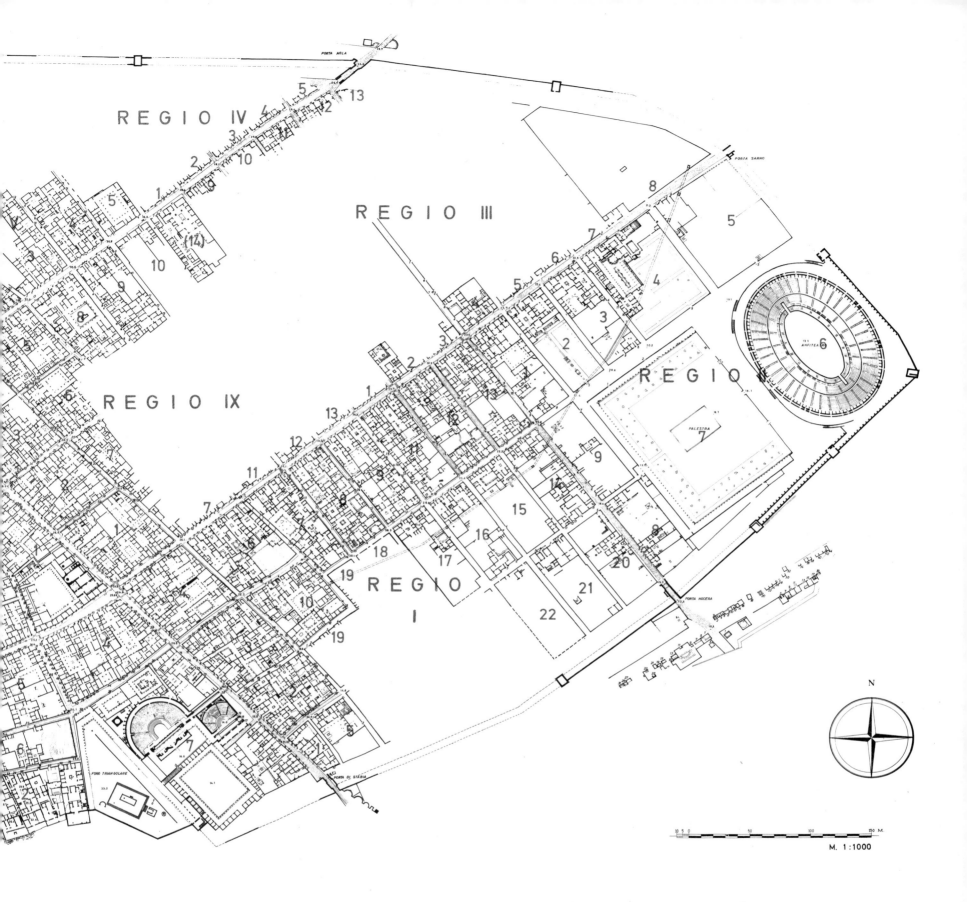

REGIO IV

REGIO III

REGIO IX

REGIO

REGIO I

PORTA NOLA

PORTA SARNO

PORTA NOCERA

PORTA DI STABIA

FORO TRIANGOLARE

AMFITEA

PALESTRA

N

10 5 0 50 100 150 M.

M. 1:1000

74: Villa of Diomedes on the Via dei Sepolcri. *1780–1812:* Via Consolare (VI, 1, and insula occidentalis). *1813–23:* Forum (VII). *1830 et seq:* House of the Faun (VI, 12, *2–5*). *1845:* Marina Gate in the southwest corner of the city. *1851–52:* Stabiae Gate in the northeast corner of the city. *1857–61:* Stabian Thermae (VII, 1). *1877–78:* Central Thermae (IX, 4, *5–10*). *1879:* House of the Centenary (IX, 8, *3, 6*). *1893:* House of the Silver Wedding (V, 2). *1894–*

95: House of the Vettii (VI, 15, *1*). *1903–5:* House of the Golden Cupids (VI, 16, *7*). By the end of the nineteenth century the city had been laid bare west of the Strada Stabiana (between the Vesuvius Gate and the Stabiae Gate) together with the west insulae of regio I, insulae 1–5 of regio V, and insulae 1–10 of regio IX. *1909–10 and 1929–30:* Villa of the Mysteries.

Beginning in 1912 the excavations were concentrated

chiefly in regii I and II south of the Via dell'Abbondanza (between the Strada Stabiana and the Sarno Gate). *1950–60:* Nuceria Gate and Necropolis, House of Fabius Rufus (VII, occ., *16–19*). *1970:* House of Julius Polybius (IX, 13, *1–3*), investigation of city wall outside the Sarno Gate. *Not yet excavated:* the residential districts to the north (regii IV, V), an area south of the Via dell'Abbondanza (regii III, IV), and part of regio I east of the Stabiae Gate.

On royal orders, Alcubierre began to excavate at Pompeii on April 1, 1748. He first uncovered the residential quarter around the intersection of what are now known as the Strada di Nola and the Strada Stabiana. He then proceeded with virtually no plan or forethought, skipping from there to dig out the Amphitheater and then the Villa of Cicero just inside the gate to Herculaneum. Luckily, along with Alcubierre there was a Swiss engineer, Karl Weber, who conscientiously drew ground plans and noted the findings on them. His plan of the Villa of the Papyri, unearthed in Herculaneum in 1750, is a model of the skill in measurement attained at the time (plate 172), and modern excavations have proved his plans of the villas in Stabiae to be of astonishing precision.

Not until August 16, 1763, was there proof that it was Pompeii that was being dug up. On that day was found the inscription of Titus Suedius Clemens, the emissary Vespasian sent to Pompeii after the earthquake to safeguard public property. By then, Charles III had left Naples to assume the Spanish throne left vacant at the death of his brother in 1759, ceding the Kingdom of Naples to his son Ferdinand, aged three. Even as an adult, Ferdinand never managed to work up much interest in the diggings at the buried cities, but when he married, his wife Carolina, a daughter of the Austrian Empress Maria Theresa, did her best to encourage the explorations, seconded by her brother, Emperor Joseph II, who, in 1769, visited Pompeii in person. After the death of Weber, Francesco La Vega took over the direction of the project, a post he continued to hold even after the Neapolitan throne was taken in 1806 by Joseph Bonaparte and in 1808 by Joachim Murat and his wife Carolina, Napoleon's sister. Under the new rulers the excavations took on new enthusiasm. Carolina insisted on receiving regular reports of the activities there, and Pompeii began to be exhibited with increasing pride to visiting foreign dignitaries.

When Ferdinand was restored to his throne in 1815 work continued in Pompeii, as it did under his successors, though with sometimes less, sometimes more enthusiasm depending on their individual interest. Important zones like the Forum and Amphitheater, the Via dei Sepolcri, and the northwest quarter were laid bare, but excavation techniques remained much as at the outset. A new era in this respect was not ushered in until Victor Emmanuel II became the first king of a united Italy in 1861 and had the good fortune to find the ideal man for the post of director of excavations.

But before proceeding, special mention must be made of one earlier event: in 1788 work began on remodeling the Palazzo degli Studi in Naples, the palace housing the royal university, into a museum for the antiquities being brought to light which, until then, had been stored in the royal villa at Portici. The move took many years, and it was apparently not until 1822 that everything was installed in the new building, which eventually became the Museo Nazionale.

Among the many writers who concerned themselves with the dead cities, Johann Joachim Winckelmann (1717–1768) made an outstanding contribution in his two "epistles" and "reports" concerning Herculaneum. These were not only the first clear accounts of what was found and its significance but also the first genuinely scientific archaeological publications. Especially thorough was his treatment of the written scrolls found in the Villa of the Papyri in Herculaneum, four of which, at that time, had been successfully unrolled. In March, 1787, Goethe visited Pompeii and Herculaneum, and the deep impression made on him—"I can scarcely imagine anything more interesting"—lasted throughout his long life, nurtured especially by his friendship with Wilhelm Zahn, who in 1827 began the publication of his volumes on "the most beautiful ornaments

and most noteworthy paintings from Pompeii, Herculaneum, and Stabiae." That compendium was preceded by the series cataloguing the treasures in the Reale Museo Borbonico, the new royal museum, which began publication in 1824 and by 1857 had reached a total of sixteen volumes.

From 1860 to 1875 the excavations were under the supervision of the appointee of Victor Emmanuel II, Giuseppe Fiorelli, and only with his arrival on the scene can one begin to speak of methodical work in the modern sense. Before him, the approximately fifty acres of Pompeii that had been laid bare made up no consistent and cohesive area but were only isolated sites scattered here and there. The first goal of Fiorelli was to expose all the connections between these sites, and this required removing the tons of debris accumulated in the course of the unsystematic digging done under the Bourbons. Then he decided to assign numbers to the houses and worked out a system by which the entire city, including the zones as yet unexcavated, was divided into nine districts or neighborhoods called *regiones*. Within each district each block of houses or *insula* was assigned a number, as was each house entrance within the block, ending up with an address every bit as clear as that of any city dweller. Thus, as an example, IX, 2, *12* means simply district or *regio* IX, *insula* 2, entrance *12*.

Until Fiorelli took over, anything attractive in the way of painting found on the walls—a single figure, a scene—had been simply cut out and removed to the museum. He promptly put an end to this senseless destruction of ensembles and their context. One of his most brilliant ideas was to have plaster casts made of the forms impressed into the lava by the bodies of dead humans and animals, thereby enabling us to reconstruct in detail their last grim moments.

His successor was an architect named Michele Ruggiero, who was in charge from 1875 to 1893. Along with his very proficient excavations in districts V, VIII, and IX, Ruggiero set about restoring buildings, something which Fiorelli had shied away from but which was indispensable if they were to be preserved. Ruggiero proceeded with the utmost scientific conscientiousness, and the reconstruction of the imposing atrium in the so-called House of the Silver Wedding is to his credit, besides which he exercised much ingenuity in making it possible to preserve the wall paintings *in situ*.

Ruggiero formulated the plans for what needed to be done and the methods that were to be used, and they were respected and extended by his successors: Giulio de Petra from 1893 to 1901 and again from 1906 to 1910, Ettore Pais from 1901 to 1905, and Antonio Sogliano, who was director of excavations under De Petra from 1905 to 1910. All worked chiefly in the west half of the city, but Vittorio Spinazzola, in charge from 1910 to 1924, set himself the goal of linking up this area with the already exposed Amphitheater. To this end he set to work on the Via dell'Abbondanza, laying bare the entire street and its house fronts, though not the buildings behind them. This was an entirely new approach, which resulted in bringing to light one of the most important business streets of Pompeii, with its shop signs, election notices painted on its house fronts, utensils used in the shops and inns, all of which—a real innovation—were left on the spot where they belonged.

By 1924 Spinazzola had just reached the area of the Amphitheater, so that the starting point for his successor was to all intents and purposes given. That successor proved to be an excavator of great style, Amedeo Maiuri, who had the great fortune to be able to devote thirty-seven years to his task, from 1924 to 1961. Trained under Sogliano and Spinazzola,

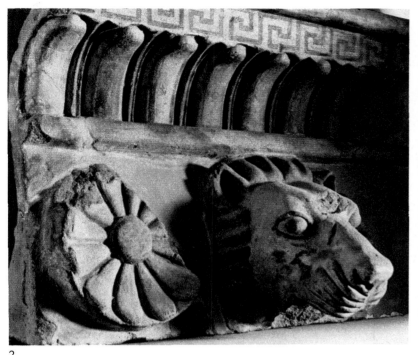

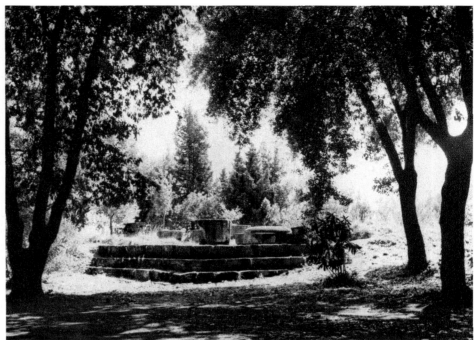

2

3

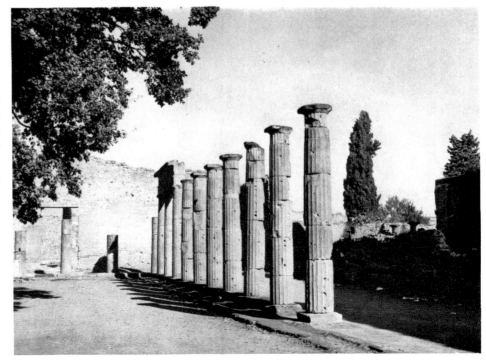

4

2 CYMA (GUTTER BRACKET), FROM THE GREEK TEMPLE. *Terra-cotta, height 16 1/2". Antiquarium, Pompeii.* Numerous terra-cotta fragments from the roof of the earliest temple in Pompeii have been found, and they provide evidence of a number of different phases of building. This gutter bracket belongs to an early period, as far back as the first third of the fifth century B.C. Its base, with alternating rosettes and lions' heads, is surmounted by a hollow molding embellished with a pipebowl pattern and a painted meander border. The terra-cotta slabs were painted red, brown, and yellow. Stylistically, the closest parallels are to the art of Sicily and Magna Graecia, the Greek settlements in southern Italy, and it is thought that the terra-cottas were produced in Ischia, the ancient Pithecusae, at the mouth of the bay of Naples.

3 GREEK TEMPLE. Nothing remains of this temple, built about the middle of the sixth century B.C., except its base and steps. It would seem to have had six Doric columns across the front and eleven on the long sides. A colonnade of such dimensions around a relatively small cella, the main sanctuary with the statue of the god, strongly suggests the influence of Magna Graecia. It is not certain which god was worshipped here.

4 EAST PORTICO OF THE TRIANGULAR FORUM, *viewed from the south.* The porticoes erected in Hellenistic times around the large triangular plaza enclosing the Greek temple continued to use the Doric order, but their late date is revealed by the high, slender shafts which must have made a striking contrast to the squat ones of the much earlier temple. In the background is an atrium with Ionic columns which constituted the entrance to the Triangular Forum.

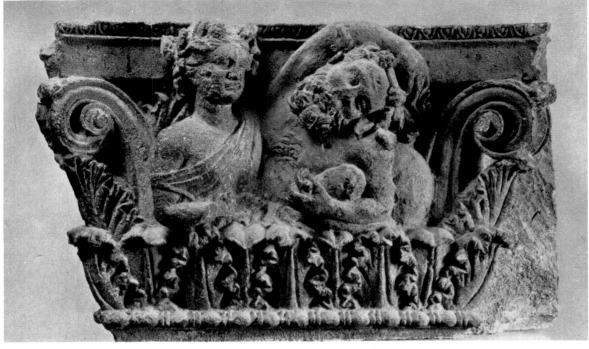

5

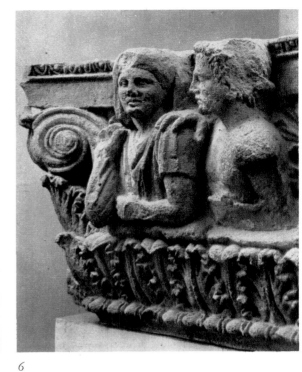

6

5, 6 CAPITALS, FROM THE HOUSE OF THE FIGURED CAPITALS (VII, 4, 57). *Tufa stone, height 19 1/8". Antiquarium, Pompeii.* These fine carvings come from one of several houses dating from the Tufa Period that had figured capitals on the pilasters flanking the entrance. As was customary, both sides were carved so that one faced the street, the other the threshold. In this one, from the right-hand side of the portal, the front (plate 5) has a row of acanthus leaves surmounted by two corner volutes between which a drunken Silenus sprawls, his right hand thrown over his head, his left clutching a wineskin to his bosom, while an ivy-crowned maenad looks on. The carving on the entrance side (plate 6) is more sober, with

a nude young man on a couch resting his right hand on the shoulder of a woman with coif and veil. Traces of color on the companion piece to this capital tell us that such architectonic sculpture was originally painted.

7 VIA DELLA FORTUNA, *looking east.* The broad, straight street, also known as the Strada di Nola because it continues directly to the gate on the road leading to that town, is one of the main arteries of the city and belongs to the area built up in Samnite times. The facade of the House of the Faun, seen here in the left foreground, exemplifies the dignified and rather stately character of

the upper-class houses of the Tufa Period. The entrance is embellished by two pilasters with Corinthian capitals and was originally covered with stuccowork.

8 CUBICULUM IN THE FIRST STYLE, HOUSE OF THE CENTAUR (VI, 9, *3–5*). The walls of this bedroom are decorated in the manner typical of Samnite times, in the so-called First Style (see p. 165), with painted stucco imitating the marble facings of a real stone wall. The horizontal zones are separated by markedly projecting cornices which have the usual fine dentate patterning on their moldings.

7

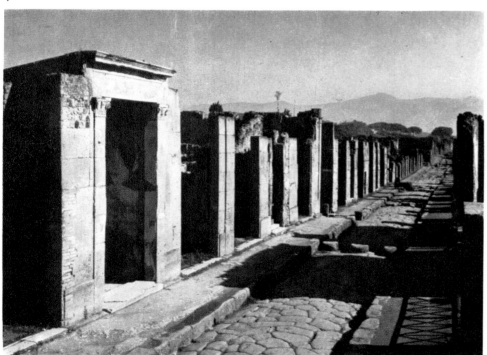

8

9 LARARIUM. HOUSE OF LUCIUS CAECILIUS JUCUNDUS
(V, 1, *26*). The owner of this house on the Strada
Stabiana was a banker, and the accounting tablets found
here have provided invaluable clues to events around the
time of the earthquake. At the left of the entrance is this
large pedestal in gray-streaked marble with red marble
moldings on which the two-tiered shelf held the statuettes
of the Lares, the household gods. The relief at the top of
this pedestal is matched in style and subject by another
which, in modern times, has been set into the wall above
it, though it is not known where this second relief was
found nor even if it belonged to this same house.

Of no particular artistic value, these unpretentious
folk-style reliefs are of note only because they depict the
earthquake of A.D. 62. The one on the pedestal shows a
gate tipping drastically to one side and, close-by, a temple
toppling over. There is an equestrian statue on a high
pedestal to either side of the temple and, in front of its
steps, a podium with an altar. Although there are only
four columns across its front instead of six, this was un-
doubtedly intended to be the Temple of Jupiter on the
Forum, together with the triumphal arch to the west of
it (see plate 15: *4*). To the right of the temple are depicted
two liturgical vessels used in sacrifices, a pitcher and a
patera, then an altar with an unidentifiable sacrificial
animal in front of it and, behind it, a female bust thought
to portray the Bona Dea. Since the Italic earth goddess
Tellus was venerated also under the name of that Roman
divinity, nothing could be more natural than that pro-
pitiatory offerings should be brought to her after an
earthquake. To the right of the altar, an altar servant
(*victimarius*) is shown with a ribbon-bedecked bull which
it was his task to put to death, and at the edge of the relief
there are other liturgical vessels.

On the upper relief, set into the wall, there is no dif-
ficulty in recognizing the city waterworks and, alongside
it, the collapsing Vesuvius Gate. To the right, outside the
city wall, a masterless team of oxen flees in terror—its
successful escape was doubtless the reason it was pictured
here and suggests that the relief was carved as a thank
offering. The tree at the right margin denotes a sanctuary
in the countryside. To the left of it, an altar holds sacri-
ficial offerings and what may be three drinking horns, and
at its foot can be made out, with some difficulty, a berib-
boned garland and an animal, perhaps a lamb. The other
objects defy identification. Above the altar is a wreath
with bows or loops.

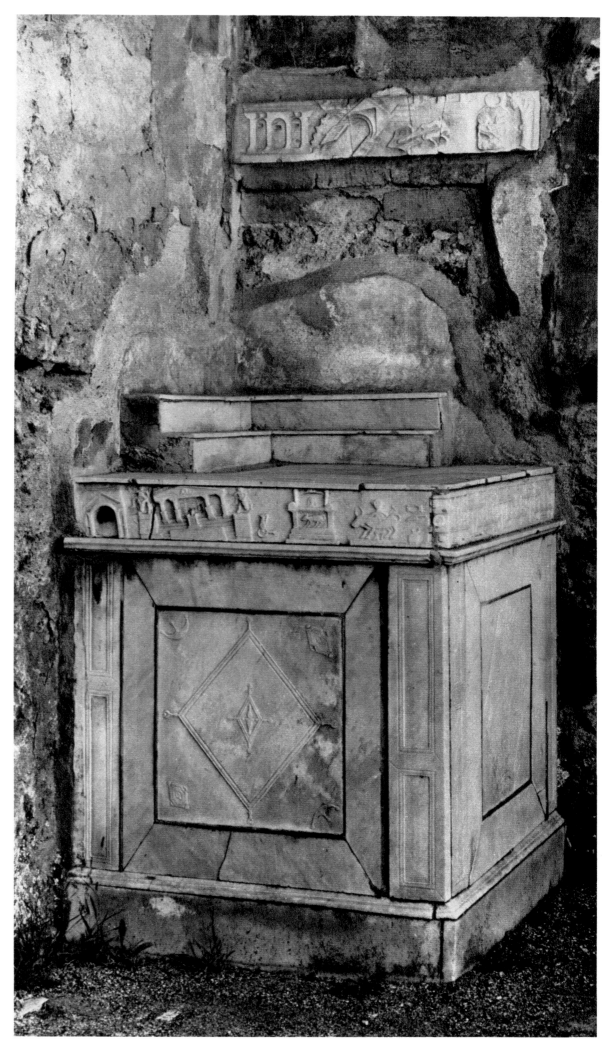

10 TEMPLE OF ZEUS MEILICHIOS. After the earth-
quake, this temple on the Strada Stabiana took over the
function of the Capitol, the chief religious edifice of the
city. A podium against the rear wall of the cella held
terra-cotta statues of Jupiter and Juno and a bust of
Minerva. Although this small sanctuary was mentioned
in an Oscan inscription on the Stabiae Gate, the present
building seems to date only from the time of Sulla.

In the court, the altar stands athwart the axis of the
temple whose four-columned front rose above a high,
outside flight of steps. The capitals of two pilasters have
survived, the smaller doubtless from a doorpost, the other
perhaps from a corner of the cella.

11 BACCHUS AND MOUNT VESUVIUS (*detail of a fragmen-* ▷
tary painting), *from the Lararium, House of the Centenary
(*IX, 8, 3, 6*). Wall painting transferred to panel. Museo
Nazionale, Naples.* This is a decidedly unusual picture
for a shrine to the Lares in a private home. There is the
customary serpent over the altar (see plate 288) as in so
many lararia, but above it Bacchus himself appears,
behung with clusters of grapes and pouring wine from a
goblet to be drunk by his panther companion. Although
certainly not realistic, and no reliable guide to what it
looked like before its cone erupted, the mountain was
unquestionably meant to represent Vesuvius.

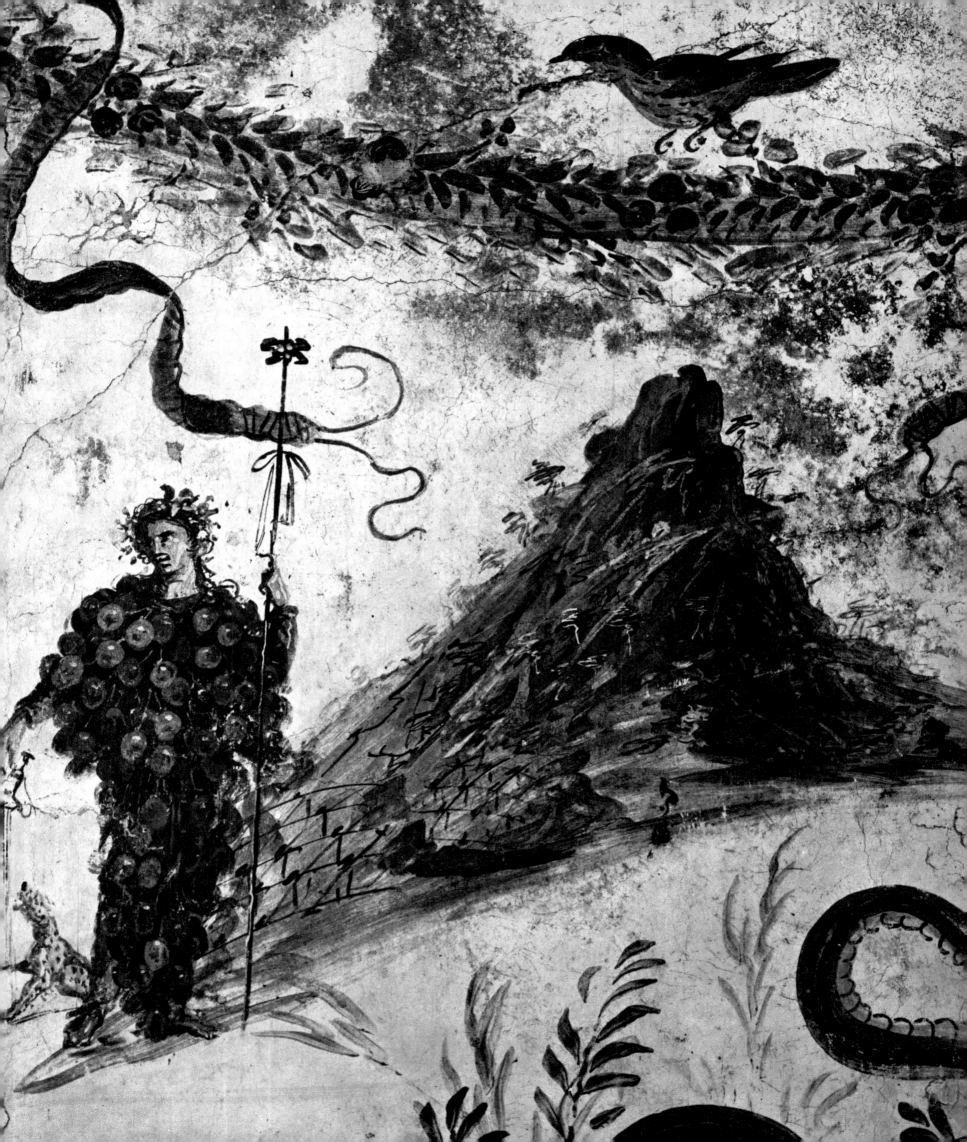

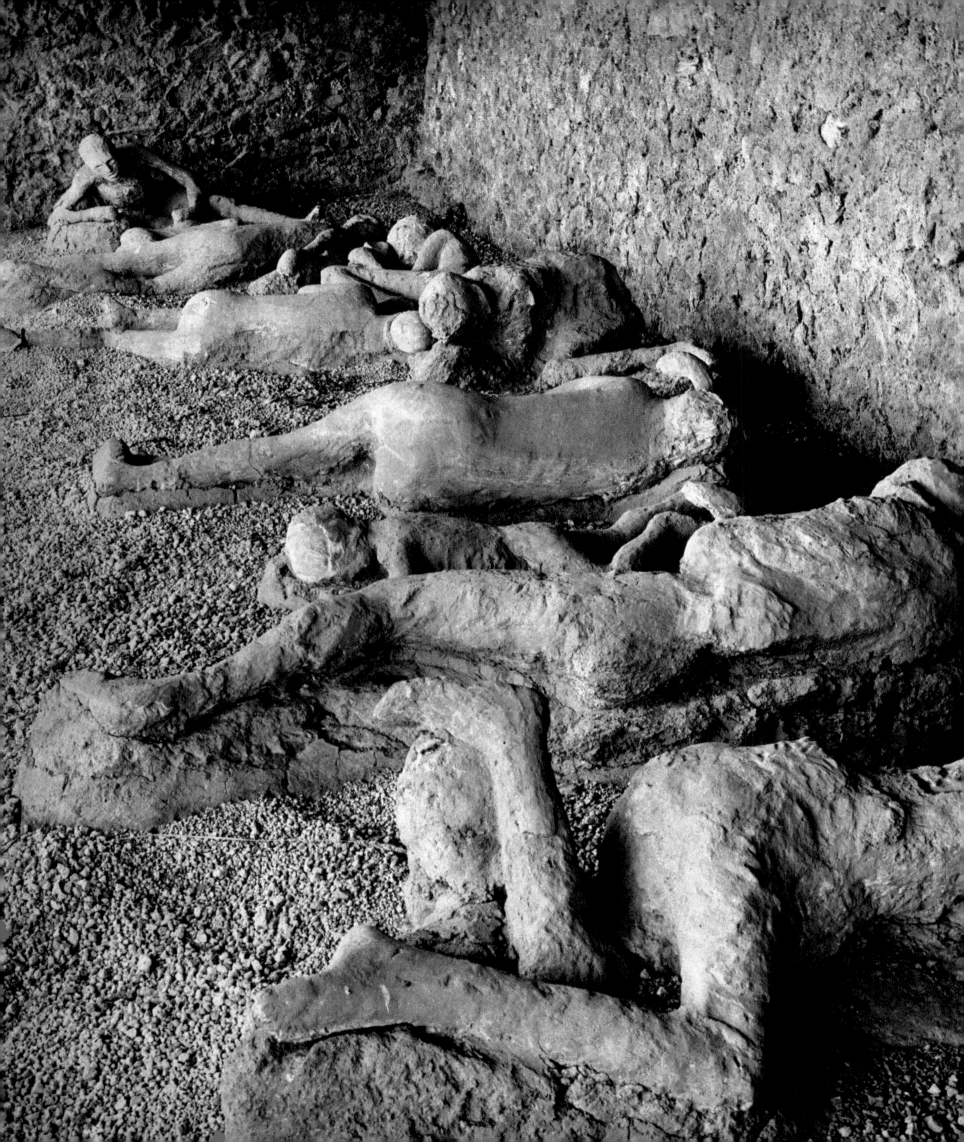

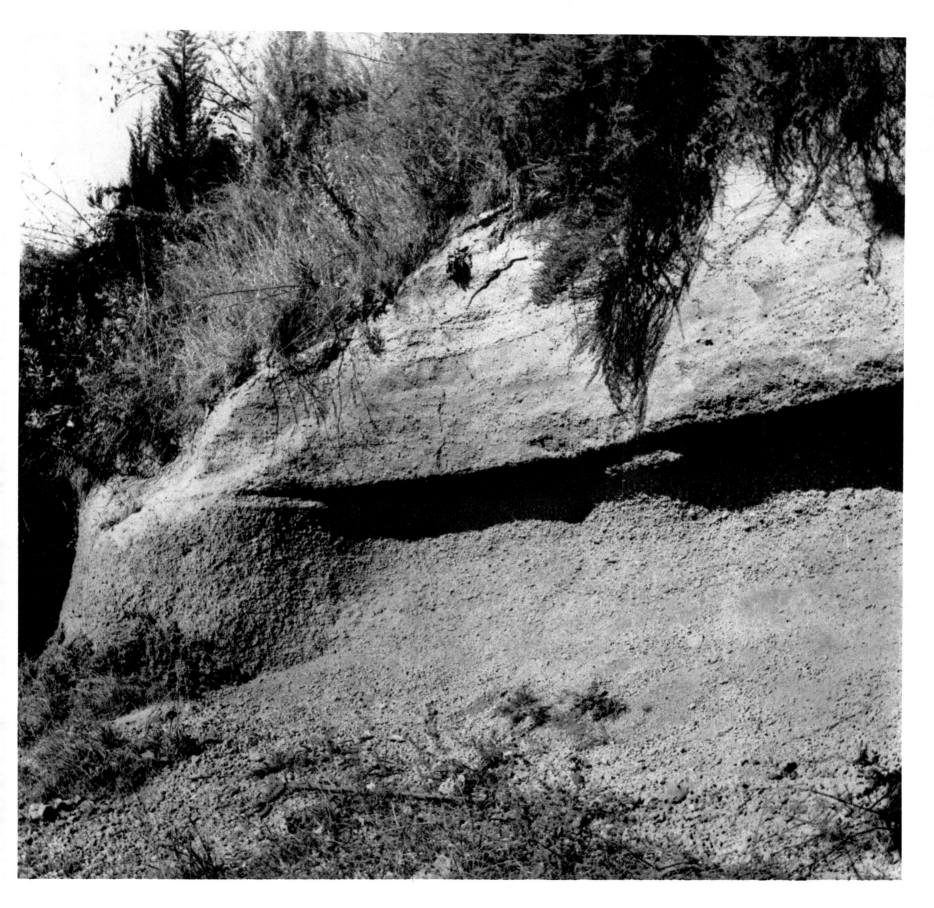

12 CASTS OF BODIES AT THE NUCERIA GATE. Not only within the city but also outside its walls bodies have been found of Pompeians whose lives were snuffed out in the terrible catastrophe. Wherever they fell their bodies were buried under lava which, in time, hardened into something as accurate as a sculptor's mold. The casts made from these bodies give us a terrifyingly immediate picture of the death throes of these helpless people. Among the most dramatic finds in the excavations carried out since World War II were a great many such bodies caught by death at the Nuceria Gate.

13 STRATIFICATION OF THE VOLCANIC MASS OUTSIDE THE VESUVIUS GATE. The best place to observe the stratification of the lava mass spewed forth by the volcano is outside the north wall of the city. Beneath a layer of humus is a stratum of ashes mixed with sand and stones which in turn covers a third stratum with tiny pumice stones. The latter, as can be noted here, are light and tend to roll down, whereas the layer of hardened ash holds together firmly.

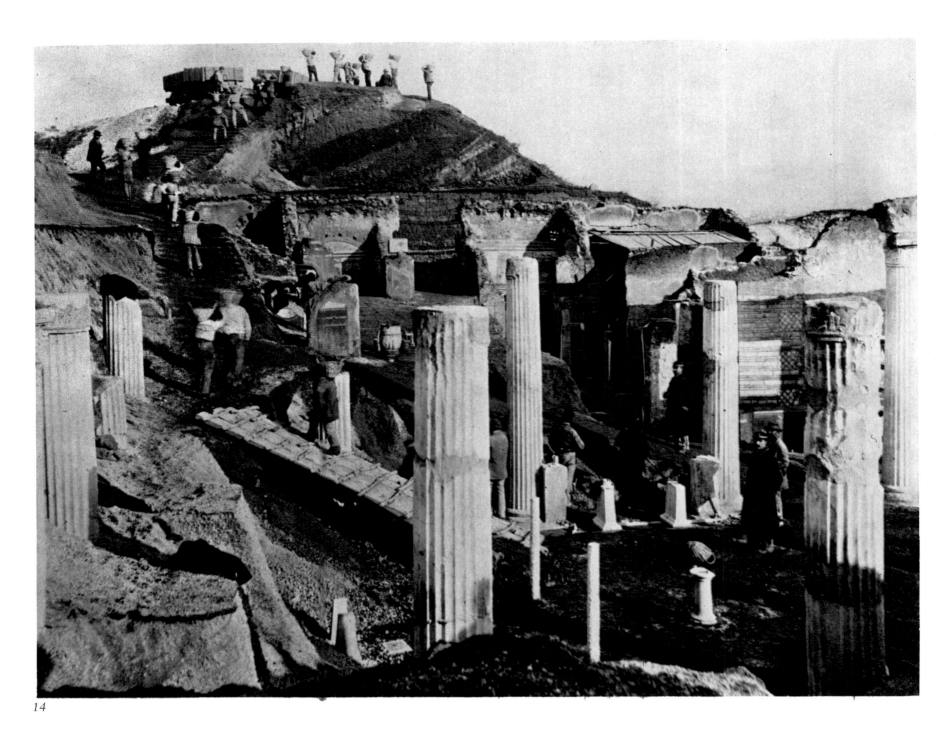

14

14 UNEARTHING THE HOUSE OF THE VETTII (VI, 15,
1). Work began at this house in September, 1894,
and this photograph, probably taken even before 1895,
shows how the diggings had already approached the
floor level of the peristyle and exposed its small, decor-
ative columns and table bases. The workers with shovels
are in the atrium, and in the background can be seen the
entrance to the house. We see, too, that no time was lost
in raising a protective roof over the oecus with its lovely
decoration (plate 301).

he brought to his work his own unique, extraordinary energy. Not only did he set about exposing all the houses behind the facades on the Via dell'Abbondanza, but he also filled in every last blank spot on the map of Pompeii. Among his major achievements was the unearthing of the world famous Villa of the Mysteries, of which only a part had been exposed in 1909, and also the Necropolis outside the gate of Nuceria. In 1927 he took up the long abandoned work at Herculaneum, and during his superintendency he also furthered the investigations of Libero d'Orsi at Stabiae, where various villas were laid bare. At Pompeii he had an untiring and highly meritorious colleague in Olga Elia.

To Maiuri we also owe certain detailed excavations intended to cast light on the early history of Pompeii. These had been attempted previously only sporadically, by F. von Duhn at the Greek temple in 1889 and by Sogliano at the southeast corner of the Basilica and in the vicinity of the Macellum in 1884 and again in 1890. They were resumed by Maiuri in greater style and with more refined archaeological techniques. He also turned his attention to the precinct of the Temple of Apollo and to the House of the Surgeon (one of the earliest in the city), these being of great importance for the understanding of pre-Roman Pompeii. This new field was further explored by the German Archaeological Institute in its stratum diggings in the House of the Faun, another of the early buildings.

With all this intense concentration on excavation, it was inevitable that the work of restoration would have to take second place. When Alfonso de Franciscis took over from Maiuri he recognized the urgency of another approach and promptly ruled out further diggings to concentrate on conserving what had already been unearthed. Only in recent years has he returned to excavation, at the House of Julius Polybius in Pompeii and at a sumptuous villa in Oplontis. It is to be hoped that he will in time have as rich a harvest as his predecessors.

THE CENTER OF PUBLIC LIFE

In only two places does the network of streets and lanes in Pompeii broaden out into large architectonically conceived open squares or plazas: in the Triangular Forum (plate 4) and in the Civil Forum. Although the triangular area at the south end of the older part of the city contained the venerable Doric temple and was linked to the theater and the Samnite Palaestra, the public life of the city centered much more on the Civil Forum. This forum played much the same part in Pompeii as does the main piazza of any Italian town, where as a rule one finds a major church, if not the cathedral itself, the *palazzo comunale* or town hall, and the market. So, too, in Pompeii the Forum was bounded at either end by the Temple of Jupiter and the public offices of the city administration and gave access to the central market and what could be called the bourse. Here a large part of the business life of the city was carried on, much as in most southern countries where the main plaza of a town is still the favorite place to carry out transactions, and where merchants from neighboring towns came to meet their Pompeian suppliers and customers. Public actions took place here, and the noblest right of the Roman citizen, the right to vote, was exercised in the Forum or an adjacent building when the Pompeians met once a year to select the men to guide the fortunes of their city.

The City Authorities and Their Selection

In one of the most radical changes to accompany the constitution of Pompeii as a Roman colony, in place of the *meddix*, who was the highest official in Samnite times, the authority was shared by two leaders, just as Rome itself was governed by two consuls. Like the meddix before them, the *duoviri*, as they were called, had to act as judges and in that capacity bore the title of *duoviri iure dicundo*. They were the highest judicial authority and also exercised the functions of *quaestor*, the Samnitic *kvaisstur*, an office whose existence, however, can be verified only for the earliest phase of the transition from Samnitic community to Roman colony. They were also responsible for taking the census every five years, a task carried out in Rome by the censor. This chiefly consisted in assessing the citizens' private wealth in order to assign them to the appropriate tax groups. The duoviri in whose term a census fell received the title of *duoviri quinquennales*.

If any of these twin positions became vacant during a term, or when an emperor like Caligula preempted one of the posts as a public honor, the city council could select an official to work alongside the remaining duovir, assuming the title of *praefectus* which, in inscriptions, is usually followed by the words *ex lege Petronia*. Nothing is known of this Petronian law, but it is presumed to date from the first half of the first century A.D. A man could become praefectus after having been duovir, as in the case of Gaius Cuspius Pansa the Elder who, according to an inscription in the Amphitheater, held the post of duovir four times before being installed by the city council as praefectus.

Two *aediles*, likewise serving for one year, were responsible for keeping the streets clean and for supervising the public baths and the market which, in a commercial center such as Pompeii, naturally played a great role. One of their special tasks was the organization of the gladiatorial combats and animal baitings in the Amphitheater. Compared with the duoviri the aediles had a much more limited sphere of operation, and candidates for the highest office in the community often served in this lower rank first. In inscriptions detailing a *cursus honorum* (the curriculum of a person in public service) for individuals who held both posts, that of aedilis was always listed before that of duovir. However, such epigraphs do not consistently use the term aedilis; very often they merely designate the person as duovir (in distinction to duovir iure dicundo) or *duovir v.a.s.p.p.*, presumably meaning *viis aedibus sacris publicis procurandis*, that is, the duovir who takes care of the public thoroughfares, the temple, and religious activities.

As with all Roman positions, great honor was attached to being duovir or aedile. Not everyone could aspire to these ranks. The basic requirement was that the candidate hold Roman citizenship and be a man of some means. This applied also to the members of the city council, the *decuriones*, of whom there were usually one hundred. We know that in Comum, the modern Como, a *decurio* had to own 100,000 sesterces, a fairly considerable amount of money, though no doubt this varied from city to city as much as did the prescribed minimum age limit. Moreover, members of certain professions, among them actors and gladiators, could not be elected decurio, and there were detailed provisions to bar people convicted of crimes from ever entering the *ordo decurionum*. Since the members of the city council served for life, it is understandable that great care had to be exercised in their selection.

The decurions could be elected by the population, but the council

itself could co-opt additional members or fill vacant positions or, conversely, those posts could be assigned by the duoviri quinquennales every fifth year in conjunction with the census. We know about these three possibilities from Roman civil law but have no information about which were actually applied in Pompeii. In any case, in Pompeii, too, the council of decurions was the highest authority by grace of whose decisions the duoviri carried out their functions. On epigraphs having to do with public undertakings, there is always the formula, *ex d(ecreto) d(ecurionum)*: by decree of the decurions. This appears also on tombs whose site was granted to worthy citizens by the city and on the pedestals of statues erected by the community in gratitude to public benefactors.

Municipal elections were held early in the year. As a first step, the candidates had to present themselves before the magistrates and request that their names be entered on the election lists. The election battles that followed were every bit as energetic as ours today. Appeals and manifestoes covered the walls of houses, especially on much-used business streets such as the Via dell'Abbondanza (see plate 183). Hordes of *scriptores* (sign painters), some of whose names we know since they often added their own signatures, went about writing out the merits and promises of the candidates in large red letters wherever the *dealbatores* (whitewashers) had readied a surface for them. A good deal of such election propaganda has survived, for the most part from the time after the great earthquake of 62 and especially the years immediately preceding the final disaster of 79. In their briefest form they run something like: *C. Iulium Polybium d(uovirum) i(ure) d(icundo) o(ro) v(os) f(aciatis)* (I beg you, make Gaius Julius Polybius a duovir iure dicundo!). To which was often added the words *d(ignum) r(ei) p(ublicae)* to lend greater weight to the appeal. Very often, too, there is the name of the backer of a candidate or at least a supporter, generally the master of the house on whose wall the appeal is written, which in many cases has given invaluable clues to the owners of particular houses.

With no information about how elections actually proceeded, we must depend on what is known about other communities. Probably the inhabitants of each of the voting districts into which the citizenry was divided came in their own group to cast into the urn the small tablets bearing the name of the candidate of their choice. Rigorous controls were necessary to prevent individuals ineligible to vote from slipping in among the others or to stop people from attempting to vote twice. For this there must have been enclosures or barriers specially set up, as seems to have been the case in a building at the southeast corner of the Forum (plate 15:3). Along its north wall there are postholes in the raised pedestrian sidewalk which must have served for some sort of temporary wooden construction utilized only on specific occasions and which may well have been a kind of rail fence making a passage just wide enough for one person at a time to pass through and vote. For this reason the building has long been called the Comitium, the point of assembly for elections, though there is no absolute proof of this. The building was severely damaged by the earthquake of 62 and was not yet fully restored by the year 79, so that during those seventeen years the elections must have been organized in different fashion elsewhere.

There is even less certainty about where the decurions, duoviri, and aediles met and had their offices, though it may have been in the three buildings on the south side of the Forum (plate 15:9–11). It is difficult to assign specific functions to each of them, but the middle one had wall shelves, which suggests that it may have been the Tabularium, the city archives, and the one to the west may have served as the assembly room for the city council, but these are still conjectures.

The Temple

With the south end of the Forum taken up by the buildings of the city administration, the north end was mostly reserved for religious purposes. There, on a high podium, rose the Temple of Jupiter within whose cella stood the statue of Jupiter, father of the gods, along with statues of Juno and Minerva (plates 15:4, 16, 20, 22). This is not the earliest religious building in the city, being preceded by the Doric temple on the Triangular Forum and even by the sanctuary of Apollo. Nor does it belong to the tutelary divinity of the colony, Venus Pompeiana. But dedicated as it is to the highest of the Roman gods, this temple of the supreme Roman trinity, known also as the Capitol, inevitably occupies the prime position on the largest plaza of the city. In its architectonic design, with high steps leading up to it, a deep pronaos, and the cella walls paralleled by a flight of columns, the building in Pompeii clearly reveals the influence of the Etruscan-Italic temple as described by Vitruvius. Contained within its high podium are rooms whose purpose is still not clear. While they may well have been used to store the liturgical objects or sacrificial offerings for the temple, these chambers, which are accessible from the east, may just as well have served as the public treasury of the city (*aerarium*), as was the case in Rome with the Temple of Saturn.

However, the Temple of Jupiter is not the olny religious building on the Forum. The entire middle of the west side is occupied by the long flank of the precinct of the Temple of Apollo (plates 15:1, 18, 19), the only sanctuary on the Forum whose beginnings can be traced back to archaic times. Originally it was directly connected with the Forum. The space between the pillars on the back wall of the east hall was not closed off, so there was direct access from the court of the temple. Later only three passages were left open, and the others were walled up. Most probably this was done after the earthquake, when the entire precinct underwent a thorough restoration in the course of which not only was the temple itself faced with new stucco in the form of white areas intended to imitate stonework, but the halls themselves were transformed. The Samnite columns were clad in a thick coat of stucco, as were the Ionic capitals, which thereby acquired a form belonging to none of the three classical orders, though closest to the Corinthian. The rear walls of the porticoes were provided with mural paintings in the style of the time of Nero.

The edifice on its high podium appears to blend the formal characteristics of the Greek ambulatory temple with the Italic type we see in the Temple of Jupiter, since its forehall is unusually deep for a peripteros, a trait perhaps inherited from the southern Italic style. It may be, too, that its appearance owes something to a predecessor, because the phase we see dates only from the late Samnite period.

The two temples on the east side of the Forum were not built until after the earthquake. Diagonally across from the southeast corner of the Temple of Jupiter is one of the most modern buildings in Pompeii (plate 15:7). A broad court with two large rectangular niches on the sides lies in front of an apse which encloses an aedicule. The apse was undoubtedly covered by a half cupola, while the court must have remained open, and the floors and walls would have been faced with marble. Work was still going on at the time of the eruption, but had it been completed this ensemble would have been one of the handsomest in Pompeii, and even now its richness shows itself to be very much in the spirit of the reign of Nero. Its purpose is not entirely certain, the most likely explanation still being that it was a shrine for the veneration of the tutelary gods of the city. It may be that it was in its court that the ceremony of sacrificial

thanksgiving and expiation took place, which is depicted in one of the reliefs in the lararium of the House of Lucius Caecilius Jucundus (plate 9). The altar in the middle of the sanctuary of the Lares may well have served for just such a propitiatory offering to Tellus, the earth goddess.

Directly next to it on the south is the temple which, on the basis of the relief depictions on its altar, has been identified as consecrated to the cult of the emperor (plates 15:8, 30–32). Situated in the middle of the east side of the Forum, and opening out on it, the small edifice, with four columns across the front, contained the statue of the emperor and rose from a high podium. Its court is enclosed by a wall whose shallow niches are decorated alternately with round and triangular pediments. Since the entire precinct with the walls, court, and temple dates only from the last years of Pompeii—here, too, the marble revetment was never completed—the emperor venerated must have been Vespasian. Excavations have revealed that buildings from Samnitic and Republican times had stood in this site earlier. Apparently they were commercial halls or at least ones of nonreligious character.

Thus four temples arose around the Forum. Undoubtedly the religious festivities in honor of the divinities worshipped in them must have spilled over into the vast plaza, which has often been likened to a great festive hall open to the heavens. Access by wheeled vehicle was strictly forbidden, with steps or low stone posts strategically placed in each of the streets adjoining the Forum to block anyone who might attempt it (plate 24).

Commerce and Trade

No private buildings were located on the Forum. Everything there that was not consecrated to religion was devoted to trade, money changing, and the exchange of goods. The south end of the west side is occupied by the imposing Basilica (plates 15:2, 35, 36) opening on the porticoes of the Forum, a huge structure with a two-storied hall in its interior. Erected in Samnite times, its main purpose was not to house the law courts, as was formerly supposed, but to provide quarters for a bank and an exchange, activities of fundamental importance for a city like Pompeii, so dependent on its far-ranging commercial connections. Unfortunately we know nothing more specific about what went on there, neither written sources nor archaeological finds offering any clear indications.

Diagonally opposite is the edifice which, according to the inscription over the entablature of the forehall (repeated in smaller letters over the side entrance in the Via dell'Abbondanza), was dedicated by the priestess Eumachia, in her name and that of her son Marcus Numistrius Fronto, to the Concordia Augusta and to Pietas (plates 15:6, 29). The building is composed of a *chalcidium* (forehall), *porticus* (colonnaded hall), and *crypta* (covered passage running behind the colonnades and along the east side).

The reference to Concord and Piety in relation to the Imperial house is best understood as alluding to filial love and here concerns the relationship between the emperor Tiberius, who ruled from A.D. 14 to 37, and his mother Livia, a bond most conspicuously celebrated in Rome in a large altar dedicated to Pietas. A statue of Concordia was in fact brought to light in the building endowed by Eumachia. It stood in the large apse in the middle of the east end of the hall. In the crypta behind it was a statue of Eumachia herself (plate 33), which according to the inscription on the base was erected at the expense of the *fullones* (guild of cloth fullers). If they could do this in such a prominent place, the building must have been

at their disposal. It does appear to have been a large guild hall used for the sale of cloth, in which case Concordia and Pietas played a role like that of other tutelary divinities in Roman market places who almost always had their sanctuary at the rear of a broad court.

The place where the apse opens out is appropriately emphasized by architectonic means, since it is there that the colonnade of the east porticus projects as if to make a baldachin. Other than this, however, the hall and crypta give no evidence of any built-in structures which would tell us more about the kind of activities that went on there. The building must have been very elegant: extensive vestiges of its marble revetment have been found, though they seem to have made up a complete facing only on the rear wall of the forehall.

Opposite the east wall of the Temple of Jupiter, filling the entire northeast corner of the Forum, is the Macellum or food market (plates 15:5, 28). This, too, is organized around a large inner court in which stood a pavilion on twelve columns whose rectangular bases alone have survived. In this airy construction—it had no walls but only a roof resting on twelve columns—were found great piles of fish scales, so that it must have been here that the fish were cleaned before being set out on the market stalls. For the proper effect one must think of the building with wooden booths and stalls, and it is not unlikely that the columns, too, were of wood, which would explain why nothing of them has survived. Behind the porticoes around the court were a number of food shops and no doubt also what we would call delicatessens, since a macellum was no ordinary market but a place where food and delicacies of a certain quality were sold.

Here, too, in front of the east wall, there was a chapel ostensibly dedicated to the Imperial cult. Although the two statues found there cannot be identified precisely, in all probability they depicted members of the Julian-Claudian house under whose protection the market was placed. North of the small sanctuary is a room with an altar in the middle where feasts were probably consumed on the occasion of those religious ceremonies so frequent in Roman territories and which here may have been celebrated by a lay collegium devoted to the Imperial cult, it being highly unlikely that other gods would have been served in such immediate proximity to an Imperial chapel. What is even more likely, however, is that the market authorities had their seat in this room. Judging by the counter sloping to the front, the meat market seems to have occupied the southeast corner of the Macellum, and fish may have been sold alongside it since there is a gutter for waste water behind it.

The building as we see it today dates only from the reign of Claudius, therefore from some time between A.D. 41 and 54, and was restored after 62, judging by the paintings in the west hall, which are in the so-called Fourth Style and date from the reign of Vespasian (A.D. 69–79). At that time also the pavilion in the center of the court (*tholos*) was being rebuilt in more solid form, but the work had only begun when the final interruption occurred.

After the earthquake, a hall went up in the northwest corner of the Forum which also may have been used for selling food or, at any rate, as a large warehouse or storage place (*horreum*). South of it, opening into the wall and separating the enclosure of the Temple of Apollo from the Forum, is the recess containing the *mensa ponderaria*, the table where weights and measures were controlled (plate 244). The table consisted of two slabs, one above the other, into which receptacles were set. These were filled with the quantity of grain, or whatever was being checked on, and the grain was then emptied out through an opening in the bottom. Initial-

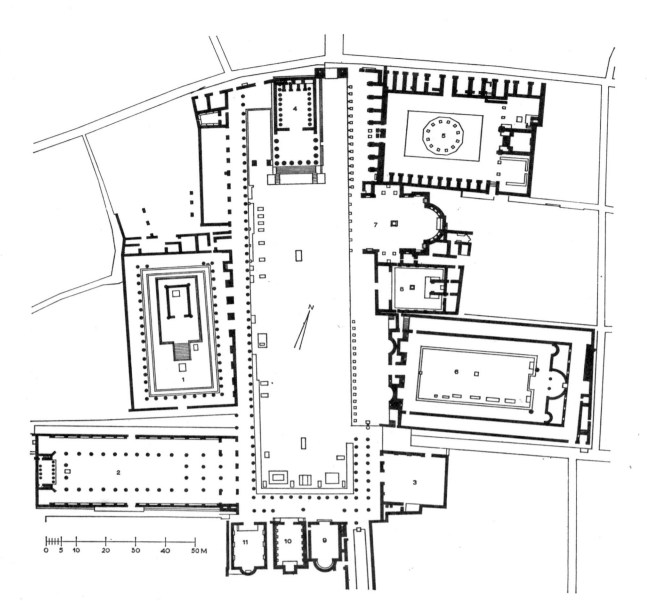

15 PLAN OF THE FORUM. 1) Temple of Apollo; 2) Basilica; 3) Comitium; 4) Temple of Jupiter; 5) Macellum; 6) Building of Eumachia; 7) Sanctuary of the Lares Publici; 8) Temple of Vespasian; 9–11) Administrative buildings

ly all calculations were done according to Samnitic measures recorded in an inscription in Oscan letters, but in the time of Augustus the conversion was made to Roman standards, and the depths of the receptacles were changed. No new inscription was set up specifying the new measures, but on the front of the table we can read that the two duoviri iure dicundo, Aulus Clodius Flaccus and Numerius Arcaeus Arellianus Caledus, "by decree of the city council had had the measures adjusted"—*mensuras exaequandas ex dec(urionum) decr(eto)*. The first-named official is known to have fulfilled his third duumvirate together with Marcus Holconius Rufus in the year 3 B.C., so the inscription on the table must be from about that time, which means that Oscan-Samnite measures remained in use long after the city became a Roman colony. Similar steps were taken elsewhere, notably at Nola and Minturnae, where the same sort of inscription has been found from somewhat the same years.

The Architectonic Plan of the Forum

As we have seen, buildings intended for many different purposes and from quite different times lined the Forum. If the facades of all of them had been visible around the open Forum, the effect would have been much like the picturesque patchwork of styles characteristic of so many medieval piazzas in Italy. However, to create an architectonic unity Pompeii had recourse as early as the Samnitic period to a particular achievement of

Greek architecture, the circumscription of an open space within a colonnade. Excavations in Pergamum, Priene, Miletus, and other Greek cities in Asia Minor have revealed a number of outstanding examples of this. The long fronts of the porticoes were conceived in proportion to the area to be enclosed and create a fully unified frame within which the temple they surround makes a most impressive effect. In the Imperial Forum of the capital, the Romans carried this artistic principle to a point of crystalline symmetry and truly regal majesty.

When Pompeii was still alive and intact, the colonnade in the open plaza concealed from view all the buildings on the Forum with the exception of one: the Temple of Jupiter. The triumphal arch to the left of the temple closed off the space optically, and one wonders if there was not originally a similar monument on the right or, at any rate, if one was perhaps intended, since in the final state of the Forum as we know it the symmetry is broken and the arch to the east lies much farther back.

Viewed as a whole, the plaza of the Forum achieved the same effect as the court of a temple and belongs in form to the same type. The fact that only the facade of the Temple of Jupiter is seen from the Forum is an Italic trait, and in earlier Hellenistic examples it was usual for the columns to continue around and behind the religious edifice.

The colonnades on the west and south sides of the Pompeian Forum are complete and uniform, but on the east side a change sets in at the level of the Building of Eumachia. The material remained the same, the travertine which in Roman times began to replace the tufa used by the Sam-

nites, and the architect continued the two-storied construction, although there was no practical need for it at that point. Above the ground story of the Forum colonnades there was—or was intended to be had the work been completed—a terrace along which people could walk, but in front of the Building of Eumachia the colonnade is two-storied for artistic reasons only, simply to match the height of the edifice itself. However, by subtle differences in the intervals between columns and in their shape the building behind this stretch of the portico receives special emphasis, as it does also by the dedicatory epigraph on the lower entablature. When the colonnade reaches the Macellum, however, there are rather greater differences, since there the lower story even uses another order, Corinthian rather than Doric (plate 21). The space left between the colonnade and the fronts of the buildings behind it acts as a kind of forehall and helps to disguise whatever divergences there may be between the orientation of the buildings and that of the Forum. This is especially so with the Building of Eumachia and the Macellum, whose axes are not at a right angle to the Forum. At the Macellum this was somewhat compensated for by varying the depths of the shops facing the porticoes (plate 15:5), in the Building of Eumachia by constructing double walls toward the Forum—a glance at the plan shows how ingeniously the acute angle resulting from the difference in north-south axis between the Forum and the Building was exploited to squeeze in alcoves and small rooms (plate 15:6). The Temple of Apollo on the west side of the Forum likewise differs in orientation, and there the adjustment was achieved by reducing, from north to south, the thickness of the pillars along the wall parallel to the colonnade on the Forum (plate 15:1).

The plaza of the Forum itself was further articulated by a highly effective and impressive element. As in every Roman public place, there were numerous statues in honor of leading citizens. While only the pedestals have survived, they suffice to give an idea of the artistic principle applied here.

The middle of the plaza remained unencumbered, as was usually the case with forums, since there had to be room for markets, assemblies, and festivities. Along the sides, however, the statues were lined up in front of the columns in close succession, so much so on the south side as to constitute almost a barricade. All of them faced the middle and were placed so that they formed an inner ring within the larger ring of the colonnaded portico. The pedestals of two equestrian monuments, however, project rather more into the plaza, the one at the north end in particular but also the one on the south, which stands well clear of the column base behind it. The result is that the longitudinal extension of the plaza, which is about three and one-half times its width, acquires a rhythmic scansion, and it is almost as if the pedestals were meant to mark off an inner area within the overall surface of the Forum.

All this must be understood as referring to the final state of the Forum, the end result of a long history broken off abruptly in a single day. After the severe damage of the earthquake it was never fully put in order again. The colonnades were still unfinished, and in long stretches the old tufa stone facing had not yet been given the revetment of travertine which, in Imperial times, was introduced to harmonize with the portico.

THEATER AND AMPHITHEATER

No Roman city of any size and importance in the Latin West was with-

out its theater and amphitheater, though this was not true everywhere in the East. Their architectural types and appearances were so thoroughly fixed that even the most unprepossessing vestiges suffice to identify them in any ruin or excavation. Furthermore, differ as they may in character and function—the one intended for dramatic performances, the other for animal baiting and gladiatorial combats—as well as in origin and appearance, the theater as inherited from the Greeks, with its stage proscenium and its semicircle of seats for the audience, has enough in common with the Roman invention of the oval amphitheater that nothing prevents their being discussed together. Both forms have found similar solutions to the basic problem of accommodating a great number of spectators and of providing the means whereby that virtual horde can be gotten to their places and then out again in the most rational and expeditious manner.

There is nothing unusual, then, about the fact that Pompeii had both types of buildings, but what was decidedly out of the ordinary was the style and antiquity of its amphitheater and the architectonic arrangement whereby two theaters, one small and one large, were grouped in a single ensemble together with adjoining buildings and porticoes.

The Great Theater

Pompeii had its theater (plates 45–47) at least a century before Rome acquired its first permanent stone building for that purpose, the one built under Pompey the Great in 55 B.C. No doubt this reflects the Greek influence which so deeply permeated the Samnite town. The site chosen was the slope northeast of the Triangular Forum and southeast of the Samnite Palaestra, in the vicinity of the gate to Stabiae. In accordance with the Greek tradition, the semicircular seating area or *cavea* was embedded in a natural hollow of the slope and enclosed the *orchestra*, which was the name given to the horseshoe-shaped playing area directly in front of the first row of seats. This is typical of Greek theaters, which either had a circular orchestra or extended its sides so much that a full circle could be fitted in between the stage and the cavea. The Roman theater, on the contrary, had a semicircular cavea.

Between the stage and the hemicycle are two lateral passages to the orchestra called the *parodoi*. In Samnite times these were still open, but when the newly founded Roman colony built a smaller, covered theater (*theatrum tectum*) alongside the large open theater, the parodoi were roofed over to make covered passageways.

The first stage structure was built in the second century B.C. and set directly on the ground. It comprised two *paraskenia*, projecting wings at either side with walls set obliquely to the *skene*, the more or less solid building which constituted the permanent scenery and in which three gateways or arches opened on the orchestra. This type, like the cavea, is Hellenistic and underwent considerable change in Roman times: the paraskeniae were abandoned, and instead the rear wall of the stage (*scaenae frons*), which continued to have the obligatory three openings (they adjoined the dressing-room building behind the stage), was flanked by aedicules closed off on the side facing the public. The most important innovation in Roman times was the raising of the height of the stage (*proskenion*) where the action took place.

This is as much as can be concluded from the vestiges that remain, and this is true too for the pools or fountains in the orchestra area, which were frequently modified over the years. Much is uncertain, including the detailed chronology. We do have two inscriptions found in the theater

itself from which we know that Marcus Holconius Rufus (plate 25) and his brother Celer had the *crypta*, *tribunalia*, and *theatrum* built or remodeled at their expense. This would have been in the reign of Augustus, when the brothers were politically active. By *theatrum* was meant the semicircular auditorium for the public, and it was given marble seats at that time. In the course of this remodeling, four concentric semicircular walls were laid under the cavea to protect the terrain from landslides. The *crypta*, a covered corridor, was connected to the upper gallery and supported additional rows of seats. By raising the cavea in this fashion, the theater could accommodate about five thousand spectators.

The hemicycle, in its final form, consisted of three tiers. The lowest one had seats for distinguished persons and was reserved for magistrates and other dignitaries. This was an honor often boasted of on tomb inscriptions. The next tier up, divided by stairs into five *cunei* or wedges, was accessible from the lower passageway, while the highest seats were reached from the Triangular Forum. Above the parodoi were located the *tribunalia*, what we would call boxes or loges, and these were set aside for the officials who organized the spectacles. The architect employed by the Holconius brothers recorded his name in an epigraph as *M. Artorius M(arci) l(ibertus) Primus*, indicating that he was a freed slave who, as usual, had taken the family name of his master.

As early as Samnite times, a broad Doric quadriporticus lay behind the large theater (plates 46, 54). It was linked to the east parodos by a passage, and a covered stairway led up from the northern colonnade to the Triangular Forum. In case of rain, the spectators of the lower tiers (*ima cavea* and *media cavea*) could find shelter in the quadriporticus (which functioned exactly like a modern theater foyer), while those in the upper seats (*summa cavea*) could take cover under the porticoes of the adjoining Forum. The forehall on the side of the Forum was the most impressive entrance to the theater and was used for ceremonial processions, which then descended by way of the open staircase into the large quadriporticus and thence into the theater proper. Together with the smaller theater, behind whose stage a corridor led to the quadriporticus, this made up a grandiose ensemble in which different levels of the Triangular Forum and the large quadriporticus were linked in an ingenious and functional manner. Few other cities the size of Pompeii had anything comparable.

In the course of time the portico underwent a few changes, but its purpose remained the same until the earthquake badly damaged the theater. The upper part of the cavea was not rebuilt, although an imposing new permanent stage setting was made, this time with a rounded middle recess and two rectangular ones at the sides. The proskenion too, on the side facing the public, was redone in equally elaborate fashion, though the marble revetment of the stage was never completed. As with the buildings on the Forum, the theater is an example of the large-scale planning involved in the municipal building program after the earthquake. After the year 62, the large four-winged portico which had served as a foyer was converted into barracks for the gladiators (plate 46), the Amphitheater having resumed operations quite soon after the quake, while work on the theater went slowly. A number of small chambers were inserted into the large porticus on two stories, the upper rooms being reached by a wooden gallery. Behind the east colonnade lay the kitchen and beyond it a large assembly room or social hall. A good deal of gladiatorial equipment was found in the rooms, and one of them was apparently used as a prison, since four men locked up in it died in the final catastrophe.

That the theater played an important part in Pompeian life is evidenced by the innumerable masks depicted in relief, mosaic, or painting that decorated so many of the houses (plates 39, 41, 42), and doubtless many of the wall paintings took their subjects from currently popular plays. Nonetheless, it has not been possible to determine just what the repertory was, though some scholars have claimed to recognize allusions to the comedies of Menander and Plautus and the tragedies of Seneca in certain inscriptions. It is legitimate to conclude that both of the dramatic genres were performed in Pompeii, since the masks of each of them appear often in domestic decoration, and tragic and comic actors were depicted in equal measure (plates 38, 40, 43, 49) along with personages of the *Atellanae*, the old Oscan ribald rustic farces. All actors wore masks, the standard practice of the time. Movable scenery was not unknown nor was the curtain, though it rolled down at the start of the play and up at the end. To protect the audience from the broiling sun, an awning was stretched between the stage and the outer wall of the theater, but just how it was made is uncertain.

The Small Theater

Apparently it was shortly before 80 B.C. that the duoviri Gaius Quinctius Valgus and Marcus Porcius were instructed by the council of decurions to initiate and complete the building of a theatrum tectum, as we know from the building inscription. This small theater, holding not more than fifteen hundred persons, lay southeast of the great theater, its long side reaching from the latter's parodos to the north wing of the large quadriporticus (plates 47, 48). With its semicircular cavea fitted so snugly into the rectangular building that the upper tiers are cut off by the side walls, the general plan recalls that of the Greek *bouleuterion*, the assembly hall of the council. Here, too, as in the large theater, the lower rows of seats were broader and were set aside for the dignitaries. These rows are extended as far as the beginnings of the parodoi and make concentric stairs used to reach the lower ambulatory (*praecinctio*). Above the parodoi again there are tribunalia, and the stage had three towers at its rear and two at the sides.

The building never underwent much remodeling. It retained the atlantes purporting to hold up the long wall separating the tribunalia from the cavea as well as the lion's feet terminating the parapet just before the praecinctio, sculptures which go back to the time of Sulla. However, the floor of the orchestra was eventually paved with marble tiles, and both the material and the rectangular pattern point to Augustan times. In an epigraph in bronze letters set into the floor, still visible when Mommsen and Mau were investigating Pompeii, the duovir M. Oculatius Verus is credited with having seen to the paving. The stage, too, originally decorated with paintings in the Second Style, was given a marble facing.

In the eclogue to his wife (*Silvae* iii. 5, 91), Statius praises the "*geminam molem nudi tectique theatri*," the double structure of the open-air and covered theaters of his native Naples. These were probably the prototype for the ones in Pompeii, where Neapolitan influence is always possible. Since the theatrum tectum was an *odeum*, designed for listening to recitations and music but not for watching plays, the two theaters complemented each other and jointly constituted the cultural center of the city.

The Amphitheater

C(aius) Quinctius C(ai) f(ilius) Valgus M(arcus) Porcius M(arci) f(ilius) duo vir(i) quinq(uennales) coloniai honoris caussa spectacula de sua peq(unia)

fac(iunda) coer(arunt) et coloneis locum in perpetuom deder(unt). This inscription, found twice in the Amphitheater, names the same officials as were responsible for building the small theater. Here, however, they are identified as *duoviri* in a quinquennial year, an honor which was the occasion for them to use their own funds to erect a stadium for games—*spectacula* as they are called here—and to present it to their fellow citizens as a gift in perpetuity. The epigraph cannot be dated with precision, but on the basis of the position they held it must be from somewhat later than the one in the small theater, and therefore about 70 B.C.

The Amphitheater in Pompeii (plate 50–52) is the oldest surviving example of its type. Its site in Pompeii was cleverly chosen. Set solidly into the southeast corner of the city wall, its mighty oval could be propped up against it, thanks to rising ground to the northeast and southeast, while the other sides are free. High arches support the outer walls, which are further strengthened outside by staircases leading to the upper corridor above which there was yet another ring of places, these apparently reserved for women, who were strictly segregated from the men.

The arena, together with the lowest rows of seats, was sunken into the terrain, thus making it possible to keep the outer walls relatively low and yet provide places for twenty thousand spectators. The playing area made no provision for underground chambers in which to keep caged animals, unlike the Colosseum in Rome or the Campanian amphitheaters in Puteoli (Pozzuoli) and Capua. The arena was reached by two corridors in the axis of the building that led downward, the southern one, however, being turned at a right angle, necessitated by the fact that the earth embankment prevented a straight course.

The absence of subterranean cages has been taken to mean that animal baiting could have played no great role in Pompeii and that the main concentration was on gladiatorial combats. However, the announcements of games that survive in the form of wall inscriptions also generally mention the *venatio*, the combat with a wild animal, whenever there was a major spectacle. Just what these were can be deduced from the proud declaration on the Tomb of Aulus Clodius Flaccus that in his second duumvirate he had bulls, wild boars, and bears hunted down or pitted against each other in the Amphitheater. These were native fauna, and it is unlikely that exotic beasts were brought there.

Gladiatorial combats probably derive from the bloody games in honor of the dead in Etruria and were taken up quite early in Campania. It was in the school for gladiators in Capua, headed by C. Lentulus Batiatus, that in 73 B.C., about the time the Amphitheater was built in Pompeii, a revolt broke out instigated by Spartacus. Just how seriously Pompeii took its games is obvious from the pitched battle between the local fans and the Nucerians that flared up in A.D. 59 in the Amphitheater and left many dead and wounded (plate 50).

Wealthy Pompeians were patrons of their own troops of gladiators, as in the case of Gnaeus Alleius Nigidius Maius who, as priest of the Imperial cult, celebrated the consecration of an altar (presumably the one in the Temple of Vespasian) with gladiatorial combats and is known to us only through four advertisements for the games. The spectacles began with a ceremonial entrance (*pompa*) in which the fighters appeared in parade armor (plate 55). It is no wonder that the gladiators, most of whom were foreigners and slaves risking their lives at every passage at arms, fascinated the women of Pompeii: their names were often written on walls accompanied by such epithets as *dominus*, *medicus*, or even *suspirum*—master, healer, answer to a maiden's prayer! And the richly bejeweled woman whom death caught in the gladiators' barracks behind the theater when Vesuvius erupted is more likely than not to have been one of the innumerable upper-class women who admired the musclemen.

THERMAE AND PALAESTRAE

An integral aspect of Roman civilization was its bathing customs. The humblest townlet had its public baths. In the most inaccessible corners of the Empire Romans refused to do without their baths, even in military posts in the Egyptian desert, where water was at a premium. In the large establishments of the capital people gathered not just to bathe but also to conduct business and politics. Poets read their works aloud in the bathhouses, while the Roman *jeunesse dorée* lounged about in them and did whatever spoiled youth does.

From Baiae, where he lived above the baths, Seneca wrote a half-desperate, half-comic letter describing the racket that he had to put up with day in and day out which was "enough to make a man regret that he had ears": grunts and groans of the weight lifters in the palaestra, masseurs' hands slapping flesh, water forever splashing in the swimming pool, the cries of vendors of sausages and cakes—a babel and ruckus that only one who has lived in southern climes can begin to imagine.

The procedure followed in the Roman baths was set down by the physician Galen from Pergamum, who lived from A.D. 129 to 199: "After entering, the visitors first spend some time in the hot air room, then get into the warm bath, then get out and change over to the cold one, finally rub themselves down to stop sweating. But this is only the first stage of the bath and serves to warm up the substances of the entire body, to loosen them up, to even out their differences, and to relax the skin and clean out whatever has accumulated under it. The second stage, on the contrary, serves to convey a salutary moistness to the dry parts of the body for those whose bodily constitution is dry. The third stage, in which the cold bath is used, aims to cool off the entire body, close up the pores of the skin, and reinvigorate one's powers. Finally, the fourth drains the body of impurities through hefty sweating without exposing it to the danger of a chill."

Although the sequence could be varied and steps omitted, what Galen describes is the complete process which conforms precisely to the order of the rooms as found in virtually all Roman thermae. Vitruvius laid down a number of rules for the architectural plan of bathhouses which also give us some interesting sidelights on the matter: people bathed mostly between noon and evening, for which reason, the great architect said, the rooms with warm baths should get their light from the southwest or south; there were separate sections for men and women, and the architect advised that the *caldaria muliebria et virilia*, the warm baths of both sections, should be located alongside each other so that both could be heated from the same source.

A decided innovation appears to have been introduced about 100 B.C. when Gaius Sergius Orata—the same man who, according to Pliny (*Naturalis Historia* ix. 168) "in the time of the orator Lucius Crassus and before the Marsic War" introduced oyster cultivation into the gulf of Baiae—invented a system for heating the floors. Since the name used was *hypocaustum*, this may have been merely an adaptation of an older Greek technique. Later, however, the heat was radiated from the walls behind which there were breast-shaped tiles (*tegulae mammatae*) or clay heating pipes (*tubuli*) that conveyed the heat to hollow spaces under the floor (*suspensura*). For the first time it was possible to keep the room with the heated baths at the right temperature.

Thermae require a steady supply of fresh water, so in the *castellum aquae*, the water tower in Pompeii (plates 62–64), one of the three distributing conduits was reserved for the bathhouse. The reservoir for the three outflows was so arranged that it was still filled to the brim with water for the public baths even when a low water level caused the supply to private dwellings to be cut off.

The Thermae of Pompeii

When the earthquake of A.D. 62 badly damaged the thermae, along with causing so much other destruction, the city not only proceeded to restore them but also set about building an additional and much more modern installation. This, more than anything else, indicates what importance bathing had in the daily life of Pompeii, in public and also private facilities (plate 56). Thus even as minor a provincial center as Pompeii offers the researcher into this subject abundant material surviving in good state and dating from relatively early.

The earliest bathhouse in Pompeii, the Stabian Thermae at the intersection of the Via dell'Abbondanza and the Strada Stabiana, dates back to pre-Roman times. As early as the first half of the first century B.C. it was already being remodeled. According to an inscription, the duoviri Gaius Uulius and Publius Aninius saw to the building of the *laconicum* (the sweat bath) and the *destrictarium* (the room where the athletes scraped oil and dirt off their bodies after exercising) and had the colonnade and the exercise grounds rebuilt (*reficiunda*). About that time, too, north of the Forum, bathhouses known as the Forum Thermae were built. Thus both installations were centrally located and in the immediate vicinity of the main plaza of the town. Being relatively early, much of their plan and installation was decidedly out of date by the last years before the eruption, when the new so-called Central Thermae were begun farther north on the Strada Stabiana at the corner of the Strada di Nola.

If we follow a visitor through the Stabian baths (plate 58) we see him come in through the main entrance (*A*) on the Via dell'Abbondanza and stand in the south wing of the portico (plate 59) which runs along three sides of the trapezoidal-shaped palaestra (*B*), the west side being taken up by the swimming pool, the piscina (*C*), lying between two rooms in which the athletes can oil themselves for exercise or have the oil and dirt scraped off afterwards. This latter part of the building is the latest in date, built only after the earthquake of 62, as its handsome colored stucco decoration attests.

Our visitor now goes to the southeast corner of the portico through a low antechamber (*IV*; plate 61) to enter the splendidly decorated *apodyterium* (*VI*; plate 239), where he strips and puts his clothes into one of the wall niches designed for that purpose. He then takes himself to the *tepidarium* (*VII*), the heated room in which he prepares for the considerably higher temperature of the next room, the *caldarium* (*VIII*), where he indulges in a steam bath exactly as prescribed by Galen. In both these rooms the floors and walls are heated by the system described above, and in both there is a large tub (*alveus*) in front of the east wall, something which is normal for a caldarium but not for a tepidarium, where as a rule no one bathes. In the west apse of the hot-bath room, however, there is a large basin (*labrum*) in which one washes oneself down with cold water.

From here the visitor goes out again by way of the tepidarium and the antechamber (*IV*) to reach the cold bath in the *frigidarium* (*V*). This is a round room into which four alcoves open and whose cupola has a round

opening to admit light. This round opening is one of the most ancient features of a bathhouse, as are the small round windows in the apodyterium and in the caldarium. It was not until the construction of the new Central Thermae, still being built at the time the city was destroyed, that large modern windows were used.

In the frigidarium several high steps lead down into the cold bath, where fresh water splashes out uninterruptedly from a high spout. To our loss, the painting in this room is now much faded. It once showed a rich garden landscape with statues and fountains, and the cupola was painted blue and studded with stars, all of this designed to give the bather the feeling of being in the open air.

The women's bath (*1–6*) north of the men's section has the same sequence of rooms except that the frigidarium was replaced by a tub in the corner of the apodyterium (*2*), which was directly accessible by two corridors leading from the streets on the east and the west so that it had its own separate entrance. The rooms in the women's bath are smaller than those in the men's, and the decoration is simpler. As recommended by Vitruvius, the *praefurnium* or heating room lies between the caldaria of the two sections. Along the north side of the palaestra are small cells for private baths. These are patently old-fashioned, having neither light nor heat, and were no longer in use in Imperial times.

The Forum Thermae are much the same as the Stabian but are smaller and have neither piscina nor palaestra, the court to the south of the men's baths (now a tourist restaurant) being a garden and not the usual gymnasium. Although this bathhouse was in use for about 150 years, it retained its out-of-date equipment unimproved: the tepidarium was heated by no more than an open coal brazier such as is still often found in southern Europe. The lighting of the rooms and the installation in the caldarium (plate 57) and frigidarium correspond to those in the Stabian Thermae. Although the rooms were redone with new and sumptuous stucco decoration after the earthquake, scarcely anything was done to modernize them, so it is understandable that a larger and technically up-to-date installation such as the new Central Thermae was indispensable.

The Samnite and the Roman Palaestrae

In the space between the large theater and the east portico of the Triangular Forum, the Samnite quaestor Vibius Vinicius erected a building from funds left by a certain Vibius Adiranus. The building's purpose was for what the Oscan epigraph called the *vereiiai Púmpaiianai*, a term generally taken by earlier scholars to mean "Pompeian youth" but now more often thought to refer to some sort of political-military association in the city. While the inscription does not give the Samnitic designation for the building, there is not the slightest doubt that it was a palaestra.

A palaestra was a normal adjunct to a bathhouse but could exist on its own as a place for physical exercise and sport, an outdoor gymnasium. In both name and style of architecture the palaestra is clearly of Greek origin. The plan of the Samnite palaestra in Pompeii (plate 66) is simplicity itself: a colonnade of slender Doric columns in tufa stone surrounds a small court measuring roughly twenty-six by sixty-two feet. Behind the west portico there are three rooms which were obviously apodyteria and destrictaria. They are not large, and the proportions of the installation as a whole make it obvious that this palaestra must have served only some sort of club or confraternity. Indeed, as soon as the large palaestra was built, this one seems to have been no longer much frequented, a conclusion

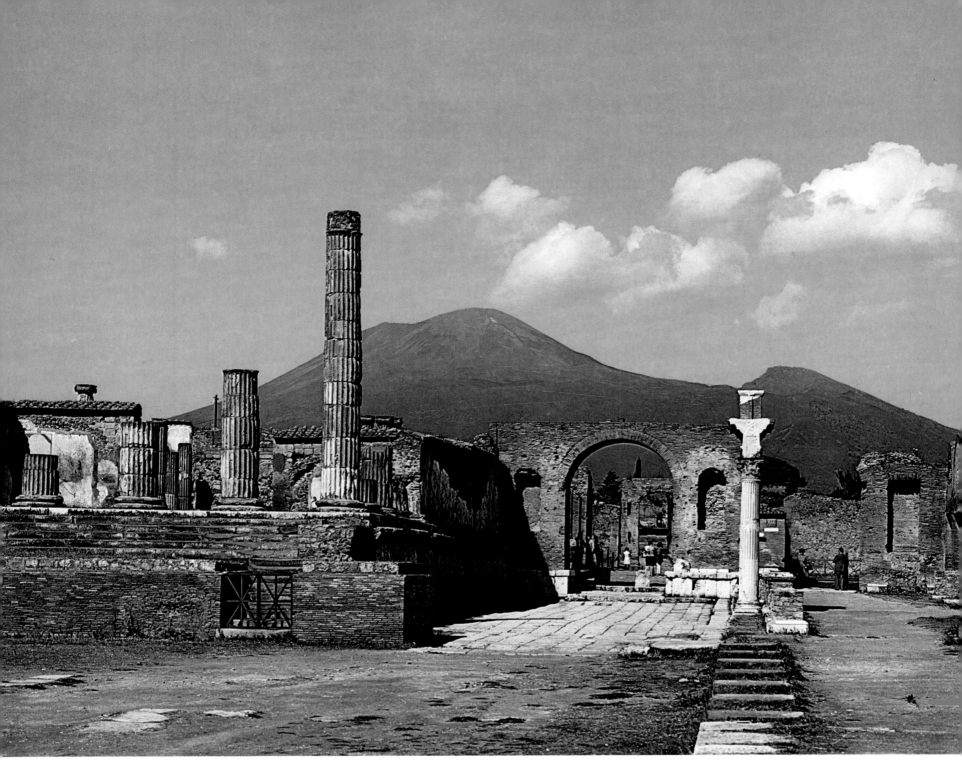

16

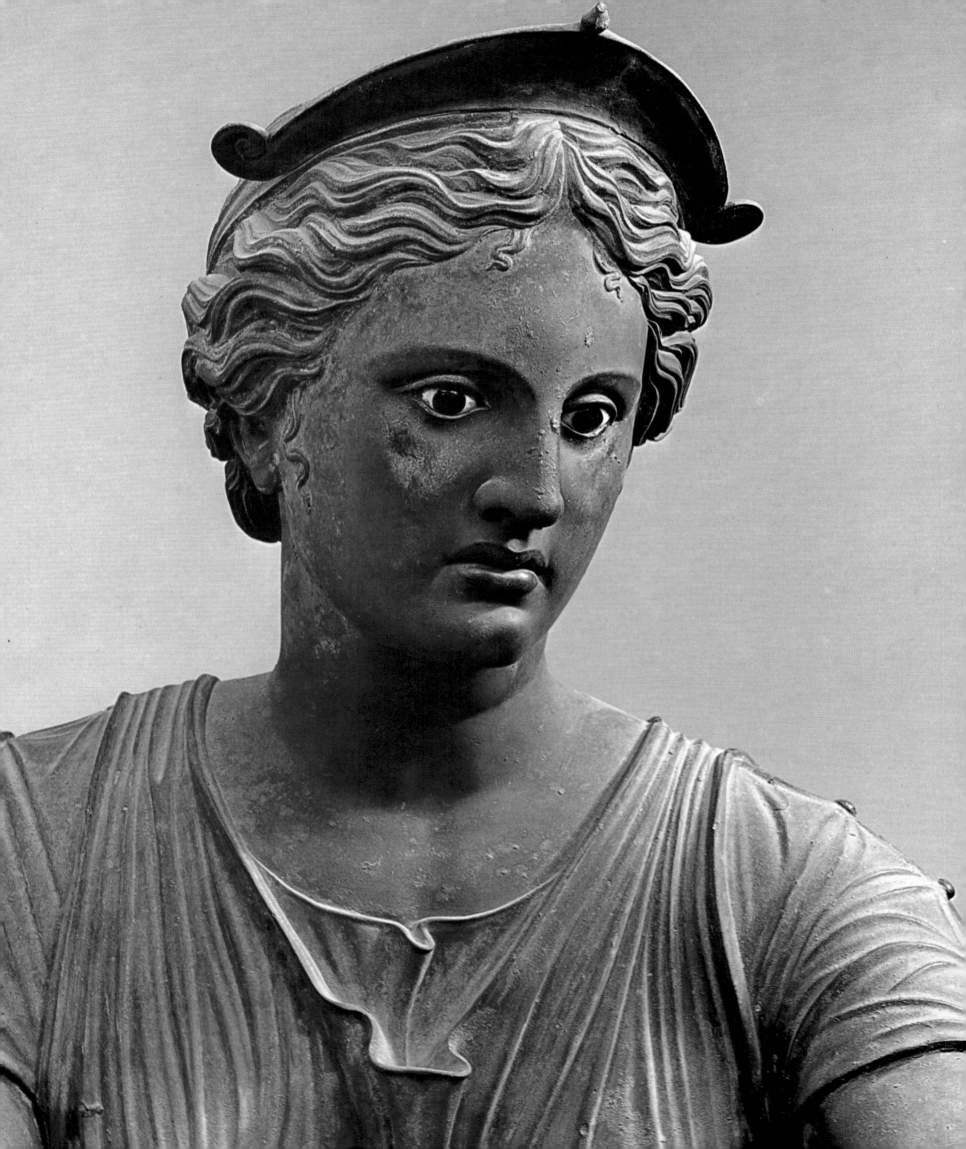

18

Preceding page:

16 NORTHWEST CORNER OF THE FORUM. At the left the Temple of Jupiter rises above a ten-foot-high podium with a broad flight of steps. A wide platform (here cut off at the left margin) held the altar, though it may also have served as an orator's tribune. Although they have not survived, we know that equestrian statues stood alongside the stairs on either side (see plate 9). The temple front, with its six Corinthian columns, faced the Forum and had a pronaos extending a full four bays in depth. In the cella there was a two-storied colonnade, and a high platform held statues of Jupiter, Juno, and Minerva. Built in Samnite times, the temple was badly damaged in the earthquake. To its right there is a single-arched gate and, alongside that, the forehall of the Macellum.

 17 DIANA (*detail of a fragmentary statue*), *from the Temple of Apollo. Bronze. Museo Nazionale, Naples.* The fragment of a somewhat under-lifesize, full-length bronze figure was found in the court of the Temple of Apollo, where the statue was probably a companion piece to that of Apollo (see plate 18) and presumably stood in front of the third column of the left colonnade. Only the head and upper body have survived, and even then the left forearm and hand are missing. The eyes are of an enamel-like substance set into the bronze. Composed so as to be seen in profile, the goddess would no doubt have been drawing a bow like her male counterpart. It has been thought that the prototypes were Hellenistic and must have belonged to a group depicting the death of the children of Niobe at the hands of the archer gods Apollo and

Diana. In any case, the statues were not copies but, instead, variants done in early Imperial times in a decidedly smooth and rather lifeless manner.

18 COURT, TEMPLE OF APOLLO. *Height of the bronze statue of Apollo, 57 1/2".* In the background on the left is the temple with the right-hand column of the pronaos and the high, outside staircase. There were six columns on the narrow sides, ten on the long sides, all of them Corinthian. The cella began only at the level of the fourth pair of columns along the sides. Dating back to the Tufa Period, the building was restored after A.D. 62, as were the porticoes glimpsed here on the left, though their two stories were reduced to one at that time. The thick stucco covering the columns was applied during restoration after

the earthquake. As we have seen, the statue of Apollo as archer had a counterpart in that of Diana (see plate 17).

19 TEMPLE OF APOLLO, *with altar and sundial.* Old views show the Ionic column to the left of the stairs with a sundial which, an inscription tells us, was made at the expense of the duoviri Marcus Herennius Epidianus and Lucius Sepunius Sandilianus. The altar in front of the steps is crosswise to the axis of the temple and bears the epigraph: *M(arcus) Porcius M(arci) f(ilius), L(ucius) Sextilius L(uci) f(ilius), Cn(aeus) Cornelius Cn(aei) f(ilius), A(ulus) Cornelius a(uli) f(ilius) IIIIv(iri) d(e) d(ecurionum) s(ententia) f(aciundum) locar(unt),* thus advising that the *quattuorviri* (duoviri and aediles) commissioned the altar by decree of the council.

19

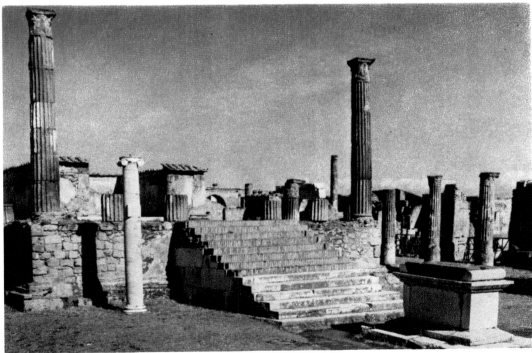

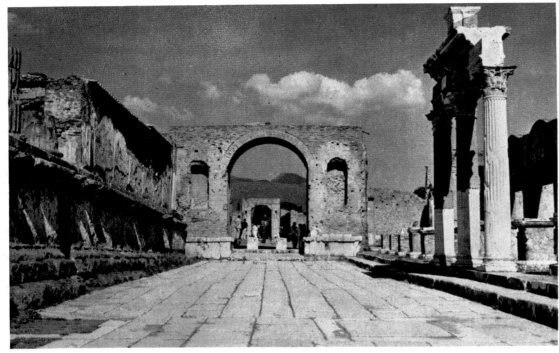

20

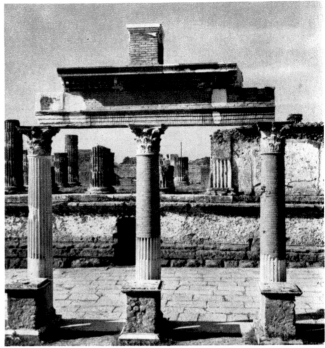

21

20 TRIUMPHAL ARCH ON THE FORUM. The northeast entrance to the Forum is spanned by a single-opening brickwork arch whose pylons each have a niche for a statue. On the basis of an inscription found nearby, which names the first of these statues, it has been supposed that the persons so honored were Nero and Drusus, the oldest sons of Germanicus. The arch was crowned by an equestrian statue, perhaps of Tiberius, though this is not certain. To the left is the Temple of Jupiter, to the right the portico in front of the Macellum.

21 FOREHALL OF THE MACELLUM, *looking toward the Temple of Jupiter*. The portico prolonging the Forum colonnades and marking the entrance into the Macellum from the Forum had a two-storied order in white marble with its upper tier of columns rising from rectangular bases. The missing parts of the structure are now restored in brick. Facing the interior, in front of each column on the ground tier, was a statue, but only the bases survive.

22 TEMPLE OF JUPITER, *viewed from the southwest*. At the right we see the front of the temple, at the left the triumphal arch which closes off the Forum on the northwest. It is smaller than the one on the northeast, and its pylons are not provided with niches for statues. The name of the individual it was built to honor is not known. In the foreground are parts of the architrave of the portico along the Forum.

23 SOUTH PORTICO OF THE FORUM, *viewed from within*. The porticoes built in tufa stone in Samnite times survive on the south side of the Forum and along the east side as far as the Via dell'Abbondanza. They made up a double colonnade, a second row of columns being interposed between the outer row and the walls of the buildings behind it. Above the Doric columns, the lower thirds of which were not fluted but only beveled down, there was originally a wooden beam acting as the lower fascia of the architrave. The second band of this architrave was sculpted with the usual metopes and triglyphs. Here one can see the holes through which the beams were pushed to support the upper story. Especially striking are the squat proportions of the columns and the wide intervals between them.

24 NORTHEAST TRIUMPHAL ARCH ON THE FORUM, *viewed ▷ from the north*. At the left are the remains of the columns that once framed the statue niches. Through the opening of the arch we see the forehall of the Macellum, again with a glimpse of the three columns seen in plate 21. Statue bases are lined up in the passage behind them and against the wall to the rear. The two stone posts in the middle of the road in the foreground served to block vehicles from entering the Forum.

22

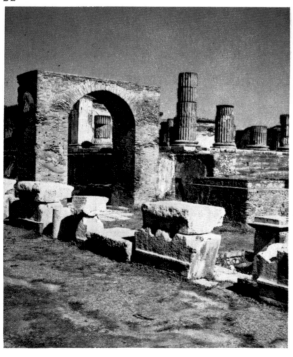

23

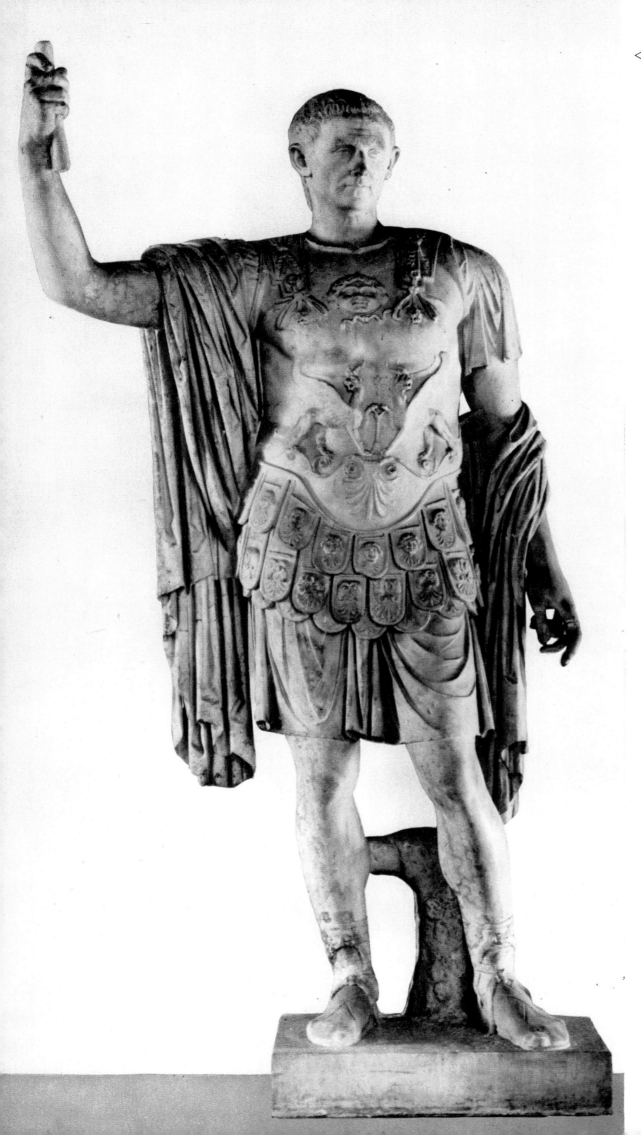

25 MARCUS HOLCONIUS RUFUS IN ARMOR. *Marble, 6' 7 1/2". Museo Nazionale, Naples.* Parts of this over-lifesize statue, which once stood at the intersection of the Via dell'Abbondanza and the Strada Stabiana, were painted in realistic fashion: red hair, purple mantle, black sandals. An inscription on the base records the public career of Holconius Rufus: *tribunus militum a populo* (military tribune elected by the citizenry), five times *duovir iure dicundo,* twice *duovir quinquennalis,* as well as priest of the Imperial cult and *patronus* of the colony. He and his brother were responsible for enlarging the Great Theater, in gratitude for which the Pompeians erected a statue to him there as well, though it has not survived. The fourth duumvirate of Rufus fell in the years 2 and 1 B.C., and since the next quinquennial year would have been 1 B.C.–A.D. 1, perhaps the statue was put up at that time. The somewhat dryly carved head is consistent with Republican portraiture of Italic type, while the decoration of the armor with a head of Medusa and two griffins clearly reflects Augustan classicism.

26 WEST PORTICO OF THE FORUM, *viewed from within.* ▷ Already in early Imperial times the Samnite tufa stone porticoes began to be replaced with new ones in travertine, but the work was interrupted by the earthquake in A.D. 62 and never completed. The colonnades were two-storied, with a Doric tier below supporting a slenderer Ionic order above. The technique used in the lower entablature was that of the vertical arch, which means that the otherwise unsupported blocks above are wedged between the trapezoid blocks that rest on the columns, whose sides taper upward.

Following page:
27 TEMPLE OF FORTUNA AUGUSTA. The temple is not on the Forum proper but at the intersection of the main artery, the Strada di Nola, with the street leading away from the triumphal arch at the northeast. Two distinctly separate flights of steps led up to a four-columned front facing west with a vestibule three bays deep behind it. In front of the formerly marble-faced rear wall of the cella we see the aedicule that housed the statue of the goddess worshipped here. As a bringer of good fortune to the Imperial house, her cult was served by the *ministri Fortunae Augustae,* a collegium instituted in 3 B.C., according to an epigraph. It is presumed that the temple was built not long afterward.

28 MACELLUM, WITH THE CHAPEL FOR THE IMPERIAL CULT. At the east end of the broad court of the Macellum there was a room, reached by some steps, which was dedicated to the Imperial cult. It contained five statues, two pairs set into niches on the long walls (one niche is visible here) and the fifth, and most important, standing on a base in front of the center of the rear wall. The only two statues found here have been thought to portray Octavia, the sister of Augustus, and her son Marcellus, but there is no basis whatsoever for such an identification, nor is it even certain that the statues represent members of the Julian-Claudian Imperial house.

29 PORTAL, BUILDING OF EUMACHIA. After the earthquake this frame, with its handsome pattern of spiral acanthus leaves and tiny animals, was fitted into a larger portal. It dates from the reign of Tiberius and owes something to the style of the Ara Pacis in Rome.

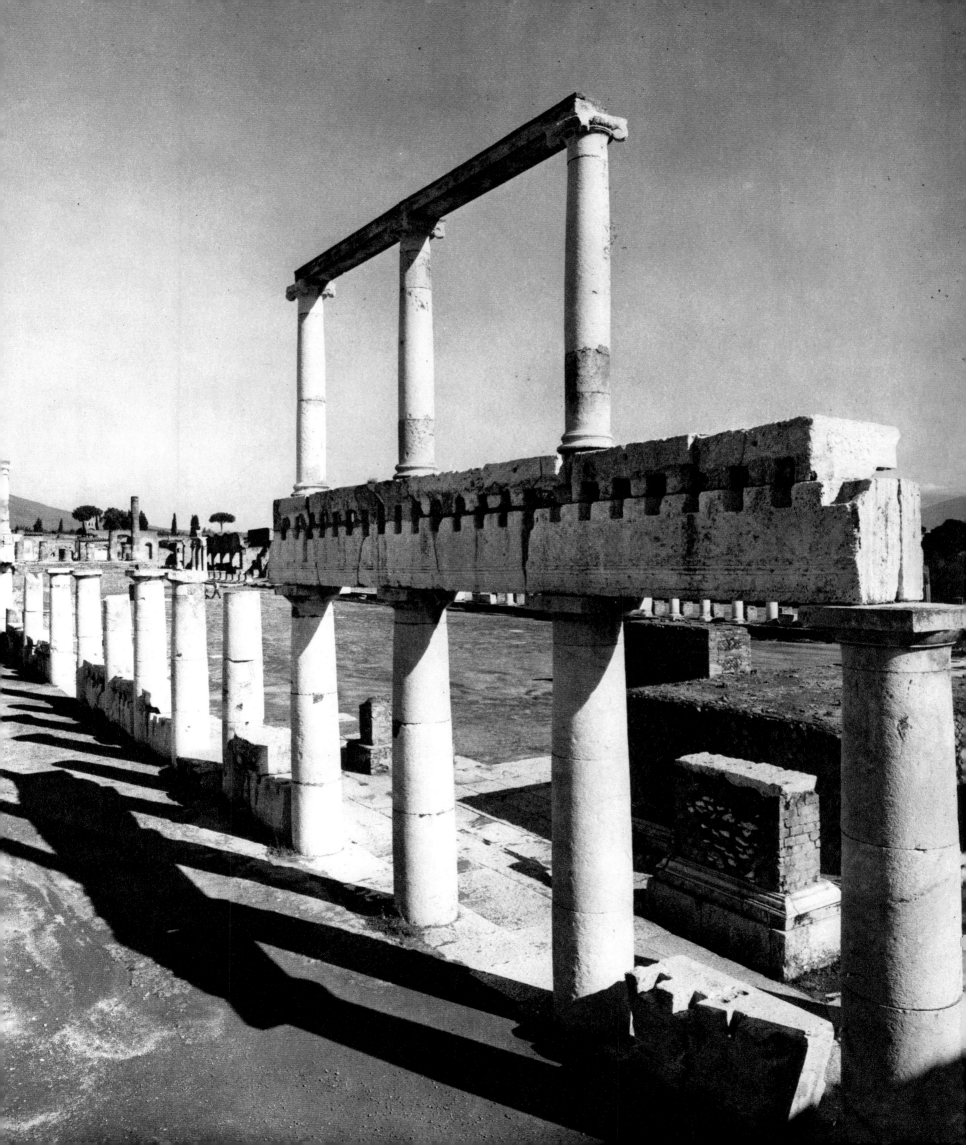

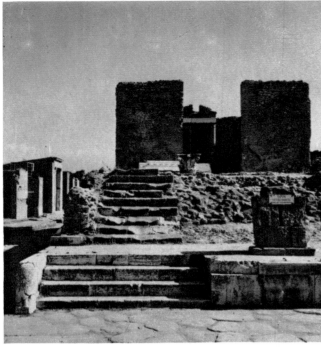

27

28

29

30–32 ALTAR. *Marble, 50 × 44 1/8 × 35 7/8". Temple of Vespasian.* After the earthquake, a new temple dedicated to the emperor was built on the east side of the Forum. Its cella rose from a high podium and can be observed in the background in plate 31. In its court there is an altar to the Imperial cult which consists of marble reliefs set into a concrete inner core. Although its dating is disputed, there is much to suggest that the altar must be contemporary with the temple itself.

30 RIGHT SIDE OF THE ALTAR. The garland of fruit is suspended from bucrania (ox skulls) and adorned with ribbons at its ends. Below it are objects used in the liturgy: on the left the *mantele,* the fringed cloth worn by the assistants (*camilli*) during sacrifices and used for drying the hands; on the right the *acerra,* the chest containing the incense; below it the augur's staff (*lituus*). The panel on

the opposite side of the altar also depicts objects connected with the sacrificial rites.

31 FRONT OF THE ALTAR. A drape hangs over a temple front—presumably that of the Temple of Vespasian itself —whose pediment bears a Roman shield (*clipeus*). In the foreground a priest offers a ritual libation from a vessel supported on a tripod. Behind him are two lictors, an altar servant (*camillus*) with a bowl, and an acolyte with a pitcher for libations. Behind the altar stands a flute player, to the right a group of three *victimarii* (attendants charged with slaughtering the animals), nude except for the *limus,* an ample loincloth. The *victimarius* to the fore leads the sacrificial bull and holds in his left hand the ax (*securis*) with which the animal will be killed. Above the molding of the altar is the sacrificial table with, at either end, two bolster-like rolls (*pulvini*) decorated with rosettes and fish-scale patterns. It is not impossible that the relief

depicts the sacrifices that must have attended the consecration of the Temple of Vespasian itself.

32 BACK OF THE ALTAR. Here the decoration is simpler: two laurel branches flanking the *corona civica,* the oakleaf wreath of Augustus, set against a clipeus.

33 THE PRIESTESS EUMACHIA (*detail*), *from the so-called Building of Eumachia. Marble. Museo Nazionale, Naples.* The statue of Eumachia, erected in her honor by the guild of cloth fullers, portrays the priestess with her mantle draped over her head, its lappet held in her right hand. For his inspiration the sculptor turned to Greek sculpture of the fourth century B.C. The statue has come down to us in splendid condition, only a few folds of the mantle having had to be restored, and there are still traces of paint—a rich red—in the hair, though not in the eyes which were, presumably, brown.

30

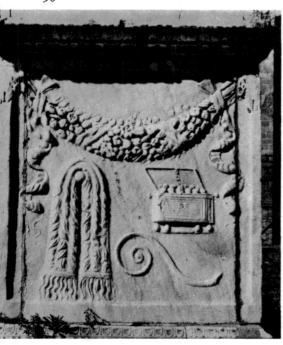

31

32

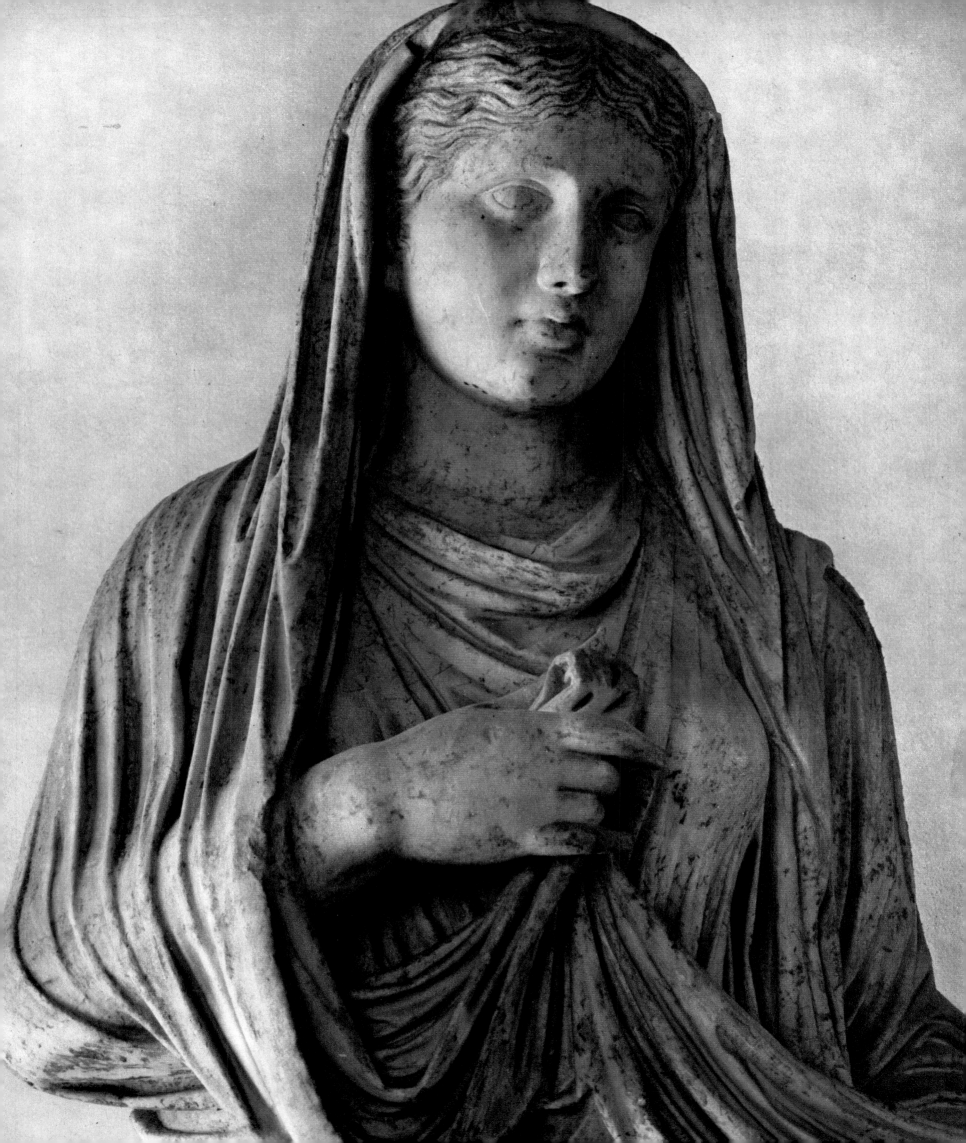

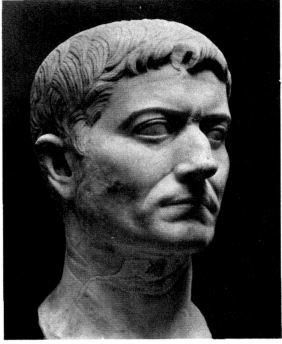

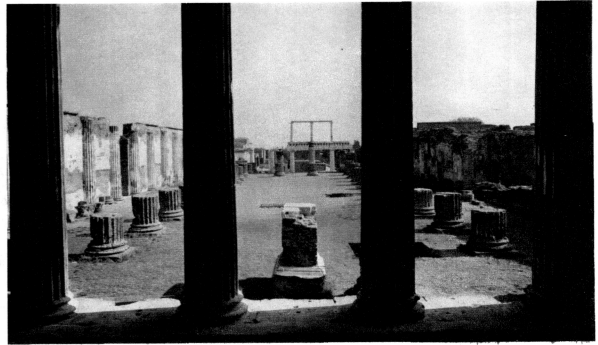

34

35

34 MALE PORTRAIT, *from the House of the Golden Cupids* (VI, 16, 7). *Marble, height 13". Antiquarium, Pompeii.* The head was found in a house belonging to the Poppaeus family, relatives of the empress Poppaea Sabina, second wife of Nero, and among the most prominent citizens of Pompeii. This fact makes it likely that the individual portrayed here held some sort of important public post. The portrait, one of the very finest ever unearthed in Pompeii, dates from about 40 B.C. and is greatly indebted to Hellenistic influences. Except for minor repairs on the neck, it is in exceptionally good condition and still has traces of red in the hair.

35, 36 BASILICA. Two graffiti scratched on the walls are of great help in identifying the function and date of this building. In one, C. Pumidius let posterity know that, on a date corresponding to October 3, 78 B.C., he was here. This gives a *terminus ante quem,* the latest possible date at which it could have been built. In any event, in style it doubtless belongs to the late second century B.C. Written

repeatedly on the south wall is the word *bassilica,* and in fact this is the oldest surviving example of the architectural form in use throughout Antiquity and perpetuated in the Early Christian churches. The building has a vestibule with five entrances as well as secondary entrances on the sides. A two-storied portico surrounds the central colonnade, and on the west there is the so-called *tribunal,* a high room with a two-storied columnar front.

37 PORTRAIT OF A YOUNG MAN. *Marble, height 12 1/4". Antiquarium, Pompeii.* In the course of excavating the so-called House of Championnet on the southern slope of Pompeii, this lovely head was brought to light in the rubble which may have rolled down from the Temple of Venus. Ostensibly from early Augustan times, the subject was promptly identified by Maiuri as Marcellus, the nephew and son-in-law of Augustus, but this is unsure since no authentic likenesses of him are known. The head would have been set on a full-length body draped in a toga.

38 THE TRAGIC ACTOR, *from a house in Herculaneum.* ▷ *Wall painting transferred to panel, 15 1/2 × 15 1/2". Museo Nazionale, Naples.* This picture was found with three others, "two and two leaning against the wall so that the painted side of each was to the outside," according to J. J. Winckelmann. This suggests that they had been done somewhere else and brought to the house to be set into the wall. In front of a wall marked only by a door, the actor sits triumphant, in white chiton with gold girdle, his purple mantle on his lap, his sword and scepter in his hands. He has obviously been playing the king in a tragedy and has removed his mask, with its exaggeratedly high headdress known as an *onkos,* and set it down in front of an open casket over which bands and straps from costumes have been thrown. Kneeling in front of it, a woman —a muse?—writes a dedicatory formula on a board. Another actor, who appears to be taking off his costume, gazes down at her. The prototype of this serenely balanced composition was certainly Hellenistic, and this copy was done about 25 B.C.

36

37

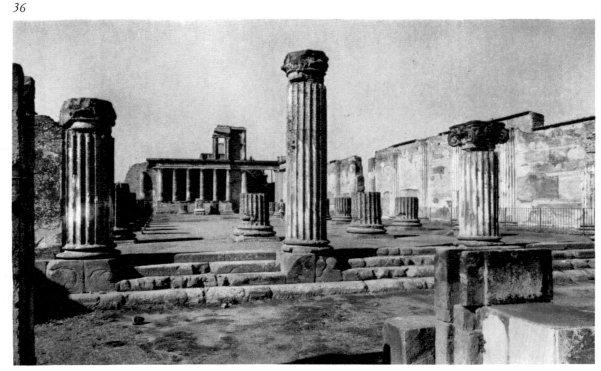

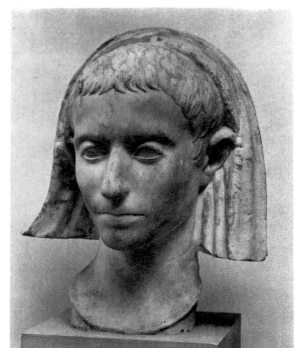

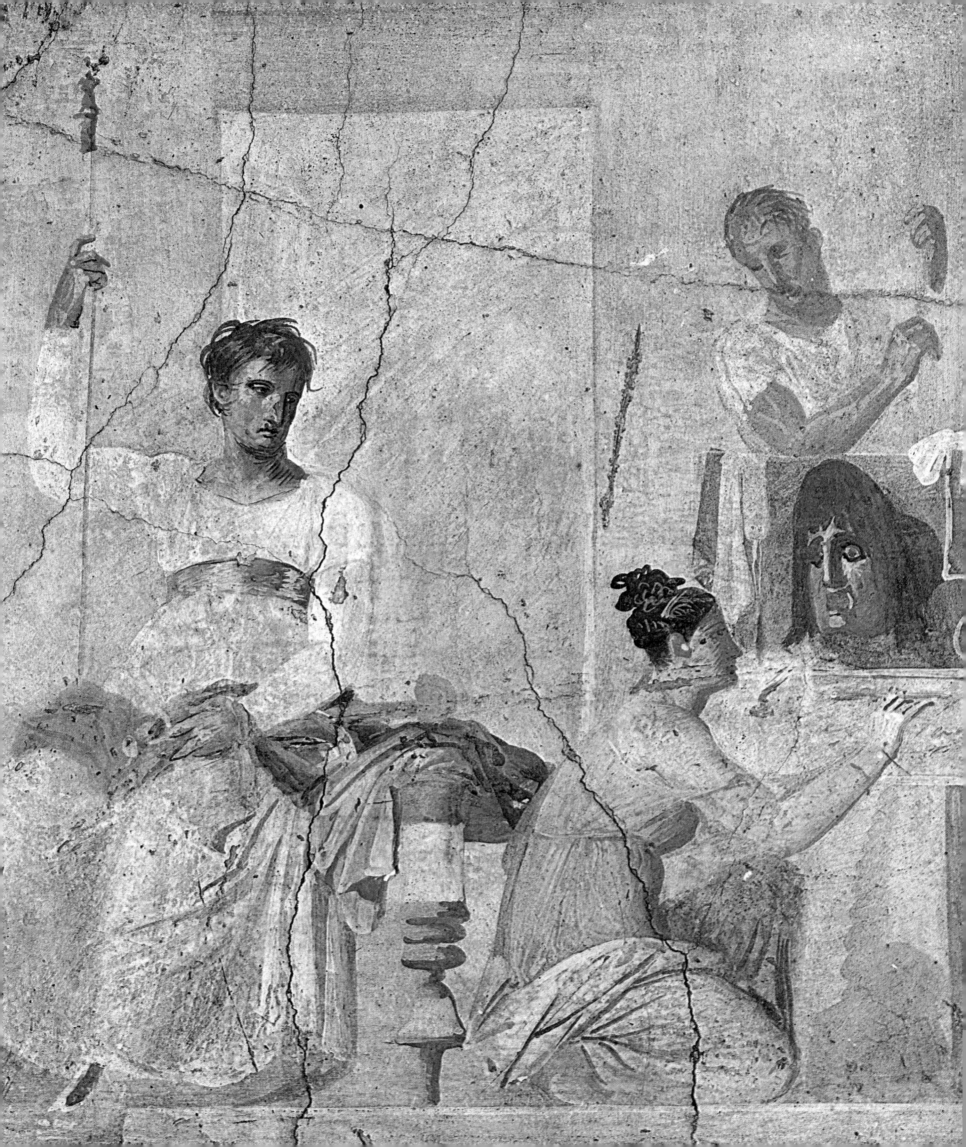

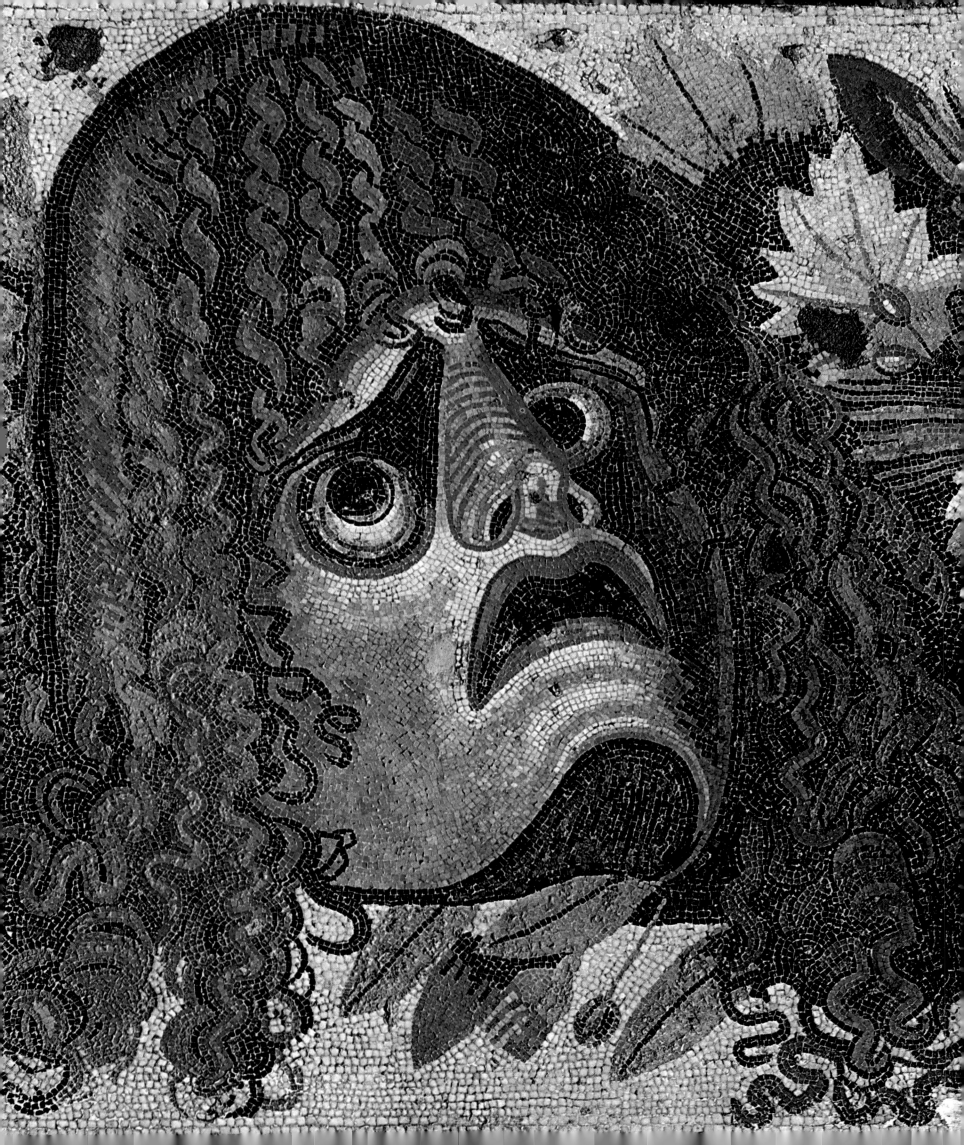

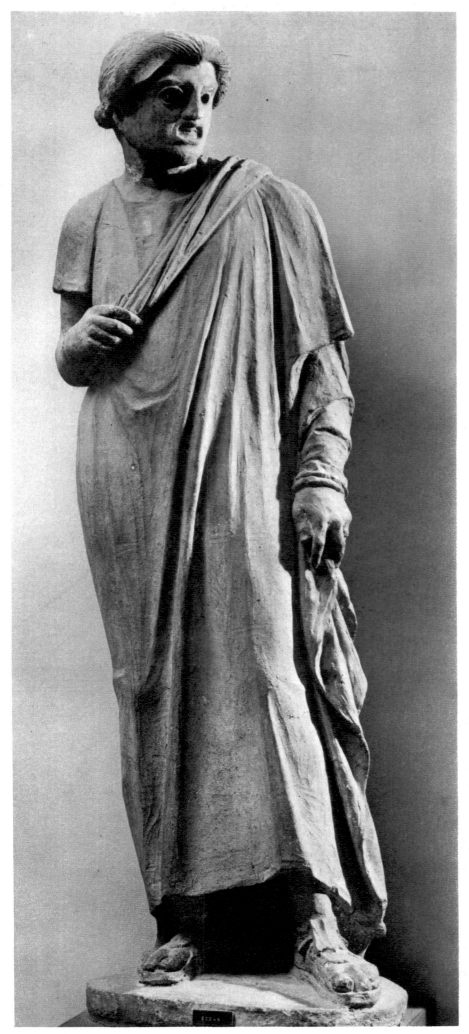

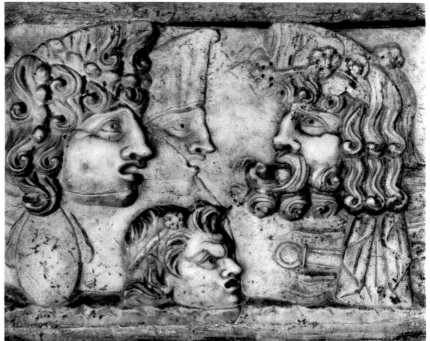

41

39 TRAGIC MASK *(detail), from the House of the Faun* (VI, 12, 2–5). *Mosaic. Museo Nazionale, Naples.* This is from a mosaic frieze (plate 108) originally on the sill between the fauces and the atrium in the House of the Faun. The tragic mask, with its high onkos and shoulder-length hair, belongs to a male character, as denoted by the darker skin coloring, and is typical of those worn by youths in Hellenistic tragedies. Like the house itself, the mosaic dates from shortly before 100 B.C.

40 AN ACTOR, *from a house in regio* VIII, *Pompeii. Terra-cotta, height 45 1/4". Museo Nazionale, Naples.* This and a female companion piece were unearthed in 1762 and were the first full-length terra-cotta figures to be found in Pompeii. Dressed in Roman fashion, the man wears the usual short-sleeved tunic under a mantle (*pallium*) draped across his left shoulder. He has been recognized as an actor because he is representative of a type found in the Latin comedy which grew out of the Greek so-called New Comedy. The work can be dated about A.D. 70.

42

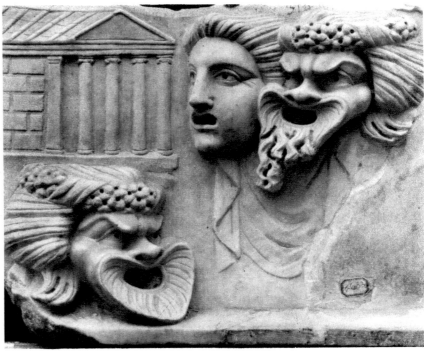

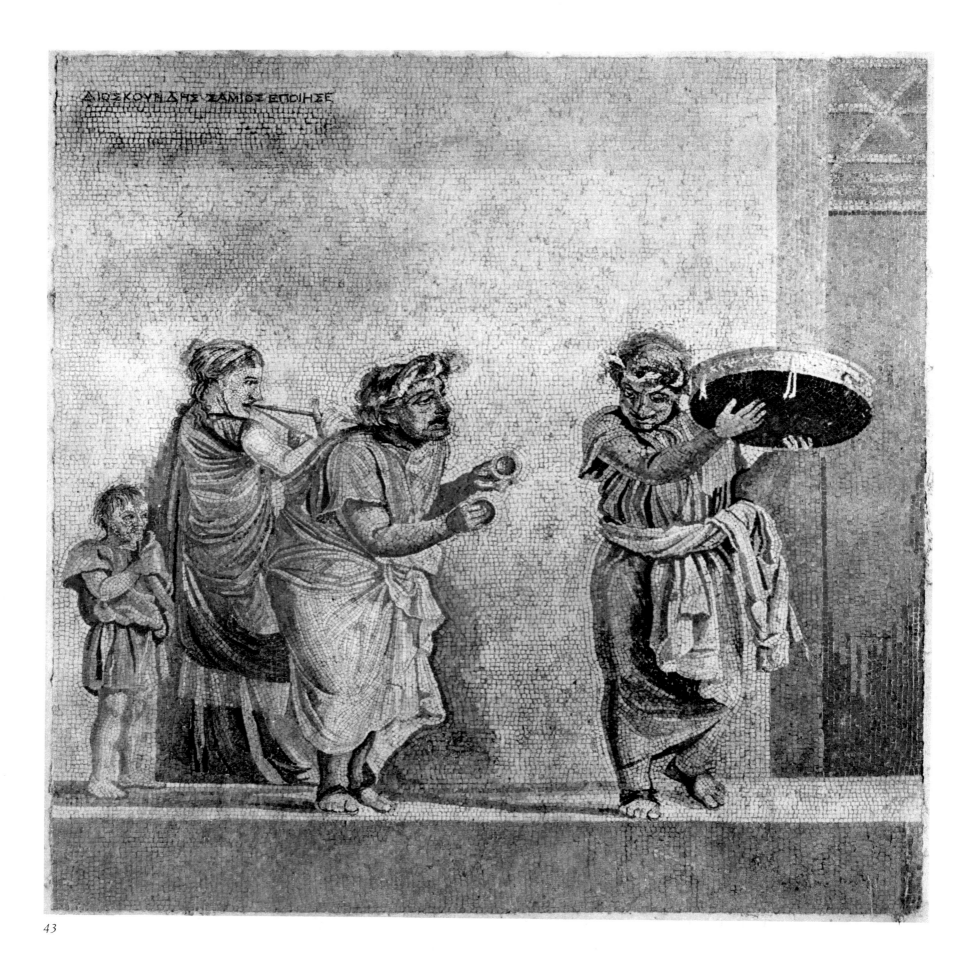

ΔΙΩΣΚΟΥΡΙΔΗΣ ΣΑΜΙΟΣ ΕΠΟΙΗΣΕ

◁ 41 MASKS. *Marble relief, 11 3/4 × 16 7/8". House of the Golden Cupids* (VI, 16, 7). On this marble relief, set into the south wall of the peristyle of the house, there are two female tragic masks in the upper left and below them a shield, on the right a bearded, male tragic mask above a drape and a sword, and on the ground a satyr mask.

42 MASKS, *from Pompeii. Marble relief, 11 5/8 × 16". Museo Nazionale, Naples.* In the upper left corner is a temple, on the right, masks of a youth and an old man wearing a wreath, both lying on a drape, and at the bottom the mask of a slave. All three were worn by characters in the New Comedy.

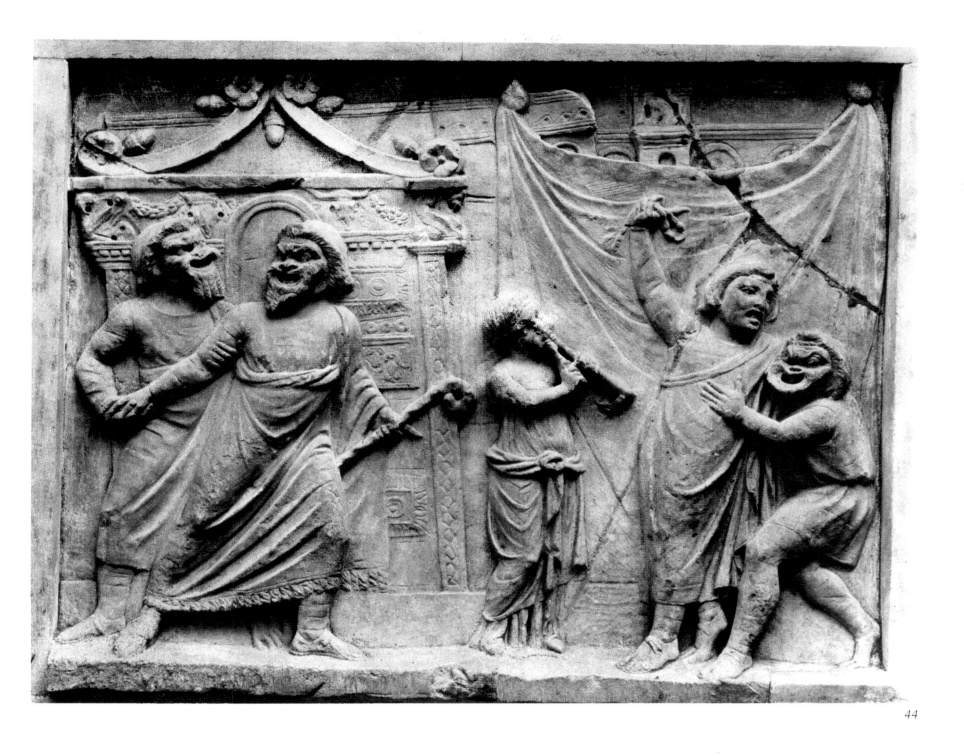

◁ 43 STREET MUSICIANS, *from the Villa of Cicero. Mosaic, 16 7/8 × 16 1/8″ (without border). Museo Nazionale, Naples.* Together with a companion piece depicting a comedy scene with three women and a boy, this mosaic emblem (the term used for a mosaic picture composed separately and then set into a floor) was found in 1763 in the villa thought to have belonged to Cicero. Both works are signed by the mosaic artist Dioscurides of Samos and were done about 100 B.C. The prototype for this scene, most likely a kind of ex-voto for winning a theatrical contest, dates back to the third century B.C. and was also used for a painting found in Stabiae. The middle figure playing the small cymbals appears in a Hellenistic terra-cotta statuette in Athens that was probably done in Myrina.

The musicians cavort on a narrow stage, which is no more than a strip of flooring. In front of the door at the right margin a tambourine player dances wearing a wreath and a youth's mask, these being worn also by the other dancer playing tiny finger cymbals. Both of these

instruments were used in the cult of Cybele, for which reason the figures have also been identified as *metragyrtes,* the begging musicians in the service of Cybele who also figure in the New Comedy. An aulos player wearing the mask of a hetaera completes the lively scene, together with a nasty-looking dwarf. Done entirely in very small stones, the richly nuanced coloring, which runs through all shades of blue, yellow, red, and brown and also helps to model the figures plastically, can give us at least an idea of Hellenistic painting, since none of its panel pictures has survived.

44 SCENE FROM A COMEDY, *from the Farnese collection. Marble relief, 17 3/4 × 20 7/8″. Museo Nazionale, Naples.* Although this relief does not come from the Vesuvian towns but probably from Rome, where the Farnese collected their antiquities, similar works could have ex-

isted in Pompeii, and it is included here as a unique depiction of the comic genre. The action is set in front of an architectural prospect such as theaters of the time always had. Over the right half hangs a curtain, presumably to conceal a part of the set not involved in this particular scene. In front of a richly decorated door, a visibly agitated man with bearded mask and knobby staff is prevented from rushing off to the right by another bearded man who clutches him by the arm. His rage is directed against a youth staggering home drunk after a night of carousing who flourishes aloft the girdle he wore to the banquet (and can probably now no longer tie around him) and seems to be singing along with the music played by a young girl with an aulos, the only figure without a mask. A slave has all he can do to prop up his young master and put a damper on the boisterous revelry, knowing all too well that it is on his head that the old man will vent his rage. Done in the early first century A.D., the relief certainly represents a scene from some particular play.

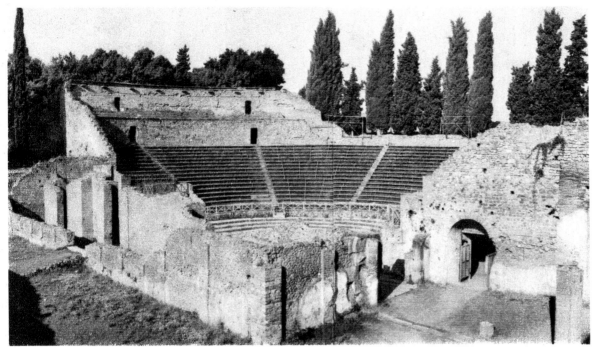

45

45 GREAT THEATER OF POMPEII, *viewed from the east.*
In the foreground we see the stage building from the
back. The semicircular wall is the central recess of the
stage front with the middle door of the permanent stage
setting. The space behind it served as a dressing room for
the actors. Beyond the ruins of the stage there is the
cavea, the hemicycle for the audience. The tiers of seats
have been reconstructed in iron scaffolding for the per-
formances now presented here in the summer, but the
original disposition has been preserved, with wedge-
shaped sectors (*cunei*) separated by the stair aisles. Behind
the wall above the cavea is the ***crypta,*** a vaulted corridor,
and above it there is yet another **tier** of seats. In the far-
thest wall there are still the original rings that held the
wooden poles, from which an awning (*velum*) was
suspended on sunny days. The entrance to the stage is in
the right foreground, and the arch to its right leads to the
parodos, by which the spectators entered the orchestra.

46 LARGE PERISTYLE BEHIND THE GREAT THEATER, *viewed*

from the north. The east corner of the stage building
can be seen in the right foreground, and beyond it is the
stairway which connected the north portico with the
Triangular Forum and from which a smaller staircase
came off at a right angle in the courtyard behind the
stage building. Behind the roofed-over portico at the
rear are the rooms that were outfitted after the earthquake
as lodgings for the gladiators. The modern reconstruction
of the wooden gallery which ran around the area and gave
access to the rooms on the upper story can be seen at the
left, under the sloping roof. There are seventeen Doric
columns on the short sides, twenty-two on the long
ones, and after the earthquake they were re-stuccoed and
the lower part of their shafts was painted red, the upper
fluted part yellow or, in the case of the two in the middle
on both the east and west sides, blue.

47 PLAN OF THE THEATER AREA. 1) Entrance portico
of the Triangular Forum; 2) Triangular Forum; 3) Sam-
nite Palaestra; 4) Water tank; 5) Great Theater; 6) Small

Covered Theater; 7) Gladiator barracks; 8) Temple of
Zeus Meilichios; 9) Temple of Isis; 10) City wall

48 SMALL THEATER (THEATRUM TECTUM). Here we ▷
are looking into the playing area or *orchestra* from the east
parodos, the roofed-over entranceway. The four lower
rows of the cavea, reserved for notables, end at the sides in
the semicircular steps used by the general public to reach
the seats behind the stone parapet. The auditorium proper
is separated from the parodoi and what we would call the
bōx seats above it by a wall at the end of which, on each
side, there is a sculpted telamon, and there is further
sculpture on the parapet which ends in lion's feet. The
highest rows of seats in the upper part are cut off by the
outer walls of the building, which are at a right angle to
the stage and served to support the roof. The theater was
built in the first years of the colony and never underwent
any significant alterations except for the colored marble
pavement in the orchestra, which was laid in Augustan
times.

46

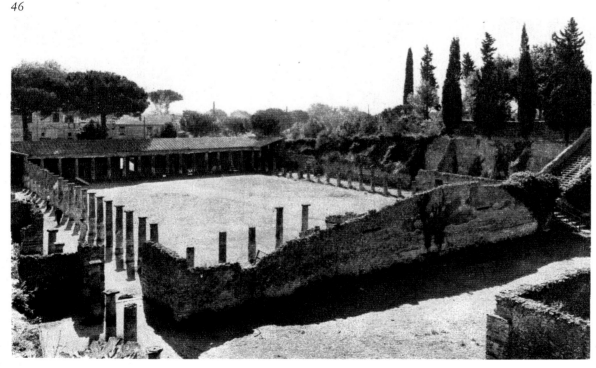

47

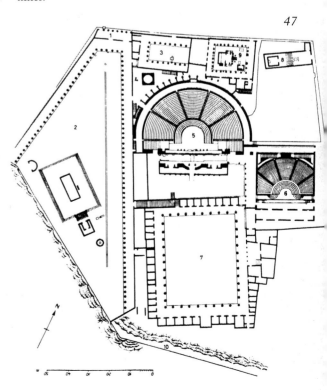

48

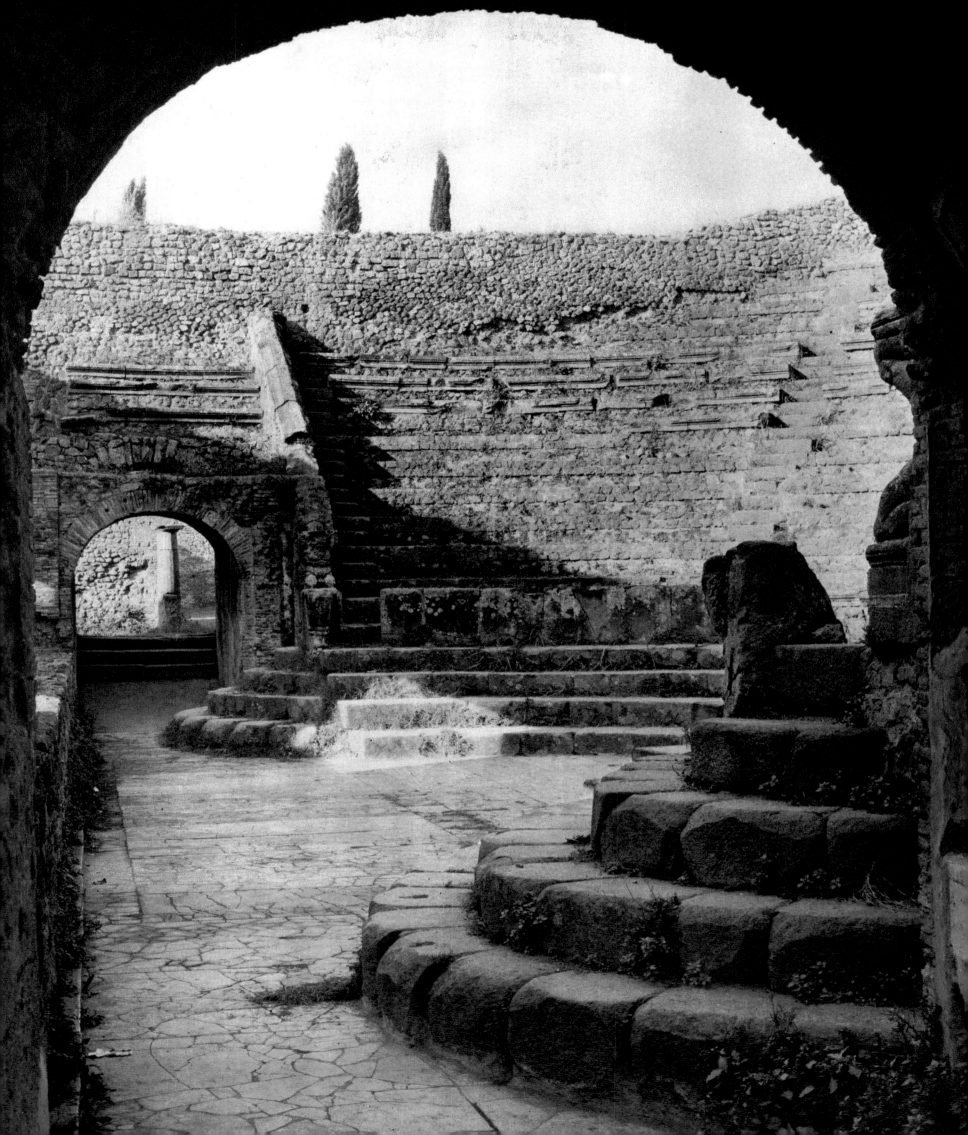

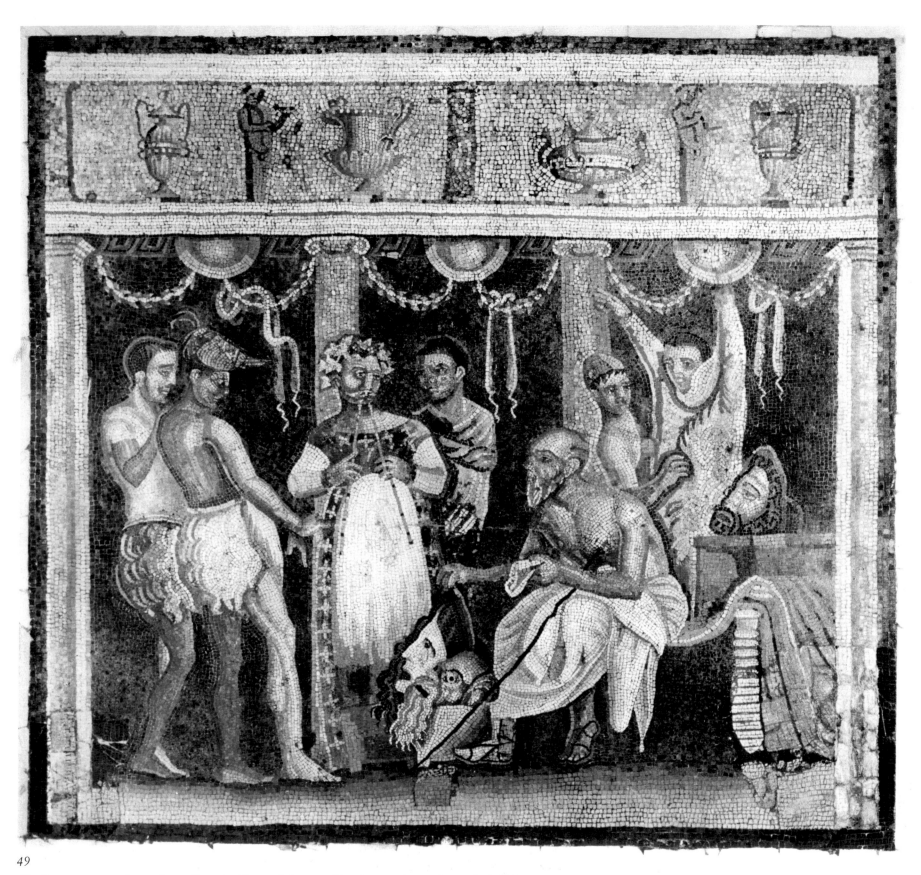

49

49 REHEARSAL OF A SATYR PLAY, *from the House of the Tragic Poet* (VI, 8, 5). *Mosaic emblem, 20 1/2 × 20 7/8″ (without black tessellae frame). Museo Nazionale, Naples.* Although found in the tablinum of a house redone entirely after the earthquake—not a bit of its decoration that survives dates from before A.D. 62—this emblem is often dated about 100 B.C., though in fact it can only come from the time of Nero. If nothing else, its coloring, with its special emphasis on shades of blue, bears this out.

The architectural setting consists of two square pillars framing two columns which support an attic, a low stretch of wall above the entablature, decorated here with golden vases. In front of it sits the bald but bearded leader of the chorus (who could be the author of the play also) wearing only the type of mantle known as *himation* and sandals. Resting under one arm is the knobby staff which is part of his costume, and his right hand holds a female tragic mask by its high headdress. There is a mask of Silenus at his feet and a bearded mask on the ledge behind him. Two actors stand in front of him, both wearing the pelt of some wild animal around their loins, one nude to the waist and with a mask (restored in modern times) pushed back above his head, the other wearing a short-sleeved singlet. The actor to the fore appears to be working out move-

ments to the music of the aulos (a double-oboe), and yet another actor stands behind the musician. On the right a wardrobe servant wearing a pointed cap helps an actor into the shaggy costume of a Silenus.

The mosaic doubtless goes back to a Hellenistic panel painting, perhaps one commemorating a victory in one of the annual theatrical contests, and the fact that it is a copy may explain the errors in perspective: the upper and lower parts of the columns are in different planes, the angle of viewing of the coffered ceiling to the left of center is different from that of the left-hand pillar.

50 THE FIGHT BETWEEN POMPEIANS AND NUCERIANS IN THE AMPHITHEATER, *from a house in Pompeii* (I, 3, 23). *Wall painting transferred to panel, 66 7/8 × 72 7/8". Museo Nazionale, Naples.* Clumsy in perspective and crude in drawing as it is, this picture of the bloody brawl that took place in A.D. 59 (see p. 31) shows us the Amphitheater as it was, with a high outside staircase, an arcade around the exterior, and the upper tier set back from the others. The city wall with two prominent towers looms up in the background, and at the right there is the large palaestra (see plate 68). An awning, made in separate sections, is stretched across the spectators' seats. Here for once we have a reliable date: the picture could not have been done earlier than the free-for-all it commemorates.

51 PLAN OF THE AMPHITHEATER. Only in the plan does it become clear that the Amphitheater is neither a perfect ellipse nor a perfect oval because the platform the audience reached by the outside staircase, and from which they then went down to their seats, does not follow the shape of the cavea.

52 AMPHITHEATER, *viewed from the southeast.* Even overgrown with vegetation, the various sectors of the seats can still be made out. The lowest rows, reached through the vaulted corridors in the left foreground and rear right, are separated from those above them by a high balustrade. The loges reserved for women were on the very highest tier. Although the Amphitheater was built about 70 B.C., if we follow the inscription commemorating their installation, the banks of stone seats could not have been in place before the reign of Augustus.

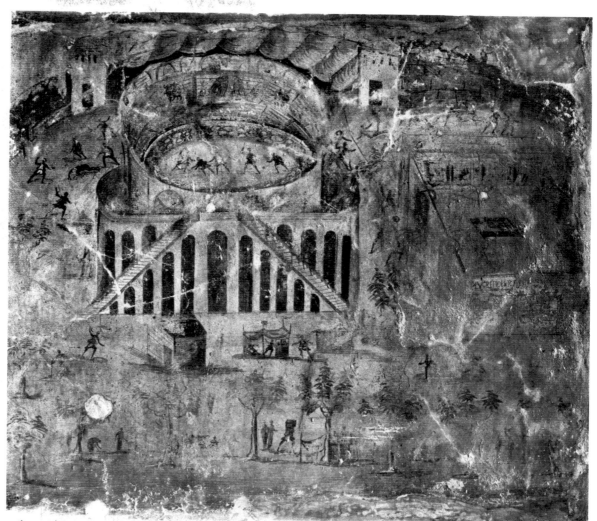

51

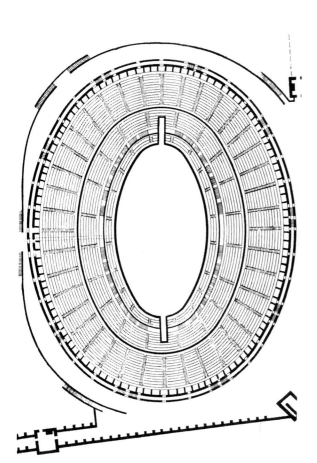

52

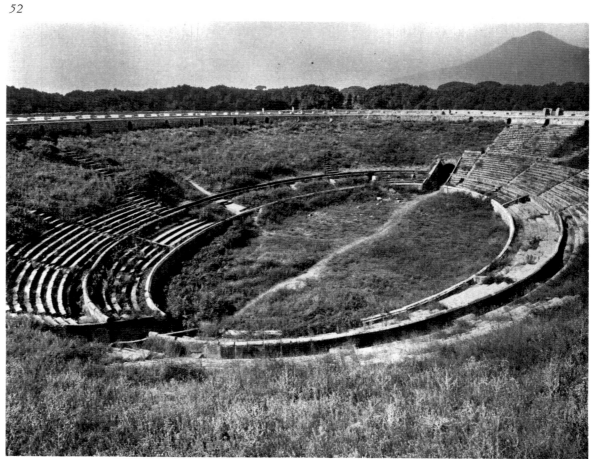

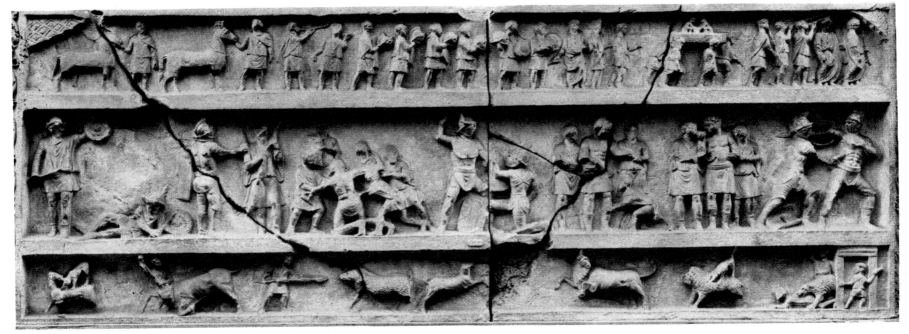

53

53 FRIEZE OF GLADIATORS, *found outside the Stabiae Gate. Marble relief, 4′ 11″ × 13′ 10 1/2″. Museo Nazionale, Naples.* Because it was found outside a city gate, it is likely that this relief came from a large tomb. In the upper zone there is a procession led by two lictors and three musicians, two playing the Roman straight trumpet known as a *tuba,* the third with a hooked trumpet called *lituus.* Then, carried on the shoulders of four men, comes a litter (*ferculum*) on which two smiths hammer on an anvil, and behind this are two *harenarii*—amphitheater attendants—and the *editor muneris,* the impresario or patron of the games. Other *harenarii* carry helmets and shields and then, preceded by a trumpeter, two attendants lead horses in gala trappings. The procession has been interpreted as having to do with the *probatio armorum,* the control of weapons by the *editor* before the games start.

The second zone, which has the highest relief of the three, shows five gladiatorial scenes. From left to right: 1) a gladiator raises his shield in a sign of victory while his opponent lies sprawled on the ground; 2) a gladiator stands alongside the umpire, waiting to be proclaimed victor or ordered to continue the combat, while five *harenarii* help his battered opponent up from his knees; 3) a gladiator is about to deliver the death blow to his adversary, who pleads for mercy; 4) a pause between rounds: one gladiator stands between two *harenarii* while a third treats a wound in his leg and another fighter, likewise between two attendants, is about to drink from a beaker; 5) a gladiator thrusts his sword at the breast of his opponent.

The lowest zone is taken up with combats against or between animals (*venationes*). Again reading from left to right: 1) dog against billy goat; 2) *bestiarius* (animal fighter) against bull; 3) *bestiarius* against boar; 4) bull against young stag; 5) dog attacking boar; 6) bear attacking a man while two *harenarii* look on in horror, one of them just turning to flee.

54 GLADIATORS' BARRACKS. Here we have the west corner of the portico in the large "foyer" behind the Great Theater which, after the earthquake, had to be used to house the gladiators and their dependents (see plates 46, 47).

55 PARADE HELMET OF A GLADIATOR. *Bronze, Museo Nazionale, Naples.* Bronze helmets like this were not used in combat but for the *pompa*—the procession before the matches—and other gala occasions. This one has a companion piece whose crown is decorated with a glorification of Rome, whereas here the theme is the fall of Troy. In the center, Menelaus and Helen stand in front of the city wall. On the left side (not visible here) there is the slaying of Cassandra and Priam; on the right, the flight of Aeneas. The side pieces show Sinon dragged before Priam by two Trojans, but it is less certain that the sacrificial scene on the crest and the wounded man between weapons on the brim have to do with the story of Troy. The helmet was produced by a Campanian workshop during the reign of Tiberius.

54

55

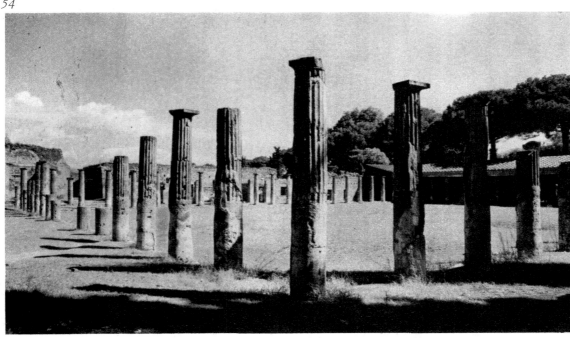

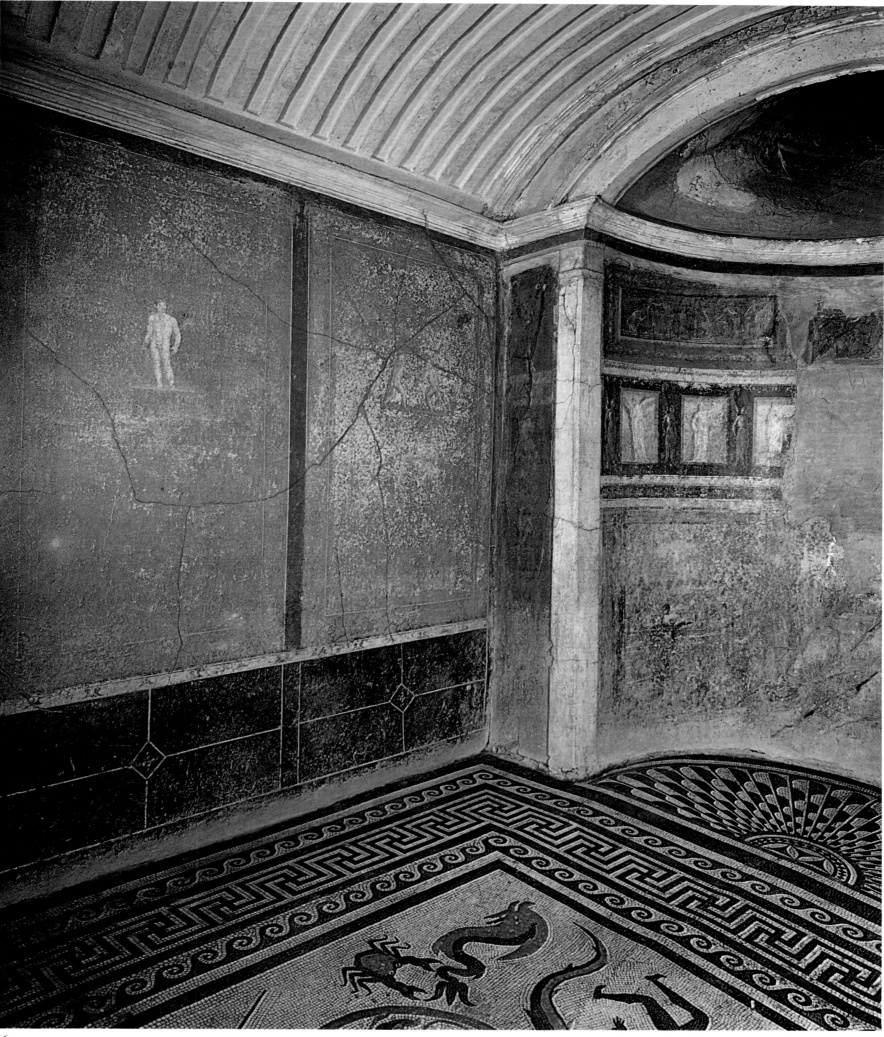

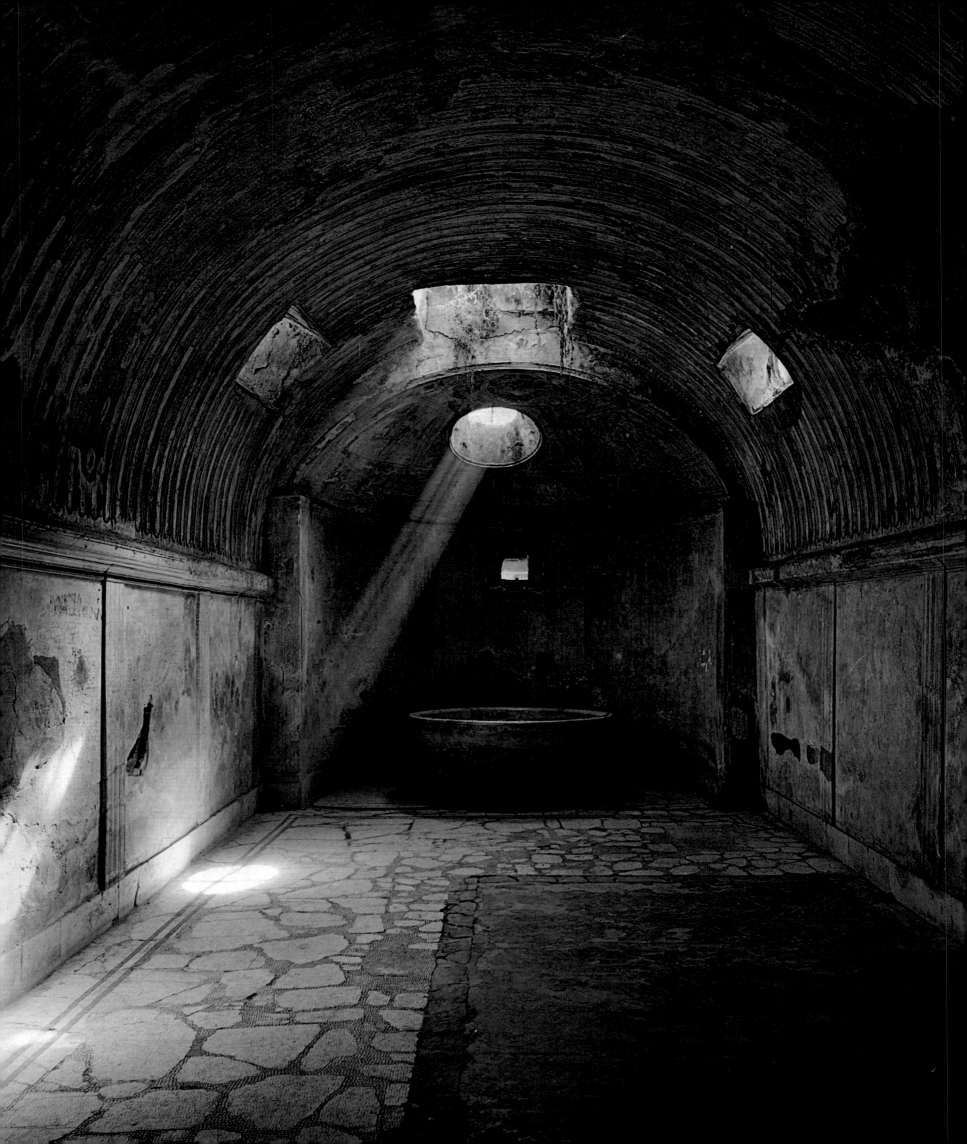

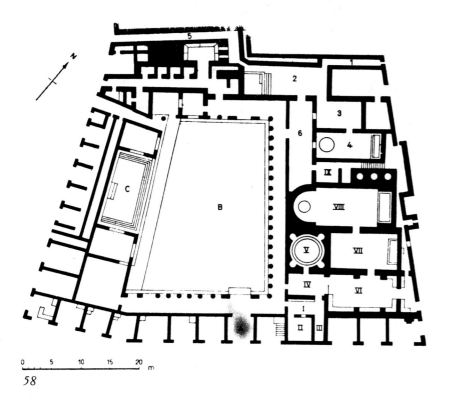

58

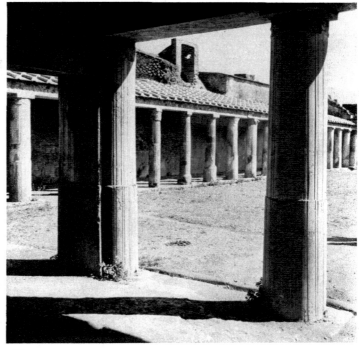

59

Preceding page:

56 CALDARIUM, HOUSE OF MENANDER (I, 10, 4). Small as this private bath is—only seven and one-half by twelve and one-quarter feet—it is nonetheless the most elegant in Pompeii. It was redone after the earthquake, but without changing the black-and-white mosaic floor which goes back to late Republican times. The paintings are in the Fourth Style, with athletes against a green ground on the long walls and, above a dado around the alcove, river landscapes and a frieze with women bathing.

◁ 57 CALDARIUM IN THE MEN'S BATH, FORUM THERMAE. Like the private caldarium just seen, this public bathhouse, too, has a fluted, stucco vault. Only the half cupola in the alcove has stucco reliefs. A large, round window in the cupola affords light, and the floor and walls were warmed

by hot air. The large marble basin in the apse held cold water used for sponging down, and its bronze inscription boasts that it cost no less than 5,250 sesterces.

58 PLAN OF THE STABIAN THERMAE. *A*) Entrance; *B*) Palaestra; *C*) Piscina; *I–VIII*) Men's baths; *IV*) Vestibule to the men's section; *V*) Frigidarium; *VI*) Apodyterium; *VII*) Tepidarium; *VIII*) Caldarium; *IX*) Laconicum; *1–6*) Women's baths; *1, 5*) Entrances to the women's section; *2*) Apodyterium; *3*) Tepidarium; *4*) Caldarium; *5*) Anteroom

59 PALAESTRA. STABIAN THERMAE. The large trapezoidal exercise court with its swimming pool on the west side was originally framed on three sides by porticoes with

Doric columns in tufa stone. After the earthquake the columns were given a thick coating of stucco, which made them look disproportionately squat, the capitals were decorated with stucco vine tendrils, and, in conformity with the taste of the time, the lower parts of the columns were painted red. In the left foreground can be seen one of two pillars on this north portico which have an engaged half column, a motif introduced to balance the entrance on the opposite side.

60 INSTALLATION FOR WARMING THE FLOOR. *Tepidarium in the men's section, Stabian Thermae.* With the room itself destroyed, we can see how the floor was constructed. It rested on pillars of hollow brick through which air, warmed in the hot bathroom, circulated.

60

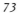

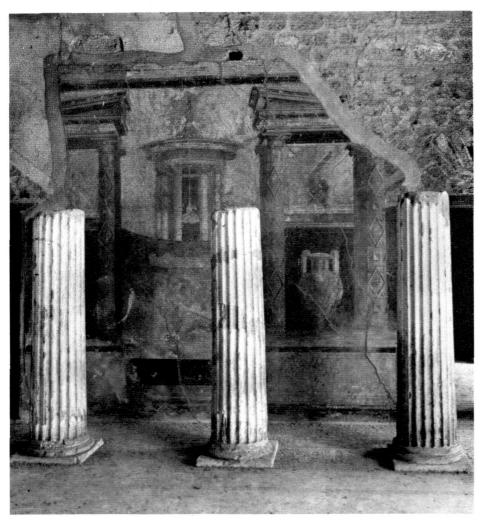

73

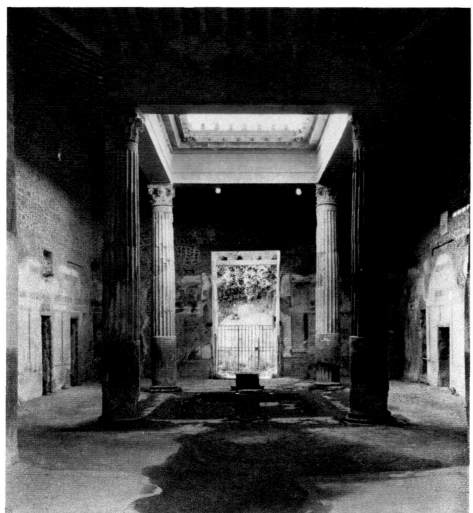

74

73 CORINTHIAN OECUS, *House of the Labyrinth* (VI, 11, 9–10). In this wealthy house, which gets its name from a mosaic in an exedra, a large room off the garden was designed according to the Vitruvian principle of the *oecus corinthius,* with the walls paralleled by rows of single-tiered columns. If it was a triclinium, as seems likely, the servants waiting on table would have passed back and forth in the space between the columns and the walls. The paintings in the Second Style were done about 40 or 35 B.C. Here, painted on one of the long walls, is a kind of propylon with broken pediment beyond which there is a view of a round temple in the center of a colonnade. On the right, a convincingly three-dimensional painted amphora stands on the same painted podium from which the painted columns rise. In exploiting the illusionistic possibilities of perspective, the aim was to make the room appear larger, although as in the house of Marcus Obellius Firmus (plate 81), the lower part of the wall was blocked off by a painted hanging curtain.

74 ATRIUM, *House of the Silver Wedding* (V, 2). This is a splendid and noble house excavated in 1893 in honor of the silver wedding of the King and Queen of Italy. Its tetrastyle atrium is the largest in Pompeii, with an area of fifty-four by thirty-nine feet and with tufa stone Corinthian columns a full twenty-two and one-half feet high. On the *compluvium,* the opening admitting not only light but also rainwater to be caught in the basin below, one can make out the gutter spouts which have been restored and set back in place, while on the edge of the *impluvium,* the catch basin set into the floor, there is a marble outlet through which the rainwater was passed on to the cistern. In front of it stand a pedestal for a fountain and a marble bowl to catch the water that spouted from a fountain statuette which has long since disappeared.

75 FIRST PERISTYLE, *House of Ariadne* (VII, 4, 31, 51). ▷ The house, also known as the House of the Colored Capitals, extends the length of an entire insula. It has two peristyles, both oriented on the north-south axis. The southern one, seen here, surrounded a pool in the center of the court and is composed of tufa columns, four one way, six the other, whose Ionic capitals were once painted. Whatever modifications may have been made, the basic plan goes back to Samnite times.

Following page:
76 ATRIUM, *House of the Ara Maxima* (VI, 16, 15). One would not expect to find such excellent Fourth-Style paintings in a house of these very modest dimensions. At the left we look into the triclinium, where a painting of Selene and Endymion (plate 259) serves as the center-piece of a panel. There is no tablinum, only a square recess in the wall, yet it is richly decorated with a picture of Narcissus contemplating his reflection in the midst of lush vegetation. Above it, to either side of a landscape associated with the cult of Dionysus, a maenad appears to be stepping out of a door and descending a staircase, a *trompe-l'oeil* effect of the kind much favored in Fourth-Style wall decoration.

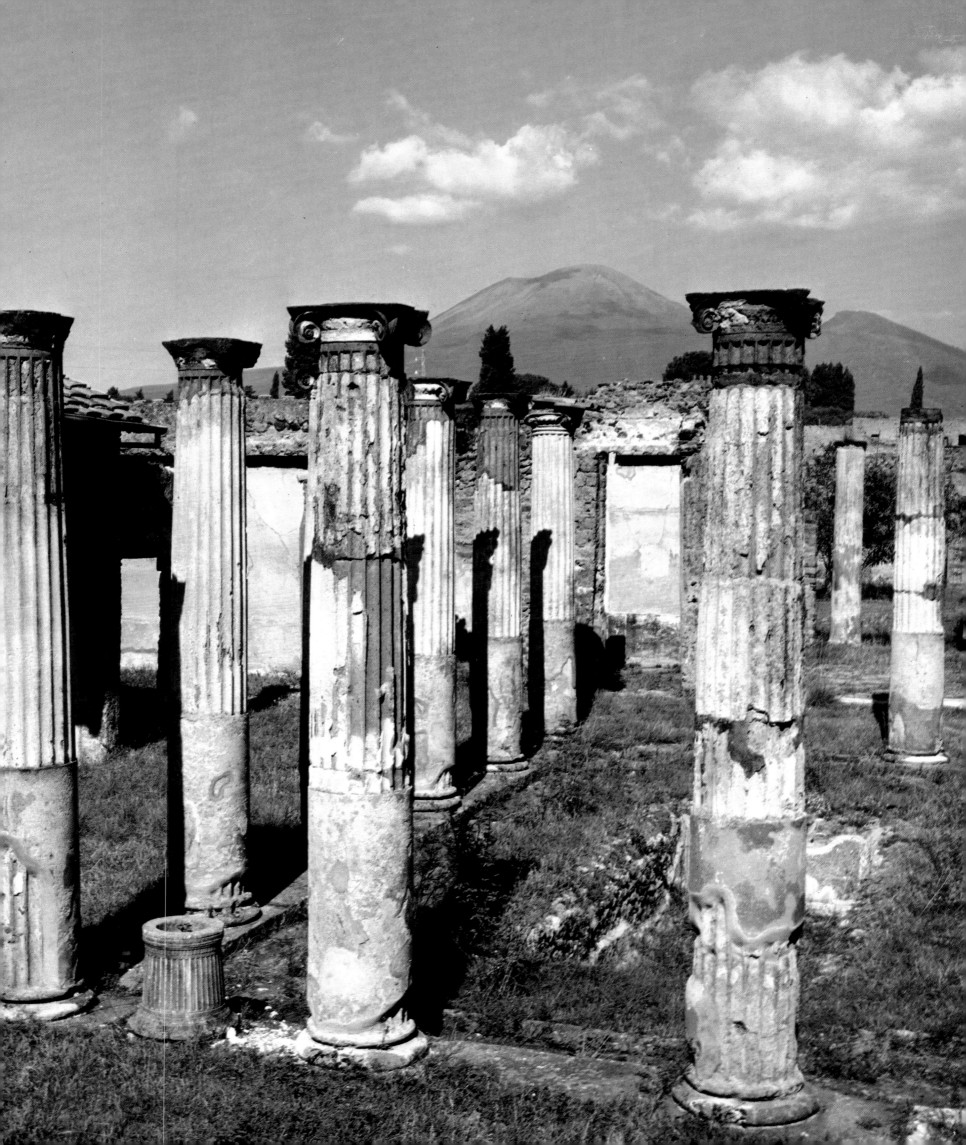

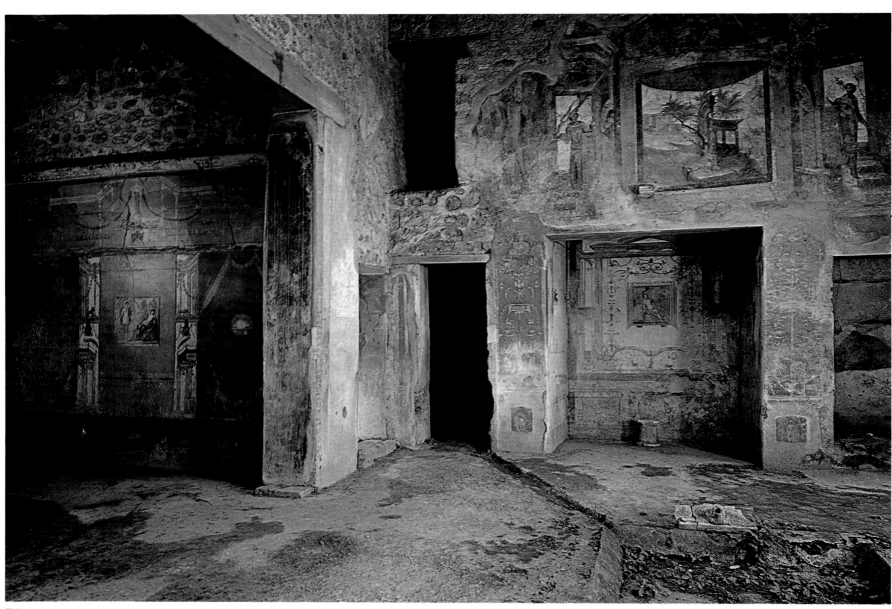

76

supported by the fact that when the Temple of Isis was built after the earthquake, through the generosity of a wealthy freedman, its plot of ground could be extended so far to the west as to involve knocking down the east portico of the old Samnite palaestra.

The most interesting find here was a statue base in front of the south portico (plate 66). Alongside it and overtopping it is a small flight of stairs used, it is presumed, in ceremonies in which the statue that once stood on the pedestal was crowned. There is also a stone table next to it which is often thought to be an altar, though its form does not support that conclusion and suggests, instead, a simple table on which perhaps was displayed the wreath destined for the victor in such ceremonies. Fortunately the statue itself has survived (plate 67) and shows the youthful Achilles as nude spearbearer, and this, too, accords with the idea of such a ceremony. Pliny (*Naturalis Historia* xxxiv. 18) speaks of "*nudae (effigies) tenentes hastam ab epheborum e gymnasiis exemplaribus, quae Achilleas vocant*" (statues of nude youths, like the ephebi frequenting the gymnasiums, who carry a spear and were referred to as Achillean).

The palaestra was only large enough for such sports as boxing, wrestling, or standing jumps but would simply not do for races or javelin throwing, these latter not being provided for until a large palaestra was built west of the Amphitheater in early Imperial times (plate 68). Moreover, the new facilities included a swimming pool, approximately 115 by 72 feet set in the center of the broad rectangle, with its bottom sloping from west to east.

The architectonic disposition of the new palaestra is of impressive simplicity. The east side facing the Amphitheater is bordered by a crenellated wall, the other sides by long porticoes. Behind the south colonnade are rooms with the same function as our locker and shower rooms. The rhythmic succession of columns in the west portico is interrupted in the middle by a broader intercolumniation with pillars and engaged half columns. Here the rear wall opens out into a rectangular chamber against whose west wall stands a large pedestal. This chamber served for veneration of the god to whose care the palaestra was entrusted and perhaps also for the Imperial cult.

Not all the damage caused here by the earthquake had been repaired by the time of the eruption. Not only had the wall decorations and flooring of the porticoes not been completed, but the water conduits had not yet been laid for the large swimming pool, so it is uncertain as to whether this new palaestra, so important in the life of Pompeian youth was ever in use during the city's last years.

THE POMPEIAN HOUSE

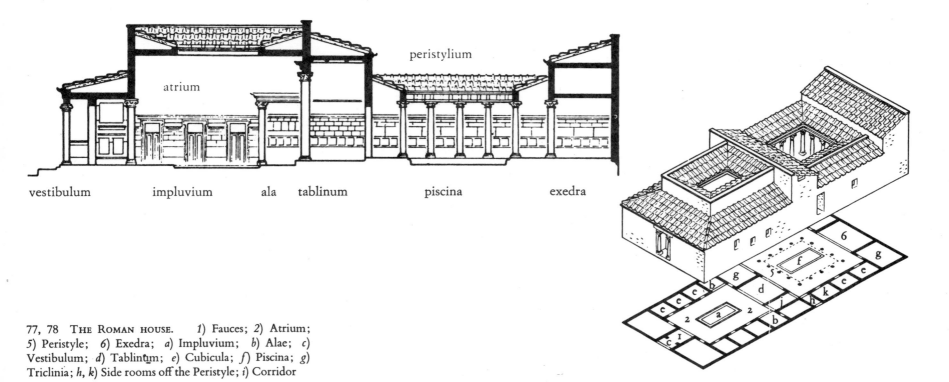

77, 78 THE ROMAN HOUSE. *1*) Fauces; *2*) Atrium; *5*) Peristyle; *6*) Exedra; *a*) Impluvium; *b*) Alae; *c*) Vestibulum; *d*) Tablinum; *e*) Cubicula; *f*) Piscina; *g*) Triclinia; *h*, *k*) Side rooms off the Peristyle; *i*) Corridor

The richest and most significant sources for our knowledge of Antique architecture that excavations have brought to light in Pompeii and Herculaneum are unquestionably the dwelling houses themselves. Nowhere else have they survived in such exceptional state nor in such great numbers. Without them, we should know all too little about Roman domestic architecture, though they are by no means necessarily typical of dwellings throughout the Roman empire. They are what they are, typical only of a particular time—roughly between the third century B.C. and A.D. 79—and a particular place, Campania, a region which became extensively Hellenized at an early date. Many of the houses were built well before Pompeii became a Roman colony and so were patently not Roman but southern Italic-Hellenistic in style. Furthermore, many things we

associate with Rome were not—or not yet—taken up in Pompeii, among them the large, many-storied apartment houses found in Ostia from the second century A.D. on. To these the Pompeians obviously preferred the traditional *domus*, the one-family house. Moreover, the fact that Pompeii was not a metropolis but a country place was clearly expressed in its domestic architecture, most strikingly in the airy, broad peristyles and quiet enclosed gardens.

Strolling through the streets of Pompeii, one is struck by the preponderance of long plain house fronts scarcely broken even for windows. The Pompeian house shut itself off from the street, taking its light from its interior courts and from openings in the roof. It is not outdoors but indoors that it reveals the elaborateness of its construction and as much diversity as is possible in a standard type of house always composed of the same basic elements.

Passing through the *vestibulum* (plates 77, 78:*c*), a recessed entranceway before the house door, and then the *fauces* (plate 78:*1*), a corridor lying behind it, one comes to the heart of the Italic house, the *atrium* (plates 77, 78:*2*), a more or less square court covered by a roof sloping inward, which has an aperture (*compluvium*) in the center to admit both light and rainwater. Gutters carried the rainwater down into a shallow catch basin set into the floor, the *impluvium* (plates 77, 78:*a*), whose dimensions match those of the aperture in the roof. This basin, in turn, fed the water so collected into a cistern, usually through a cylindrical opening at its rear.

Vitruvius (*De Architectura* vi. 3, 1) distinguished five varieties of inner court (*cava aedium*), by which he meant the equivalent of the atrium. Three of them can be identified with certainty in Pompeii. Most frequent is the *tuscanicum* type (plate 76) whose roof rests on crossbeams and has no vertical supports. In the *tetrastylum* type (plate 74) the roof sits on four columns, one at each corner of the impluvium. If more than four columns surround the basin and support the roof, then we have the type least frequent in Pompeii, the *corinthium* (plate 85).

With the impluvium taking up the center of the atrium, only the roofed-over area around it was available for other purposes. Though originally used as a dining room by Romans, this was no longer so in Pompeii, nor did it contain the fireplace used for cooking, as was the case when the atrium was still a large hall in which the life of the family centered. Instead, it was mostly a kind of reception hall used for formal visits and special occasions, and when one looks at such imposing atria as those in the House of Sallust or the House of the Silver Wedding (plate 74) it is clear how appropriate it was to such functions. Often the *arca*, the family strongbox (plate 184), had its place here, solidly locked, bolted, and cemented into the floor. Often, too, the shrine of the Lares, the tutelary divinities of the house, was set up in a corner of the atrium, as were the portraits of ancestors so indispensable to the Roman pride of race and family. Probably this shrine was in one of the two *alae* (plates 77, 78:*b*), alcoves created where the hall opened out to the sides and whose function is otherwise not clear. A number of examples of a characteristic item of furnishing have survived, a marble table whose top often sits on elaborately sculpted feet. This is the *cartibulum*, mentioned by the grammarian Varro as customarily used, in his youth, to hold bronze vessels (*De Lingua Latina* v. 125: "*Haec in aedibus ad compluvium apud multos me puero ponebatur et in ea et cum ea aenea vasa*").

The other rooms were grouped around the atrium. Those immediately contiguous to the fauces at the front of the house, especially when it fronted on a main street, were often replaced by shops (*tabernae*), which frequently opened only on the street and had no access to the house itself. This was particularly true when the houseowner or his freedmen had no goods or services to sell themselves and, instead, rented out space, an expedient much more frequent after the earthquake when many of the wealthy were so hard hit that they had to eke out whatever was left them with this sort of income. The taberna, its full width open to the street, is still a feature of southern Europe, and it survives, too, in the bazaars of the East. Besides backrooms, in most cases there was an upper floor (*pergula*) in conjunction with the shop. In the tall Samnite houses it could take the form of a built-in wooden mezzanine, but in Roman times, when ceilings were made lower, it was a small room which might have its own staircase from the street and could therefore be rented out as a more or less adequate place to live, quite isolated from the family who were one's landlords. In Latin, to describe someone as coming from humble circumstances, it sufficed to say he was *natus in pergula*.

The bedrooms (*cubicula*; plate 78:*e*) were located along the sides of the atrium. This, however, did not respect the dictum of Vitruvius (*De Architectura* vi. 4, 1) that sleeping rooms ought to have an eastern exposure because they need the morning light ("*cubicula . . . ad orientem spectare debent; usus enim matutinum postulat lumen*"). Some of the bedrooms, in fact, were decidedly cramped and gloomy. Occasionally the bed was installed in a raised alcove, and almost always its place was in some way marked by a change in the pattern or figuration of the mosaic floor and wall painting and by a different type of ceiling.

In the axis of the atrium, in line with the vestibule, was the *tablinum* (plates 77, 78:*d*), an area which always opened on the hall to its full width but could nevertheless be closed off by a curtain or even by wooden folding or sliding doors in the manner of a folding screen. There is a splendid example in Herculaneum in the so-called House of the Wooden Partition. Of the living rooms around the atrium, the tablinum is usually the largest and often the most sumptuously decorated. A large opening in the rear wall—a window or even a corridor—linked it to the garden. Used as a dining room, it shared this function with the adjoining rooms (plate 78:*g*), but also served to receive visitors and for more formal occasions. From no other spot was there a better overall view of the house.

The series of rooms culminating in the tablinum mark the end of the portion of the Pompeiian house deriving from the early Italic tradition. Often there was, in addition, an upper story, but what little we know of these is deduced from a few rare vestiges. According to Varro (*De Lingua Latina* v. 162), the entire upper story was called the *cenacula* because it served originally as a dining room, but there must also have been rooms for relaxation and sleeping, for the slaves if for no one else. In any case, it was seldom a matter of an entire floor but, instead, more usually a few rooms above part of the ground floor.

The form, design, and function of the part of the house lying to the rear and accessible either through the tablinum or a narrow corridor alongside it (plate 78:*j*) derived from a fusion of Italic and Greek notions which had already been achieved in the tufa period of Pompeii. The nucleus of the Greek dwelling was the peristyle, a colonnaded court of the sort unearthed at Priene, Delos, and elsewhere. Pompeian architecture adopted this, and the colonnade surrounded a garden which was generally planted in geometrical patterns and which itself surrounded a sunken pool (plates 77, 78:*f*). Here there was opportunity for inexhaustible variety in arrangement, and the houses in Pompeii afford endless evidence of the care and attention lavished on this intimate area where the family could be together in privacy. Around the cool and shady colonnade could

be grouped the rooms for sleeping, dining, and relaxation in whatever plan pleased and suited best, with no regard for rules or tradition. In the same axis as the garden there was often a large chamber, the *exedra* (plates 77, 78:6), which afforded a pleasant view into the garden. Adjoining this there might be other rooms called *oeci*, a name which betrays its Greek origins and shows clearly that the entire ensemble of peristyle and surrounding rooms was taken over from the Hellenistic East. Of the types described by Vitruvius, the *oecus corinthium* is represented by especially handsome examples in Pompeii (plate 73). In his definition (*De Architectura* vi. 3, 9) there are two distinguishing traits: simple columns supporting an architrave and a vault over the central part of the ceiling. Technically this involved no particular difficulty. A ceiling of rush matting was suspended beneath the roof and then molded into the desired form and stuccoed over to maintain its shape.

These oeci could also serve as *triclinia* (plate 78:*g*), a name commonly applied to the dining room when the Greek custom of reclining at table began to catch on. The *kline* or couch with room for three persons can be either a movable piece of furniture or built-in masonry (plate 87). Three couches were assembled in a horseshoe around a round table, the one on the right (*lectus summus*) reserved for the guest of honor, the one on the left (*lectus imus*) for the host, and between them lay the middle bed (*lectus medius*).

Triclinia were also set up in the open air, in the garden under the overhanging roof or a pergola where, in the heat of summer, the householders and their guests could bask in the magic of a southern night with the gentle music of the fountain as background. Well versed in the hydraulic art, the Pompeians had fountains even in their indoor dining rooms, as in the grottoed triclinium of the Villa of Julia Felix. Whatever plan and design were used, great pains were always bestowed on the appearance of the rooms devoted to the pleasures of the table.

Our model longitudinal section and ground plan (plates 77, 78) must be thought of as generalized diagrams derived from many different room arrangements. For one, they do not show the housekeeping rooms. Besides the kitchen, for whose location there was no set rule though it was mostly near the peristyle, less often in the atrium area, there were, of course, storage rooms, and the larger wealthy houses had bathing facilities with all the equipment and installations to be found in the public baths (plate 56). Toilets likewise were not lacking. However, all these facilities were laid out and grouped as best suited the house and the family, with no set plan.

The ideal house presupposed in these plans is built on a longitudinal axis, but often the site and dimensions of the plot of land called for other solutions. Thus the Vettii had to dispose their peristyle at right angles to the main axis and do without a tablinum (plate 80). In the House of the Ara Maxima the tablinum was replaced by a large alcove (plate 76), and it was just such smaller houses that had to be laid out quite differently, whether their owners liked it or not. On the other hand, there were houses that took up an entire insula, like the House of the Faun (plate 79), which has often been likened to a palace. In such an elaborate dwelling there was place for more than one atrium and peristyle and even for the entire ensemble of rooms associated with each of them. More than forty ground floor rooms are no rarity in houses like this, which often were enlarged beyond their original nucleus by purchase of an adjacent plot of ground. Social position and the quirks of fate of entire families can be read in the domestic architecture of Pompeii, and it is its surprisingly promiscuous jumble of modest and great houses that makes the city

speak to us today as a living organism, with something still of its ancient charm and diversity.

However, whatever the size and plan, each and every house did aim at a pleasant vista through a succession of rooms. To achieve this, columns were shifted out of line, door openings displaced, rigorous symmetry defied—anything to make possible a direct and uninterrupted view along a single axis. Roman architecture had a special preference for leading the eye through an alternation of shadowed rooms and sun-drenched open areas, and it is precisely this that explains the more or less fixed sequence of atrium, tablinum, peristyle, and oecus.

Nature, too, was made to conform to architectonic principles. One of the most characteristic examples of this is the garden behind the House of Loreius Tiburtinus (plate 89), where the vista from the oecus did not comprise merely a broad, open garden but instead a succession of pavilions

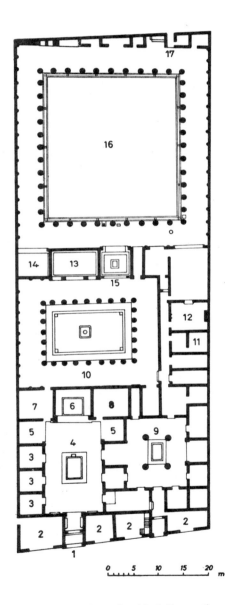

79 PLAN OF THE HOUSE OF THE FAUN (VI, 12, 2–5). *1*) Entrance; *2*) Tabernae; *3*) Cubicula; *4*) Atrium tuscanicum; *5*) Alae; *6*) Tablinum; 7, *8*) Triclinia; *9*) Atrium tetrastylum; *10*) Peristyle; *11*) Bath; *12*) Kitchen; *13*) Alexander Exedra; *14, 15*) Summer triclinia; *16*) Large Peristyle; *17*) Rear entrance

over the canal (*euripus*), which culminated in the garden room. By such means the eye was constrained to follow a preordained architectonic progression rather than roam freely about in an undefined area. Where space was at a premium, illusionistic painting was called on to make the garden area appear deeper (plates 84, 86). But in all gardens, large or small, much was made of set pieces, of statuary in the form of marble basins, herms, and figures (plate 88). Inclined as we are nowadays to poke fun at cheap garden statuary, the ancient Romans would have considered such decoration right and proper and, indeed, indispensable, though among them, too, some people had good taste, some did not. But good or bad, no Roman could imagine a garden unenlivened by statuary.

The House of the Faun

Right up to the last days of Pompeii, splendid old residences built by the Samnite patricians in the years before Pompeii became a Roman colony stood in the midst of modern Roman houses. Not that they always remained as they had been at first. Some had undergone alterations and had been redecorated, sometimes even divided up and converted. Others, where the owners looked askance at modern innovations, had contrived to preserve their old character despite the number of years and social changes, still turning to the street the dignified facades that befitted their distinguished inhabitants. None, however, maintained a conservative character more pristinely than the house that filled the entire insula 12 of regio VI (see plate 1) and today still, almost a century and a half since its discovery, remains the finest example of a Late Hellenistic family residence in all Pompeii.

Its excavation began on October 7, 1830, in the presence of August von Goethe, and in his honor and that of his great father the house for many years was known as the House of Goethe until, with time, that name gave way to the more poetic one of House of the Faun, in consequence of the fine bronze statuette found in its Tuscan atrium (plates 99, 100). The owners of the house appear to have belonged to the distinguished Samnite family of the Satrii, and its last mistress, whom death caught in her frantic attempt to hide her jewels from the flaming lava, was named Cassia—if one is to trust the inscription on a gold finger ring (plate 211)—and was probably related to the Satrii by marriage. None of this is certain, of course, but the house does seem to have been in the possession of the same family ever since it was built in the second century B.C. The family seems to have had a decided feeling for preserving its heritage from the past as well as to have been financially secure enough to maintain its social footing unimpaired throughout two centuries.

On the street front facing the Via della Fortuna there were shops flanking the house door (plate 79:1,2). Since the two to the west were later made accessible from the Tuscan atrium, they were most likely run by the master of the house himself, though there are no other signs anywhere in the building of any rooms that might have been used as offices or storerooms or for making anything, and the more than 3,600 square yards of the house, which filled an entire insula, would appear to have been used for residential purposes only.

The rich decoration characteristic of this house begins at the main entrance (plate 79:1). Consoles project from the upper half of the wall of the fauces and support a kind of small temple front in stucco with four freestanding columns, between which its door appears to stand out in relief. Probably in the broader space between the central columns there

were once statuettes of the gods to whose protection the house and all who entered it were entrusted, so that the vestibule also served as a lararium.

Once past the splendid mosaic frieze of tragic masks at the inner threshold of the vestibule (plates 39, 108), one is directly in the main axis of the house and has an uninterrupted view through the tablinum (plate 79:6), the north and south colonnades of the small peristyle (plate 79:10) and the exedra (plate 79:13), into the large peristyle (plate 79:16) all the way to its rear wall. This long vista—a particular feature of this architectural style—takes on new fascination from each point in its course but especially from the two rooms conceived in terms of such a view, the tablinum and the exedra, each of which lies between two courts (if we can apply that term to the atrium with its only partially covering roof).

The atrium is flanked by alae (plate 79:5) and a row of cubicula on the west (plate 79:3), whereas the rooms on the east side, with the exception of the southernmost ones, act as corridors to the eastern part of the front section of the house. There the rooms are arranged around an *atrium tetrastylum*, a four-columned atrium (plate 79:9), and the alae are cleverly shifted to the middle, so that the left-hand one lies to the south of the right-hand ala of the Tuscan atrium, which itself has a large window opening on this adjacent court. This atrium is lower and smaller than the main one, which measures no less than fifty-two and one-half feet in length, and even if the original stuccowork on the four columns (subsequently modified) was of good quality and painstakingly executed, the rooms that open out on it have nothing like the elegance of those around the west atrium. This is consistent with the fact that the housekeeping rooms are reached through the smaller court while the Tuscan atrium leads to the more handsome, formal rooms.

However, only one of the "better" rooms does in fact open broadly on the main atrium: the tablinum framed by two powerful stucco pilasters (plate 79:6). The two rooms contiguous to it have large windows, even though they are adjacent to the small peristyle, and the room on the left (plate 79:7) actually opens onto the peristyle (plate 79:10). Both of these rooms were triclinia, and since the tablinum is set a step higher than the pavement of the atrium it may have been used for the same purpose. With its large window looking out on the garden it would have made a pleasant place for dining during the summer months.

The small peristyle (plate 79:10) is set crosswise to the main axis. Its colonnade is composed of Ionic columns in tufa stone covered by finer white stucco, and its Doric triglyph frieze also was stuccoed over and most likely painted as well. Such a mélange of classical orders was not unusual in Hellenistic times; we have already encountered it in Pompeii in the Temple of Apollo (plates 18, 19). The small garden had a fountain which did not lie in the exact middle but rather slightly to the west, though still not in the axis of the tablinum. Only its handsome marble base, on which the basin would have rested, has survived.

Besides the rooms mentioned, in the southeast corner of the peristyle there was yet another small chamber, perhaps a cubiculum, and alongside it a corridor led to the tetrastyle atrium. On the north side there is a large exedra (plates 79:13, 107), the most elegant room in the house not only because its floor consisted of nothing less than the great Alexander mosaic but also because its front is marked by two slender Corinthian columns on square bases as well as by two Corinthian pilasters. The impressive effect owed something, too, to the fact that the columns and capitals were painted red. None of the neighboring rooms can be entered from the small peristyle, and only the east "summer" triclinium (plate 79:15) has a window looking into this intimate inner court. The other rooms, a

dining room in the northwest corner (plate 79:14) and the large oecus on the east wall, which, however, lies beyond the corridor separating the court from the utility rooms, look out only on the large garden (plate 79:16) surrounded on all four sides by a portico. The Doric columns of this large peristyle are in brick (plate 102). It is not certain if the southern arcade was two-storied and therefore used the small Ionic columns now scattered about in the garden. The east and west arcades, on whose rear walls a row of engaged half columns echoes the motif of the colonnade, have nothing but streets behind them. Only the north arcade, with its secondary door to the street (plate 79:17), is backed by yet another series of rooms which, like those of the south front, are irregularly shaped because the long and short sides of the plot of ground do not meet at right angles. Along with rooms for the doorkeeper and the gardener, there was a lararium here, too, at the back of the house.

The utility rooms were all relegated to the east side of the house, between the tetrastyle atrium and the large garden. They were linked by a corridor which also served to separate them from the dignified small peristyle. The first room to the south of the large oecus that extends onto the garden was the kitchen (plate 79:12) followed by the bath (plate 79: 11). Alongside the latter lay the toilet, and the last room along this service passageway was used either for storage or for the slaves.

The large-scale plan of this very elaborate house was clearly conceived as a unit and executed all at the same time, as appears from the excavations done by the German Archaeological Institute. Diggings have shown that there were earlier limestone buildings on the site, but as early as 180 B.C. the entire insula was built over with a single house nearly identical with the House of the Faun as we know it. The decisive alteration made at the end of the second century B.C. had to do with the large peristyle whose area had served as kitchen garden (hortus) and was converted at that time to its present architectonic plan. In the years around 180 B.C. all the rooms along its south end were oriented toward the small peristyle, and the large oecus in the southeast corner did not as yet exist, its place being occupied by smaller rooms. Among these was a bath which is, in fact, the earliest private bathing facility as yet discovered in Pompeii. It was only about 110 B.C., when the large peristyle was erected, that the bath was moved south of the kitchen where we see it now.

The clarity and logic of the plan of this Late Hellenistic house—palazzo might be a better word—was never matched in Pompeii. Even a glance at its ground plan shows how orderly its strictly rectangular layout is, with no superfluous nooks and corners and never a compromise. While the eye recognizes the visual unity of the two atria, it also perceives each as the core of an independent ensemble, and yet they are interlocked with considerable adroitness and architectural skill. If we assume the series of rooms around the tetrastyle atrium to be utility and housekeeping rooms, as their character entitles us to, and recognize the rooms in the main axis as areas devoted to the pleasure, not the business, of living, then we are struck by the way the latter increase in floor space from the Tuscan atrium at the front of the house through the small peristyle to the large porticoed garden at the rear, while at the same time the dimensions of the utility rooms decrease in the opposite direction, toward the front. All this testifies to an architect of brilliant talent in the employ of a patron who was as cultured as he was wealthy and who can only have belonged to one of the most distinguished families of the last flowering of Pompeii as a free community of proud Samnite stock.

The refined character of the house is further borne out by its furnishings. No other house in Pompeii was still so richly decorated in the so-called First Style as late as the last years of the city. Widely favored in Hellenistic times in Greece and the Near East, this purely nonfigurative style of mural decoration imitates in painted stucco the marble facings of a wall, giving the impression of blocks and bosses of stone standing out in relief by the subtle use of color, often in bright hues. Even as early as the time Pompeii was converted to a colony, this kind of decoration was thought of as fusty and out of date compared with the fashionable Second Style, to say nothing of the styles that followed it. Despite this, the House of the Faun was preserved with a dogged fidelity to past tastes and glories. Even where the wall paintings had to be renewed, the old style remained the model. It is to this austere Hellenistic decoration, loyally perpetuated by the descendants of the original owner of the house and with no concessions to modern fashions, that these rooms owe much of their rather grave and noble appearance.

Some of the walls are not painted but instead have colored figurative mosaics of the sort favored at the time of the Second Style for "emblems," mosaic compositions set into the center of a floor. Such floor mosaics, composed with small pebbles, had been customary ever since the Greek classical period. The House of the Faun was the source of the richest lode of figurative mosaics found in Pompeii, and the depiction of the Battle of Alexander (plates 104–6) from the floor of the exedra (plate 79:13) would have sufficed to ensure its fame even without considering the many other splendid examples of this art that it contained, beginning virtually at the front door with the frieze of masks in the fauces (plates 39, 108).

In the first room on the right of the Tuscan atrium there was an erotic emblem with a satyr and maenad which modern prudishness has locked away in the Gabinetto Segreto of the Naples museum. The right ala was decorated with a mosaic of cats, the left one with a small mosaic of doves which, however, dates only from a later restoration. The tablinum (plate 79:6) was without such decoration and had only a floor of colored flagstones assembled to make cubes seen in perspective, though the fact that it was framed by black and white mosaic bands, like the most precious of mosaic emblems, shows the high value attributed to it. In the right-hand triclinium (plate 79:8) there was a mosaic of a winged cherub riding a tiger (plate 103), in the left-hand one (plate 79:7) a mosaic with marine animals gathered around a combat between a spiny lobster and an octopus. Only fragments were found of the mosaic in the room next to the exedra (plate 79:15), a scene with a lion bringing down a tiger whose delicate execution places it also in the Late Hellenistic period.

These emblems, composed of tiny inlaid bits of stone or glass (tesserae), copied Hellenistic prototypes, but it is still not certain if they were executed on the spot or imported already finished. That they may have been done here is suggested by the fact that the ornamental borders have much in common with those of other Pompeian mosaics, besides which the same material was used here as in other houses in the city and is found also in the nonfigurative inlaid floors. The question can only be answered properly by scientific study of the mosaics themselves and their materials, and this is blocked by the fact that the works have been irrevocably transplanted to the walls of the Museo Nazionale in Naples. Nor, for the same reason, can one say if the mosaics were set into a tightly locked framework, a bedding of terra-cotta perhaps, in which they could be transported. The mosaic with the satyr and maenad had such a framework, as did the mosaic with the lion and tiger, but these two examples do not suffice to settle the question once and for all, and it is tempting to think that these splendid works of art were created on the spot by a workshop specially engaged by the head of the house.

The Mosaic of the Battle of Alexander the Great Against the Persians

"It is the most royal picture in the world," exclaimed Ludwig Curtius when he attempted to sum up the ethos of the great mosaic that the excavators came upon, on October 24, 1831, in the large exedra of the House of the Faun and which immediately impressed them as being far superior in both style and execution to everything in this medium known from Antiquity. At first they only understood it to represent a battle between Greeks and "*barbari*"; but by 1832 the correct interpretation was arrived at by Antonio Niccolini, Francesco Maria Avellino, and Bernardo Quaranta. Goethe wrote on March 10, 1832, to Wilhelm Zahn, who had sent him drawings of the mosaic, that "there may well be no question that the mosaic depicts Alexander as conqueror and Darius, among his troops, overcome and himself constrained to flee."

But the identification of the subject does not exhaust other questions. To begin with, we do not have the slightest idea about the technical composition of the ground into which the tesserae were set. No early source explains this, and it is too late now to determine it from the work itself, which is solidly set into the wall in the Naples museum. The place where it was found has been thoroughly dug up, and at the most an occasional white tessera, part of the original framework around the mosaic, has been turned up there. In any case, it does not seem as if the mosaic was laid on a base of terra-cotta or stone, or at least nothing of the sort has ever been reported. Obviously the most extraordinary precautions were taken when it was removed and brought to the museum, since it is a matter of record that the work shows no evidence of any significant later damage. Thus whatever is missing had already been lost in ancient times, most likely in the great earthquake. A few places had been patched up quite crudely with larger stones, but the large gaps, most conspicuous in the left half of the picture, were filled in with tinted stucco. Was this a temporary measure applied while waiting to initiate a long and difficult restoration? But could the picture really have been restored and the gaps filled in? After more than 150 years did the painting which served as the prototype for the mosaic still exist? And was there a workshop at hand capable of carrying out such minutely detailed restoration? It is conceivable that the aim may well have been merely to preserve as much as possible of the original state.

Surrounding the huge mosaic is a border of larger stones inlaid in a type of dentate pattern often used for stucco cornices or moldings in the First Style. In each of the four corners there is a colored rosette, a motif more typical of Western than of Eastern Hellenistic art. Within that border there is a blank brown strip, thought by some to be part of the original picture, considered by others as an addition by the mosaicist.

That the mosaic must have been a copy of a prototype—which could only have been a painting—is betrayed by a number of inconsistencies, especially in the center of the picture (plate 106). Look at the hind parts of the horse seen from the rear: in defiance of anatomy its left haunch is extended upward to just under the swishing tail. And there is the curious case of the particularly conspicuous helmeted head to the right of the rearing horse: the two lance shafts behind the soldier's head simply stop there, uncompleted on the right from which one would expect them to come. Then again, to the right of that same head, there is a suggestion of the head of a horse whose position in space is impossible to determine and beneath which there are the hind parts of a horse with no hint of the rest of its body. Among the four horses of the quadriga (plate 104, right) there are parts of a white horse one simply cannot together put into an anatomi-

cal whole. All of this is clear evidence that the mosaicist misunderstood details of the original. Many writers have also thought that the brown strip (not seen here), which is separated by a fine white fillet from the picture itself, was added in order to fill the space available in the House of the Faun. And, for the same reason, the mosaicist is supposed to have increased the sky area above the lances and, at the same time, compressed a number of details in the central group, which is exactly where, as noted, we find the worst errors in drawing. Here, however, one can object that it is just that compression which creates the tension and excitement of the scene. Following this same reasoning, it is likely that the mosaic is true to the height of the original painting, in which case the blank strip across the bottom is essential as a counterweight to the broad strip of empty sky above. It may also be added that the mosaicists went to considerable trouble in inlaying it with the same type of small stones as the figured scene itself, and therefore they quite obviously conceived of it as part of the pictorial field.

The action of the battle is concentrated in the center, in the space between the two royal opponents, who are linked by neither gesture nor gaze but only through a third figure. Alexander, at the head of his Macedonian cavalry, charges from the left (plate 105). Fortunately, despite much damage, most of his figure and the head and forelegs of his warhorse Bucephalus survive. He wears armor with a gorgon's head on the chest and bundles of lightning flashes on his epaulets. Bareheaded, with hair disheveled by the force of his furious onslaught, he has caught sight of the Persian king towering high in his chariot in the thick of the fray and directs against him the full violence of his attack. But a Persian officer has thrown himself between the two mortal foes, a young man of the immediate entourage of Darius, as his earring and richly worked garment, rendered with painstaking exactness, make clear. In his attempt to defend his lord, his horse has been killed under him. From the right, another Persian rushes to him, bringing the sorely pressed officer a fresh steed. But even before the officer has had time to dismount from his dead horse, Alexander's lance has run him through. In unbearable agony the mortally wounded Persian clutches at the shaft, his left arm despairingly raised above his head as if to fend off another blow, his mouth open in a shriek. His would-be rescuer holds back the shying horse, depicted from the rear in bold foreshortening.

But the sacrifice of the young Persian has, for the moment, diverted Alexander's forward thrust against Darius, his horse rears up, and he is forced to rein it in lest he be thrown off. His lance is deeply imbedded in the body of the officer; his only other weapon is the sword whose pommel is seen above the neck of his horse (plate 105). In short, the Greek king is in a desperate position, and the Persian horseman just to the right of the fallen officer prepares to seize the advantage, his sword clutched high, his horse rearing, his eyes fixed on Alexander (plate 106, left margin).

The charioteer of the Persian king has also grasped the situation and does his utmost to get his master out of the melee before fortune turns against him (plate 106). He has already turned the high chariot around to flee from peril, clutching the reins in his left hand, brandishing the whip in his right. His entire force is concentrated on the difficult maneuver with an extreme of tension one can read in his face, recklessly determined as he is to bring his master to safety at whatever cost. The heavy chariot becomes a juggernaut crushing even Persian soldiers in its path. One soldier struggles in vain to raise himself from under the hoofs of one of the horses, another thrusts his burnished shield, in which his face is reflected, against the great wheel which, in the next instant, will run him over.

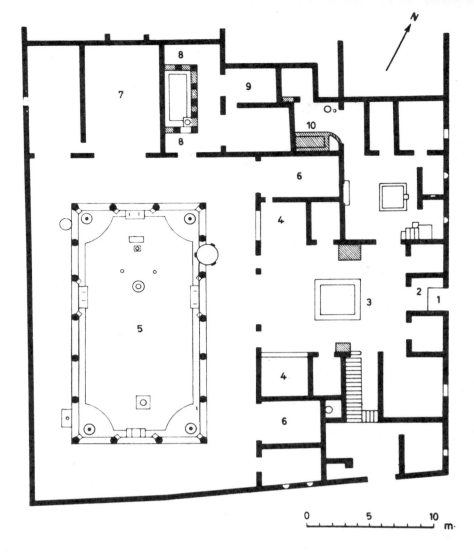

80 PLAN OF THE HOUSE OF THE VETTII (VI, 15, 1). *1)* Vestibulum; *2)* Fauces; *3)* Atrium; *4)* Alae; *5)* Garden in the Peristyle; *6 (north)* Ixion Triclinium; *6 (south)* Pentheus Triclinium; *7)* Large garden hall; *8)* Small Peristyle; *9)* Cubiculum; *10)* Kitchen

But Darius himself has no thought of flight. He leans far over the edge of the chariot to stretch out a hand to the faithful, dying officer who tried to save Darius. His eyes, wide with horror, are not directed toward his foe but toward his officer, and he seems to be calling the dying man to him. Had he glimpsed the peril and in the very last moment tried, desperately but with a glimmer of hope, to warn his loyal defender? But now he can no longer help even himself, for he has shot all his arrows and the bow in his left hand is therefore useless. Darius is weaponless.

The scene as a whole is an expression of Greek ethos. Its subject is not only victory over the foe but also the human destiny of the enemy. To make the central focus of the picture the heroic sacrifice of the Persian nobleman and the tragic helplessness of the Persian king who, indifferent to his own fate, has eyes and ears only for the agony of the man who is giving his life to save him, is entirely in line with the classical way of thinking and is paralleled by the Greek reliefs of battle scenes in which the vanquished are portrayed with deeply felt sympathy. No later epoch of ancient art had the capacity to depict the conquered with such vividly gripping feeling.

The battle rages around this central group. Unfortunately the figures of Alexander's troops are almost entirely destroyed, except for the helmeted head behind him (plate 105) and the profile of a foot soldier, probably an unhorsed rider, since the presence of an ordinary infantryman so close to the king is unlikely. Then in the background there is the forest of lances. Do they belong to the fleeing Persians or the attacking Greek cavalry? Both have been claimed, but the key is certainly the fact that there is only a single type of lance, and it is the same as the one Alexander wields and as that glimpsed alongside his horse. A single type of weapon can only imply one and the same army, besides which no positively identi-

fiable Persian bears a lance. It must therefore be the dread Macedonian *sarissa*, and the Greek cavalry must be carrying their weapons high on their shoulders as they wheel their horses around to reverse direction. This is also why the Persians on the right seem to be rushing back into the battle to warn their king against this maneuver, and why, too, the charioteer desperately wheels his horses around to flee from the center of the action. A red cloth is hoisted on one of the sarissas, a signal to attack, as we know from Plutarch's description of the battle of Sellasia where the Illyrian troops were ordered "to hold themselves back until from the other wing the king has a purple cloth (*phoinikis*) hoisted high on a lance" (*Philopoemen* 6).

The landscape in which the battle takes place is only sketchily indicated. In the foreground there are rocks which are cut off by the front and left edges of the picture, and in the left half of the composition, behind the head of Bucephalus, a tree shoots up whose gnarled branches writhing skyward suggest that it is dead and withered. These set pieces play an important part in the composition. The rocks demarcate its foremost plane, and together with the weapons strewn about the ground they define the space between the viewer and the clashing armies. For its part, the tree constitutes a formal counterweight to the Persian king and his charioteer, the only figures to tower above the heads of the Greek and Persian horsemen. Slightly inclined to the left, its trunk and branches seem to echo the divergent axes of the bodies and outstretched arms of Darius and the charioteer, besides which it is at about the same distance from the left edge of the picture as the group on the chariot is from the right. It suffices to think of the picture without the tree to recognize that the composition depends on it for its balance.

The center of the composition is dominated by two diagonals straining

in opposite directions: the Persian officer being killed and the Persian on foot trying to hold back the shying horse. Both tangents are further reinforced by other figures, that toward the right by the charioteer and the helmeted head in the center of the picture, that toward the left by the Persian with sword at the ready, by the rearing horse mounted by Alexander, and above all by Darius, the latter tangent being a highly effective means of tightly interlocking the two halves of the composition.

Unfortunately, we cannot determine much about how the picture was completed on the left, but it surely must have had as strong a definition as is made on the right by the wheeling chariot horses and the Persian horsemen all looking toward the center. The horses serve also to accent the spatial impression of depth, linking as they do the plane of the chariot with that of the foreground in a counter movement to the horse seen from the rear in the center, which leads the viewer's eye deeply into the picture. There, too, in the center of the composition, the diagonals help to create an impression of depth. To the right of center, one diagonal leads across the shying horse to the Persian attempting to hold it back and culminates in the figures in the chariot. To the left of center, the other diagonal runs from the head of the fallen horse across the body of the wounded officer to the tree in the background. What spatial depth there is in the composition is achieved mainly through the corporeal solidity of the figures and their relation to the background. Other devices to render space and depth are used only sparingly.

Just which battle is depicted remains a question, though for most commentators it must be either the one at Issus in 333 B.C. or that at Gaugamela of two years later. The Persians all wear headgear which swathes their chins (of a type the Greeks called *tiara* or *kyrbasia*) and the tight-sleeved kaftan (*kandys*), which very much suggests winter, the season when the bloody encounter at Issus did in fact take place. However, this attire alone is not enough to decide the question, and a number of details will not fit into any of the descriptions of battles we have in classical sources, so that one wonders if the painter of the original prototype may not have aimed at something more generalized, with incidents and details borrowed from a number of accounts. But even if all the details were correct and backed by reliable sources, it would be quite wrong to apply to a Greek painting the sort of standard we expect from modern war reportage.

Among the proposed identifications of the painter of the prototype, it is still Philoxenus of Eretria who remains the most likely candidate. To support this there is the statement of Pliny the Elder (*Naturalis Historia* xxxv. 110) that Philoxenus painted for King Cassander of Macedonia (316–297 B.C.) "*Alexandri proelium cum Dario,*" though with no mention of the site of the battle. Against his candidacy the objection has been raised that, again according to Pliny, in rapidity of execution Philoxenus outstripped even his teacher Nicomachus, who could turn out a picture in a few days' time. The care exercised on details in this mosaic would seem therefore to militate against Philoxenus as the original author. Whoever it was who could achieve such richness of effects with a palette based on no more than black, white, yellow, and red, he must have been one of the major artists of the years about 300 B.C.

The House of the Vettii

Just as the House of the Faun can be taken as representative of a Samnite patrician residence, so the House of the Vettii (regio VI, insula 15, en-

trance 1) can stand as the model dwelling of the wealthy merchant class, demonstrating what high standards domestic architecture could attain in Roman times even on a relatively restricted plot of ground. As it now stands, it is one of the handsomest houses from the last period of Pompeii. Severely damaged by the great earthquake, it was almost fully redecorated with splendid paintings in the Fourth Style. However, the fascination it exerts on today's visitors is not only a matter of its painted walls but also of its well-restored garden and rooms, complete even with roofing. The result of this restoration is that one gets a stronger and fuller impression of what its interior was once like than can be gotten from the House of the Faun.

The full names of the two proprietors of the house are known; they are Aulus Vettius Conviva and Aulus Vettius Restitutus. Because Conviva was an *Augustalis*, a member of the confraternity responsible for maintaining the cult of the emperor, it has often been proposed that the two Vettii were freedmen of someone named Vettius, since "*liberti*" were admitted to membership in that particular association in Pompeii. But this cannot be taken as evidence, and Restitutus and Conviva ·were more likely solid citizens of the Vettii family, which was numerous in Pompeii and among whose members a number are known to have been magistrates and candidates in elections. In any case, nothing in the elegant and tastefully conceived house smacks of the ostentatious display of wealth one might expect of parvenus.

The shape of the plot of ground available made it necessary to devise a most ingenious alternative for the regulation sequence of rooms (plate 80). Passing through the vestibulum (*1*) into the fauces (*2*)—which has a painting of Priapus (plate 282) on its west wall, placed there to watch over the owner's prosperity and divert all evildoers from the premises—one has an unexpected view of the garden (*5*) directly behind the Tuscan atrium (*3*) without the usual intervening rooms, there being no tablinum opening off the rear wall of the atrium as was customary elsewhere. Instead, between two painted pillar-like segments of wall a broad passage was left open, which was higher than the two narrow passageways to the sides, thus preserving the pattern, if not the fact, of the normal tablinum with its adjoining rooms and corridors.

The household strongbox stands on the south wall of the spacious atrium which, as usual, opens into alae to either side (*4, 4*), the one to the south having been at some time walled up and converted into a kind of storeroom. Opening off the southeast corner of the atrium is a room which is not only the largest in this front part of the house but is of dimensions quite unusual for a room in this position. It is decorated with elegant paintings in the Fourth Style against white backgrounds (plate 301). Exactly opposite it, in the northeast corner, a door, which leads to the kitchen, opens on a second and smaller atrium on whose west wall there is a niche for the household Lares (plate 289). The only way two atria could be laid out in such limited space and so deftly interlocked was by reducing the number of cubicula on the north side of the large Tuscan atrium.

Directly behind the principal atrium and disposed crosswise to the main axis of the house is the garden peristyle (*5*) with its fountain and numerous handsome statuettes (plate 88). In characteristic Roman fashion, the rectangular fountain basins of the long sides were disposed directly in line with the atrium in order to enhance the vista from the front of the house. Between them, in the center of the garden, there is a round table. Two dining rooms (*6, 6*) open off the east portico, and the right-hand ala has a large window looking into the garden. The largest and most sumptuously decorated room in the house is situated on the north side of the

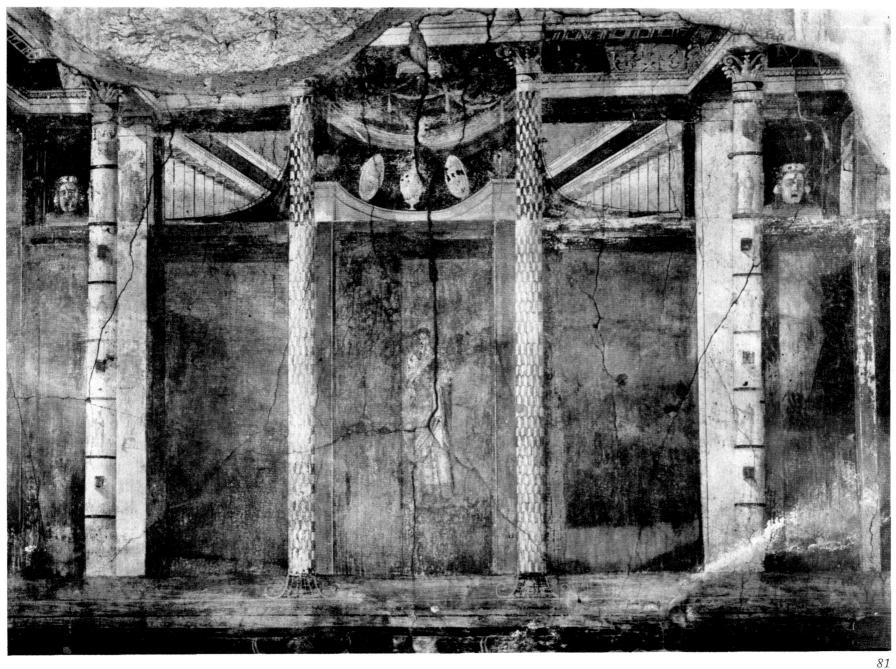

81 WALL DECORATED IN THE SECOND STYLE, *House of Marcus Obellius Firmus* (IX, 10, *1–4*). Happily, a considerable part of the decoration in this lordly residence, with its two atria and very large garden, came through the earthquake intact. The paintings in the large garden room were done about 20 B.C. and are excellent examples of the late phase of the Second Style (see pp. 203–5). The lower part of the painted wall is filled by a kind of red folding screen or partition behind painted columns covered with scales and bosses and supporting an architrave with undercut molding. Above it, between the central columns, painted vessels stand on what appears to be the cornice of a semicircular niche. To either side of center, the surface is opened up to give an illusionistic view of a colonnade leading steeply into the distance. Painted masks appear on the painted cornices of the two side fields, and the only human figure on the entire wall is the tall female in the center.

82

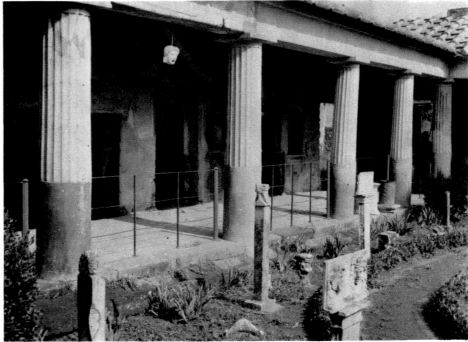

83

82, 83 Peristyle, *House of the Golden Cupids* (VI, 16, 7). The house was owned by Gnaeus Poppaeus Habitus, perhaps a relative of Nero's wife Poppaea Sabina, and what it lacked in size it made up for in elegance. The peristyle was decorated with herms and reliefs of masks (see plate 41), and other marble masks carved in the round were suspended between the columns. This part of the house had been put in order again after the earthquake, but work was still going on in the atrium when the greater disaster stopped it forever.

84 Peristyle, *House of Venus* (II, 3, 3). The house takes its name from a large painting of Venus reclining on a shell and attended by two cupids. This painting occupies a large part of the back wall of the garden, the rest being taken up by a painting of a garden scene with a large marble bowl, thus making an artful extension of the real garden. The wall paintings, like the peristyle itself, date from after the earthquake.

85 Facade and view into the atrium, *House of Epidius Rufus* (IX, 1, 20). The house sits on a podium above street level, and its entrance, in the left foreground, is reached by steps to either side. The atrium belongs to the Corinthian type, with a roof resting on sixteen Doric tufa columns from pre-Roman times. Impressive in its arrangement, the room could be taken for a garden peristyle were it not for the tufa impluvium in its center.

86 Wall painting in the garden (detail), *House of*

Venus (II, 3, 3). As we have seen (plate 84), to the right of the painting of Venus there is another depicting a garden scene in whose center is a marble basin—much like what we would call a birdbath. And, in fact, one bird sits on its rim, two others disport themselves to either side of its base. Garden landscapes like this were not exclusive to Pompeii, one of the finest being in the Villa of Empress Livia near Primaporta, outside the gates of Rome.

87 Garden triclinium, *House of Aulus Trebius Valens* (III, 2, 1). Outdoor dining rooms like this were no rarity in Pompeii, with its sultry Southern climate. The permanently placed couches and round table were set in an

84

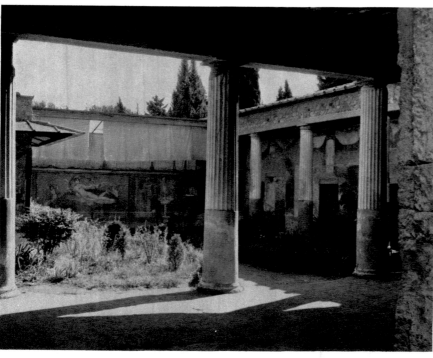

85

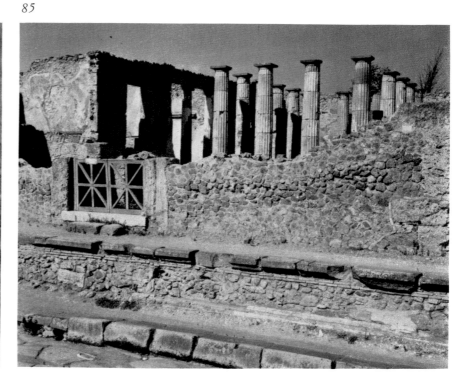

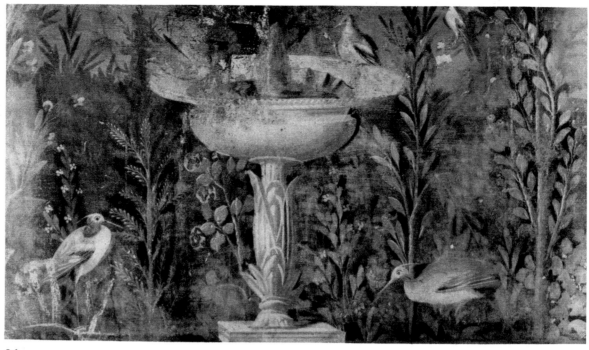

86

airy portico open to the garden in whose center a semi-circular basin with playing fountain brought a breath of coolness to the diners. The checkerboard pattern on the end wall was much favored during the reign of Vespasian.

88 HERMS AND STATUETTES. *Peristyle, House of the Vettii* (VI, 15, *1*). In the House of the Vettii (see pp. 72, 93 and plates 109–12) the garden in the peristyle has been set up as it was, with its sculptural decorations and playing fountains. Rectangular basins in the middle of each side and round ones at each corner were fed by water from twelve small fountain statuettes on high pedestals, one of which is seen in the background here, a shepherd with Phrygian cap possibly meant to be Paris. Here also are

two double-faced herms on vine-entwined marble colonnettes.

Following pages:

89 EURIPUS, *House of Loreius Tiburtinus* (II, 2, *2*). When it was rebuilt after A.D. 62 this already sumptuous house acquired a large garden to the south. It was laid out on a somewhat lower level and traversed by a canal (*euripus*) some 164 feet long. The canal and garden were aligned with a large oecus, so that the view from that room led through an entire system of vine-covered pavilions, pools, and fountains. Marble statuettes and pergolas further enchanted the eye, and there were side paths through the garden that ran parallel to this sequence of terraces and cascades, though they were not connected with it. The way the *euripus* was laid out on an unswerving

axis, inducing the eye to follow it through a succession of architectural structures, was a virtual hallmark of Roman garden design.

90 PORTICO ALONG THE GARDEN, *Villa of Julia Felix* (II, 4, *3*). As in the House of Loreius Tiburtinus, here, too, the garden was oriented on a north-south axis in relation to the house. A portico extends along the entire length of its west side, with a series of rooms coming off it. Instead of the usual columns, however, here there are slender, fluted, rectangular marble pillars. In front of the large triclinium, which looks out across the euripus to the pergola on the east wall of the garden, two taller pillars vary a rhythm which might otherwise seem monotonous. Here again we are looking at reconstruction done after the earthquake.

87

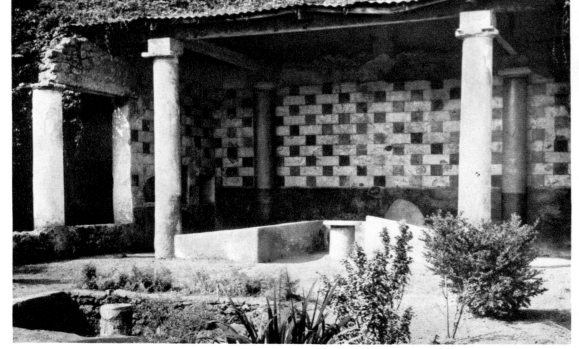

88

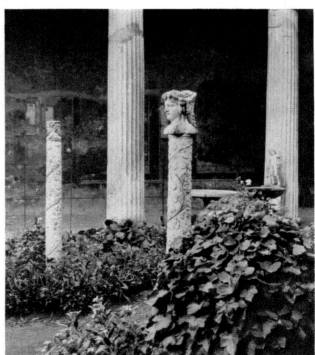

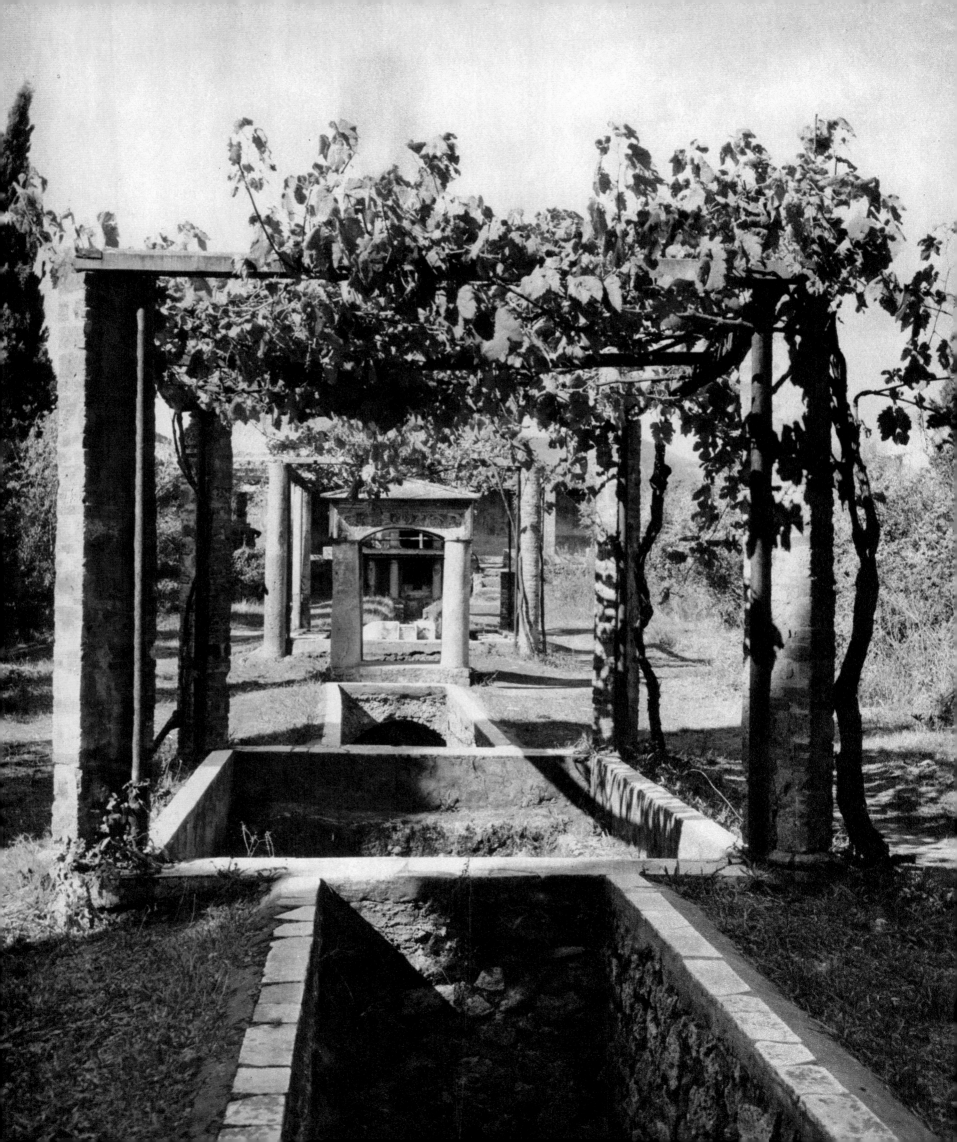

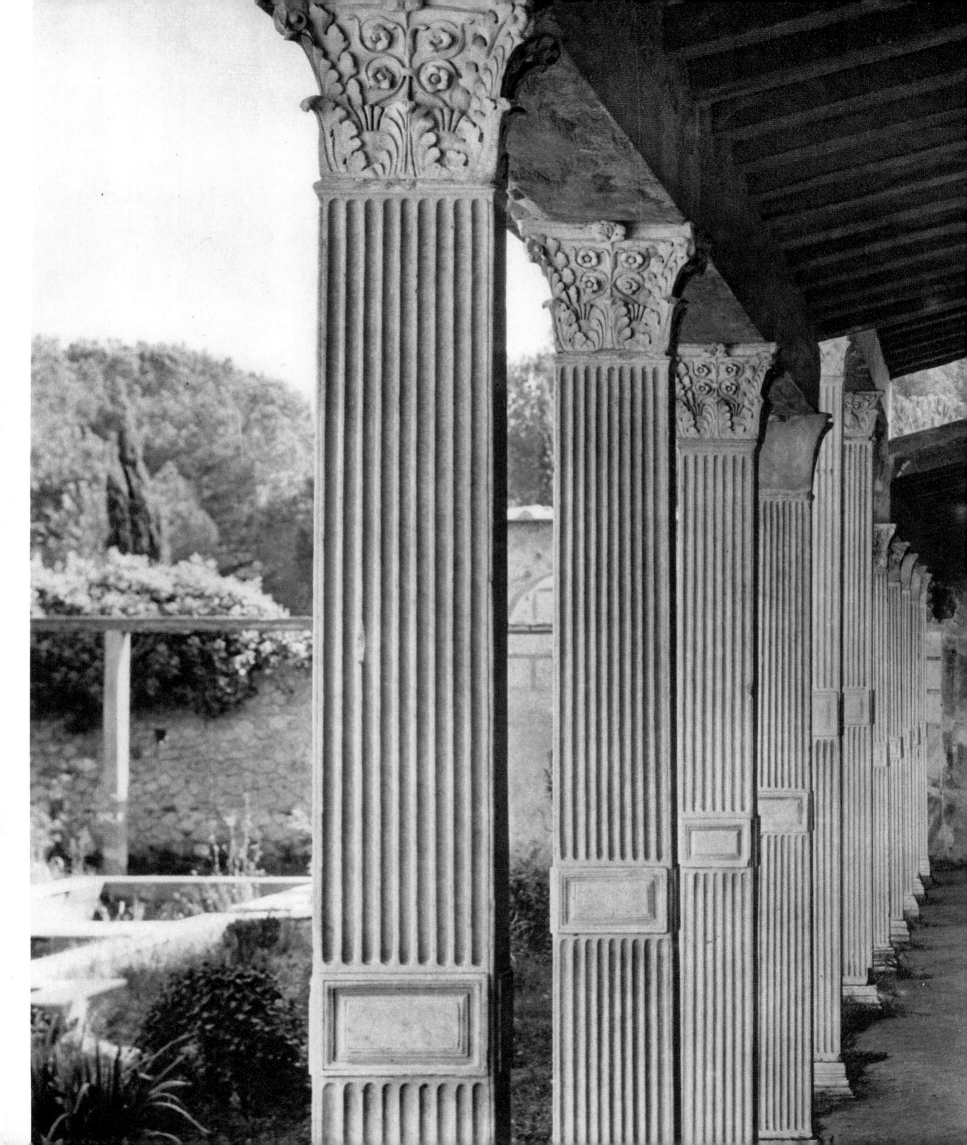

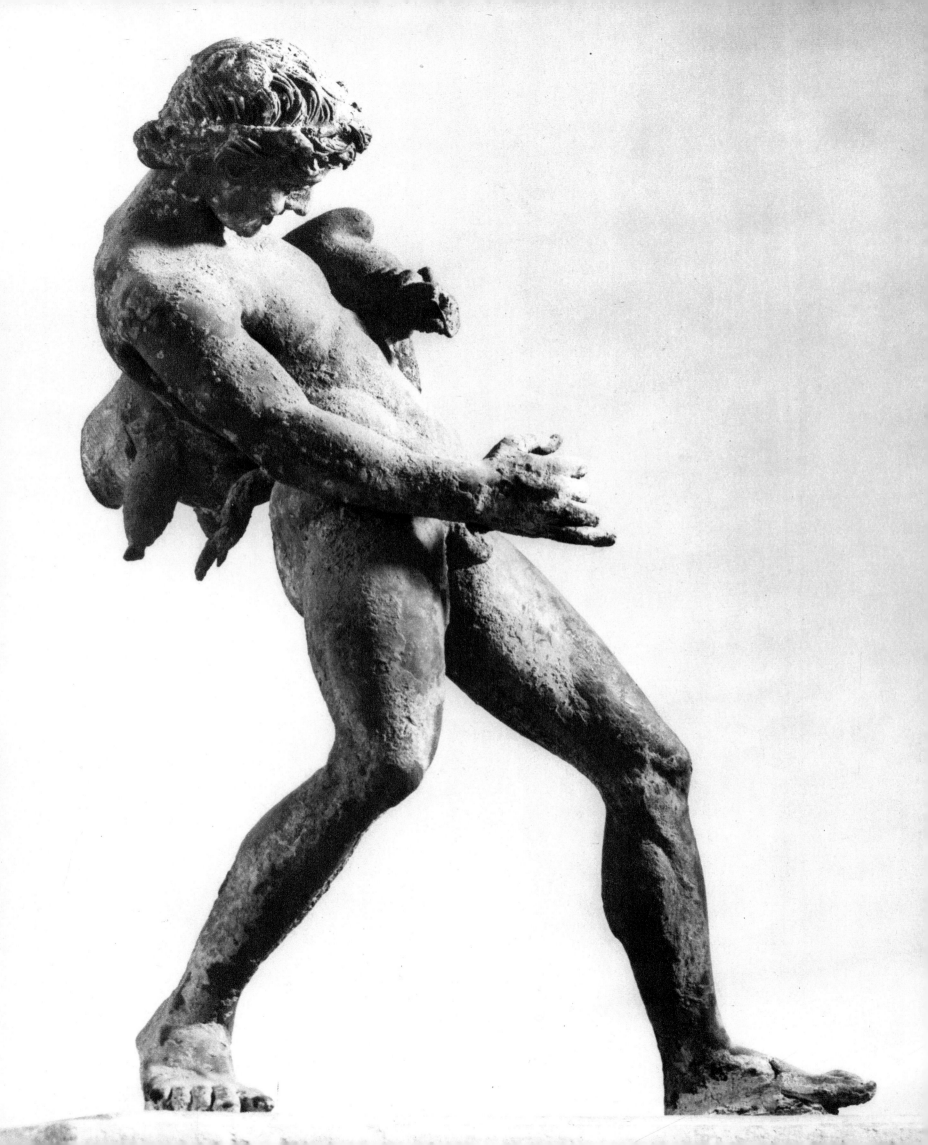

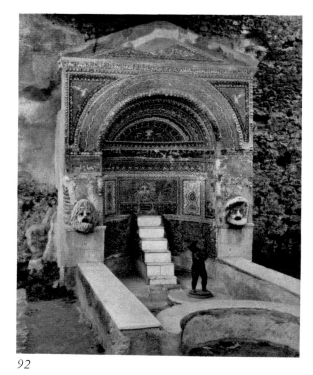

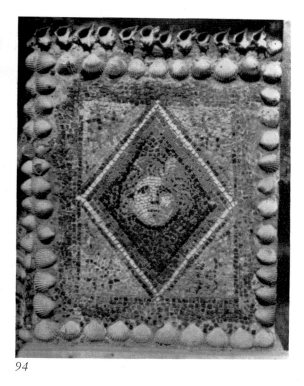

92

93

94

◁ 91 SATYR WITH WINESKIN, *from the House of the Centenary* (IX, 8, *3, 6*). *Bronze fountain figure, height 20 1/8″. Museo Nazionale, Naples.* The satyr leans backward perilously, either because he is truly drunk or in order to balance the heavy wineskin he supports with his left arm. In happier days water spurted from the wineskin into a fountain basin (the pipe was connected to the bottom of the wineskin where it hangs down behind him), and the satyr's right hand seems to be trying to stem the flow of the precious fluid. Lively and full of character, the figure goes back to a prototype of the mature Hellenistic period.

92, 93 FOUNTAIN. *Height 11′3 7/8″. House of the Great Fountain* (VI, 8, *22*). The fountain in this house is perhaps the most splendid in all Pompeii. The water flowed out of a shallow slit in the center of the niche and ran down the steps into the basin with its concave front

side. A fountain statue of a boy holding a fish stands in the basin, and two marble theater masks adorn the front of the niche, which is entirely faced in mosaic and has various ornamental motifs such as birds in the lateral spandrels, a vessel in the lunette, and a mask of Oceanus (plate 93) above the water outlet. The fountain dates from after A.D. 62.

94 FOUNTAIN (*detail*). *House of the Bear* (VII, 2, *45*). The gorgon's head in a lozenge comes from the lower part of the left-hand frame of the fountain niche. The ground is composed of small mosaic tesserae in blue glass paste, the standard material for all such fountains in the time of Nero and the Flavians. Characteristic, too, is the use of real shells for frames and borders.

95, 96 FOUNTAIN. *House of Marcus Lucretius* (IX, 3,

5). A small garden slopes away from the fountain whose water outlet is in a mosaic niche designed to resemble a half shell. A marble Silenus stood in the niche and the water ran out of his wineskin to splash down five steps into a shallow marble trough, and this in turn led down to a round basin with a playing fountain in its center and marble statuettes around its rim. Like the other fountains shown here, this, too, was constructed after the earthquake.

97 FOUNTAIN. *House of the Scientists* (VI, 14, *43*). Here are the familar motifs: the half-shell niche, as in the House of Marcus Lucretius, birds like those in the spandrels in the House of the Great Fountain, the blue mosaic background, as well as real shells used as an effective contrast to the mosaic tesserae, here most particularly in framing the arch between the two large birds. The ornamental details suggest that the Fourth Style was not far off.

95

96

97

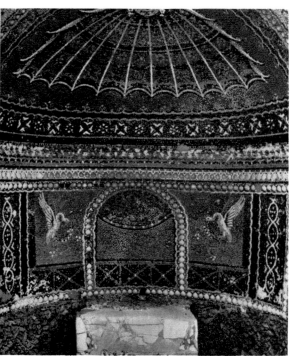

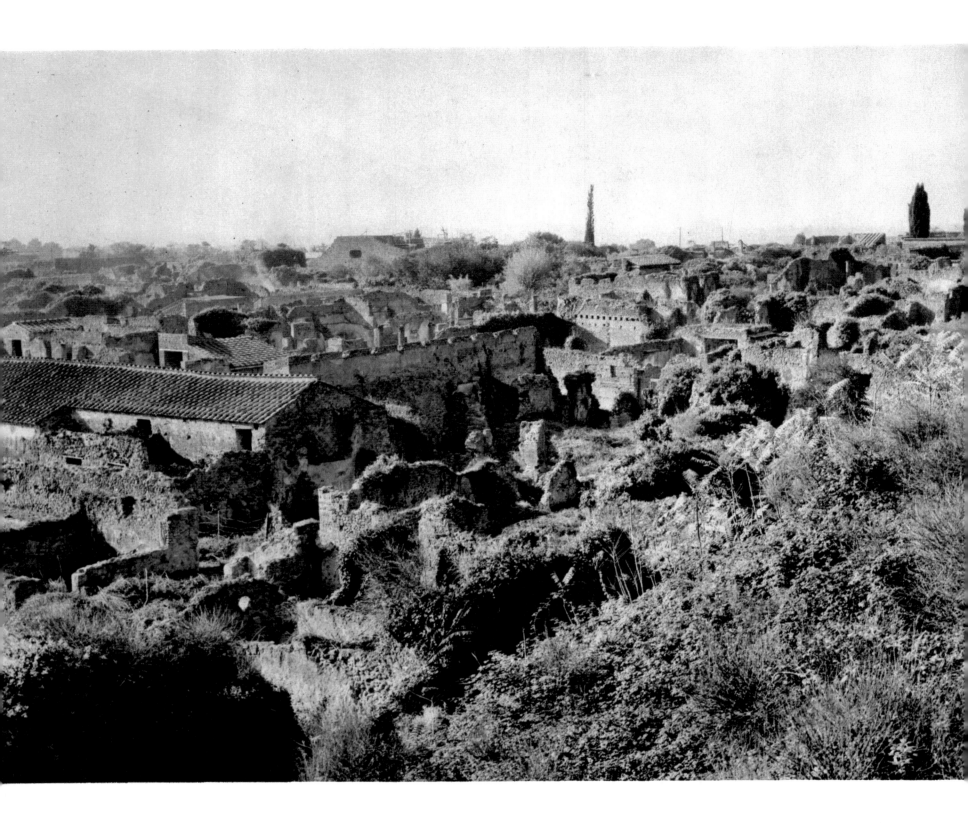

98 VIEW TOWARD THE WEST FROM TOWER X OF THE CITY
WALLS. What we see here are mostly the houses of
regio VI, which extended right up to the city wall. While
we cannot really see it as it was, because most of the
buildings are lacking their roofs, this nevertheless gives a
good idea of the regular gridiron plan of this newer
quarter of the city.

99, 100 DANCING SATYR, *from the House of the Faun* (VI, 12, 2–5). *Bronze, height 30 3/4″. Museo Nazionale, Naples.* The statuette, often mistakenly referred to as a faun, was found lying alongside the impluvium in the Tuscan atrium of the house indebted to it for its modern name. It may have decorated that water basin, though this is not certain. It is magnificently preserved, with a break only in the left ankle which, however, had already occurred and been repaired in ancient times. The base is not the original one and has been shortened. Dynamically balanced on his toes, the satyr would seem to be stamping out the rhythm of his dance and snapping his fingers in time to it. In both form and expression the thrown-back head (the eyes are modern insets) recalls the mature phase of Hellenistic art, whereas the decorative and almost over-studied movement seems to suggest a date no earlier than the late first century B.C.

99

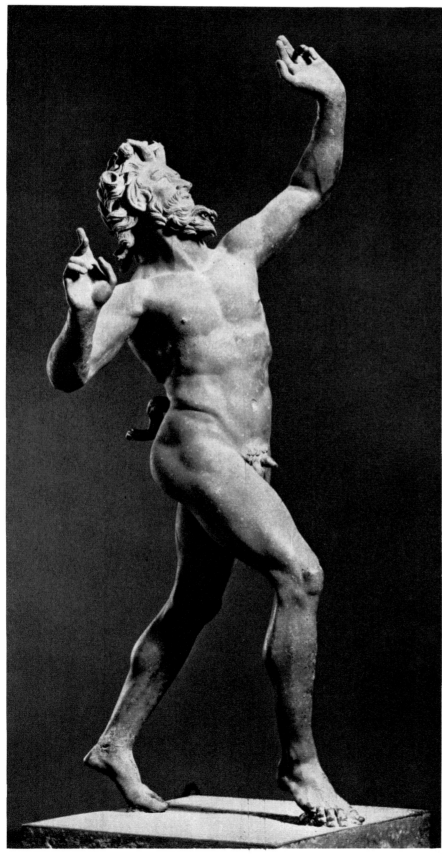

100

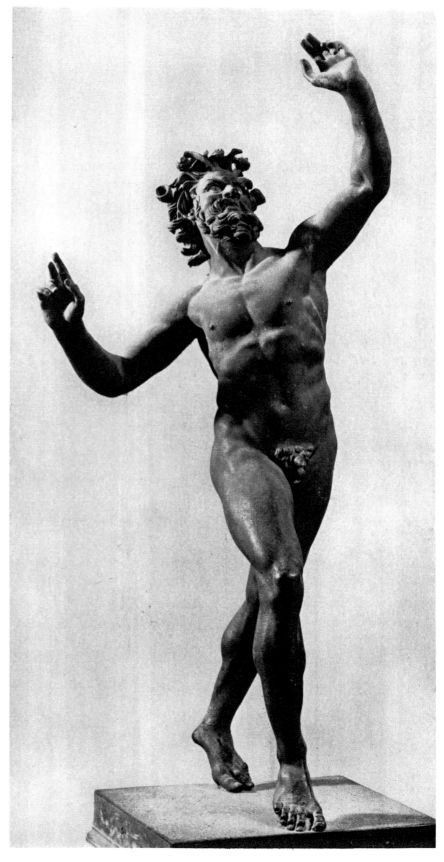

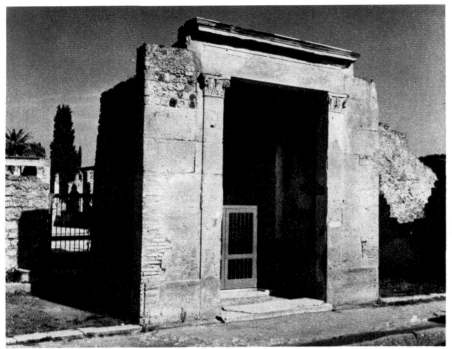

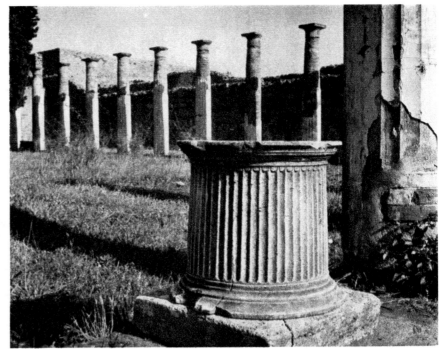

101

102

101 PRINCIPAL ENTRANCE ON THE VIA DELLA FORTUNA, *House of the Faun.* The broad portal is framed by two pilasters with Corinthian capitals, and on the doorsill the word HAVE is spelled out in colored stones to welcome the visitor. The two fragments of wall remaining at either side testify to the excellent level of masonry in Hellenistic times. Near the entrance, which could be closed off by a three-winged door, were two shops (*tabernae*).

102 HOUSE OF THE FAUN, *view into the large peristyle.* More than a third of the entire area of insula 6 is taken up by the large garden that constitutes the north end of the house. The Doric columns of the portico surrounding it on all four sides were covered with fine, white stucco, as was the rule in the First Style. In the foreground is a *puteal,* the mouth of the cistern fed by the gutter running in front of the colonnade.

Following pages:
103 THE TIGER RIDER, *from the House of the Faun. Mosaic, 33 1/2 × 33 1/2″ (central field). Museo Nazionale, Naples.* This mosaic was set in the middle of a white tessellated floor in the room to the right of the tablinum that opens on the Tuscan atrium. The picture is framed first by garlands and masks and then by a Greek wave frieze using larger stones. The title by which the image is identified in archaeological literature is not quite correct, since the animal unmistakably sports a lion's mane. The winged boy uses one hand to rein in his feline steed, the other to clutch to his chest a huge beaker brimming with wine. He stares into the beaker while the lion twists its head around and licks its chops at the sight of the delectable potion. A thyrsus lies under the animal's left forepaw, making an unequivocal reference to Dionysiac rites, though it is not possible to identify more precisely the winged genius astride the lion. Whatever the Dionysiac allegory implied, the image quite certainly goes back to a Hellenistic prototype.

104 THE BATTLE OF ALEXANDER THE GREAT AGAINST THE PERSIANS, *from the House of the Faun. Mosaic, 8′ 10 3/4″ × 16′ 9 5/8″ (without border). Museo Nazionale, Naples.* A denticulate border of larger stones (not seen here) surrounds the entire picture field which is composed of very

small stones—something like thirty to the **square** centimeter—estimated to total about one **and one-half** million.

105 THE BATTLE OF ALEXANDER THE GREAT (*detail of Alexander*). The portrait of the Macedonian king is extraordinary for its lifelike immediacy, with no attempt to embellish or glorify his appearance. Behind him there is a glimpse of the head of a Macedonian who, to judge by his richly decorated helmet, must be a high-ranking official, which may be true also of the man on foot, a remnant of whose profile can just be made out at the level of the king's right forearm.

106 THE BATTLE OF ALEXANDER THE GREAT (*detail of Darius on his battle chariot*). It is extraordinary with what care the most insignificant details of costume, arms and armor, and mounts and vehicles were rendered here in the difficult technique of mosaic: look, for instance, at the golden band around the neck of Darius, the ornamental mountings of his chariot, and the Persian garments. Yet there are strange inconsistencies that perhaps have an explanation (see p. 70).

107 ALEXANDER EXEDRA, *House of the Faun.* The room which once had the great mosaic on its floor opens to its full width on the first peristyle (see plate 79), with two Corinthian columns on square bases supporting the entablature. A window, so large that it extends almost the width of the room and allows for only a low parapet of wall below it, opened on the garden with the large peristyle whose porticoes are seen in the background here. Thus there were two fine views from this bright and airy room: in one direction toward the more intimate peristyle court, in the other toward the spacious garden with its long colonnades.

108 FRIEZE OF MASKS, *from the House of the Faun. Mosaic, 19 5/8 × 94 1/2″ (without black frame). Museo Nazionale, Naples.* We have already seen a detail (plate 39) of this richly elaborate mosaic, which served as a doorsill between the fauces and the atrium in the House of the Faun. The long picture field framed in a black band is filled with a garland of fruit intertwined with ribbons. There are three colorfully patterned hoops which have been explained as

frames of the Roman *tympanon,* a hand drum. In front of the garland lie two tragic masks with high onkos, female and male to judge by the complexions. Much richer than other mosaic garland friezes in Pompeii, this one is often assumed to have a prototype from as far back as the third century B.C. However, like the mosaic of the winged boy on the tiger, it was executed toward the end of the second century B.C., using fine tesserae of one-eighth of an inch and less, as can be seen in plate 39, where they are almost lifesize.

109 IXION ROOM, *House of the Vettii* (VI, 15, 1). The north triclinium on the east side of the garden (see plate 80) gets its name from the painting on its rear wall which shows Hephaestus (Vulcan) putting Ixion to the wheel in the presence of the wronged Hera and Hermes. Nephele, beloved of Ixion, sits grieving on the steps of the throne. The left wall has as its principal picture Daedalus presenting the wooden cow to Pasiphaë, the right wall shows Dionysus contemplating the sleeping Ariadne. In the light-background side panels of the long walls there are figures soaring in air—here a satyr with the Hora of summer—within a delicate ornamental border. Below the architectural vistas on the walls, painted masks and winnowing baskets lie on the upper edges of oblong pictures-within-picture which depict naval battles. This middle zone of the wall rests on a dado painted to resemble colored marble incrustations. The highest zone, just under the ceiling, has fantastic architecture with figures of gods. The room was painted after A.D. 70.

110, 111 LARGE GARDEN ROOM, *House of the Vettii.* The room, decorated shortly after A.D. 62, boasts the most elegant paintings in the early Fourth Style known in Pompeii. The dado around the base of the walls is composed of three zones: at the base, large figures framed by vines and objects; then, in black panels set into the intermediate band of red, mythological scenes such as that of Apollo victorious over the python (plate 111); at the top, in a continuous black band, the famous scenes with cupids and psyches (see plate 204). The topmost zone of the walls is opened up into architectural vistas in the same manner as in the Ixion Room (plate 109). The ultimate elegance is achieved by the finely drawn tendrils, blossoms, candelabra, and other ornaments (plate 111).

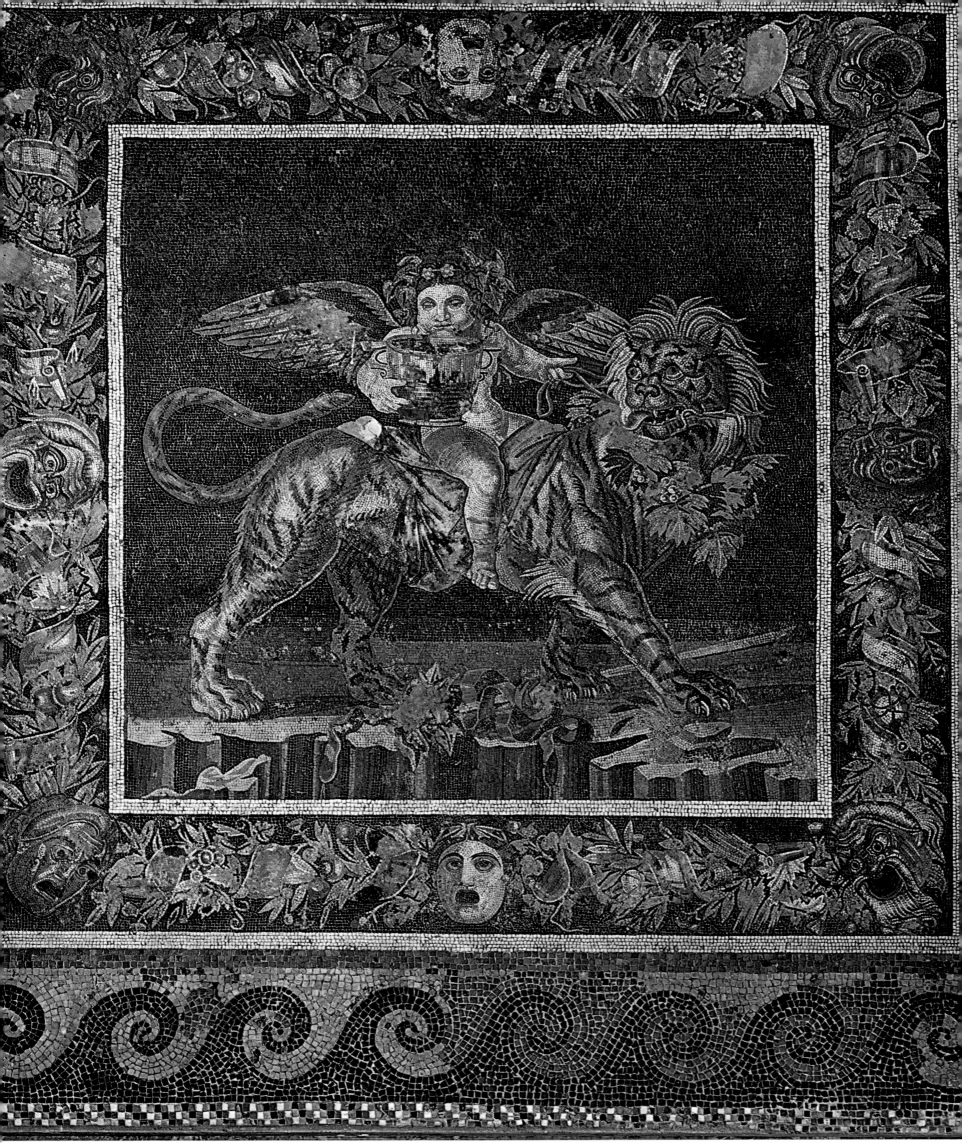

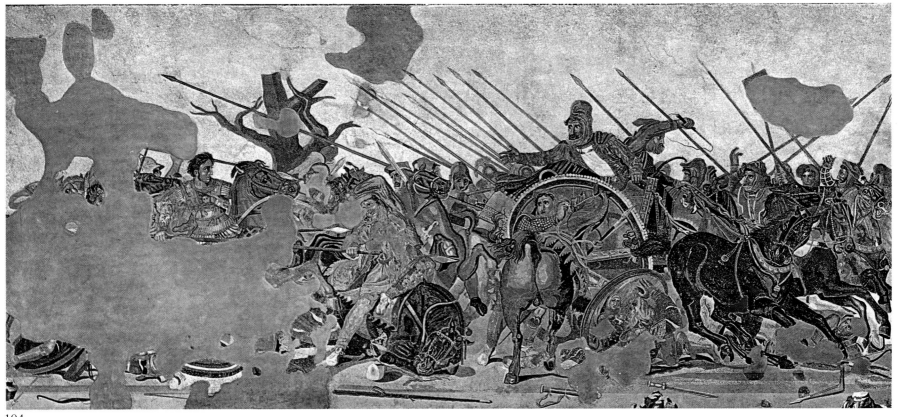

104

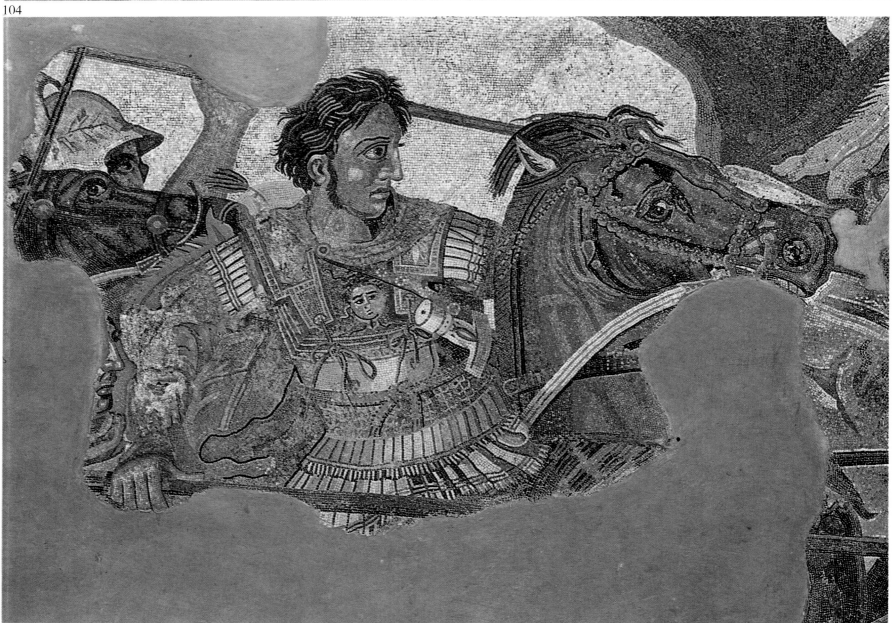

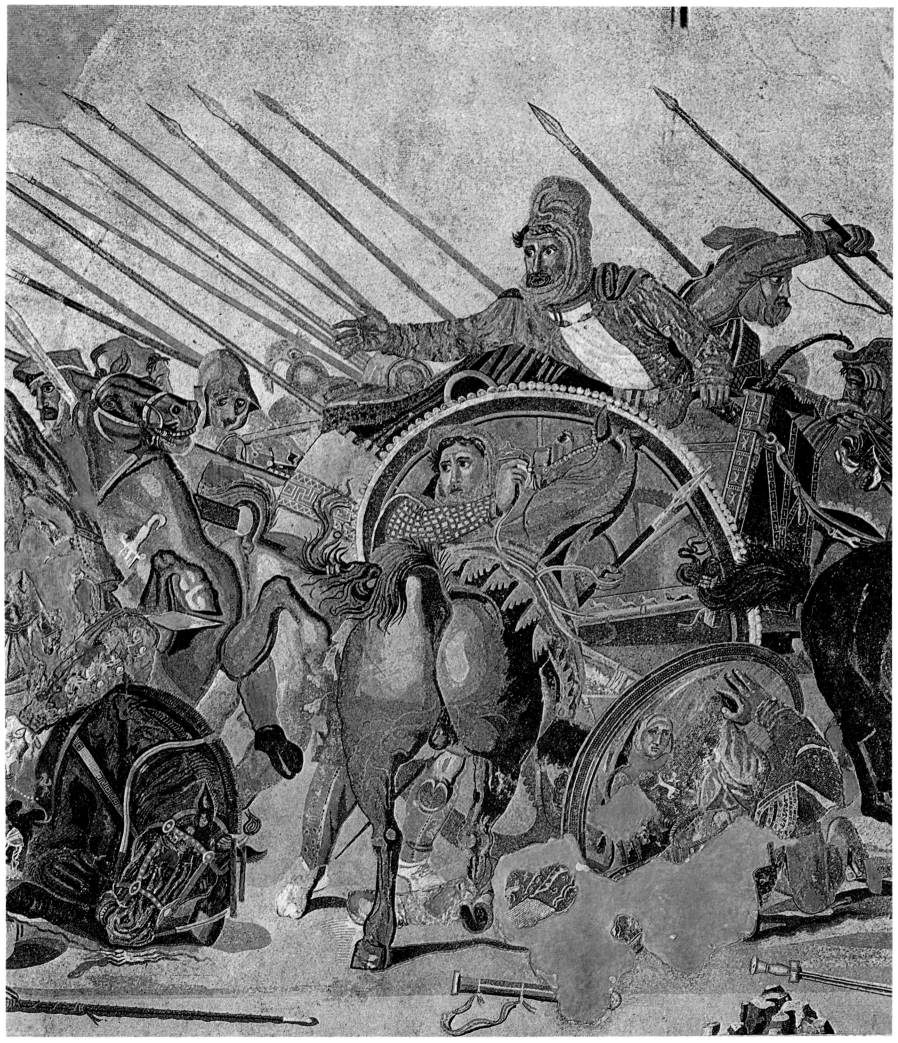

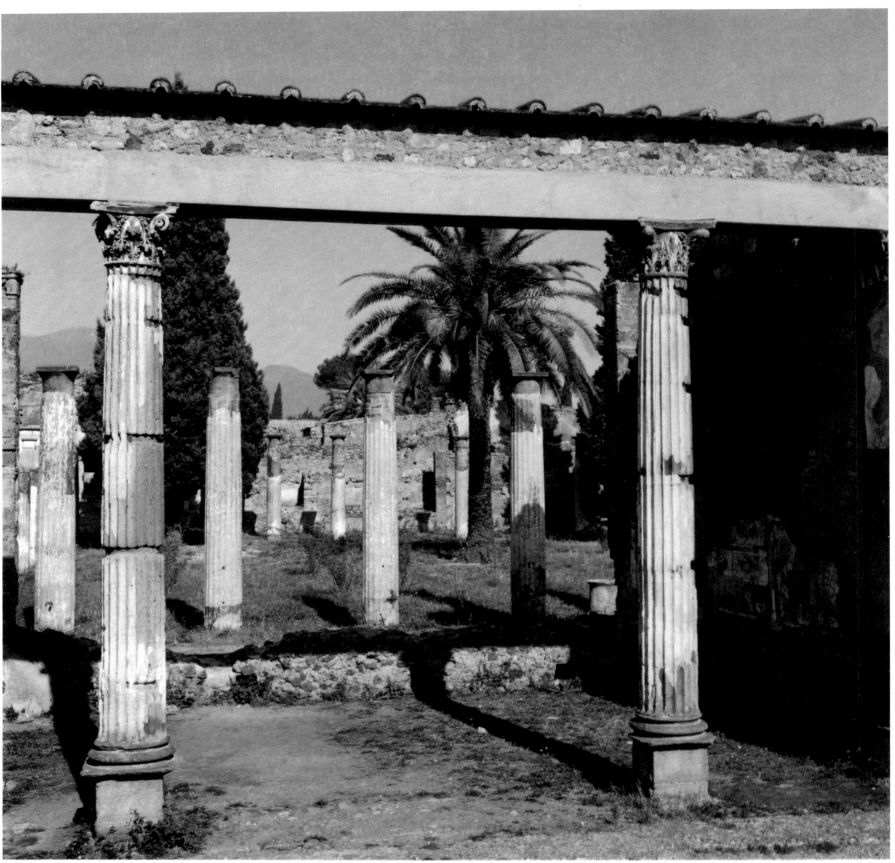

107

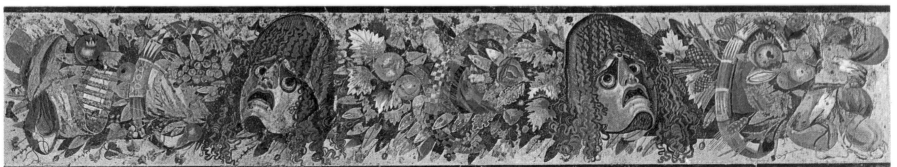

108

10

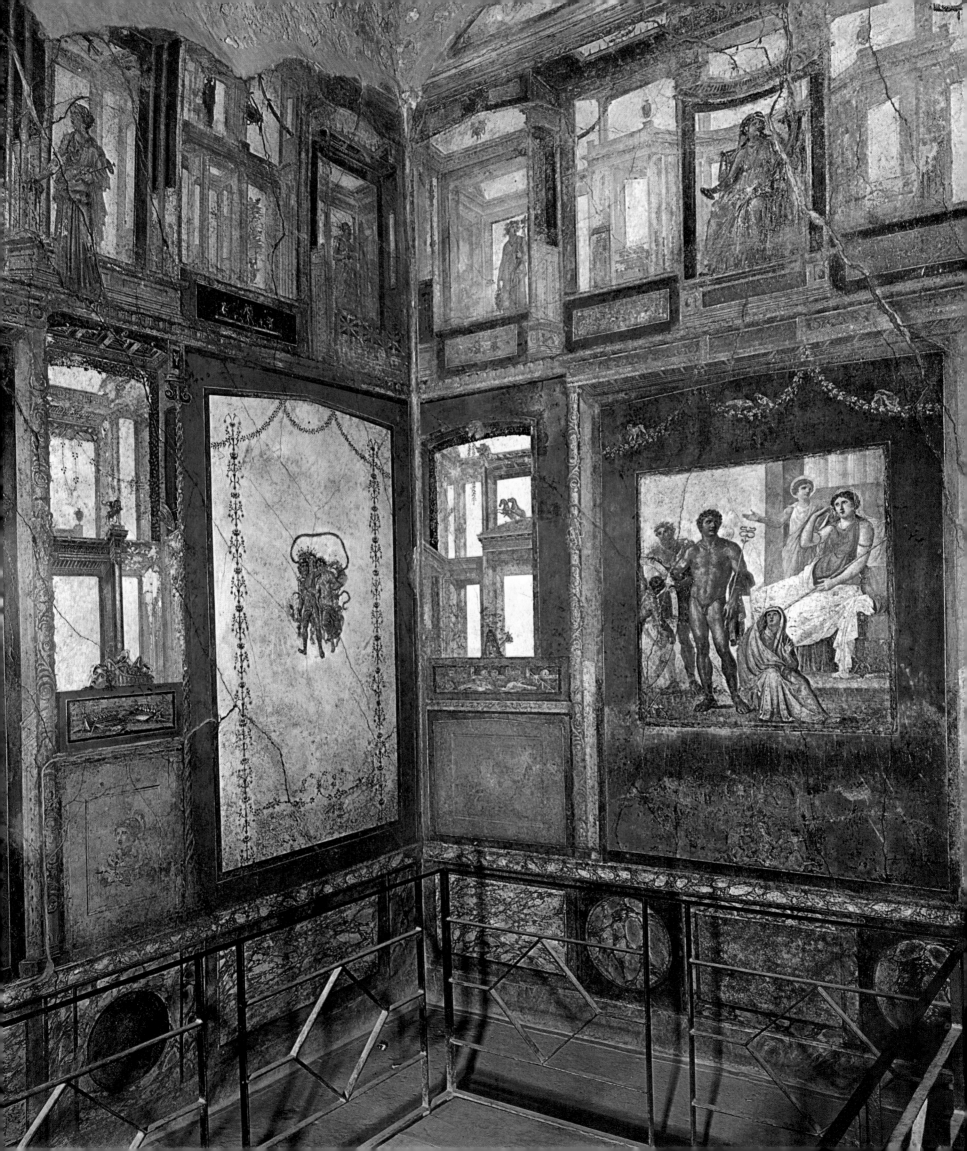

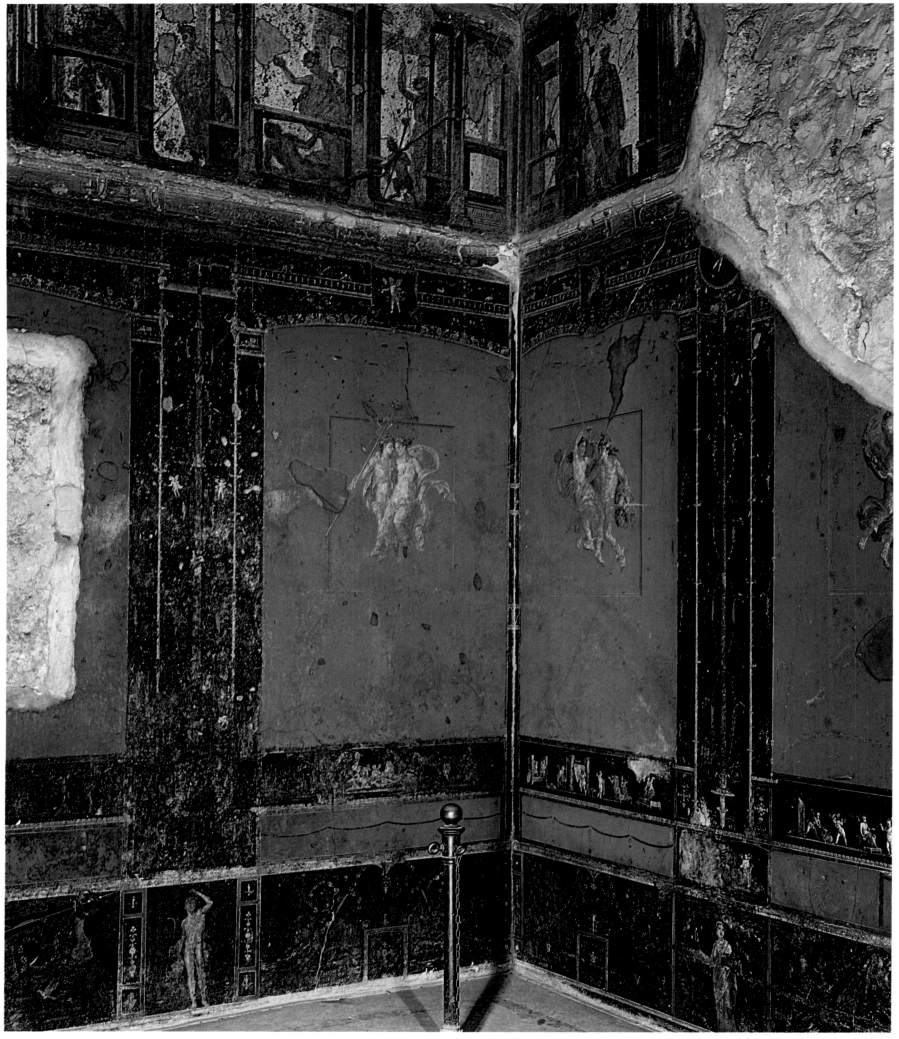

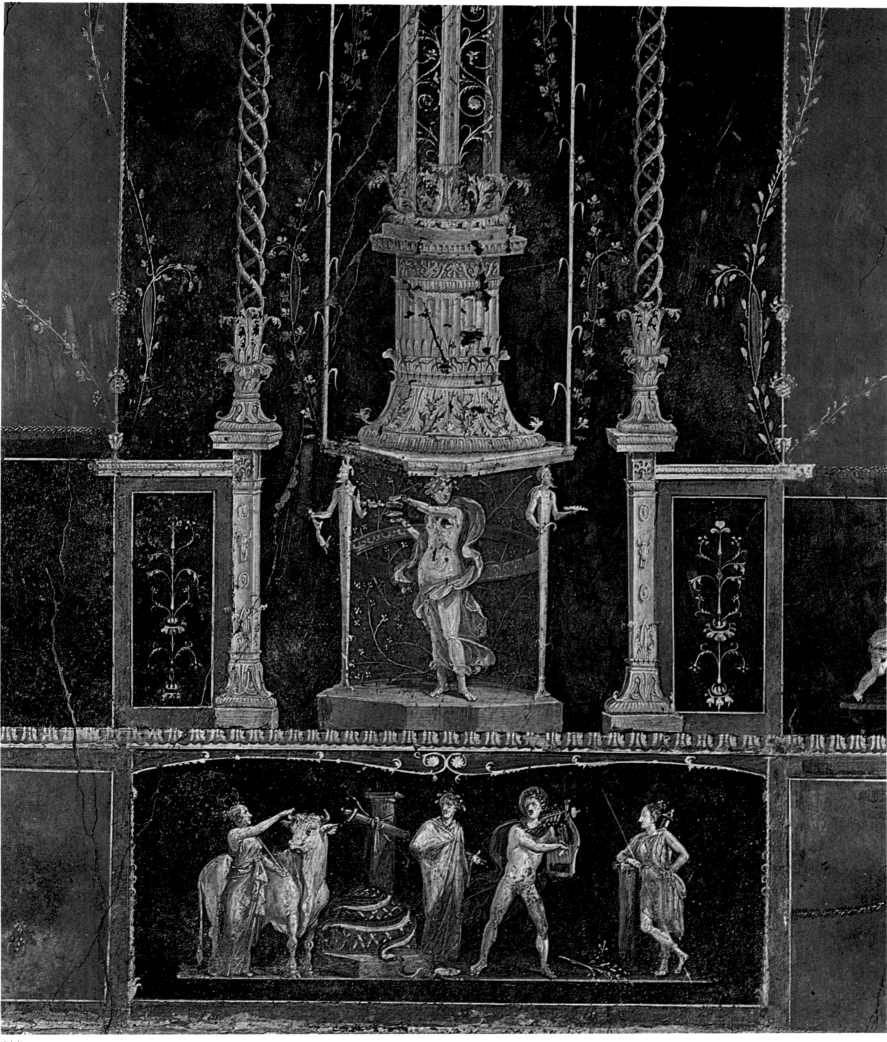

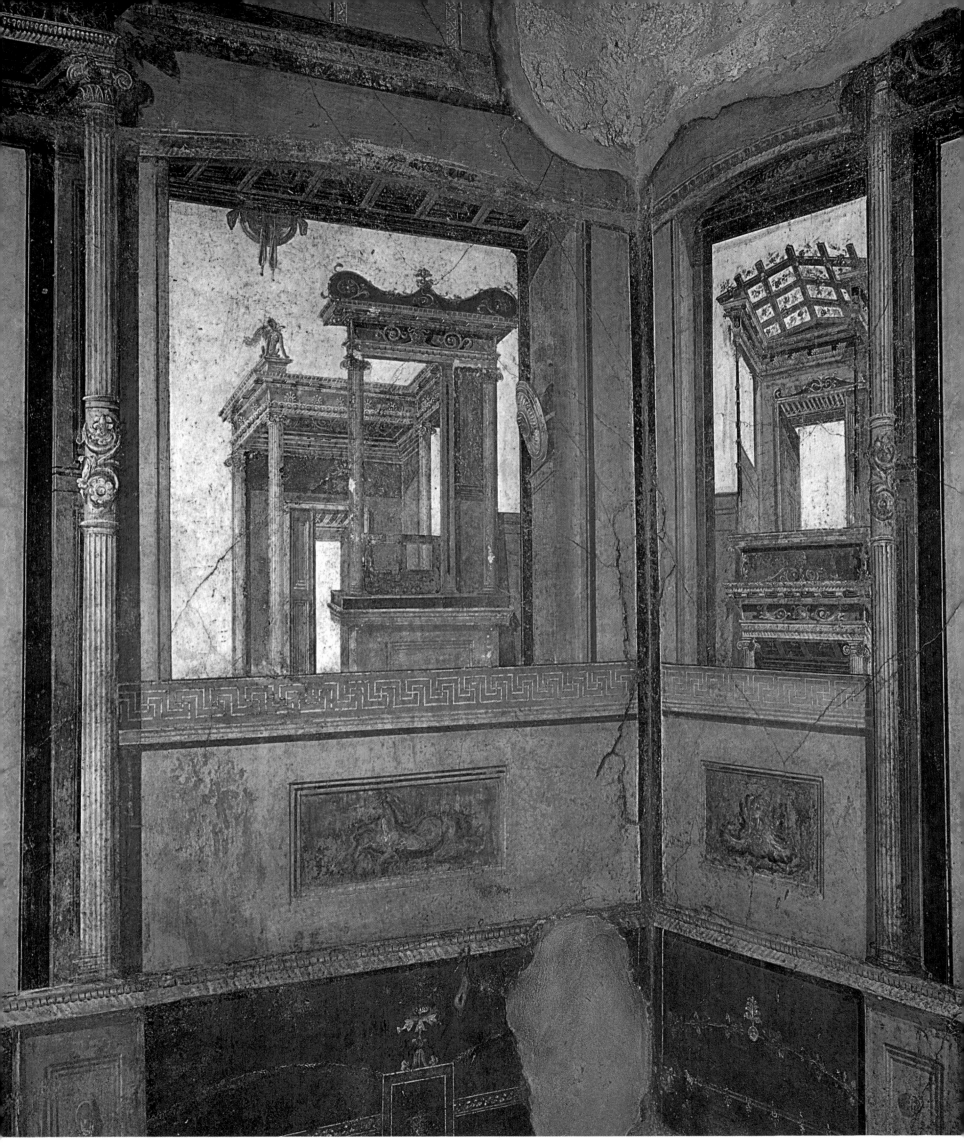

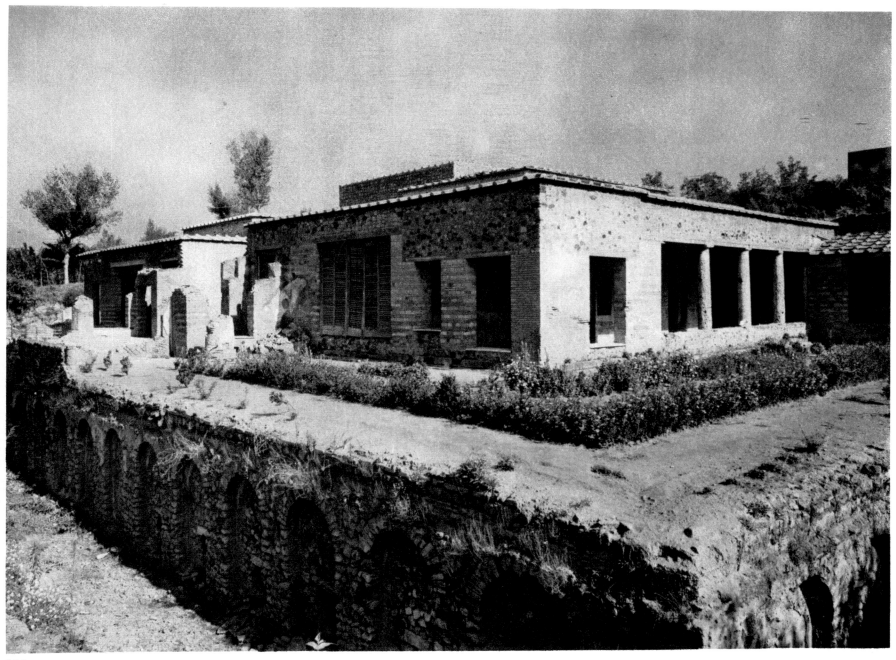

113

112 PENTHEUS ROOM, *House of the Vettii.* In the south triclinium on the east side of the garden (see plate 80) the rear wall has as its principal painting the story of Pentheus rent limb from limb by maenads, the north wall has the infant Hercules strangling the serpents (plate 261), the south wall the punishment of Dirce. Here we have the side panels with vistas of airy pavilions rising above the painted partitions. Representing a somewhat later phase of the Fourth Style than the large garden room, its decoration dates from about A.D. 70.

113 VILLA OF THE MYSTERIES, *view from the southwest.* The terrace embellished with blind arcades was used for a garden. At the left margin can be seen the exedra of the terrace lounge, which lay within a columned pavilion. The large window to its right is in the vestibule of the room with the great frieze. At the corner, in the foreground here, another lounge has a view to both the south and the west. The adjoining portico continued around the entire west part of the villa in Hellenistic times, and it was only with the Romans that the various new rooms mentioned here were built into or carved out of it.

Following page:
114 GREAT FRIEZE, *right-hand portion of the south wall, Villa of the Mysteries.* Part of the great frieze which continues around the entire room, this section stands isolated to the right of the window and constitutes the culminating episode in the sequence, the toilette of the initiated bride. A servant attends to her hair while a small winged Eros holds the mirror for her. On the west wall adjoining this there is another Eros, this one standing looking on, his elbow propped on a half pillar. Such infant gods of love had long played their part in Greek art in scenes from the life of women.

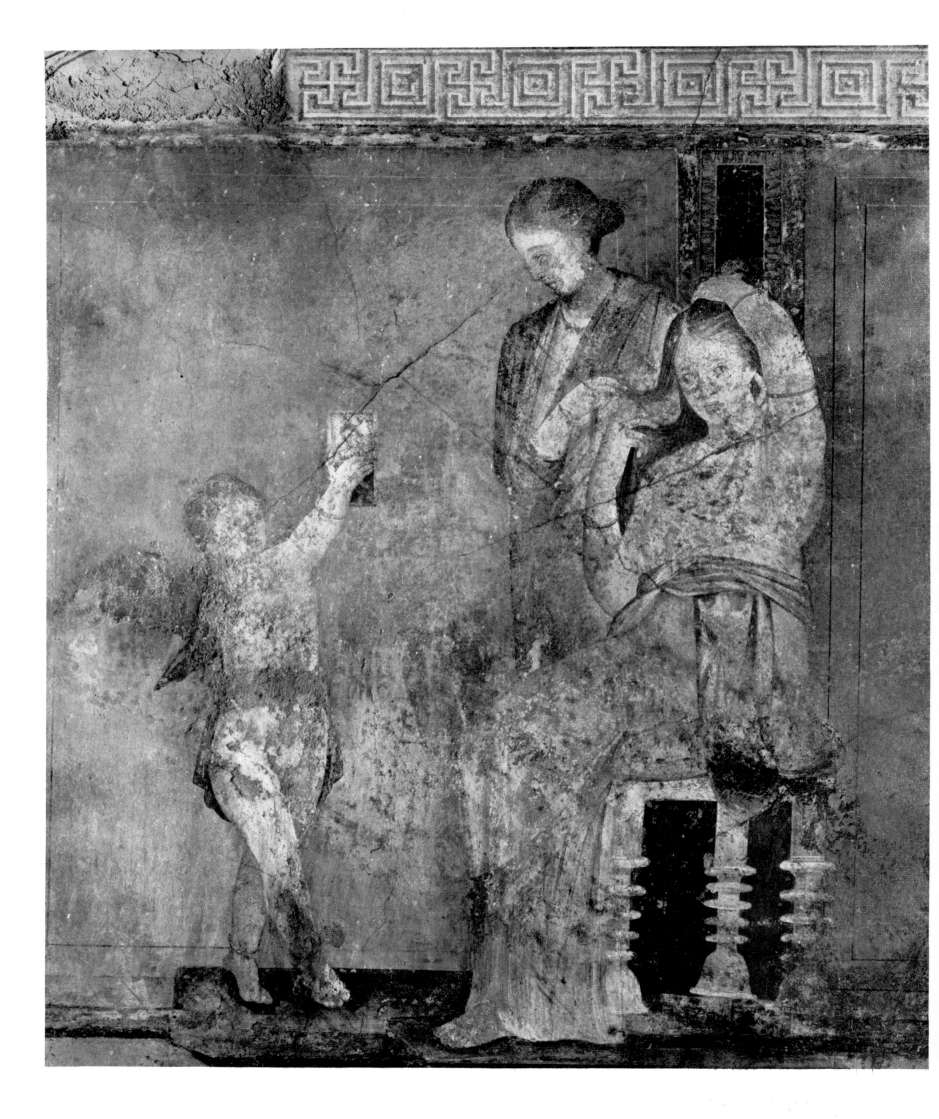

peristyle (7) and is arranged so that from it one looks through the entire length of the garden with its statues and ornamental fountains. Here, as in the House of the Faun and all the wealthier houses, family life centered around the inner colonnaded court.

The housekeeping rooms lie around the secondary atrium, and the most interesting of them is the kitchen (10) in whose fireplace there are still an iron tripod and bronze pots just as when the molten lava swept over the house (plate 203). The servants had their quarters here and probably also in the upper story, which has not survived, though it is clear that there was one on the east side of the house at least.

A doorway in the north portico of the garden opens on a second, smaller peristyle (8), this one with only three colonnades, the fourth side being made up of the wall which separates it from the large hall (7). It is supposed that the women had their quarters around this smaller court. Of the two rooms opening off the court and lighted from it, the one to the north seems to have been used as a cubiculum, that to the south as a dining room.

Although its ground area is small, with its two atria and two peristyles, the house has all the elements expected of a luxurious dwelling. The plan reveals clearly just what compromises were necessary to line up all these rooms and courtyards or to fit them one into the other. Although the ground plan lacks the broad regularity of that of the House of the Faun, each unit of the house is situated as symmetrically as feasible in relation to the lines of sight from the center. This was an essential trait of Roman architecture, as indispensable in the private dwelling as in the planning of large public squares, as we have already noted in connection with the Forum in Pompeii.

The House of the Vettii contains one of the great treasures of Roman decoration. The walls of the large garden room (plates 80:7, 100, 111) are among the most beautifully painted ones that survive from the time of Nero (A.D. 54–68) and are fully a match for the finest in Rome, even those of the emperor's own residence, the Domus Aurea. The quality is such that one suspects these paintings to be the product of a workshop brought expressly from the capital itself.

The lower part of the wall, up to the stucco cornice, exploits chiefly two colors, gleaming red in the large fields and a deep, lustrous black in the framework around the red fields. The same colors are repeated in the three horizontal divisions of the dado at the base of the wall, with its light-colored figures standing out in most effective contrast against the rich, dark background. In the justly famous scenes of the third band from below, amoretti and psyches (their female counterparts) are shown in all sorts of activities from daily life—making wreaths, pressing oil, fulling cloth, goldsmithing (plate 204)—but also engaged in chariot races and in a triumph of Bacchus. Here the imaginative conception is perfectly matched in quality by the skill of execution. But even the purely ornamental motifs are beautifully and sensitively painted, with wonderfully elongated plant stems sprouting from the narrow panels of the wall and coiling upward, intertwined with hairbreadth vines (plate 111) or, again, with delicate decorative bands running across the tops of the red fields. The heavenly couples, a god and goddess in each, that soar in translucent veils in the red fields to the sides are among the most splendid creations of the Fourth Style.

Much to our loss, the middle pictures of each wall are lacking. Undoubtedly mythological in subject, they must have been the sharp, colorful focus of the room, presumably with light backgrounds that made them stand out strikingly against the red and black of the walls. While the walls up to the stucco cornice were conceived as a unified surface firmly closed off at the top, above that point they were painted to resemble more open and airy, fantastic architecture, with scenes and structures interlocking and overlapping and seemingly vanishing bit by bit into the lighter and lighter tones of the background. The strange edifices are inhabited by mythological personages and creatures who have their part in the illusionistic perspective of these upper walls.

When we come to speak of the Fourth Style in more detail (pp. 207–8), the role of this garden room in the historical development of Pompeian painting will become clearer. These paintings are among its earliest manifestations, and how they differ from later examples can be seen without setting foot outside the House of the Vettii. They are most notable on the walls of the south triclinium—the so-called Pentheus Room—on the east side of the peristyle (plates 80:6, 112). If nothing else, the room takes on an entirely different character through the basic color of the walls, the yellow which was so favored and widely used in Flavian times. The picture fields are set off within columned aedicules of an architectonic solidity remote from the delicacy of the ornamental framing in the large garden room. The fields flanking the main ones are broken up here, opening into illusionistic views with pergolas and pavilions which are much more solid, more tangible, more *real,* than the fantasy architecture of the upper zone in the garden room. The paintings here reflect architectural elements one might have seen in daily life. These wall paintings are no less skillful than the earlier ones, but it is obvious at a glance that they could not come from the same workshop. In any case, there must be a difference in date here, because these could not conceivably have been done before A.D. 70, during the reign of Vespasian.

This is true of the north dining room as well (plate 80:6), however much it may differ from the Pentheus Room in its much richer coloring and in the treatment of the upper zone of the wall (plate 109). The flanking fields have the same sort of open vistas disposed in a similar manner, and the mythological pictures are framed in rather the same way as in the yellow triclinium. This triclinium, generally called the Ixion Room after one of its paintings, also belongs to the time of Vespasian, and in decoration it differs as much as its southern counterpart from the large red and black chamber off the garden. Thus it would seem that the restoration of the house after the earthquake must have taken many years; in fact, some less important rooms had still not been redone at the time of the eruption. However, the prosperous Vettii do seem to have been in a position to have at least their main living quarters fully redecorated with no great loss of time and with the most impressive group of paintings in the Fourth Style ever brought to light in Pompeii.

The Villa of the Mysteries

Of great importance to the history of Roman architecture in many respects, Campania also made a decisive contribution to the development of a type of building nowhere more lavishly designed nor with more numerous variations than along the gulf of Naples: the *villa urbana*, the luxurious country house situated, by preference, in some especially attractive landscape. A favorite site was Baiae, where Caesar owned a villa which then doubtless passed to Augustus and became a frequent residence for the emperors. Hadrian himself died there. Excavations in recent years have brought to light along the shores of the gulf the superb villas of Stabiae, and we have already mentioned those of Cicero in Pompeii and Agrippa

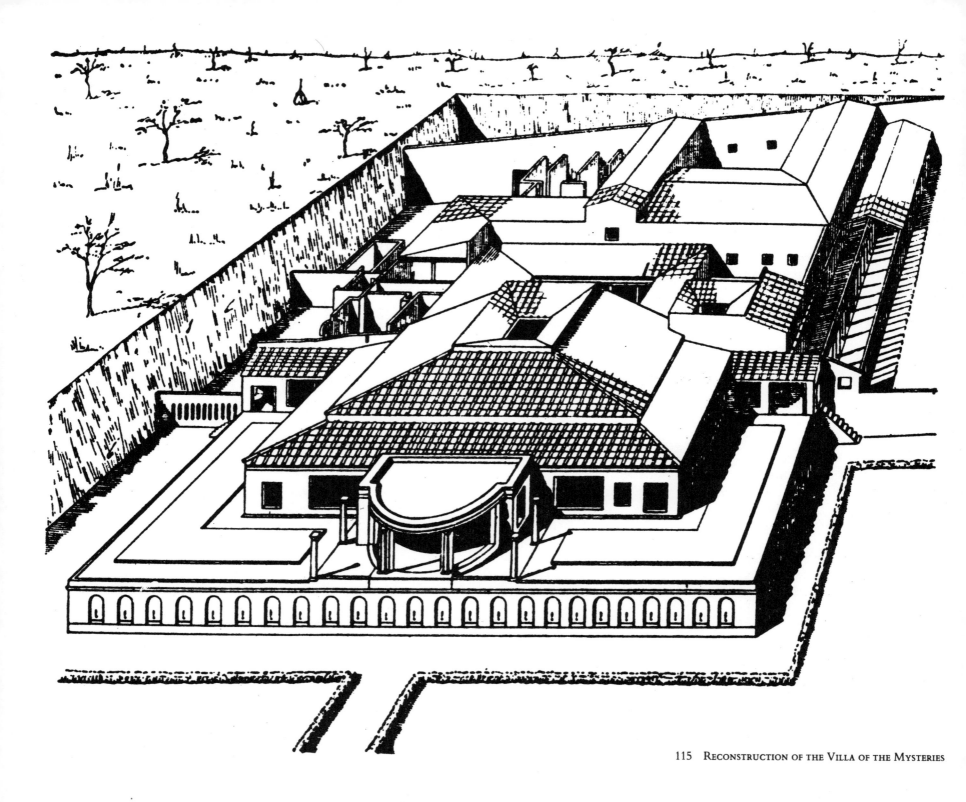

115 RECONSTRUCTION OF THE VILLA OF THE MYSTERIES

in Boscotrecase. But one of the oldest *villae urbanae* known so far lies outside the gates of Pompeii, between the two roads that come together west of the gate to Herculaneum. It is the Villa of the Mysteries, which was first discovered in 1909–10 but not systematically excavated until 1929–30, and then thanks to Amedeo Maiuri.

As we see the villa today, it is the product of over two hundred years of building. The original villa of the second century B.C. had a terrace (plate 113) which served to compensate for a sloping terrain and which contained a *cryptoporticus*, a vaulted passageway lighted only by small windows. In a letter to his brother Quintus, Cicero refers to this type of substructure as a *basis villae* (*Ad Quintus* iii. 1, 5), an indispensable feature of a villa built on a slope. Above this, in the Villa of the Mysteries, rose a three-sided portico extending back some twenty-three feet and filling the entire west side and half of the north and south sides with its straight rows

of columns. In early Imperial times the middle of the west side was remodeled to accommodate a terrace room with a semicircular apse or exedra surrounded by columns and projecting like a prow on the side of the villa facing the sea (plate 115). The corners of the Hellenistic portico behind the exedra were extended to make lounges with windows looking out on the bay across the *viridarium*, the garden with which the terrace was then embellished.

The general plan of this Samnite villa remained by and large the same in Roman times, although a number of rooms were divided up or built on. The elegant living quarters took up the west part of the building, grouped around the atrium which, in the usual manner of villas as described by Vitruvius (vi. 5, 3), lay directly behind the peristyle instead of in front of it, the latter being entered directly from the front vestibule. The utility rooms were concentrated in the southeast wing which, even in

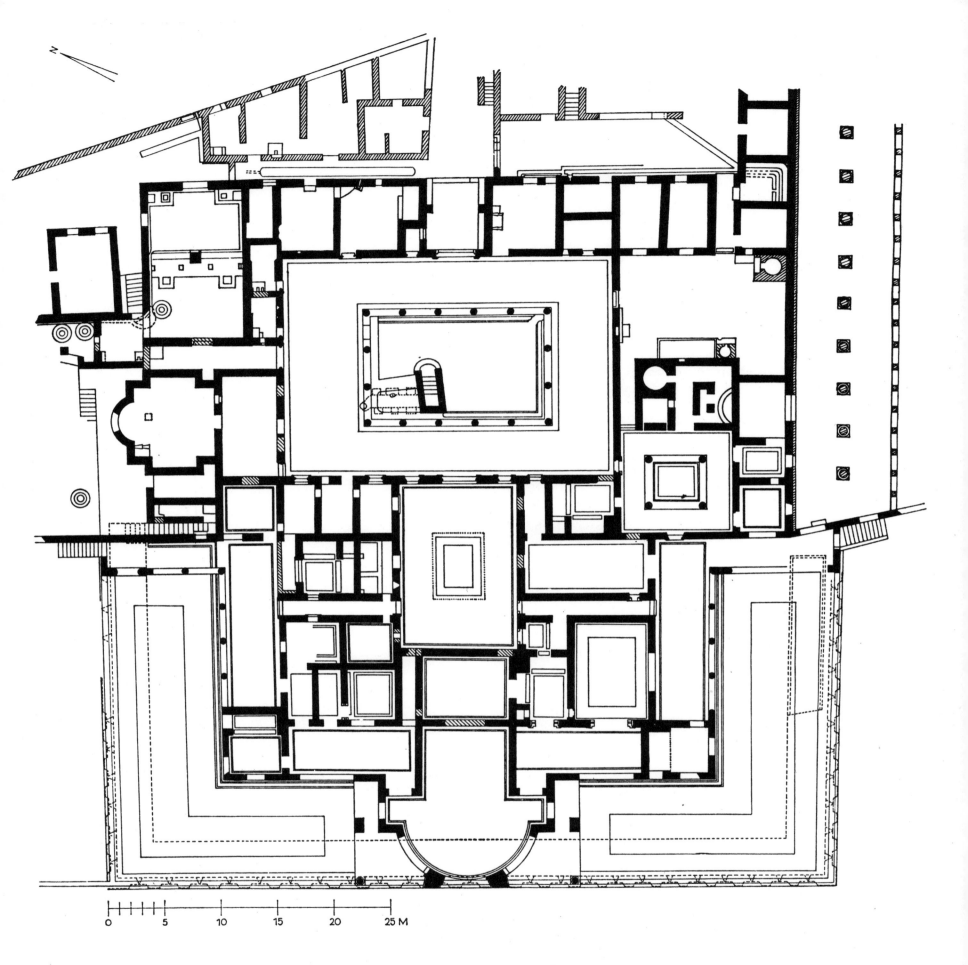

116 PLAN OF THE VILLA OF THE MYSTERIES. Both
drawings show the villa in its final state. In the middle
axis, from the top of this page down, the order of the
rooms is: entrance, peristyle, atrium, tablinum, and terrace
lounge with exedra. The Mysteries frieze is in the large
room reached by a small door from the cubiculum to the
right of the tablinum. Cubiculum 16, famed for its
decoration (plates 126, 294), is the square room above the
corridor leading to the left from the atrium. Room 15,
likewise beautifully decorated (plate 293), directly
adjoins the left lower (northwest) corner of the atrium.

later times, continued to house the bath also. The major alteration had to do with the northeast rooms which, in the final years, were used for activities connected with agriculture: the large wine press stood in a room that in Samnitic times had been a triclinium.

The central axis of the villa runs from the entrance through the peristyle, atrium, and tablinum to the semicircular exedra, but the eye was blocked along the way. As early as Augustan times the spaces between the columns of the peristyle were filled in with panels to a height of about five feet, so that the garden court was converted into something like an ambulatory with windows. However, even in Samnite times the middle of the tablinum was sealed up on the side facing the atrium, and the only passageway was through two small doors to the sides. In the reign of Nero at the latest, the doors also were closed off and the room itself opened onto the exedra. This meant that the tract affording a view of the sea and outdoors turned its back, so to speak, on the rest of the house, with side corridors and the porticoes taking over the function of linking the individual wings.

The villa maintained its stately character up to the great earthquake. One of its most splendid periods was about 60 B.C., when it was decorated with large-scale architectural paintings in the Second Style (plates 126, 293, 294). In the years after the death of Augustus in A.D. 14, rooms were added on the east side of the house for agricultural purposes, but the west wing around the atrium and peristyle continued to be the master's quarters, and its grand air was further enhanced by the large exedra looking out on the sea. Only with the disastrous earthquake of A.D. 62 did the character and fate of the villa take a turn for the worse. With the building badly damaged, the steward of a large family appears to have taken it over and turned the outbuilding into a kind of farmyard. The original functions of the splendid rooms were mostly disregarded, and everything took on a more plebeian appearance. In the fatal year of A.D. 79 the villa was still being remodeled.

The last owners seem to have been the Istacidii, a family of Samnite stock whose members rose to the rank of duovir and the official priesthood. In a room in the northeast wing, one of those used for farming activities, a seal was found with the name L. Istacidius Zosimus, which suggests a freedman installed by the owners as steward of the villa. It is not known who the earlier proprietors were, though Matteo Della Corte proposed the names of no less than Augustus and Livia, the emperor and his consort. His arguments, however, are not substantiated, and the less so because the statue of a woman found in the northeast corner of the peristyle and claimed to represent Livia can scarcely be said to resemble her in any respect.

What one would really like to know is the identity of the individual who commissioned the large frieze (plates 114, 119–25), the most extensive surviving monument of ancient painting. Since its discovery it has never ceased to challenge the wits of one scholar after another, and many questions are still without convincing answers.

The good-sized room filled with these paintings lies in the southwest corner of the villa. It is entered through either a large door from the west or a small cubiculum that adjoins it on the north, and a large window opens on the portico adjacent to it on the south. It is obvious, therefore, that there could have been nothing secret about the room, and nothing even remotely suggests that it might have been a hidden place where mysteries could be celebrated out of sight of profane uninitiates. It is rather more like a large oecus, somewhat stately but still the sort of place where one could receive visitors—in short, a kind of best parlor.

The middle zone of the walls is five and one-quarter feet in height and is completely filled with the frieze. The nearly lifesize figures are set against a background in early Second Style, with red fields framed by narrow, dark, painted pilaster strips. This architectonic background existed beforehand, and the figurative frieze was simply painted over it, as can be verified in a number of places where the color of the background has "bled" through. It is impossible to say how much time elapsed between the execution of the background and the frieze; the frieze could have been done quite early, before the middle of the first century B.C.

That the theme of the frieze concerns the life of women is demonstrated by the fact that there is not a single man among the human figures. The only human representative of the male sex is the boy on the north wall who reads from a scroll (plate 120), and he is there only as part of the personnel connected with the rite. As for the sphere of the gods, it takes its character from Dionysus and Ariadne (plate 123), who in fact constitute the focal point of the entire sequence of images. And it is to their sphere, not to that of the humans, that the sundry satyrs, sileni, maenads, and followers of Pan belong. This much we can determine. And we can identify the general range of ideas within which the action moves as one which embraces and intermingles both the terrestrial and the supernatural. As a starting point, no one has ever doubted that the last episodes in the sequence concern the toilette of a bride (plate 114) and a woman on a wedding bed (plate 119). Those episodes are the culminating point of an action that begins with preparations for a sacrifice (plates 120, 121) and proceeds by way of Dionysiac rites (plates 123,124) and a ritual flagellation to the initiation of a nubile young woman into the company of the maenads (plate 125). Much beyond this we simply cannot speculate, and attempts to equate the frieze with a specific Hellenistic or Roman mystery cult always leave too many loose ends to be convincing.

Closely related to the problem of its interpretation is the question of whether the frieze was a copy of an earlier prototype or was put together from a number of different models and conceived specifically for this Pompeian villa. To begin with, one cannot dismiss the feeling that the conception and the execution are not on the same level. Impressive as the painting may be as a whole, on closer examination there prove to be errors in drawing and occasional clumsinesses, which suggests that the composition was not executed in the same workshop as conceived it. True, it is possible that entire groups were borrowed from various earlier works of art, and this would account for discrepancies. The Dionysus and Ariadne as well as the winged daimon are known in other replicas in other mediums, all of which must go back to the same prototype. Some writers have made much of the rather frequent inconsistencies in style between more classically conceived figures, such as the veiled woman (plate 120), and others of decidedly Hellenistic cast, such as the Dionysus and Ariadne (plate 123) or the naked dancer (plate 125). But these inconsistencies prove nothing since they are to be expected if the prototype was Late Hellenistic. In any case, whoever painted the frieze in Pompeii was obliged to adapt whatever prototype he used to this particular setting, laying out the scenes to fit the two long and two short walls while allowing for the window and two doorways. So even if this was an absolutely faithful copy of another frieze elsewhere—which seems decidedly unlikely—one would have to assume a patent absurdity, that the room housing the prototype was in every respect identical with this chamber and that it was in a villa outside the walls of what was not a major cultural center.

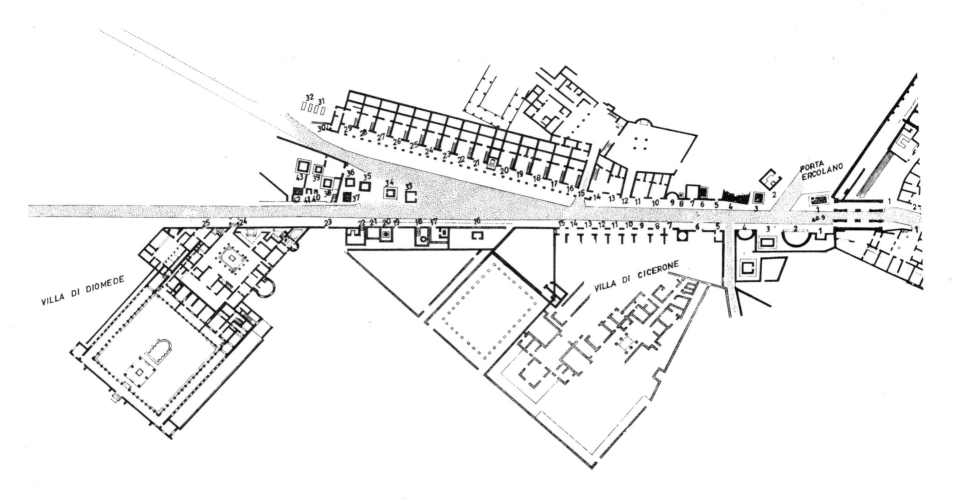

117 Plan of the Via dei Sepolcri outside the Herculaneum Gate. The numbers identified here are those of tombs seen in the plates indicated and of buildings mentioned in the text.

West side of the street: 2) A. Veius; 3) M. Porcius; 4) Mamia (all three, plate 136); 20) C. Calventius Quietus; 22) Naevoleia Tyche (both, plate 131)

East side: 6) Tomb of the Garlands; 8) Tomb of the Blue Vase (see plate 208); 9) Tomb in the form of an exedra (all three, plate 139); 37) M. Alleius Luccius Libella (plate 140); 12–15) Entrances to the Villa of the Mosaic Columns; 16–29) Portico with shops on the ground floor and living quarters upstairs

THE TOMBS OUTSIDE THE GATES

"*Hominem mortuum in urbe ne sepelito neve urito*": a dead man should be neither buried nor burned inside the city. So wrote Cicero (*De Legibus* ii. 23, 58), following the time-honored Twelve Tables of the Law, the code drawn up in the fifth century B.C. by the young Roman republic after the expulsion of the king. The custom persisted in Imperial times, and graves were still relegated outside the *pomoerium*, the legal and religious borders of the city. Whatever Rome did, so did the entire Empire. The highways between one town and another were lined with tombs. Nor were the tombs always immediately outside the city walls. They could be set in the open fields, or at any rate a good distance back from the roadside. Nevertheless, the favorite site was always close to the gate, so that the deceased would not be too far removed from the place that once was home, nor their descendants undergo any unpleasant inconvenience in visiting the family tombs.

Just as the great consular highways outside Rome were lined with tombs whose ruins still work their melancholy magic on anyone who travels the Via Appia Antica, in Pompeii, too, the roads leading away from the city had their population of the dead, and tombs have been turned up

wherever excavations have been carried out in the vicinity of the gates. Seven gates are known in Pompeii and an eighth is supposed to exist between the gate to Vesuvius and that to Nola, though this is still at best a conjecture. Necropolises have been found outside five of them, but in only two cases have the roads leading to them been excavated for any considerable stretch.

The earliest such excavation was done in the eighteenth century at the Herculaneum Gate, in the westernmost spur of the city (plates 117, 135). In Roman times the gate appears to have been called the Porta Saliniensis or Salinensis, as has been inferred from the Oscan inscription on a pilaster of the House of Pansa, which speaks of it as the *veru sarinu* (see p. 8). The road which begins there and has been given the name Via dei Sepolcri (plates 117, 136, 139, 140) was already sufficiently excavated for Goethe to have seen it when he visited Pompeii on March 11, 1787, in the company of the painter Tischbein. In the lifetime of the city, the street of the dead was the first lap of the highway connecting Pompeii with Herculaneum and eventually Naples. The living, too, had dwellings there, most notably two large villae urbanae known to us now, rightly or wrongly, as the Villa of Cicero and the Villa of Diomedes (plates 117, 127) and, on the north side, the Villa of the Mosaic Columns, which owes

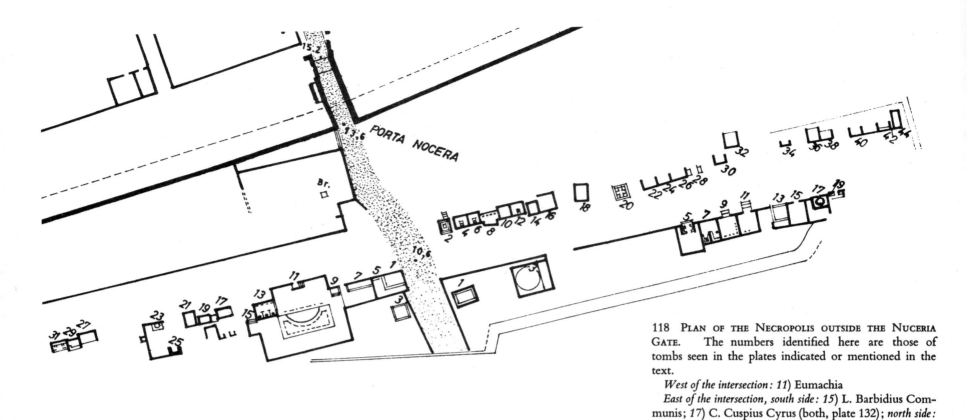

118 PLAN OF THE NECROPOLIS OUTSIDE THE NUCERIA GATE. The numbers identified here are those of tombs seen in the plates indicated or mentioned in the text.

West of the intersection: 11) Eumachia

East of the intersection, south side: 15) L. Barbidius Communis; *17*) C. Cuspius Cyrus (both, plate 132); *north side: 20*) Tomb in the form of a tetrapylon; *30*) Melissaea (both, plate 134)

its name to the columns clad in polychrome mosaic that supported a pergola in the garden. The fact that the two chief types of construction characteristically located outside the city walls and which account for so much of the poetic atmosphere of the Roman countryside, namely the villa and the tomb, should be found in such close proximity to each other is by no means an accident. Here again the Via Appia Antica can be adduced as evidence. Tombs were sited along the busy highways in ancient times because of an attitude toward the dead quite different from ours today, when we think of a cemetery as a place of last rest secluded from the bustle of the world of the living. Pompeii affords graphic proof of how casually and naturally the commemoration of the dead took its place within the activities of everyday life. This is why one finds on the Via dei Sepolcri not only tombs but also a long porticoed building which housed several tabernae, where tradesmen hawked their goods to travelers approaching or leaving the city (plate 117:*16–29*).

Samnite tombs have been found beneath both the Villa of the Mosaic Columns and the Villa of Cicero as well as outside the gate to Stabiae, so the Romans obviously utilized the same terrain as their Hellenistic predecessors, who buried their dead in chests made of tufa stone plaques and accompanied them with modest offerings. As far as we know, monumental tombs were not erected until Pompeii became a Roman colony.

The second large burial ground lies south of the city. There, in 1886 and 1887, in the area east of the Amphitheater the excavators found six funeral monuments strung along the ancient road to Nuceria. However, it was not until the 1950s that Amedeo Maiuri was able to unearth the Nuceria Gate (plate 133), through which the main north-south artery of the eastern part of the city exited on the south and joined the highway to Nuceria, which ran from the western part of the city parallel to the walls beginning at the gate to Stabiae. More than forty Roman tombs have been brought to light there (plates 118, 132, 134), many more than were found on the Via dei Sepolcri, excavated well over a century and a half earlier, and they continue into the terrain, where a modern road leads to

the Amphitheater. More than three-fifths of a mile separates the easternmost tomb from those first discovered at this site in the late 1880s.

The neighborhoods of the other gates are not as rich in tombs. Outside the Vesuvius Gate in the northwestern part of the town there are only four (plates 137, 138) and about that many also outside the gate to Nola, in the middle of the north stretch of wall, though among the latter is the beautiful sepulcher of Aesquillia Polla with its semicircular exedra within which a marble amphora crowns a tall column. Another five tombs lie along the east side of the road leading to the Stabiae Gate, and undoubtedly others would be found at these latter three gates if the roads outside them could be excavated. Further, it is to be hoped that at least a part of the burial ground one would expect to find there will be uncovered in the course of the diggings now in progress around the Sarno Gate, where the Via dell'Abbondanza ends and which is probably the *veru urublanu* (Urublana Gate) mentioned in certain Oscan inscriptions.

The Roman tombs in Pompeii extend in time from the Republic to the Flavian reign. The standard method of burial involved cremation, with the ashes consigned to an urn which was then laid away in a tomb. Pompeii did not survive long enough to participate in the changeover to the custom of burying the body itself, which came about under Trajan and led to the great Roman art of sarcophagus sculpture. Instead, at Pompeii there are only tomb chambers with niches (*loculi*) into which the urns were set, often in considerable number since the head of a family frequently made provision not only for his wife and children but also for his freedmen.

Not all tomb chambers were plain and unadorned. Some had painted decoration, though on the whole much more value was attached to the exterior of the tomb in order to impress passersby with the wealth of the family and the high standing enjoyed by the deceased in the community. Usually a wall enclosed the plot of ground where the tomb stood, but there was virtually no limit to the multiplicity and diversity of variations on the basic form of the monument.

To start with, there was the large *schola* or *exedra*, a semicircular bench inviting the visitor to take his ease on it and reflect on the merits of the departed. The oldest example of this type is the Tomb of Aulus Veius outside the Herculaneum Gate (plates 117:2, 136) which, to judge by the style of the lion's paw at either end of the seat, must go back to the first half of the first century B.C. In Augustan times the plan was repeated for the adjacent Tomb of Mamia (plates 117:4, 136), who exercised an official function as a priestess, a *sacerdos publica*, and it was under Tiberius or Claudius that Herennius Celsus erected an exedra of this sort to the memory of his young wife, Aesquillia Polla. Such monuments were discovered outside the Stabiae Gate also, but the most splendid is unquestionably the one at the gate to Nuceria (plate 118:11). Here the ashes of Eumachia, the priestess of Ceres responsible for the building of the cloth guild's basilica on the Forum, were laid away in a large sepulcher with a semicircular exedra set on a high terrace in which a door gives access into the tomb itself. In a late variant of this type found on the Via dei Sepolcri, there is a stuccoed circular niche with a semicircular bench running around the wall inside (plate 139).

In Pompeii only the lower story survives of a type of Roman mausoleum so familiar elsewhere and best exemplified by the monument of the Julius family in Saint-Rémy-de-Provence, where a small, open, round temple containing the statues of the dead rises above a square lower story where the urns are enshrined. One must imagine the mausoleum of the Istacidii to be of this type (plate 136). Its burial chamber with stucco decoration and half-column articulation can be seen on the Via dei Sepolcri behind the tombs of Aulus Veius, M. Porcius, and Mamia, and it may be that the sepulcher of Cuspius Cyrus and Cuspius Salvius outside the Nuceria Gate was also similar in style (plates 118:17, 132).

Many tombs took the form of a monumental altar, among them that of Marcus Alleius Luccius Libella, who was duovir in A.D. 26 (plates 117: 37, 140). An altar also may be set up on a stepped base as a crowning element of a tomb, a form especially favored in the last years of Pompeii. The most elaborate examples of this type are the tombs of Calventius Quietus and Naevoleia Tyche outside the Herculaneum Gate (plates 117:20, 22, 131) in which the altar-like upper part is faced with marble slabs and embellished with reliefs alluding to the official career and deeds of the deceased. A related but very special case is the monument of C. Vestorius Priscus outside the gate to Vesuvius (plate 138), where once again the form is that of a funerary altar, but this time with stucco decoration depicting allegorical figures having to do with death and the afterlife. Episodes from the life of Priscus, who had been elected aedile at a very early age, are painted together with symbolic representations on the exterior of the burial chamber and on the inner side of the high wall surrounding it.

These are only three forms of monuments out of a vast number of possibilities. To them must be added at least the tomb in the form of an aedicule or temple such as that of M. Octavius and Vertia Philumene at the Nuceria Gate. Here above a high base rises a four-columned frontispiece behind which there are three niches with portrait statues. Worth mention also are round mausoleums, perhaps at their most imposing in that same burial ground in the spacious tomb built by Veia Barchilla for herself and her husband Numerius Agrestinus Equitius Pulcher. To round out this survey, there is the Tomb of Gnaeus Vibrius Saturninus on the Via dei Sepolcri, erected by his freedman Callistus. It is in the form of a triclinium with masonry couches, table, and a small, round altar for drink offerings. The funeral meal would have been consumed here, and here too,

as in the tombs in the shape of an exedra, the bereaved could linger in quiet meditation. The urn itself stood near the entrance in a spot surrounded by a wall.

Normally each tomb bore an inscription with not only the name of the person buried there but also his *cursus honorum*, the record of the positions he had filled and the honors attributed to him by the city either during his lifetime or posthumously. Many proudly listed their own achievements and public services. On his now unfortunately lost funerary inscription Aulus Clodius Flaccus recounted in painstaking detail what public games he sponsored during his three years as duovir iure dicundo and even the number of gladiators who fought in them. If a tomb was not erected during its eventual occupant's lifetime—and if it was we know it from the formula *vivus fecit* or *faciendum curavit* used in the inscription— we are told the name of the individual responsible for putting it up.

By decree of the decurions, the city could grant free burial ground to deserving citizens, and the epitaphs announce this proudly with a formula such as *locus sepulturae* (or *monumenti*) *publice datus decurionum decreto*. These honorary burial plots generally lie close to the gates, and in fact the first tombs on either side of the Via dei Sepolcri immediately outside the Herculaneum Gate have that distinction, as do all four monuments so far unearthed outside the gate to Vesuvius. The community could go beyond this and share in the expenses up to the sum of 2,000 sesterces, the figure mentioned in the funerary inscriptions of the aediles Titus Terentius Felix and Caius Vestorius Priscus (plate 138), the duovir Aulus Umbricius Scaurus (who was commemorated also by an equestrian statue on the Forum), and the gens Septumia. The interment of Arellia Tertulla, who was granted a burial plot posthumously, was paid for entirely out of public funds: *Decuriones locum sepulturae post mortem dederunt et funus ex pecunia publica decreverunt.* In honoring her the city was paying tribute to her husband, Veius Fronto, who had twice been duovir and, in addition, Augustalis, as we know from another inscription. Similarly, Aesquillia Polla, who died at only twenty-two and whose exedra tomb at the Nola Gate we have already mentioned, owed her burial plot to the public career of her husband, Herennius Celsus, who, in her epitaph, identifies himself as having twice been duovir iure dicundo as well as *praefectus fabrum*, a term originally designating the commander of the technical or engineering corps but later used merely for the adjutant of a higher officer. In one instance the tomb itself was erected by the city as a signal honor to Aulus Veius, who was twice duovir iure dicundo, and one of those times quinquennalis and also *tribunus militum a populo* (plates 117:2, 136).

Even these few examples suffice to show how much we are indebted to funerary inscriptions for our acquaintance with the city authorities and the leading families, and they are an invaluable complement to the honorific and dedicatory epigraphs found on statues and buildings. Among the epitaphs we recognize names known to us from other places and in other connections: the Istacidii were the last owners of the Villa of the Mysteries, the priestess Eumachia built the great edifice on the Forum. But such instances are few, and we still do not know where so many of the prominent Pompeians whose names are known to us are buried. And when we walk in the streets of the dead outside the gates to Herculaneum and Nuceria, where the monuments appear in succession, we must keep in mind that they represent only a small fragment of all the tombs that must have been there. Many are lost forever, others will be unearthed in future excavations and cast new light on the history of Pompeii and the fate of its inhabitants.

119 · GREAT FRIEZE, *right-hand portion of west wall, Villa of the Mysteries.* The woman sitting on a bed, with her mantle drawn over her head, is usually said to be the mother of the bride, but there are cogent arguments in favor of identifying her as the bride herself seated on the marriage bed. Among the arguments is the fact that she wears a ring on the fourth finger of her left hand. The tablet (*tabella*) seen at the right margin is the marriage contract.

Following pages:

120 GREAT FRIEZE, *north wall, episode I, Villa of the Mysteries.* The sequence begins to the right of the door leading to the adjoining cubiculum. A young woman (at left) in fine but dignified attire, perhaps the candidate for initiation into the mysteries, walks solemnly toward the right, past a naked boy reading what is probably a sacred text from a scroll. Behind him sits a woman who holds another scroll in her left hand, a writing stylus in her right. Just passing her is a third woman, who is richly adorned and wears a crown of olive leaves. She carries a silver platter with sacrificial cakes in one hand, an olive branch in the other. Like the bride on the opposite wall (plate 114), she looks out of the picture at the viewer.

121 GREAT FRIEZE, *north wall, episode II, Villa of the Mysteries.* Seated with her back to the viewer—a sign of some secret act—a priestess crowned with an olive wreath removes a cloth from a basket a young woman holds before her, while an attendant (also wearing an olive wreath) sprinkles purifying water over her right hand in which she holds an olive branch. So far all the episodes concern preparations for a sacrifice and involve only human figures. Now, however, the Dionysiac supraterrestrial scenes begin: an aged Silenus (at right) leans against a small pillar on which he has propped the lyre used to accompany his singing.

122 GREAT FRIEZE, *north wall, episode III, Villa of the Mysteries.* On a rock sits a young satyr playing panpipes (the syrinx) together with a young satyress, who offers her breast to a female goat while a billy goat stands by. The next figure creates a striking contrast to this bucolic idyll: a maiden flees toward the left, her left hand raised as if to fend off some menace in the direction from which she has come, her right hand sweeping her mantle high above her head seemingly to protect herself. The last figure on the north wall, she also appears to be afraid of what she sees ahead of her in the first group on the east wall.

123 GREAT FRIEZE, *east wall, episode I, Villa of the Mysteries.* In content as in position, the middle group on the east wall is the central focus of the frieze: the god Dionysus, with thyrsus staff and crowned with ivy, reclines on the bosom of Ariadne, who embraces him. To the left, an aged Silenus holds up a vessel which a young satyr appears to gaze into but not to drink from: divination by reflected image would seem to be symbolized here. Another young satyr flourishes aloft a mask recently identified as representing Akratos, the daimon of unmixed wine. The Silenus looks reproachfully at the fleeing maiden (plate 122) as if she were disturbing the sacred rite. But many of these images are conjectural, and the group still eludes satisfactory interpretation. Since it is balanced on the other side of the central godly pair by a scene in which a mystery is unveiled (plate 124), it is reasonable to seek its explanation in that same context.

124 GREAT FRIEZE, *east wall, episode II, Villa of the Mysteries.* To the right of the enthroned Ariadne a kneeling woman with a long torch over her shoulder unveils a huge phallus at the foot of which lies a *liknon,* a winnowing basket for removing impurities from grain. Two women behind her look on at the awesome ceremony. To her right is the last figure on the east wall, a female with dark wings and high boots, who seems to have just flown down and thus barely touches the ground. Her left hand gestures as if to ward off the threat of the *liknon,* while her right hand brandishes a whip. This female daimon has been identified as Aedos, Dice, and Parthenos, among others, but there is no doubt that her interpretation is to be sought within the context of the mystic rites having to do with betrothal and marriage.

125 GREAT FRIEZE, *south wall, left portion, Villa of the Mysteries.* The slashing whip is aimed at a half-naked girl who has laid her head, as if in terror, in the lap of a seated woman. The woman, however, does not protect her but helps lay bare the girl's back for the ritual flagellation which is part of the initiation. The two women to the right have already been initiated. The nude one, seen from the rear, dances as if possessed by the god. The other, who is fully clothed and whose face strikes one as a portrait of some real person, seems to be bringing the thyrsus, the appurtenance of maenads, to the girl being whipped. With this the Dionysiac mystery concludes: to the right of the window on this wall is the toilette of the bride (plate 114).

126 CUBICULUM 16, *Villa of the Mysteries.* The cubiculum north of the atrium, to which Maiuri assigned the number 16, contains two alcoves, both decorated about 60 B.C. with highly impressive paintings in the Second Style. Here is the one in the east alcove (for the other, see plate 294). On the rear wall is painted an arcade above undercut moldings, on the side wall a door between two columns crowned by a gable with no supporting architrave and beneath which there is a vista of a building with porticoes.

VILLA OF DIOMEDES. The large villa on the road to Herculaneum (see plate 117) takes its modern name from the Tomb of Arrius Diomedes on the opposite side of the road. The stately manor is laid out on the same axis as the Villa of the Mysteries, obviously to profit from the same splendid panorama. Here, however, the slope of the terrain was compensated for differently. A garden surrounded by a pillared portico was laid out to the west on a lower terrace. A lounge, affording a fine view and set on the same upper level as the other living quarters, was built over the east wing of the portico, using part of the portico roof as a terrace from which to enjoy an unobstructed view of the landscape. However, except for a wide entrance the garden itself was closed off by a wall on the side facing the sea and so, despite its much greater than normal area, it retained the feeling of secluded intimacy the Pompeians sought in their home gardens.

127 VILLA OF DIOMEDES, *view of the south side.* In the foreground the pillared portico encloses the garden, to the left the outside wall runs parallel to it. In the last years of the house, a pergola with six columns—undoubtedly used as a summer triclinium—was built behind a piscina in the middle of the garden. In the foreground can be made out rooms in the upper-level living quarters. Modified and enlarged over the years, the basic structure of the villa goes back to pre-Roman times.

VILLA IMPERIALE. After World War II, when the museum of Pompeii, the Antiquarium, was being rebuilt, workmen discovered a large villa which in Augustan times had been situated outside and above the city wall. A long portico—over 260 feet have been unearthed without reaching the end—backs on the onetime defensive wall to form a splendid terrace looking out on the sea. Behind it lay a second portico of which unfortunately only the northwest corner has been located, but this one seems to have surrounded a garden. Only a few rooms are relatively intact, but the large oecus (plate 130), which was apparently in the axis of the west portico, suffices to give an idea of the sumptuousness of a villa so elaborate that it is thought to have been the property of the Imperial family themselves. The paintings are of outstanding quality, and the workshop that decorated the large oecus seems to have been in the direct tradition of the artists who were commissioned by the Imperial family to decorate the so-called Farnesina House in Rome about 19 B.C., though some scholars have argued for a date as early as 40 B.C.

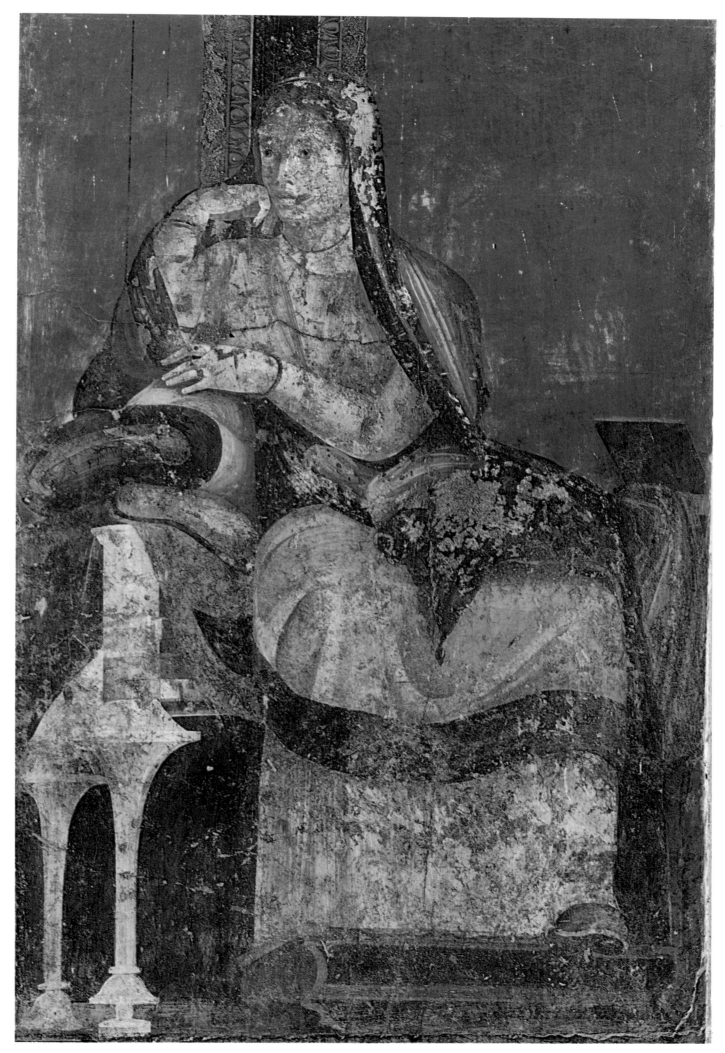

119

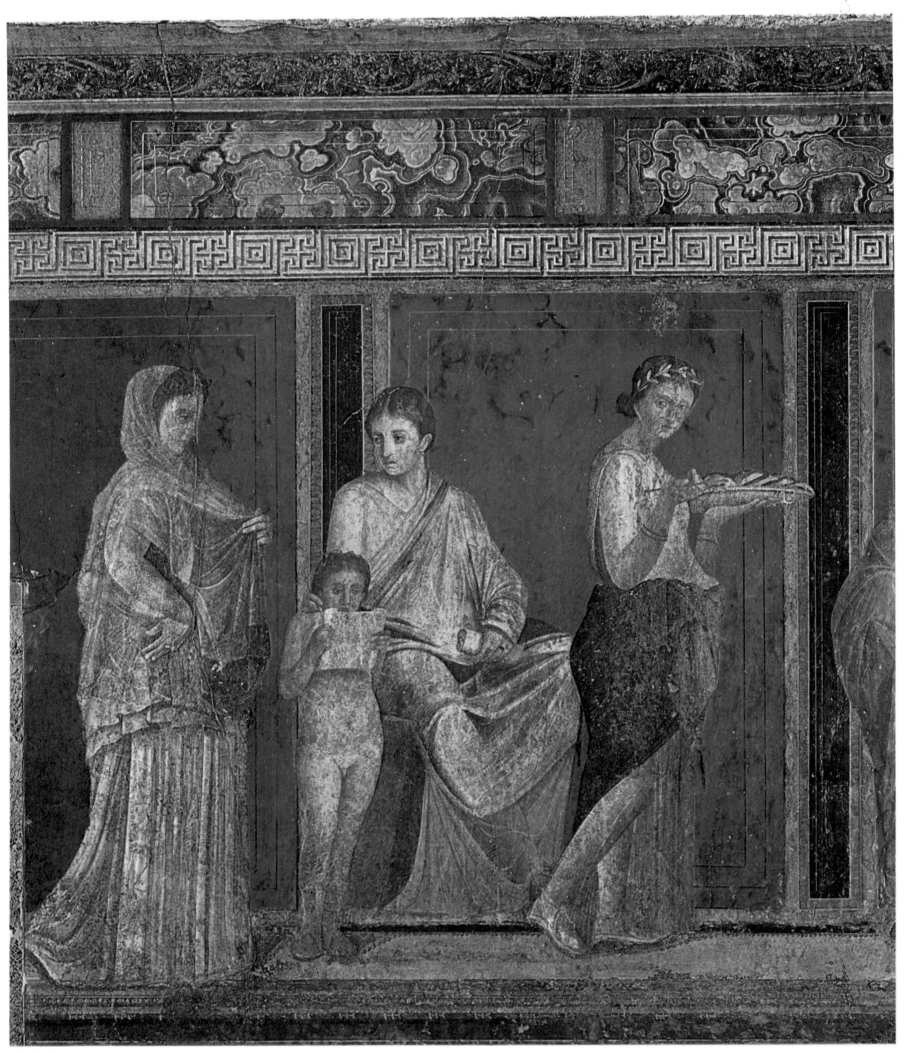

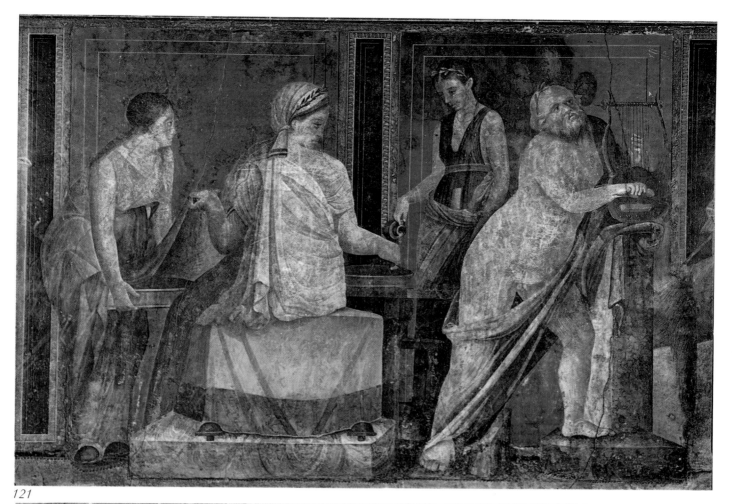

121

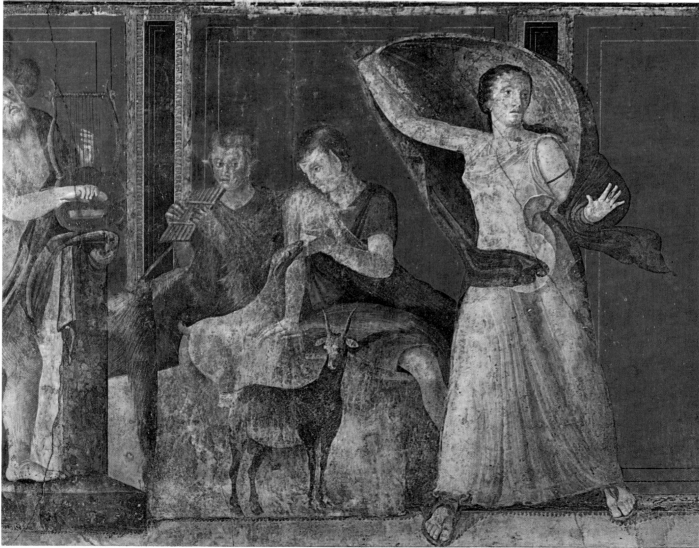

122

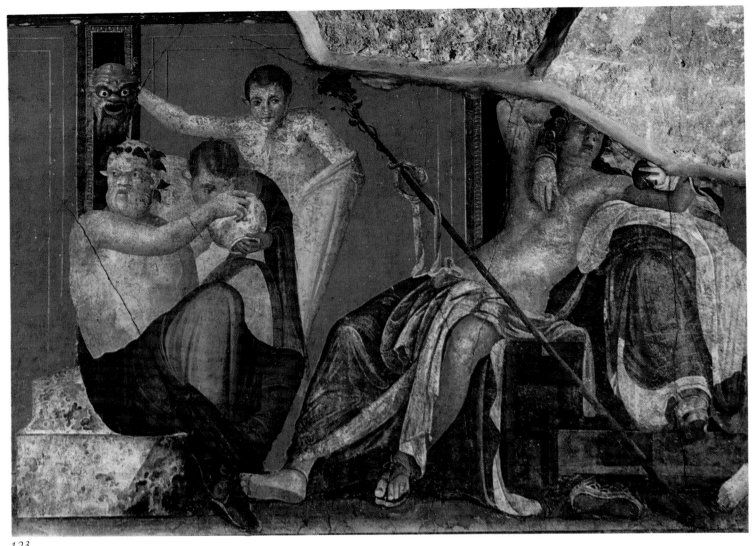

123

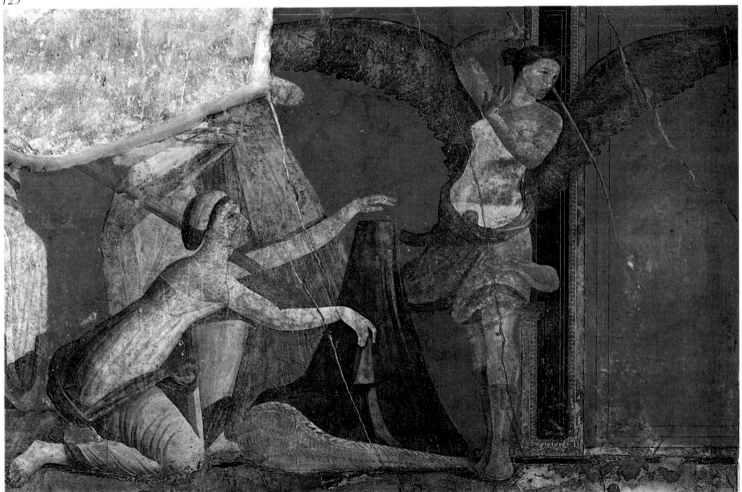

124

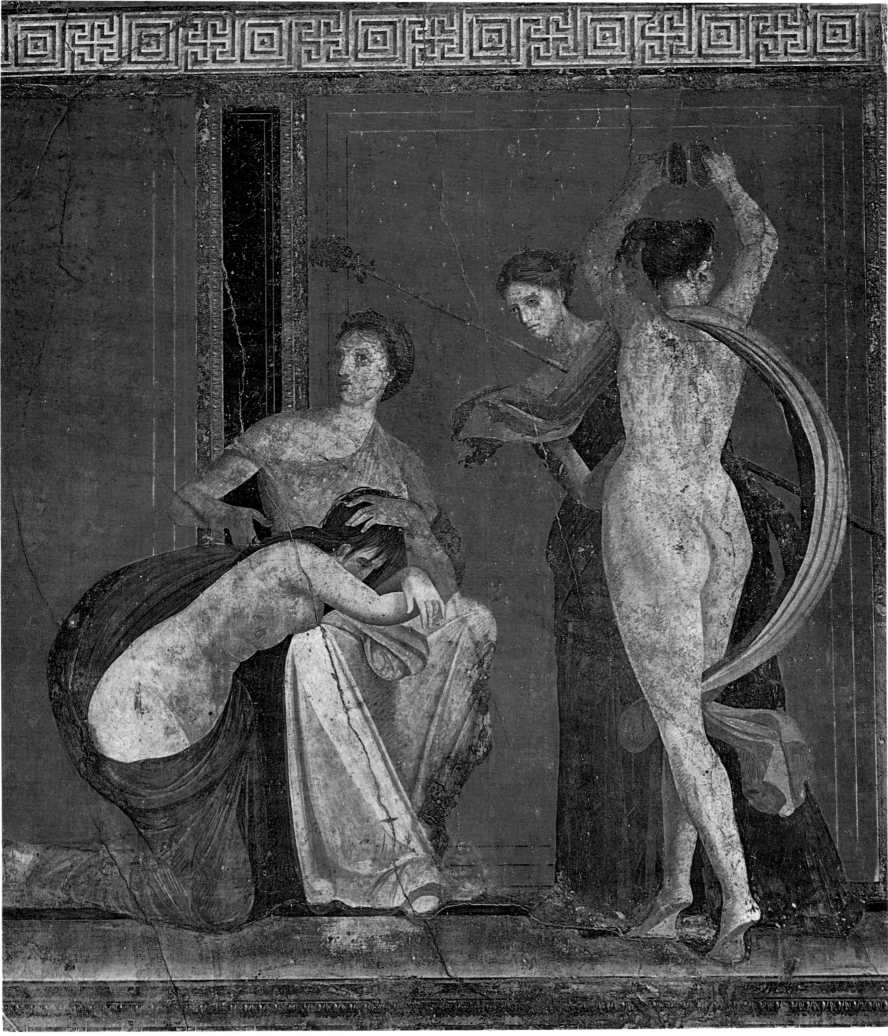

125

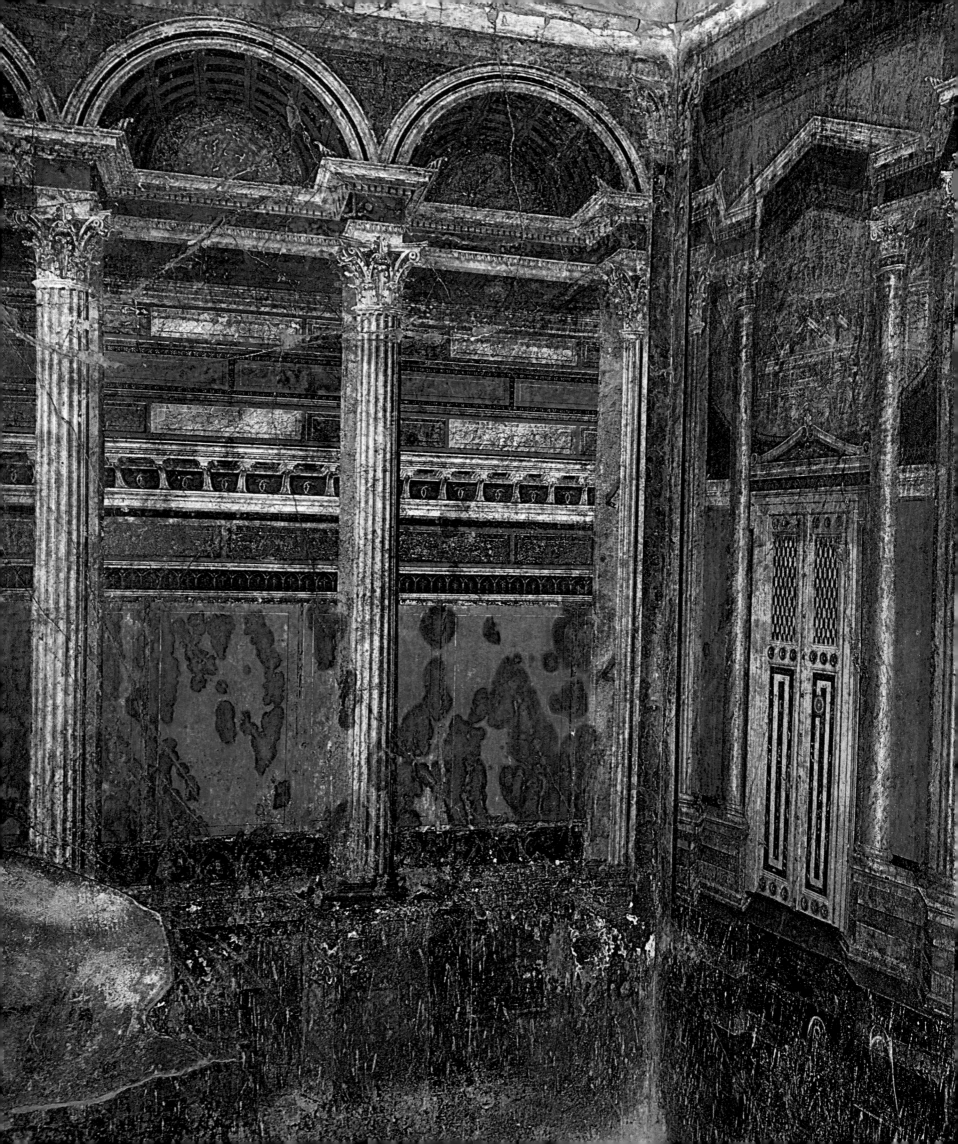

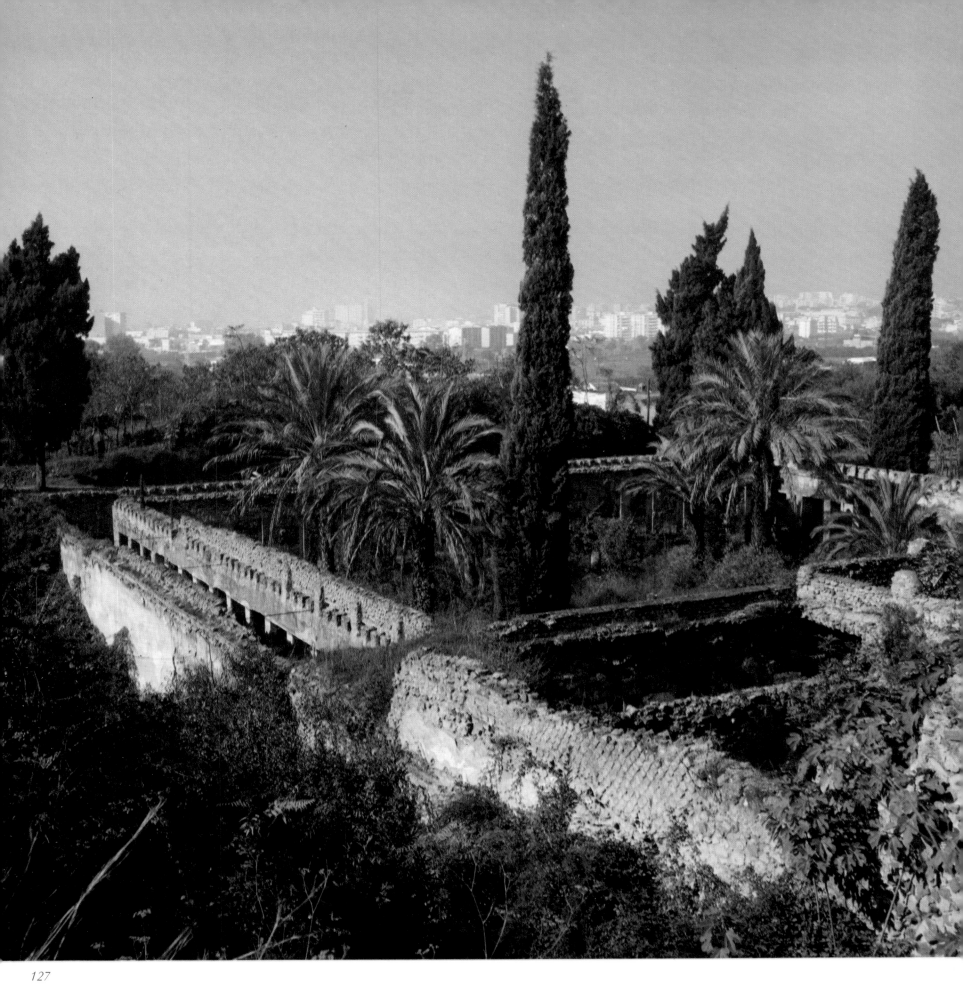

127

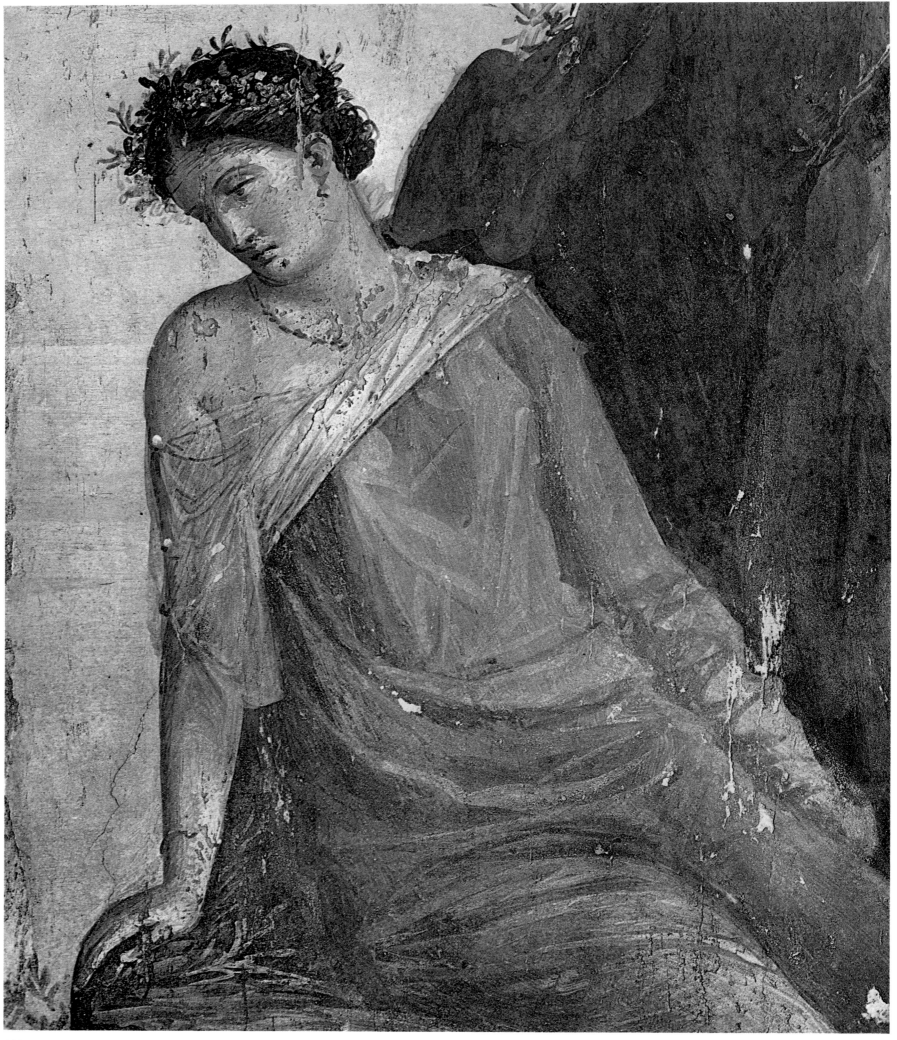

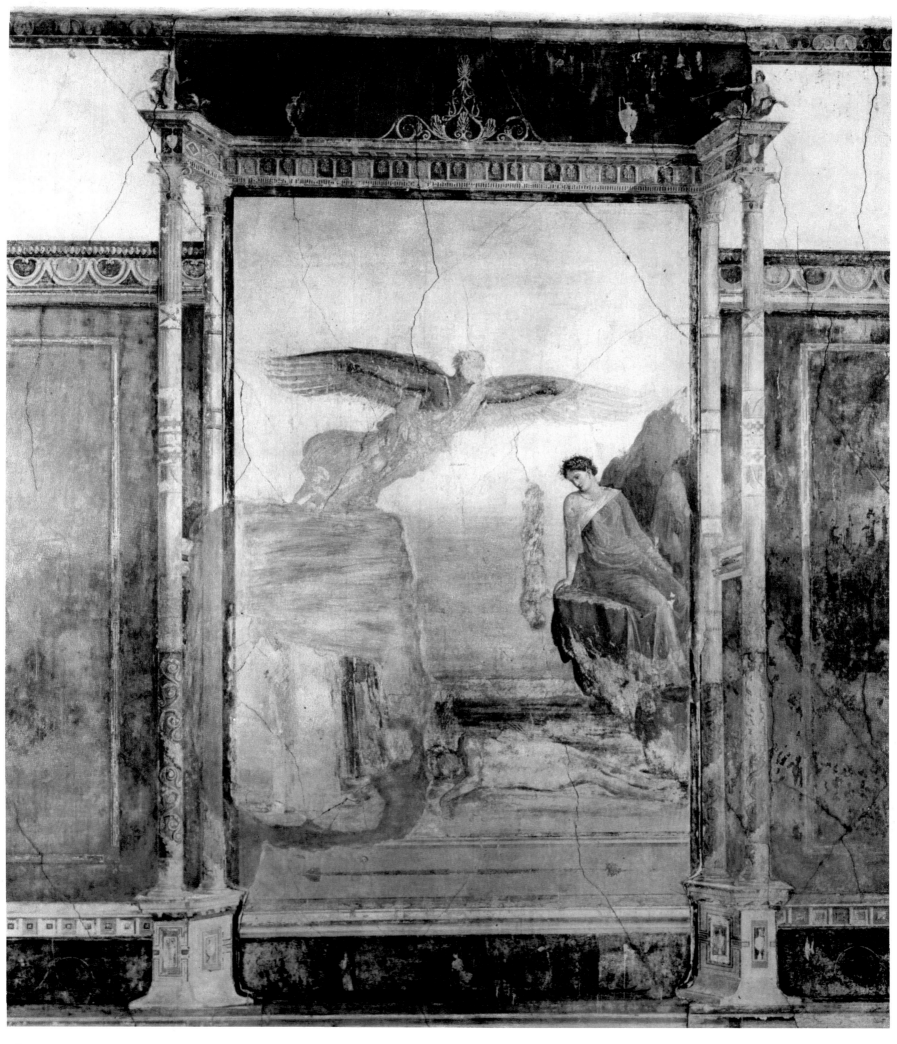

130

Preceding pages:
128, 129 THE FALL OF ICARUS. *Central picture of the south wall, Large oecus, Villa Imperiale.* The legend of the death of Icarus, who dared to fly so close to the sun that the wax holding together his manmade wings melted, is recounted with the most economical means. The overly bold youth lies dead on the shore, in the upper left his father Daedalus—who prudently avoided the upper stratosphere—still soars in the air with the wings he invented for himself and his son. On the right, a seated woman (plate 128) gazes down on the dead Icarus, and on the left were two other female figures, both now destroyed. For background there is only the sea. The coloring is delicate, the execution very fine and painstaking. In the center the

name DAIDALOS is written in Greek characters.

130 LARGE OECUS, *northeast corner, Villa Imperiale.* The high vaulted hall, whose stuccoed ceiling is one of the handsomest in Pompeii, received its painted decoration about the time of the birth of Christ. A dark-colored dado with fine linear ornamentation runs below a narrow band of delicate acanthus vines and scenes with priests, cupids, and psyches. Above this is the high middle zone with, in the center of each wall, a columnar aedicule rendered in perspective and framing a mythological painting: on the north wall, *Theseus Abandoning Ariadne;* on the east wall, *Theseus Triumphant over the Minotaur* (plate 286); on the

south wall, *The Fall of Icarus* (plates 128, 129). The wall panels with their dark backgrounds and ornamental medallions are separated from each other by slender painted columns, and above them there is a narrower white-ground zone decorated with open pavilions and oblong panels imitating hanging pictures. The uppermost zone, above the first stuccoed cornice, has fantastic architecture against a black ground and, like the ceiling, would seem to date from a later time.

131 TOMBS OF C. CALVENTIUS QUIETUS AND NAEVOLEIA TYCHE. *Necropolis outside the Herculaneum Gate.* Both tombs (see plate 117: *20, 22*) have the same form, an altar-

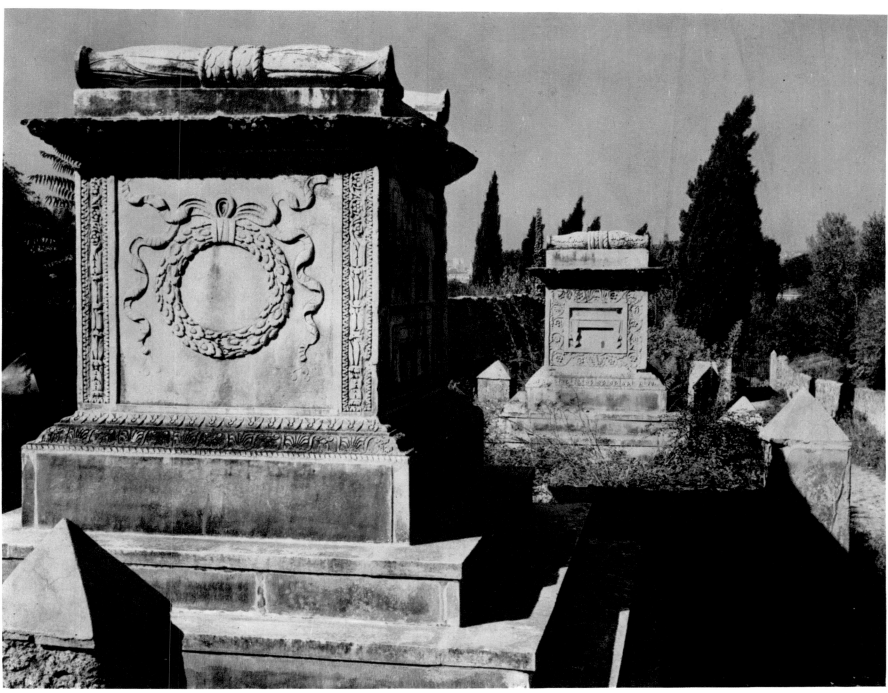

131

like structure with epigraph and reliefs which covers the burial chamber. C. Calventius Quietus, whose tomb is in the foreground here, was Augustalis and, for his good deeds, "by decree of the Decurions and with the accord of the citizenry" was awarded the *bisellium,* the honorary seat in the theater, which in fact is depicted on his monument just below his epitaph. Along with other Imperial insignia, the *corona civica,* the oakleaf wreath, may allude to his position as Augustalis. During her lifetime, Naevoleia Tyche, the freedwoman of one L. Naevoleius, saw to the building of a fine tomb for herself, her husband C. Munatius Faustus, and their freed slaves of both sexes. Munatius, identified as an inhabitant of a suburb (*paganus*), was likewise an Augustalis, and he, too, by his merits—

ob merita eius—earned the *bisellium,* reproduced in the relief on the left side of the monument. The relief on the front shows what seems to be payment of some sort of rental or deed, that on the right a sailing vessel, both probably referring to activities of the deceased. Though both monuments date from before A.D. 62, that of Tyche appears to be more recent than its neighbor.

Following page:
132 EAST SECTION, SOUTH SIDE OF THE ROAD, *Necropolis outside the Nuceria Gate.* At the left are the tombs of the freedmen C. Cuspius Cyrus and C. Cuspius Salvius and

of Vesuvia Jucunda (plate 118: *17*). Cyrus was *magister pagi Augusti felicis,* administrative official of a suburban territory. The facade of the tomb is in molded bricks, with an arch between two columns. Above this lower story, which held the burial chamber with its *loculi* (niches for the urns), there is a sort of round base in reticulated tufa stonework which doubtless held some additional structure. The tomb dates from the middle of the first century A.D., as does its neighbor with its door flanked by niches framed in columns. This latter tomb commemorates L. Barbidius Communis and Pithia Rufilla (plate 118: *15*), which in turn is followed by a somewhat taller monument lacking an identifying inscription but decorated in stucco with swords and a shield.

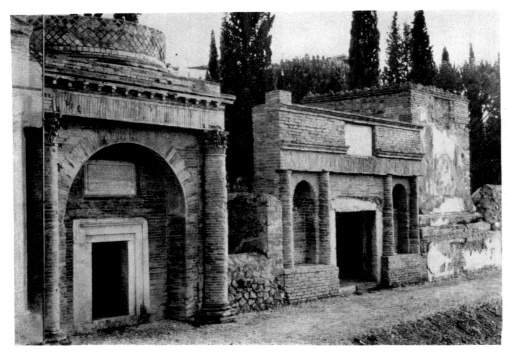

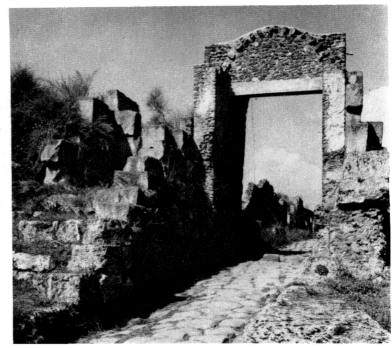

133 NUCERIA GATE, *from outside the walls.* The easternmost gate on the south end of the city was erected in Samnite times but was renovated and redone on several later occasions. It lies at the end of a long road lined with stone walls, a vestige of which is visible here on the left. The road dropped fairly steeply once outside the gate and shortly thereafter ran into the east-west highway between Pompeii and Nuceria to become one of the chief routes for commerce in the Sarno valley as well as a much used burial ground (see plate 118).

134 EAST SECTION, NORTH SIDE OF THE ROAD, *Necropolis outside the Nuceria Gate.* The tomb in the immediate foreground is diagonally opposite those in plate 132 (see plate 118:*30*) and commemorates a certain Melissaea and M. Servilius. The niches in the base were intended to hold busts or small commemorative pillars of the type known as *cippus.* The most interesting tomb of those seen here is

in the form of a tetrapylon overtopping all its neighbors. At each corner there is a pillar with four half columns engaged in it, the whole built in alternating layers of brick and stone and designed to support a four-sided arch. There is no epitaph identifying it, but it must date from the very last years of Pompeii and may not even have been completed at the time of the eruption. In the background on the right is a stretch of the city wall in large hewn stones. The short road leading from the Nuceria Gate crosses this main highway to Nuceria beyond the last tombs visible here (see plate 118).

135 HERCULANEUM GATE, *seen from the city side.* Judging by its masonry, the gate was built in the years of the Roman Republic. In addition to the large central opening for vehicles, there were passageways for pedestrians to either side. Although there were provisions for locking the central gate, these side exits always remained open.

The rough walls were plastered over, and some of that coating survives. Beyond the gate can be observed the first of the tombs.

136 SOUTH SIDE OF THE ROAD, *Necropolis outside the Herculaneum Gate.* To the left is the seplcher of the duovir and military tribune Aulus Veius, to the right that of Mamia, a priestess in the service of the city, both of them with semicircular stone seats (see plate 117:*2, 4*). In the center, behind the masonry core of the Tomb of Marcus Porcius, is the mausoleum of the Istacidii, which was originally crowned by a *monopteros,* a small, open, round temple-like structure. This group of tombs ranges from Republican to Augustan times, and they were among the curiosities seen by Goethe on his memorable visit of March 11, 1787.

137 TOMB OF M. VEIUS MARCELLUS. *Necropolis outside the*

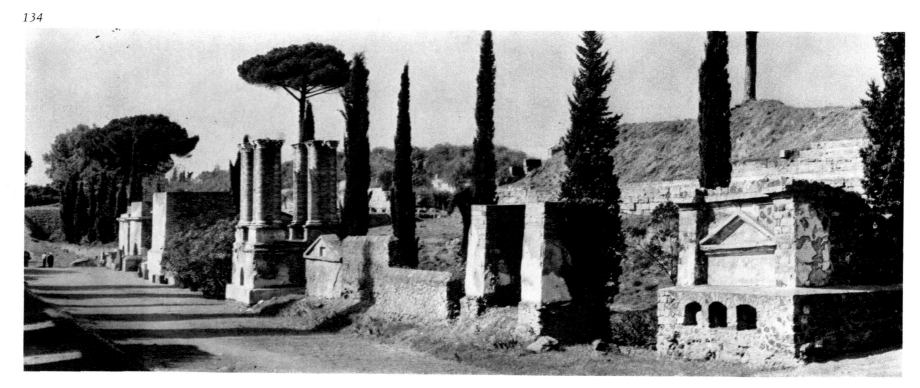

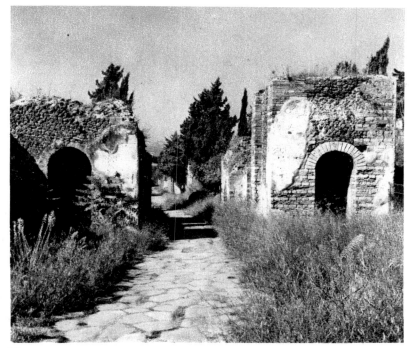

135

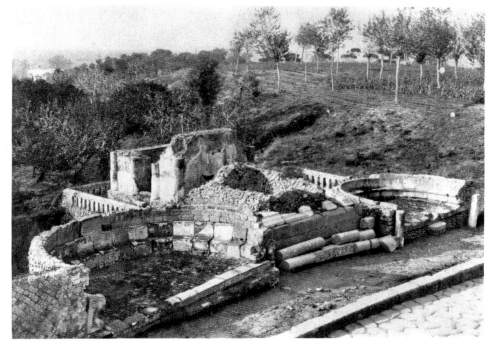

136

Vesuvius Gate. The inscription on the gable of the low sepulcher proudly informs posterity that the plot for his tomb was awarded to Marcellus during his lifetime by decree of the decurions, though it does not specify the services thus rewarded nor mention the public office he no doubt held. At the left there is a stretch of the city wall with Tower X.

138 TOMB OF THE AEDILE CAIUS VESTORIUS PRISCUS. *Necropolis outside the Vesuvius Gate.* Here again, for the richest tomb in this small burial ground, the city donated the plot along with the considerable sum of 2,000 sesterces for the funeral. The monument for this young public official, who died at twenty-two, was, however, erected and paid for by his mother, Mulvia Prisca. The burial chamber and the wall around it were painted, and on its roof, at the corners, are square blocks with cupids in relief on their sides and coiled snakes on their

tops. The center is filled by a large, stuccoed, altar-like superstructure whose front bears the epitaph flanked by relief figures of genii of death.

Following pages:

139 NORTH SIDE OF THE ROAD, *Necropolis outside the Herculaneum Gate.* This stretch of the Via dei Sepolcri has a number of fine tombs. Inside the high vaulted niche in the left foreground, a semicircular bench runs around the wall to make an exedra similar to those in the tombs of Mamia and Veius (plate 136). The plaque in the gable has no epitaph, so probably no one had as yet been buried here. As further evidence, the style of the stucco facing is that of the last years of the city. Only the substructure remains of the next tomb, where a now famous priceless blue glass amphora was found (plate 208). The high, dark cube farther along the road is known as the Tomb of the Garlands because of the festoons in relief hanging between

flat pilasters on its front. The tomb was built in tufa blocks before the middle of the first century B.C. and contains no burial chamber, which suggests that the deceased was interred in the ground either beneath or behind it. The street slopes upward, and at its top can be seen the massive Herculaneum Gate opening into the city.

140 VIA DEI SEPOLCRI, *looking toward the Herculaneum Gate.* A view like this, with the tomb-lined road rising steeply to the city gate, reminds us that Pompeii is in fact built on the slope of Mount Vesuvius. The large altar-shaped tomb in the foreground (plate 117:37) was erected by Alleia Decimilla, a priestess of Ceres, in memory of her husband, Marcus Alleius Luccius Libella, who had been aedile, duovir, and praefectus quinquennalis, and of their like-named son, who was already a decurion when he died at seventeen. The site was awarded to this distinguished family by the city.

137

138

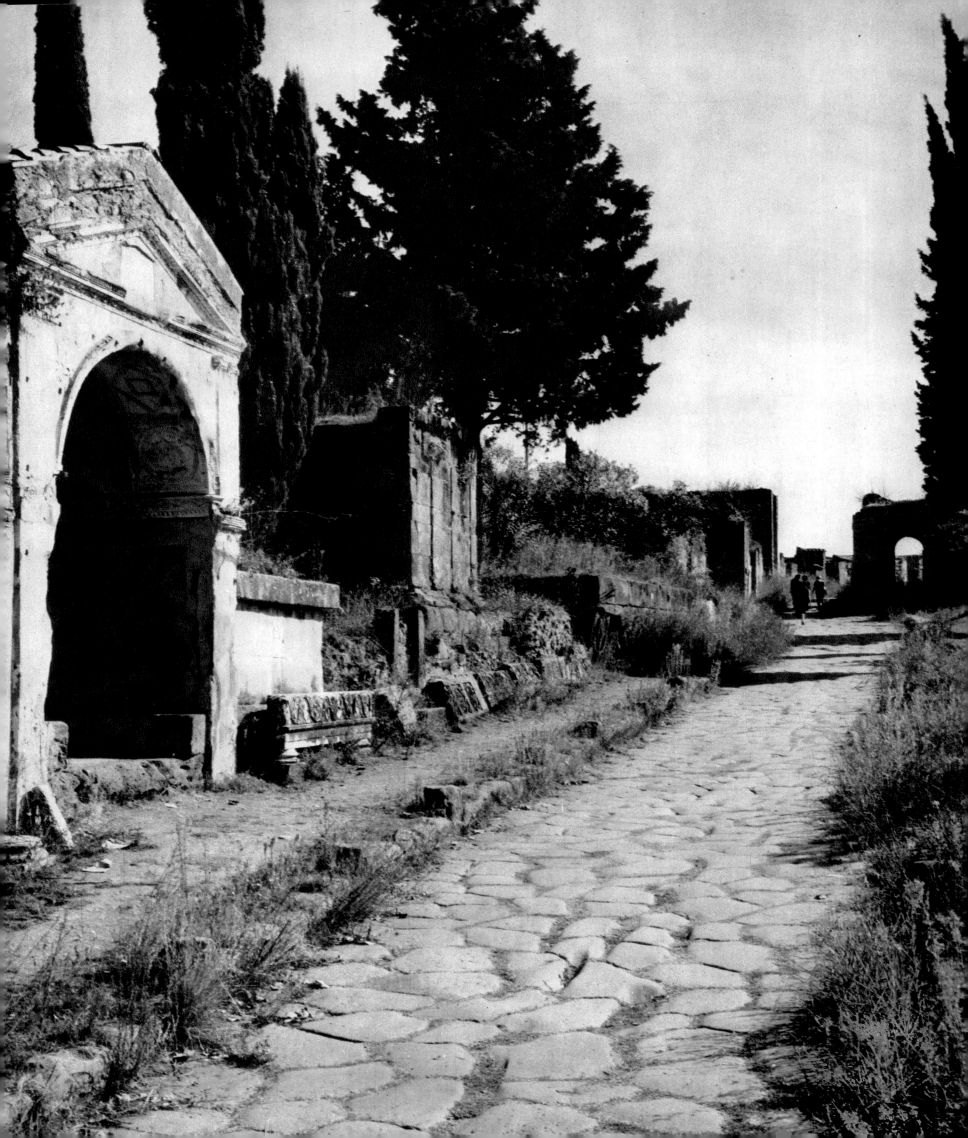

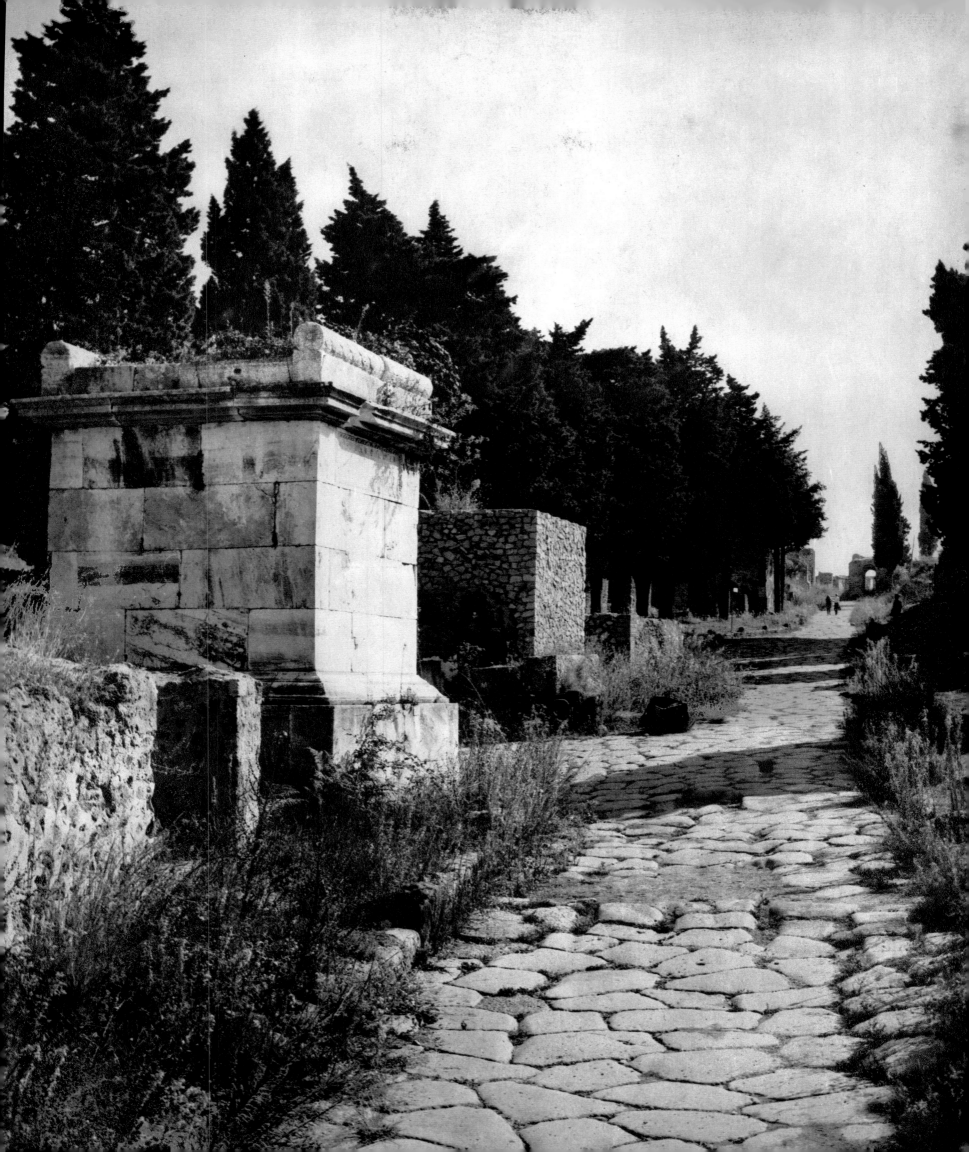

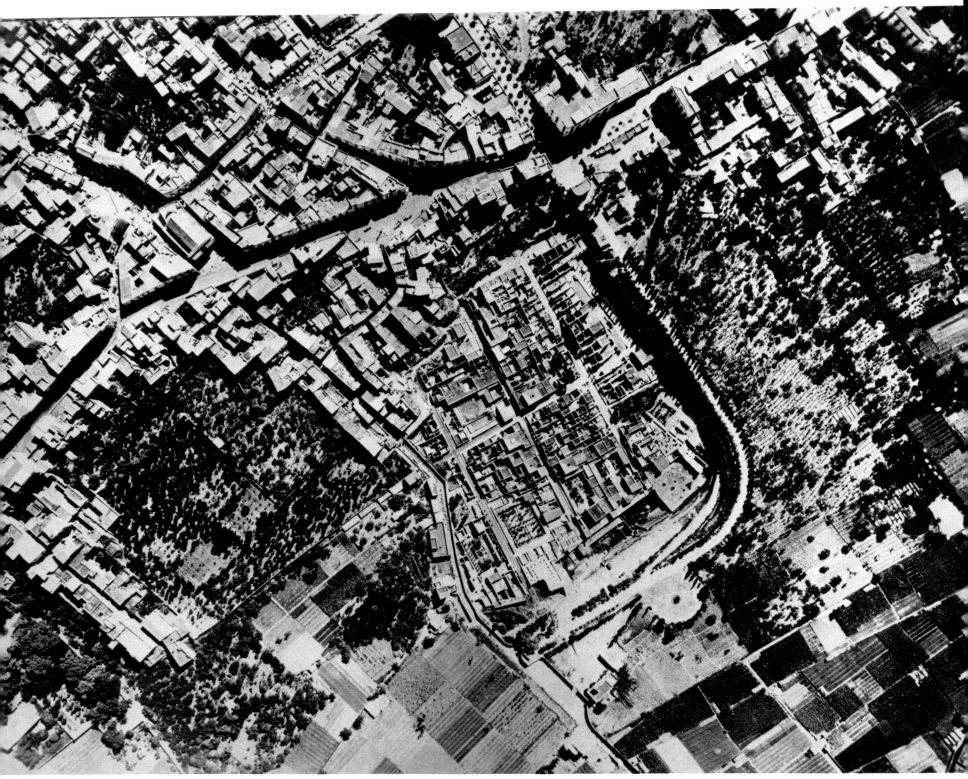

141 AERIAL VIEW OF HERCULANEUM. This panorama
should be viewed in relation to the plan on the facing page.
One sees here how the modern town of Resina—the
disorderly jumble of tall apartment houses forming
roughly a triangle in the center of the photograph—
towers directly over the excavations of the ancient city.
At the time the photograph was made, the northwest
corner of Herculaneum, including the Collegium of the
Augustales (plate 142:*IX*), had not yet been unearthed,
but it is apparent how soon the excavations would have
reached a modern main highway had the proposed ex-
propriation of the adjoining residential area been carried
through.

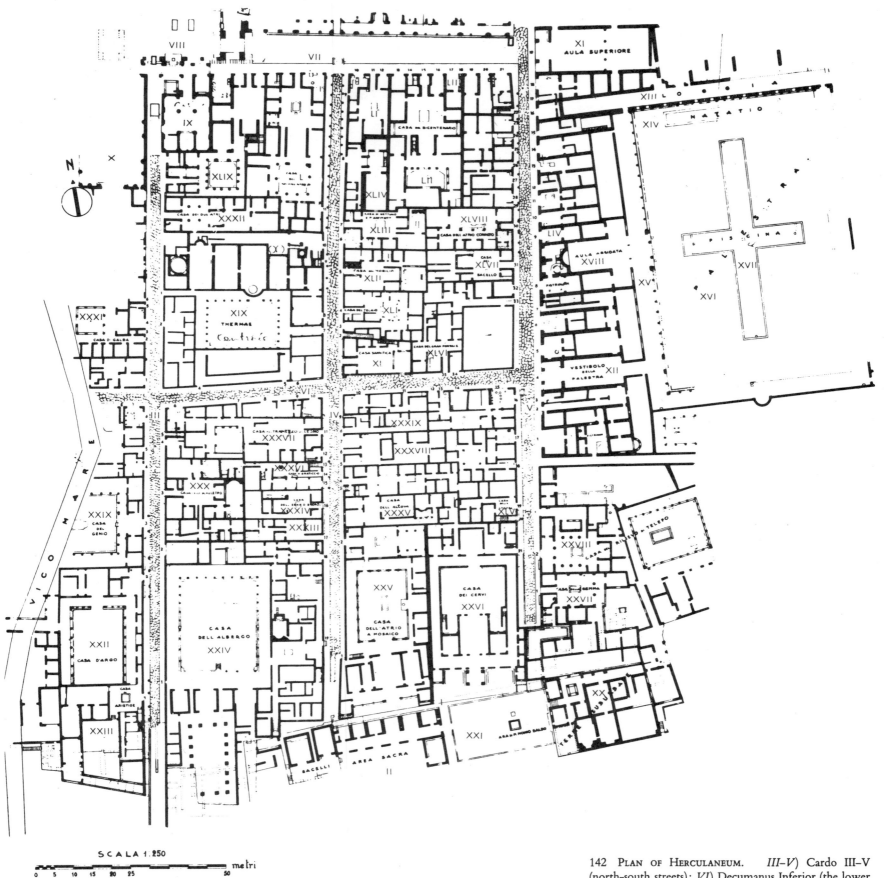

142 PLAN OF HERCULANEUM. *III–V*) Cardo III–V (north-south streets); *VI*) Decumanus Inferior (the lower east-west street); *VII*) Decumanus Maximus (the upper east-west street); *VIII*) the so-called Basilica; *IX*) Collegium of the Augustales; *XIII–XVIII*) Palaestra; *XIX*) Thermae; *XX*) Suburban Thermae; *XXI*) Monument of Nonius Balbus; *XXV*) House of the Mosaic Atrium; *XXVI*) House of the Deer; *XXVII*) House of the Gem; *XXVIII*) House of the Relief of Telephus; *XXXVI*) House with the Latticework Masonry; *XL*) Samnite House; *XLII*) House with the Carbonized Furniture; *XLIII*) House of the Mosaic of Neptune and Amphitrite; *XLVI*) House with the Large Portal; *LII*) House of the Bicentenary, with adjoining shops.

HERCULANEUM

Rediscovered earlier than Pompeii, Herculaneum affords a priceless complement to its more famous sister city. In spite of the differences between the smaller, quieter Herculaneum and the busy, commercial center of Pompeii, inevitably there was much in common between two communities in such close proximity, which were subject to the same cultural influences and historical vicissitudes. In their deaths, though, there was a crucial distinction: the avalanche of volcanic matter that Vesuvius unleashed was different for the two cities so that in Herculaneum much was preserved that in Pompeii was irrevocably lost. Without the lessons of Herculaneum, what Pompeii tells us can be at best a mutilated torso.

THE HISTORY OF THE CITY

"A small fortified town situated on a promontory high above the sea and exposed to the southwest winds, which makes for a place salubrious to live in"—this is how Strabo (*Geography* v. 4, 8) described Herculaneum. Or again: "*Oppidum tumulo in excelso loco propter mare . . . inter duas fluvias infra Vesuvium collocatum*"—a town high on a hill by the sea . . . between two rivers at the foot of Vesuvius—as it reads in the fragment that survives of the history by Lucius Cornelius Sisenna, who was *praetor* in 78 B.C. and served under Pompey in 67 B.C. in the war against neighboring pirates. Of the once commanding geographical position of Herculaneum the uninformed visitor today may well remain quite unaware. The entire terrain was leveled by the eruption, and the shoreline is now much farther out than in ancient times.

The spur of land crowned by Herculaneum belongs to the massif of Vesuvius which lies east of the town, leaving unblocked only a relatively narrow passage between its slopes and the sea. When the first settlement arose here is not known, but it was probably about somewhat the same time as Pompeii was founded. Strabo, in fact, mentions both in the same breath and asserts that both had first belonged to the Oscans, then to the Tyrrhenians (Etruscans) and Pelasgians, and finally to the Samnites. Thus here, as in Pompeii, one can assume an Etruscan preponderance. Although the Greek hegemony left no visible traces in Herculaneum, as it did in Pompeii, nonetheless it must have been even stronger here in a town that lay much closer to the Greek city of Neapolis and must have persisted until the late fifth century B.C., when the settlement fell to the Samnites.

The historical sources are silent about the fortunes of Herculaneum in Samnite times. Probably it too belonged to the League of Nuceria since an inscription testifies to the *meddix tuticus*. Beyond this bit of evidence we can only presume that it always went along with Pompeii, no source speaking of any particular role it may have played in the Samnite wars. Nor can one take seriously Livy's report (*Ab Urbe Condita Libri* x. 45, 9–10) that in 293 B.C. the consul Carvilius conquered, among other towns, one named Herculaneum, but only after a bitter combat and siege. By that date all the neighboring region had already been lost to the Samnites, and it is inconceivable that Herculaneum alone could have held out for ten years on the side of their opponents, so the place mentioned by Livy must be sought elsewhere. In the war of the Italic League, Herculaneum, like Pompeii, fought against Rome, but in 89 B.C. it was taken by the Roman legate Titus Didius with the help of a Hirpinian legion commanded by Minatius Magius, an ancestor of the historian Velleius Paterculus, who records that fact with pride (*Res Gestae Divi Augusti* ii. 16, 2).

Thenceforth Herculaneum was a Roman *municipium*. It is not known if Sulla installed his soldiers there too. At any rate, the designations *municipium* and *municipes* continued in use into the late period of the life of the town, though we know little about its administrative history. Election inscriptions, so numerous in Pompeii, are lacking there. It would seem that the Pompeian habit of covering the walls of houses with election propaganda was never adopted with anything like the same enthusiasm in the smaller town. All we have to assist us, therefore, are official inscriptions, from which we get at least the names of the *duoviri iure dicundo*, *quinquennales*, and *Augustales*.

Herculaneum does not seem to have been a commerical city like Pompeii. In its excavated part, which includes the center, the shops are concentrated on the streets known as Cardo V and Decumanus Maximus (plate 142: *V, VII*). Nor are there deep wagon ruts as seen in the streets of Pompeii, so traffic must have been very much less intense. Devoting itself chiefly to fishing and perhaps also to the sale of farm products such as the much prized wine from the slopes of the volcano, the town must have had a quiet existence and been an attractive place in which to live. As evidence, there are not only the sumptuous houses along the old sea front but also, outside the town, a large villa generally thought to have belonged to Julius Caesar's father-in-law, Lucius Calpurnius Piso Caesoninus. Moreover, Seneca (*De Ira* iii. 21, 5) recounts that Caligula destroyed "a most beautiful villa in the vicinity of Herculaneum" because his mother had been held prisoner there for a time, which suggests that it must have been the property of no one less than Emperor Tiberius himself.

The earthquake of A.D. 62 hit Herculaneum no less hard than Pompeii, as is clear from the famous description by Seneca (see p. 10). That Tacitus does not explicitly mention it in this connection means nothing more than that Pompeii was the more important and better known city. In any event, the wall decorations in Herculaneum date in very large measure only from the post-earthquake period and therefore from the reigns of Nero and the Flavians. There is one piece of specific documentary evidence: the epigraph on the Temple of the Magna Mater which was rebuilt at the order of Vespasian in A.D. 76 reads, *terrae motu conlapsum*—after it had collapsed in the earthquake.

Herculaneum, too, was still rebuilding when Vesuvius began its deadly work on August 24, 79 A.D. From the information available it has been concluded that as early as late afternoon of the first day of the eruption the city had disappeared from the face of the earth. At least it was spared the rain of lapilli, because at first the wind blew from the northwest. Instead, ash and water fused into a horrendous river of slime which rolled implacably down toward the impotent city. Faced with a menace of such proportion, the frightened population could not afford the luxury of indecision which cost the lives of so many Pompeians. The only salvation lay in immediate flight, and most of the citizenry did not hesitate. So it is that many fewer corpses have been found there than in its sister city. The road to Naples was still not cut off, but according to the letter in which Pliny the Younger described the sequence of events, the sea route offered little hope of escape.

The avalanche of slime that moved across the city and down to the sea hardened to a stony mass. What it destroyed in its path it promptly covered over to a height of as much as sixty-five feet. Some buildings collapsed, others stood, but everything remained hermetically sealed until, seventeen centuries later, men came to dig out the buried city inch by toilsome inch.

THE EXCAVATIONS

Our account of the unearthing of Pompeii has already told something of how Herculaneum was rediscovered. It is easy to see why, in the early stages of excavation, the chief focus of interest should have been Herculaneum. The rich finds turned up in the first years of digging filled the nearby villa of Charles III in Portici, and that royal patron and enthusiastic promoter of the explorations in the dead cities envisaged the undertakings primarily as the means of enriching his museum of antiquities with unique, priceless rarities.

Soon, however, Pompeii took precedence. There the terrain was more easily dug into and the ruins could be laid bare in grand style, whereas the rock-hard soil of Herculaneum could only be opened up by mining tunnels. The fact that the town of Resina had grown up on the same site as the ancient city made excavations even more difficult. At Herculaneum, finds could not be left where they were, still underground and accessible only through some grim tunnel. It was even difficult to form any idea of the shape and extent of the city by the usual techniques of surveying and measurement. In addition, the toilsome mining methods used involved considerable danger. In one of the tunnels, on August 4, 1755, an explosion of natural gas was set off by sparks from the blows of a pickax on the hard stone. Luckily the terrified workers escaped with nothing worse than a bad fright, and this seems to have been the only accident of its kind.

With all this, it is not surprising that on February 9, 1765, Marchese Tanucci, the chief authority in Naples after the departure of Charles III for Spain, should have ordered Francesco La Vega, the director of the excavations, to shift all activity to Pompeii. Work did not stop immediately, however. La Vega still had to see to reinforcing those houses in Resina whose foundations had been undermined and also to providing for the filling in of tunnels. In fact, on April 30 of the same year, Tanucci even ordered further exploration at the site of the theater, the Reale Accademia Ercolanense requiring more information in order to complete the maps they were drawing up. Nevertheless, work slackened off steadily. From year to year the reports declined in scope and substance until, in 1779 and 1780, they finally dwindled to the laconic phrase: "*Nel teatro ercolano non è occorsa novità*"—nothing new.

However, in this first period of exploration luck, if nothing else, had led the searchers to get a bearing on a number of decidedly important buildings. The start was made with the theater, which Prince D'Elboeuf had discovered by accident in 1709. Thirty years later, in what may or may not have been the Forum, Alcubierre hit on a large public building which contained large-scale paintings in the Fourth Style and which finally came to be known as the Basilica. In 1757 an epigraph was turned up which stated that the Temple of the Magna Mater (the building itself has never been located) had been restored under Vespasian in 76. The most valuable discovery, however, was undoubtedly the large villa outside the town which, because of the rich find of manuscripts there, has come to be known as the Villa of the Papyri. The results of these first diggings, then, have remained of prime significance for our knowledge of the topography of Herculaneum, and the maps and plans drawn with scrupulous exactitude by Weber and La Vega still provide the basis for unearthing additional buildings, though now, happily, with more modern archaeological techniques.

Interest flared anew in 1827 when, on the property of a certain De Bisogno, one of the old excavation shafts was found, and in it could be seen remains of antiquities. On September 26, 1827, the authorities acquired some 11,000 square yards of land from the De Bisogno family, and on January 2, 1828, the excavations were resumed under the direction of the architect Carlo Bonucci. For the first time work could proceed on land which had not been built over, so operations did not have to be confined to shafts and tunnels. The new project began with great enthusiasm—at the end of January, 1828, Bonucci could write with pride that the first month had yielded more than an entire campaign in Pompeii—and at the outset concentrated on the large House of the Argus. Evidently the investigators had lighted on a residential quarter. But then, after a number of brief interruptions, tools were laid down definitively in 1855 because everything possible had been done on the terrain purchased in 1827. They were not taken up again until 1869—soon after the new unified Kingdom of Italy under Victor Emanuel II came into being—and when work began it was still in the same quarter. Now at last it was possible to complete what had been begun in the eighteenth century, when circumstances did not permit laying bare an entire district of the town.

In 1875, when work once again came to a halt, the northwest corner of Herculaneum as we know it now had been brought to light. It comprised the houses west of Cardo III and some east of that thoroughfare, among them the House of the Skeleton and the House of the Inn, while northeast of the intersection of Cardo III and Decumanus Inferior the bathhouse was still the only public building unearthed. This was not much, but at least a start had been made at disclosing the buried city in a methodical manner.

Many years were to go by before that start could be carried further. In 1903 Charles Waldstein, a professor at Cambridge and former director of the American School of Archaeology in Athens, set about organizing an international project for further exploration of Herculaneum. His initiative, which spun itself out in years of negotiations, correspondence, and newspaper articles to arouse public opinion, did not have the results hoped for. On April 27, 1907, the then General Director of the Superintendency of Antiquities, Corrado Ricci, transmitted to the professor the official, definitive rejection of his project on the part of the Italian government. Twenty more years had to pass before the man came on the scene who would finally succeed in giving Herculaneum back to the world.

In 1924, as soon as he took over his new position as Superintendent of Antiquities in Naples, Amedeo Maiuri began to busy himself with the means of resuming work on the long-neglected excavations at Herculaneum and with the question of how to block the town of Resina from continuing to spread over the site of the buried city. In 1927, at his insistence, an area of more than seventeen acres was expropriated, and on May 16 of the same year he set about the undertaking which, despite his countless other tasks and activities, continued to be especially dear to him throughout the rest of his life. He began where work had broken off in 1875, with the houses on Cardo III, and from there proceeded to move farther and farther out, systematically laying bare everything in his path, insula by insula. Interrupted in 1942 by the war, the indefatigable and undiscourageable explorer champed at the bit until 1952 when work could begin again, but this time with the very newest technical equipment to help bore down through the resistant rock. At the same time, he had to conserve what had already been brought to light. This had to be done immediately since the carbonized wood had survived the centuries thanks only to having been

hermetically sealed off from the air. Painstaking restoration promptly undertaken in Herculaneum saved the furniture and building elements in impermanent materials which had disappeared almost entirely in Pompeii.

Now, more than ten years after the death of Maiuri, the diggings have extended to the north as far as Decumanus Maximus and the area of the Forum. Only in the south, with the houses along the sea front, have the city limits been reached. Because no one can be certain of the overall area of the city, it is hard to say what percentage of it has been exposed. Moreover, the most important public edifices, the temples and the administrative buildings, are still hidden. Our knowledge of Herculaneum is therefore very much poorer than that of its fellow victim Pompeii, but there is hope that as the years pass and the excavations continue, more of its secrets will be unraveled.

THE PUBLIC BUILDINGS

What has been unearthed so far in Herculaneum offers no sure indication of the overall plan of the city, and future investigations may have surprises in store for us in that respect. However, even now it does seem clear that Herculaneum had no older city nucleus such as was found in Pompeii. The three main north-south streets (cardines) so far unearthed run strictly parallel and at the same distance from each other (plate 142:III–V). They are intersected by the main cross street, the Decumanus Inferior (plate 142:VI), at an angle slightly off 90 degrees, with a very minor deviation west of Cardo III. This makes an entirely uniform network of streets such as appears in the new districts in Pompeii, and the only divergencies from the regular plan occur along the sea front and at the palaestra (plate 142: XIII–XVIII) and are consequences of the lay of the land at those points. Generally, this regular plan has been taken to reflect the influence of the nearby Greek metropolis of Neapolis, an interpretation which does seem to have much in its favor. As for the modern numbering system, Herculaneum unlike Pompeii was not divided into regii (a purely modern invention for the convenience of the excavators), but the insulae were given Roman numerals rather than the Arabic designations used in Pompeii, Arabic being restricted here to house numbers. However, in consulting our plan (plate 142) it must be kept in mind that the Roman numerals designate streets, monuments, and buildings but not the insulae, of which there are seven plus two others along the east side of the town in the neighborhood of the Palaestra.

If it is assumed that a fourth of the ancient city has been exhumed (and this is not certain), thus making a hypothetical total of sixteen insulae, then the most recent diggings would seem to have arrived at the city's center, at the point where one would expect to find the Forum. As a matter of fact, just at that point there happens to be a large four-sided arch, open on each side, whose vault was richly decorated with stucco reliefs and whose brick masonry was formerly faced in marble. There are pedestals for equestrian statues in front of its massive piers, and perhaps it was once crowned with a bronze quadriga. Where it rises at the west end of the Decumanus Maximus, the street reaches a quite unusual width of over thirty-nine feet and has sidewalks more than eight feet wide (plates 142: VII, 144). What is more, that final stretch of road was ostensibly closed to traffic. More than a road, it resembles a fairly narrow, oblong plaza. Postholes aligned down its center probably served to hold poles from which awnings were stretched, as they still are on market days in the sun-baked towns of the South.

If the plaza made by the widening out of the Decumanus was in fact the Forum, it would have had an entirely different aspect from the one in Pompeii, since it is only along its north side that there is a portico, the south side being taken up by private houses and tabernae. While such an identification has often been proposed, the diggings to date have not gone far enough to permit an unequivocal answer one way or the other. Not until the zone west and northwest of the four-sided arch has been fully exposed will it be possible to decide with any certainty.

West of the arch, the recent excavations have laid bare a row of brick piers which are reinforced by pilasters at the corners and were formerly faced with marble. These supported stuccoed arcades. Like the arch, this elegant construction, on grounds of technique and style, can be dated about A.D. 62 and seems to correspond to what one finds on eighteenth-century plans and drawings which located at this spot a five-gated entrance to a so-called Basilica, a building explored by Alcubierre and Weber only through tunnels (plate 142:VIII). It measures something like 180 by 115 feet, and in the interior there were colonnades on three sides. A rectangular niche occupied the center of the rear wall, and the two long porticoes ended in apses with splendid painted decoration, including the famous Fourth-Style paintings showing the finding of the infant Telephus (plate 160) and the triumph of Theseus over the minotaur, both now in the Naples museum. The painting with the centaur Chiron teaching the young Achilles (plate 159) was probably also in a circular niche here, but the precise place can no longer be identified.

Just what statues adorned the Basilica is difficult to say, since in so many cases the findings from that building were simply lumped together with those from the theater. Presumably the middle niche held a statue of Vespasian flanked by his two sons, which means that the building would have been under the protection of the emperor in the same way as the Macellum in Pompeii. Likewise unknown is the precise disposition of the Equestrian Statue of Marcus Nonius Balbus (plate 143), the most respected and influential citizen of Herculaneum, and the full-length figures of his family (plates 146, 148).

Whatever the building may have been, it was most likely not a basilica in the classical sense of an assembly hall or hall of justice. Its ground plan is rather more like that of the cloth guild's headquarters erected on the Forum by Eumachia. Some have taken it to be the senate house (curia) because the porticoes are set up on four steps above the central court and would have made an impressive place for the seats of the decurions, but this is mere hypothesis.

We are better informed about the building opposite it (plate 142:IX). According to an epigraph referring to the veneration of the emperor (Augusto sacrum), the brothers A. Lucius Proculus and A. Lucius Julianus gave a banquet here for the decurions and Augustales on the occasion of the consecration of the building, so it must have been the headquarters of the collegium attending to the Imperial cult. In front of the rear wall of its large hall there is a higher, elaborately decorated, alcove-like chamber (plate 161). This contained a statue of the emperor on a high pedestal with a painting in the Fourth Style behind it, and both long walls had paintings in which Hercules, the mythical founder of the city which took his name, was portrayed along with other gods. The lower zone of the wall was faced with fine marble and the floor paved with colored marble tiles to complete this stately setting for the cult statue of the emperor.

No exclusively religious building has as yet been brought to light in Herculaneum. The Forum was the usual site for the chief temple of a municipium, but no sure trace has been found of any temple to the Magna Mater, the mother of the gods, other than the inscription advising of its restoration under Vespasian. Similarly, the Macellum is known only from its building epigraph, according to which it was erected from his own funds by the duovir iure dicundo M. Spurius Rufus.

The building about which the early excavators were able to pass on the most information was the theater, the complex where the first diggings were done. Up to a few years ago it could still be reached by way of the eighteenth-century tunnels, though they no longer afforded any notion of the original appearance. Now, unfortunately, the building is no longer at all visible.

The site of the theater must have constituted the western edge of the city. Built by an architect named Numisius on the commission of the duovir quinquennalis L. Annius Mammianus Rufus, it was not backed by a slope, as was usual, but stood completely free. Two superimposed orders of nineteen arches each supported the *cavea*, which included four rows of honorary seats for the magistrates, sixteen rows in the *media cavea*, and three in the highest tier, the *summa cavea*, in addition to which there were *tribunalia*, loges with a separate entrance reserved, it would seem, for particularly important dignitaries. The hemicycle was not large and could scarcely have accommodated more than 2,500 spectators. However, the importance of the theater in Herculaneum lay not in its dimensions but in its extraordinarily rich details and decoration. The proscenium had columns and facing in the most valuable marbles available to Rome at that time: a yellow marble from Numidia, greenish *cipollino* from Euboea, wildly spotted *africano* from Teos in Asia Minor, lilac-veined *pavonazzetto* from Phrygian Dokimeion. Such decoration must surely date from after A.D. 62, even though the building itself goes back to the reign of Augustus. Bronze statues of emperors and leading officials adorned the walls of the summa cavea. Some of these have survived (plate 145) along with marble portrait statues (plates 146, 148), though just where the latter were displayed in the theater can no longer be determined.

As eloquent evidence of the prosperity of the city, the theater has its match in the palaestra in the eastern quarter (plates 142:*XIII–XVIII*, 150, 151), which is even more elaborate and elegant than that of Pompeii. Halfway along its excavated long side, the palaestra has a broad, high, sumptuously decorated hall (plate 142:*XVIII*) with an apse at one end and, at the other, a colonnaded front like a propylon, which emphasizes the axis and effectively articulates the long front. Above the north side ran a large loggia which made an excellent post from which to observe the athletes at their exercises and competitions. The center of the palaestra was occupied by a cross-shaped *piscina* (plate 142:*XVII*), a pool in whose center a bronze serpent spouted water from each of its five heads (plate 149). The basin was probably not used as a *natatio* since there was a regulation swimming pool along the north colonnade with the very considerable length of more than ninety-eight feet (plate 142:*XIV*). The palaestra as a whole covered a larger area than an entire insula, and for a town the size of Herculaneum its dimensions are, to say the least, surprising.

Besides these, the only other public buildings known so far are two bathing establishments. The first fills the south half of insula VI bordering on the Decumanus Inferior (plate 142:*XIX*) and was undoubtedly the central thermae of Herculaneum. The chambers for men and the much smaller section for women are aligned north of the bathhouse palaestra so that the two heating units lie side by side, thus simplifying their maintenance in the same way as at the Stabian Thermae in Pompeii. By and large these Central Thermae offer no novelties. Their fittings and decoration are simple and modest, with nothing like the splendid stucco ceilings of the Pompeian baths. It is only in the men's tepidarium and the women's dressing room that there are figurative mosaics, and these are in the black-and-white technique common in early Imperial times (plate 156).

The other bathhouse, the Suburban Thermae on the south front of the town, which in the past rose high above the sea (plate 142: *XX*), was more modern in its installation and more elaborately fitted out. Nine steps lead down from the entrance to a vestibule (plate 154) in which the *atrium tetrastylum* plan is modified in a bold and, for the first century A.D., decidedly progressive manner since it has two arcades, one above the other, which rise from the four columns. From this vestibule the bather took the usual course, through chambers with handsome stucco decorations, some with marble floors, and for the most part well lighted through openings in the ceilings. In the warm bath rooms the walls, too, were heated, and in one room a supply of as yet unused hollow bricks was found (plate 197), which were obviously intended for some improvement under way.

Like the unfinished central bathhouse of Pompeii, the Suburban Thermae in Herculaneum did not have separate sections for men and women but must have been open to them on different days. On the whole, this establishment was most like the Central Baths in Pompeii despite certain differences, and it, too, was erected after the earthquake in order to take some of the burden from the existing bathhouse and to provide more modern and efficient facilities.

Here again we have a characteristic trait of urban development in Herculaneum: large new buildings had to be relegated to the outskirts of the town or even beyond the gates, the small and densely built-up core of the city obviously affording no further space for major constructions.

PRIVATE DWELLINGS

While hordes of visitors—busload upon busload—invade Pompeii day after day throughout the year, the streets of Herculaneum remain as quiet as befits a dead city. Less impressive for today's taste than its larger and more fully excavated sister city, Herculaneum even in ancient times surely had nothing like the bustle and stir of Pompeii, where trade and commerce attracted producers and merchants from near and far. Nowhere in Herculaneum was there such a thriving business thoroughfare as the Via dell'Abbondanza in Pompeii. Its streets went their narrow course between rows of houses with scarcely a wagon track to furrow their pavement. Traffic could never have been very heavy, if for no other reason than that even a simple chariot would have found it difficult to navigate between those lines of house fronts or to scale the cardines rising steeply from the gates at the sea's edge. It is only on Decumanus Inferior and on Cardo V that shops and inns are found in any number, and even there they are not as frequent as in Pompeii, where, in the newer districts at least, they are very much a part of the overall scene. Unless one wishes to argue from this that such activities were all concentrated in districts as yet unexplored—and admittedly these districts may represent three-quarters of the city area—the conclusion is inevitable that commerce played no great role in Herculaneum.

Nevertheless, both private residences and public buildings have an undeniable air of prosperity about them. There can be no question but that Herculaneum had a stratum of wealthy citizens who were not averse to spending their money on whatever might promote the dignified elegance of their homes and their city. In one case at least the evidence is plain to see, that of Marcus Nonius Balbus, whom we have already encountered in connection with the so-called Basilica and whose life and career can be determined to some extent.

It is not known when Balbus, a native of Nuceria, elected to live in Herculaneum nor why. However, he must have put down roots there before the middle of the first century A.D., if the dating of the statue of his father (plate 146) is correct and if a statue of a maiden does indeed portray his daughter (plate 148). The fact that the city erected statues of members of his family in public places is ample evidence of his services to his adopted city and to the esteem he enjoyed there. We know of no other individual in Herculaneum nor, for that matter, in Pompeii who went further in an administrative career. Marcus Nonius Balbus was praetor and then proconsul of Crete and Cyrenaica and so had first-hand acquaintance not only with the capital but also with distant provinces of the farflung Empire, where inscriptions have survived in which the grateful communities salute him as their benefactor.

Herculaneum, too, had much to thank him for, as is clear in the unusual decree in which the city council paid homage to him after his death. It makes express reference to his *liberalitas* and to the grand scale of the endowments he made and the undertakings he initiated. One of his acts for the public good is recorded by an inscription according to which the praetor and proconsul *basilicam portas murum* . . . (the missing verb is probably *refecit* or something similar), which would mean that he had either restored or built the Basilica and the city walls and gate. Although the occasion for this generous action is not specified, in all likelihood it was connected with the reconstruction of the city after the earthquake of A.D. 62. Indeed, one wonders if it was not perhaps the personal influence of Balbus that induced Vespasian to see to the reconstruction at that time of the temple dedicated to the Mother of the Gods, a sign of favor the emperor never conceded to Pompeii. It would be interesting to know where such a distinguished citizen lived. Certainly he and others in his social class are most likely to have been the owners of the finest houses in Herculaneum, those along the seafront.

Pompeii, too, had a similar site with a splendid panorama of the bay spreading out before it, as in the House of Fabius Rufus (plate 302), whose pinkish arcades today dominate the city when viewed from the sea. There, however, the house was built in stories rising from a steep slope, whereas in Herculaneum these choice houses sit on a platform towering some thirty-three feet above the town and projecting beyond the city wall. In Pompeii as well as in Herculaneum, the city wall no longer served as fortification under the Romans so that its broad top was carved into building lots to be ceded to individual citizens.

Among the best preserved and most typical of such patrician dwellings is the House of the Deer (plates 142:*XXVI*, 157, 158) named after two fine garden sculptures of deer brought to bay by hounds. The house runs along Cardo V, so that its rooms are disposed at a right angle to the entrance. From the street, the fauces leads to an atrium without a compluvium opening in the roof. This type, known as an *atrium testudinatum*, is so infrequent that not a single sure example has as yet been found in Pompeii. The atrium here also had a wooden gallery (*maenianum*) which provided access to the rooms on the upper story. Unusual as this sort of room is, what follows is no less divergent from the standard plan. There are neither alae nor a tablinum, and the atrium opens immediately on a very elaborate dining room, a triclinium from which, by turning a full right angle to the left, one has a direct view along the main axis of the garden. Though not large, the garden was well cared for and richly furnished with sculpture. It was followed by a wide triclinium flanked by two oeci, smaller lounges for sitting or resting which opened toward the rear of the house with its fine view. Beyond this triclinium the floor plan shifted to a transverse axis. An open, airy pavilion (*pergula*) was flanked by two small open gardens (*viridaria*), and in front of it all lay a *solarium*, an unroofed terrace with a low parapet along the side facing the sea (plate 158).

The living quarters and housekeeping rooms were concentrated at the north end of the house, close to the street door. There were additional rooms above them on an upper story, as there were also above the two oeci to either side of the garden triclinium. A long portico enclosed the garden, and the adjoining rooms had windows opening on it. As in Pompeian houses, here again the garden was the most intimate part of the home, well hidden from outsiders' eyes. In this house, however, the chief focus was not the garden but the terrace with its panorama of sea and sky, and all the rooms were oriented in relation to it, just as in a villa urbana. Indeed, such elements as the solarium, viridaria, and pergula, and even the large garden triclinium were characteristic of villa architecture, not of the urban house, so that here those two quite disparate genres were fused within the relatively modest area of an insula.

A number of other houses were organized in much the same way, among them the large House of the Relief of Telephus (plate 142:*XXV*), named after a piece of sculpture found there (plate 287) and remarkable for a most elegant hall decorated with marble paneling. So, too, the House of the Gem (plate 142:*XXVII*) where, according to a wall inscription, a certain Apollinaris, physician to Emperor Titus, once sojourned. Another example, this one to the west of the House of the Deer, was the House of the Mosaic Atrium (plate 142:*XXV*), which is notable for its fine specimen of inlaid flooring (plate 164). All of these houses made use of the high bastion of the walls for their terraces. For the traveler approaching Herculaneum from the sea, it must have been an unforgettable experience to observe, as his ship drew closer, the lovely pavilions, large garden rooms, and the occasional two-storied belvedere loggias of these wealthy homes looming above the steep city walls. Certainly the most original and most elegantly impressive traits of domestic architecture in Herculaneum were to be found in these houses high above the sea front.

Elsewhere in the city the houses were of fairly modest dimensions. So far not a single palace-like complex such as the House of the Faun in Pompeii has been turned up there. The terrain was too limited to accommodate houses using the ideal schema of the Italic-Hellenistic domus so frequent in Pompeii (plates 77, 78). Sometimes there was not even an atrium into which to usher visitors, its function being taken over by a simple inner court. If there was a peristyle it was usually fairly small, and large gardens were the exception. Yet even smaller houses were often decorated and furnished in the finest style. Despite its modest dimensions the House with the Large Portal (plate 142:*XLVI*) possesses an imposing aedicule-like brick portal with figured capitals crowning engaged half columns (plate 171), and despite the fact that its rooms surrounded an almost diminutive court, they had marble floors and delightfully delicate Fourth-Style paintings (plate 162). The owner of the House of the Mosaic of Neptune and Amphitrite (plate 142:*XLIII*) had no garden at all, but

behind the tablinum he arranged an unroofed summer triclinium refreshed by sea breezes and beautifully decorated with figurative mosaics (plate 163).

Many more examples could be adduced. With less space available, Herculaneum was forced to seek more progressive solutions than Pompeii. Ground space was at a premium, and the only possibility was to build higher. Upper stories are, in fact, a very prominent feature there. Small as it is, the House with the Latticework Masonry (plate 142:XXXVI)— its walls were built of a plastered-over latticework frame—provided for two entirely separate dwellings, one on the ground floor, the other on an upper story reached by its own independent staircase (plate 167). There the builder virtually left behind the traditional plan of the *domus*, the typical Pompeian one-family house, and devised something well along the way to the urban multi-storied apartment buildings characteristic of a town like Ostia. Had the eruption of Vesuvius not brought such an early end to their development, Pompeii and Herculaneum likewise might have gone on to something like these multi-family residences. The House with the Latticework Masonry was by no means an isolated case, and almost all the examples of two-story, two-family houses belong to the time after the earthquake when, as in Pompeii, individuals and community alike made the most strenuous efforts to heal the wounds of their city and homes.

In both cities, however, some evidence of the Hellenistic era lived on, though in relation to the excavated area far less often in Herculaneum than in Pompeii. If this should prove true of Herculaneum as a whole, then it would be difficult to ascribe the relative scarcity to the changes undergone after the year 62. This means that, even before then, most of the Samnite houses must have fallen victim to some energetic building campaign launched in Imperial times.

The most impressive of such older houses to have survived destruction by either man or nature is the so-called Samnite House in the southwest corner of insula V, at the intersection of Cardo IV and Decumanus Inferior (plate 142:XL). Approaching its entrance fronting on Cardo IV, one senses the quiet distinction of the house as a whole even in its imposing portal. After passing through the fauces, whose walls still have their old painted decoration in the Hellenistic First Style, the visitor enters one of the largest atria in Herculaneum (plate 170). Although the lower zone of its walls was repainted in the newer style after the earthquake, the chamber preserved its old character. It retained its false gallery on the upper story with half columns and grilles which duly reproduce, flat against a solid wall, the appearance of the east side of the atrium where there is a real open loggia, with space between the wall and the real grilles, which affords additional light to the court below. In marked contrast to the generous dimensions of the atrium, the rest of the house is surprisingly small, with few and not very large rooms on the ground floor. What is most unusual is the lack of a garden court, which one would have thought indispensable in a dwelling of this rank. On the other hand, the upper story accommodates an entire separate apartment served by its own entrance from the street and, presumably, rented out. This latter fact strongly suggests that political or economic reversals were responsible for such a drastic change in what was once a wealthy house whose floor area must have been greater and may even have extended onto the lot subsequently built over with the House with the Large Portal.

When it came to decorating the walls and floors of their houses, the citizens of Herculaneum kept step with changing fashions. If there are no large figured mosaic emblems, it may be for the same reason that there is virtually no First-Style decoration of any sort in Herculaneum, most of

such pavements in Pompeii belonging to that style. On the other hand, there are many excellent floors in *opus sectile*, in which fine colored marble is inlaid in geometrical patterns. Something like the large triclinium in the House of the Deer shows virtually the entire gamut of the much-prized fine stone and marble in use at the time. All of the opus sectile floors belong to the late period of Herculaneum, where their style and medium seem to have been much more appreciated than in Pompeii.

In quality the wall painting of Herculaneum is certainly a match for that of Pompeii. Unfortunately, much of it was hacked off the walls by the Bourbon excavators and carted off to the royal museum, so that now it is often very difficult to say to what wall of what house a particular painting belonged. For an idea of how the paintings were originally disposed one must look at the houses excavated under the direction of Maiuri himself, who saw to it that everything was left just as it was found. While all four styles of Pompeian painting were practiced in Herculaneum, some of the workshops active there were quite differently oriented from those of the larger city and seem not to have exerted any influence elsewhere. This is especially true of the Fourth Style, which is particularly well represented there by the blue room in the House with the Large Portal (plate 162).

However, what makes the excavations at Herculaneum especially valuable is the fact that much of the wooden furniture there has survived in fairly good condition. This is not so in Pompeii where, with the rarest of exceptions, there is nothing to go by other than occasional impressions left in the hardened lava like a sculptor's plaster casts. The cupboards, tables, beds, and shrines of the Lares (plate 165) that make the houses of Herculaneum so vivid are almost our only clue to what household furnishings in the neighboring city must have been like. Of special interest is the evidence that survives of the use of wood in construction and interior architecture, a prime example of which is the folding door that served to close off the tablinum from the atrium in what has been called the House of the Wooden Partition.

Limited as the excavated part of Herculaneum may prove to be, there is already enough to reveal the unique quality of the city and, conversely, to make us realize more vividly those traits which are truly peculiar to its companion in disaster, Pompeii. Only with this double source can we genuinely appreciate the great wealth of possibilities that the art and architecture of Campania offered around the dawn of our era.

The Villa of the Papyri

The most significant and valuable ensemble as yet brought to light in Herculaneum is undoubtedly an imposing villa situated northwest of the city in a commanding position on a spur of Mount Vesuvius with a splendid view over the bay. It owes both its fame and its name to the treasure of papyrus manuscripts found in its library. So numerous are these manuscripts that generations of restorers and scholars have devoted themselves to preserving and deciphering them in what seems to be an endless task. But another and equally legitimate claim to renown is the sculptured decoration of this wealthy country house, thanks to which the Museo Nazionale in Naples can be said to possess the most important collection of antique bronzes in the world.

Unfortunately the villa itself is no longer accessible. As early as 1765 the excavation tunnels had to be closed down because of the poisonous gases rising in them. The ruin, which probably lies at least in part below

the ground water level, has returned to its long sleep under the almost impenetrable petrified slime that Vesuvius poured over it on that fatal day. Archaeologists continue to dream, in vain perhaps, that some day it can be laid bare and reawakened to life.

It was in June of 1750, two years after the Bourbons had extended their excavations to Pompeii as well, that the investigation of the villa was initiated. Although the work was under the supervision of Colonel Alcubierre, happily for posterity its actual execution was entrusted to the Swiss engineer Karl Weber, who bore the rank of major. Whatever we know about this great villa we owe to Weber. It was he who drew up a plan defining the general disposition and organization of the villa, at least as far as he was able to ascertain them, and to it he added invaluable detailed explanations (plate 172). However, the credit for first correctly evaluating and interpreting the ground plan that Weber arrived at in his underground explorations goes to a sumptuous book, *La villa ercolanese dei Pisoni, i suoi monumenti e la sua biblioteca*, published in 1883 by two Italian scholars, Domenico Comparetti and Giulio de Petra. Their study is especially important because they attempted to identify, on the basis of often insufficiently precise documents of the original excavators, just where the various statues that had been removed from the villa were first discovered. Thanks to their research, the Villa of the Papyri—forever buried as it may be—remains the basic source of information about the furnishing and decoration of Roman villas, there still being nothing comparable from which one can read so clearly the exact disposition of the sculptural decoration.

The wealth of the villa is evidenced from the outset by its dimensions, which greatly exceed those of the largest villae urbanae in Pompeii, the Villa of the Mysteries and that of Diomedes. The front facing the sea is no less than 820 feet in width: almost the total length from north to south of what has been excavated of the entire city so far. However, its exceptional dimensions are due primarily to the outbuildings and annexes northwest of the actual living quarters. These quarters correspond more or less faithfully to the general plan of the suburban villa as laid out in Pompeii.

Even if the northeast portion was not sufficiently excavated under the Bourbons to reveal all its secrets, enough was done to make the essential nucleus of the villa perfectly comprehensible. Thus, as was usual with villas, one first went through an inner peristyle, a court with ten columns on each side and with a long but very narrow marble basin running down its center which marked the axis leading through the Tuscan atrium to the tablinum. The latter term should really be placed between quotation marks, since what was a main room for formal occasions in the Italic house is here reduced to little more than a passageway to a portico running around three sides of the southeast block of the villa and affording a fine view of the bay. This observation terrace gave access to a number of rooms which would seem to have their backs to the atrium, if we can trust the plan of Weber entirely in this detail.

So far the Villa of the Papyri is not much different from the Villa of the Mysteries in Pompeii. But when one went through the large room whose opening on the center of the northwest side of the inner peristyle was marked by two columns, one stood in the main axis of a colossal colonnade measuring 328 by 121½ feet—some 72 feet longer than the large palaestra in Herculaneum! The pool down the center (*euripus*) is 216 feet long and 23 feet wide and was understandably likened by Maiuri to one of the huge swimming pools in the Imperial thermae of Rome itself. According to the plan, this monumental garden framed by columns

appears to have been closed off by a wall on the southwest side, the side toward the sea, so that from the rooms along that side of the portico one enjoyed only the man-made beauty of the garden and its elaborate decoration but not the superb panorama which we today, with our passion for "picture windows," would think it only natural to take as the main focus of interest.

From the southwest side of this large peristyle a covered walk paralleled it and then led off toward the northwest. Its end was not clearly defined in Weber's excavations, but it probably combined with the portico of the garden to make a single *ambulatio*, a place to stroll and enjoy cool shade or the warmth of the sun, according to the season and the hour of the day. From the northwest narrow side of the large peristyle a terrace about eighty-seven feet in length led to an observation tower, a belvedere. In this tract the villa is much more like the Imperial villas on Capri than the more countrified suburban villas in Pompeii. The Villa of Damecuta on the northwest point of Capri also rose high above the sea and possessed just such a long terrace linking the two parts of a sumptuous ensemble.

Quite naturally one wonders if the entire elaborate building in the final state in which the eruption caught it was erected all at the same time. Thinking back to the many alterations that the Villa of the Mysteries endured in the course of time, this seems decidedly unlikely, the more so since the closed nucleus centering around the atrium and small peristyle here are rather like what is found in the Pompeian villa. It can be assumed that the huge garden opening off the house at a right angle as well as the terrace linking it with the belvedere must have been later additions. But none of this can go beyond mere speculation, since all investigation of when and how the villa was built is inexorably blocked. We cannot even consider if and how it withstood the earthquake which did so much damage in the nearby town. All we have is a clue here and there: the reports of the eighteenth-century digging operations speak of floors in inlaid marble which, in analogy to those in the houses of Herculaneum, must have been laid down in the very last period at the earliest, that is, in Neronian-Flavian times.

The charred papyri (plate 173) were found either lying on wooden bookshelves or on the floor, and they immediately became objects of excited interest. Never before had such an extensive library of ancient texts been discovered: the complete catalogue of the fragments, as published by Emidio Martini in the volume mentioned above, ran to 1,806, though among them were many small pieces which the cataloguer merely labeled "*insignificanti*." Great expectations were aroused by the find, and it was hoped that there might perhaps even be unknown literary treasures. But from the start the difficulties involved in unrolling the scrolls were grievously underestimated. At first it appeared that the overwhelming majority of the papyri consisted of the works of Philodemus of Gadara in Palestine, an Epicurean philosopher active about the middle of the first century A.D. who, if not a great creative thinker in the judgment of a modern authority like Philippson, was nevertheless one of the outstanding figures in the dissemination of the teachings of Epicurus in Italy and must have had considerable influence on Virgil and his circle, on Horace above all, and quite obviously on Cicero.

Much seemed to suggest that this was the personal library of Philodemus himself. Besides his works, those of Epicurus and his followers were represented, and some of the writings of Philodemus were present in several copies, so that it was thought that among them there must be certain manuscripts at least from his own hand. But it is difficult to imagine him the owner of such a grandiose villa. The fact is that in his oration

143 EQUESTRIAN STATUE OF MARCUS NONIUS BALBUS.
Marble, height 8' 4 3/4". Museo Nazionale, Naples. Some
scholars think that this impressive statue came from the
Theater, others say it was placed at the entrance to the so-
called Basilica, which would fit nicely with the decree
which speaks of "the busiest place in the city." The in-
scription tells us that Marcus Nonius Balbus is portrayed
here in armor and general's mantle astride a horse which,
in accord with the standard scheme of Roman equestrian
statues, lifts a foreleg. The head of Balbus is a modern
copy made by the sculptor Angelo Brunelli (1740–1806)
after the original was destroyed in 1799 by a cannon ball
fired by the revolutionaries attacking the royal villa and
museum in Portici.

Following page:
144 DECUMANUS MAXIMUS, *looking toward the west.*
Because this major artery is about forty feet wide, it has
often been thought to be a fairly narrow plaza rather than
a road, and, in fact, nothing less than the Forum of
Herculaneum. A certain number of facts seem to bear
this out: it was barred to vehicles, and there was a colon-
nade along the north side, though the south side was
merely lined with private homes and tabernae. The well
in the left middle ground here marks the point where one
of the principal north-south streets, that is, Cardo IV, met
the Decumanus Maximus. In the background, an arch
with openings on all four sides fills almost the entire width
of the street and forms a monumental entrance to the
building known as the Basilica. Behind it, in the south-
west corner, is the Collegium of the Augustales (see plate
161).

◁ 145 L. Mammius Maximus, *from the Theater, Herculaneum. Bronze, height 7′ 4 5/8″. Museo Nazionale, Naples.* The inscription identifies the subject as a member of the sodality devoted to the cult of the emperor Augustus, the *Augustales,* and the statue was set up in the theater in late Claudian-Neronian times, thus not long before the earthquake. Excellently preserved, the work tends to a decorativeness which marks it as somewhat provincial.

146 Marcus Nonius Balbus the Elder, *presumably from the Theater, Herculaneum. Marble, height 6′ 9 1/2″. Museo Nazionale, Naples.* The inscription reads: *M(arco) Nonio M(arci) f(ilio) Balbo | patri | d(ecreto) d(ecurionum),* meaning that the statue of the father was erected by decree of the decurions to honor the son, a man who was praetor and proconsul and one of the most distinguished citizens of Herculaneum (see p. 122). The type of toga worn places the statue in the reign of Claudius. Despite the punctiliousness of the work, the general effect, especially in the portrait head, is rather dry.

147 Emperor Claudius. *Bronze, height 7′ 10 1/2″. Museo Nazionale, Naples.* Presumably this was a companion piece to a bronze statue of the same height portraying Augustus, which was found in the Basilica. It must be admitted that the over-lifesize, full-length figure, whose arms and legs had to be reconstructed from several pieces and whose forehead and left hand are modern restorations, is no masterwork in either head or body. Claudius is depicted in heroic nudity, facing the viewer squarely, almost like an architectural facade. The inscription connected with the statue gives the full title the emperor bore in A.D. 48 or 49, thereby providing a relatively sure date of execution.

148 Statue of a Woman, *presumably from the Theater, Herculaneum. Marble, height 5′ 7 3/8″. Museo Nazionale, Naples.* Statues of the family of Marcus Nonius Balbus were erected by public order in both the Theater and the Basilica (see plate 146 and p. 122). One of these cycles of statues, undoubtedly the earliest, included this beautifully preserved portrait of a girl. Only a part of the right hand required restoring, and there are still abundant traces of red paint. Executed with painstaking care, the figure goes back to a classical sculptural type of the second half of the fourth century B.C. from the circle of Praxiteles, though the way the hair is dressed places the delicate maidenly head unquestionably in the years around A.D. 40. The statue is presumed to portray a daughter of Marcus Nonius Balbus.

146

147

148

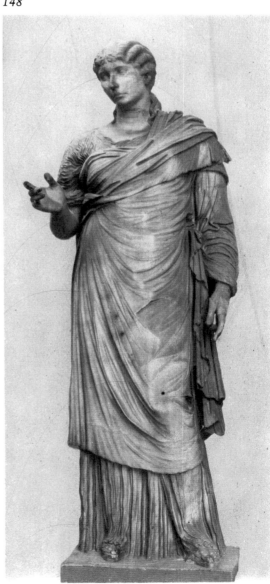

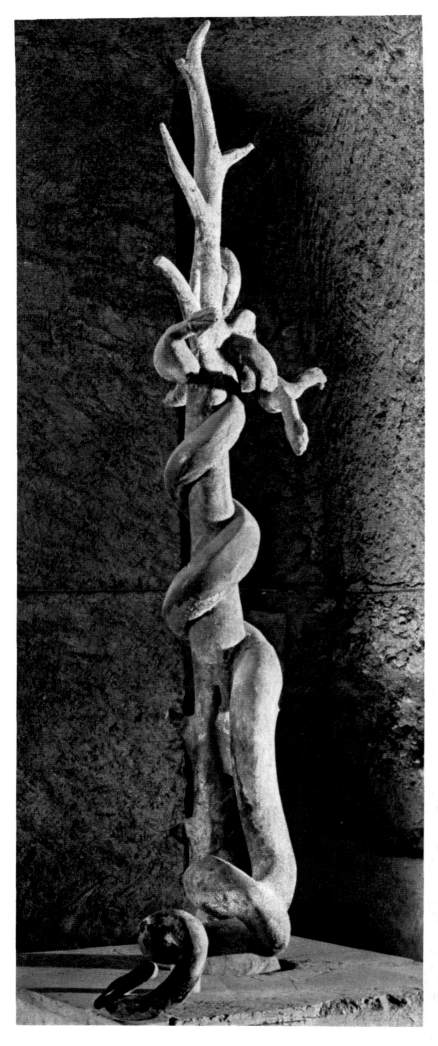

149 SERPENT FOUNTAIN. *Palaestra.* The ornamental sculpture on the fountain in the center of the cross-shaped piscina—a five-headed serpent coiled around a tree trunk—must have made a splendid effect before the golden gleam of its bronze was lost to the patina of time and the water spurting in five different directions from its five mouths was forever stilled.

150, 151 TWO EXCAVATION TUNNELS IN THE PALAESTRA. Only the west half of the palaestra has been excavated, and the large piscina has not been entirely laid bare. The dimensions of the pool have nevertheless been ascertained through the tunnels that Weber and La Vega dug through the hard rock in the eighteenth century and which, accessible still, give a vivid idea of the effort expended in the past on unearthing the buried city. Plate 151 shows how the tunnel followed the wall of the piscina.

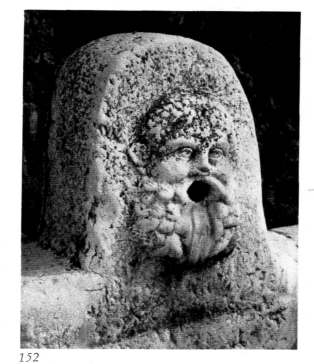

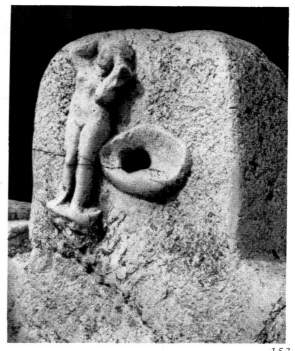

152

153

152, 153 FOUNTAINS ON THE DECUMANUS MAXIMUS. The limestone fountain with the bearded head stands approximately at the point from which plate 144 was photographed. In that same illustration this other fountain (plate 153), decorated with a nude Venus of the Anadyomene type (compare plate 209), can be seen in the left middle ground, where Cardo IV runs into the Decumanus Maximus.

154 VESTIBULUM, *Suburban Thermae.* The broadly open arcades support an opening in the roof through which the courtyard is amply supplied with daylight. At the edge of the impluvium stands a herm whose head is modeled after a late classical Apollo and in whose shaft there is an outlet (plainly visible here) for the water which splashed down into the marble basin in front of it.

154

155 Caldarium in the women's section, *Thermae.* The caldarium and the apodyterium (plate 156) have the same type of stuccoed barrel vaulting. The heated tub is set up on low steps and stretches across the entire back wall. Two marble benches on lion's feet run along the side walls. Like the dressing room in the next plate, the caldarium was lighted through a window in the upper part of the narrow wall on the south side.

156 Apodyterium in the women's section, *Thermae.* As was frequent in these bathhouses, the ceiling was undecorated except for simple stucco grooving. The shelf halfway up the walls is divided into compartments serving as clothes lockers. In contrast to the unadorned ceiling, the floor has a splendid black-and-white mosaic of a triton with an oar over his shoulder surrounded by sea creatures.

Following pages:
157 View over Herculaneum, *from the east.* This photograph is a vivid demonstration of the depth to which Herculaneum was buried. Approaching it today, one looks down on the houses, and even at the lowest point of

the terrain of the modern town—the fields at the upper left—the level is still appreciably higher than the rooftops of the ancient city. The house front farthest left marks the south end of the city, where the most lavish and largest dwellings were built on the high bastion above the former walls. In the foreground is the House of the Relief of Telephus (plate 142:*XXVIII*) whose peristyle zone is oriented differently from the rest of the house, which is aligned with the city street and insula. Behind it is the House of the Gem (plate 142:*XXVII*), and beyond the sloping roof at the left can be made out the small garden pavilion of the House of the Deer (plates 142:*XXVI*, 158): the palm trees to the right of it mark the position of the garden, the long wall in front of them faces on Cardo V. Beyond the House of the Deer is the House of the Mosaic Atrium (plate 142: *XXV*), with the large, high block of its garden room.

158 House of the Deer, *viewed from the south.* In ancient times the view we now have of the House of the Deer would not have been possible. Its south front lies over the city wall which, under the Romans, was no longer needed as fortification and so was left open for building. A low balustrade on a steep projection of the

wall marks the edge of the unroofed terrace *solarium,* from which there is a magnificent view over the bay. Behind the solarium is an open pavilion (*pergula*), consisting of nothing but four strong pillars and a roof and floor and flanked to either side by small garden plots (*viridaria*). Behind it lies the large triclinium. At the right end, accessible from the right-hand viridarium, there is a day lounge (*cubiculum diurnum*), with a window facing south. At the left end is another room with a large window lying directly against the outside wall of the House of the Mosaic Atrium, which can be seen projecting at the left margin. What we now can only imagine is the two-storied front rising above the garden pavilion.

159 The Centaur Chiron and the Young Achilles, *from the Basilica. Wall painting transferred to panel, 46 1/2 × 48 7/8". Museo Nazionale, Naples.* The painting of the devoted centaur teaching the boy Achilles to play the lyre is the finest reworking known of a statue group which Pliny says stood in the Saepta Julia in Rome and was created by an outstanding Greek sculptor (*Naturalis Historia* xxxvi. 29). The herculean figures render in masterful fashion the full-bodied, powerful forms that must have characterized the original sculpture. All in all, this is one of the most beautiful of all Fourth-Style paintings.

160 The Finding of Telephus, *from the Basilica. Wall painting transferred to panel, 67 3/8 × 47 1/4". Museo Nazionale, Naples.* The scene shows Hercules recognizing in the infant Telephus (the future founder of Pergamum) his own son begot by Auge (see plate 262) and abandoned on a mountainside in Arcadia, where the child was suckled by a doe. The imposing female personifies Arcadia, and behind her is a young satyr with panpipes and shepherd's staff. The winged female above Hercules is difficult to identify, but the lion and eagle probably symbolize Pergamum itself, where no doubt the prototype of the picture originated.

161 Collegium of the Augustales. In this hall in the headquarters of the Imperial cult (plate 142: *IX*), note the striking contrast between the alcove with its lavish painted decoration in the Fourth Style and the austere white walls with black dado elsewhere in the room. The picture on the left wall of the alcove depicts Hercules, Juno, and Minerva. The holes in the beams still contain carbonized remains of the original roof, which has been restored on the right, while the wall at the right margin is done with the half-timbering much used in Herculaneum.

162 Blue wall, *House with the Large Portal (v, 35).* Among the most beautiful paintings in this house (plate 142:*XLVI*) is this wall in a small lounging room (*diaeta*) opening on the inner court. Elaborate pavilion-like architectural structures in the Fourth Style emerge strikingly in grisaille against the gleaming, uniform blue of the wall, interrupted only by a strongly contrasting horizontal strip on which painted white curtains hang behind a varicolored and diversified decoration of vines and masks on flower stems. The center of the strip (at the left margin here) is marked by a trophy with shield, and this in turn is framed on either side by a painted archlike structure seen from below and seemingly projecting far to the fore.

155

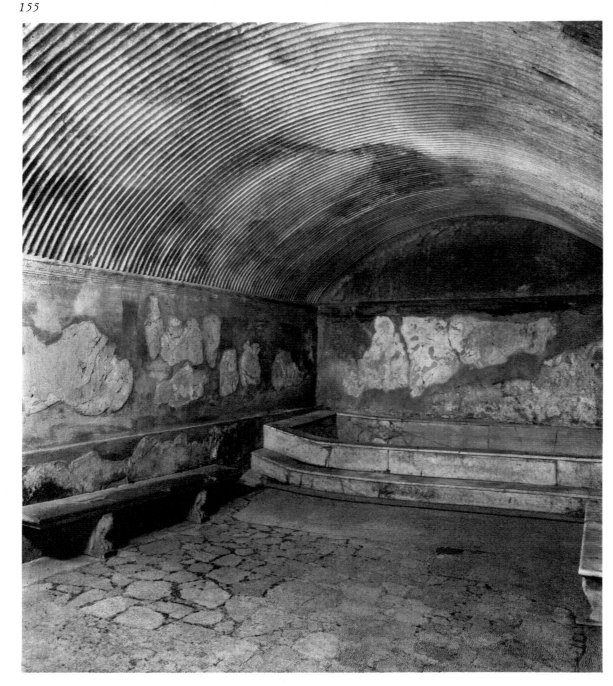

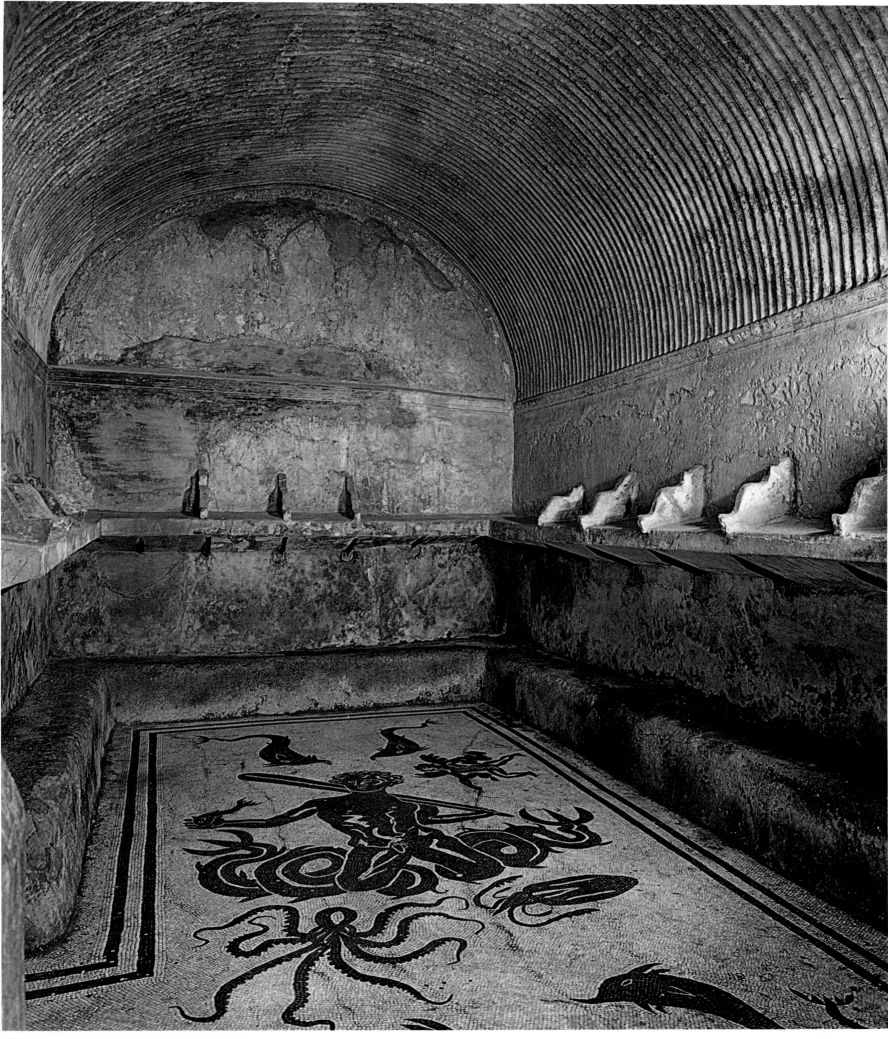

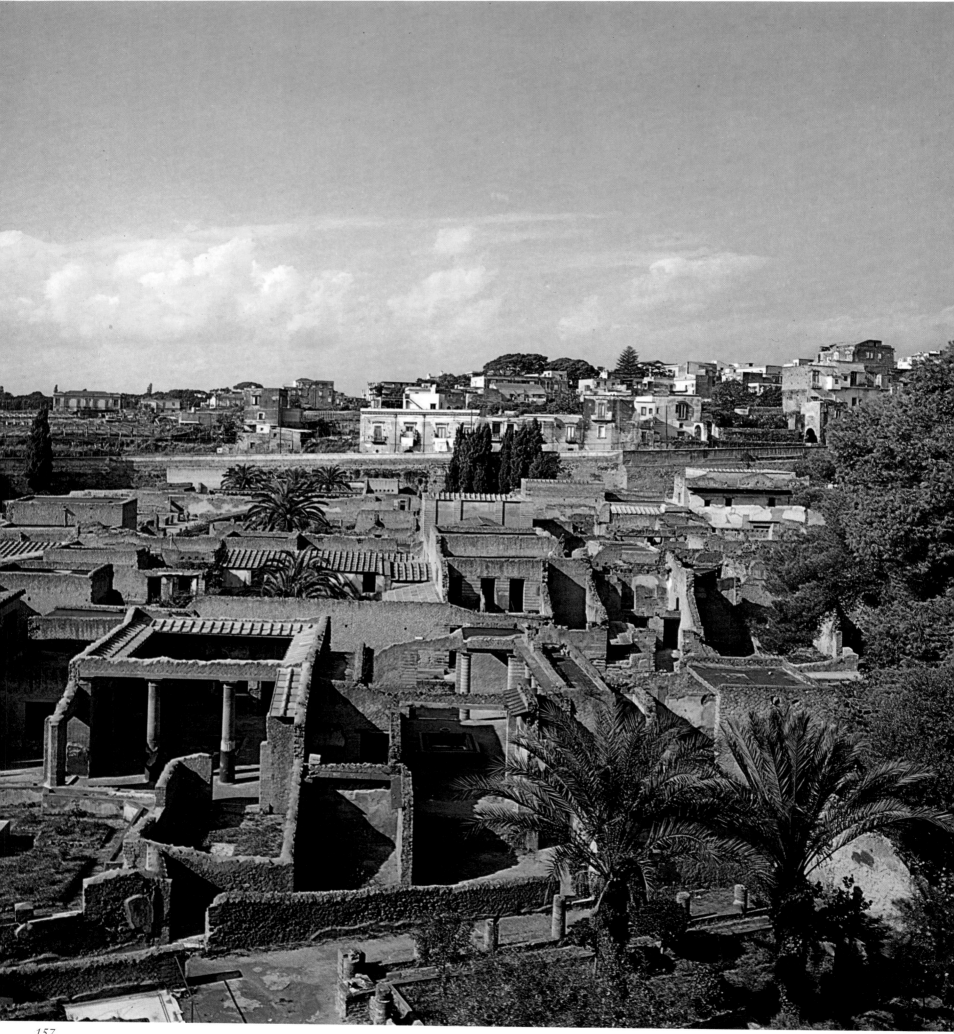

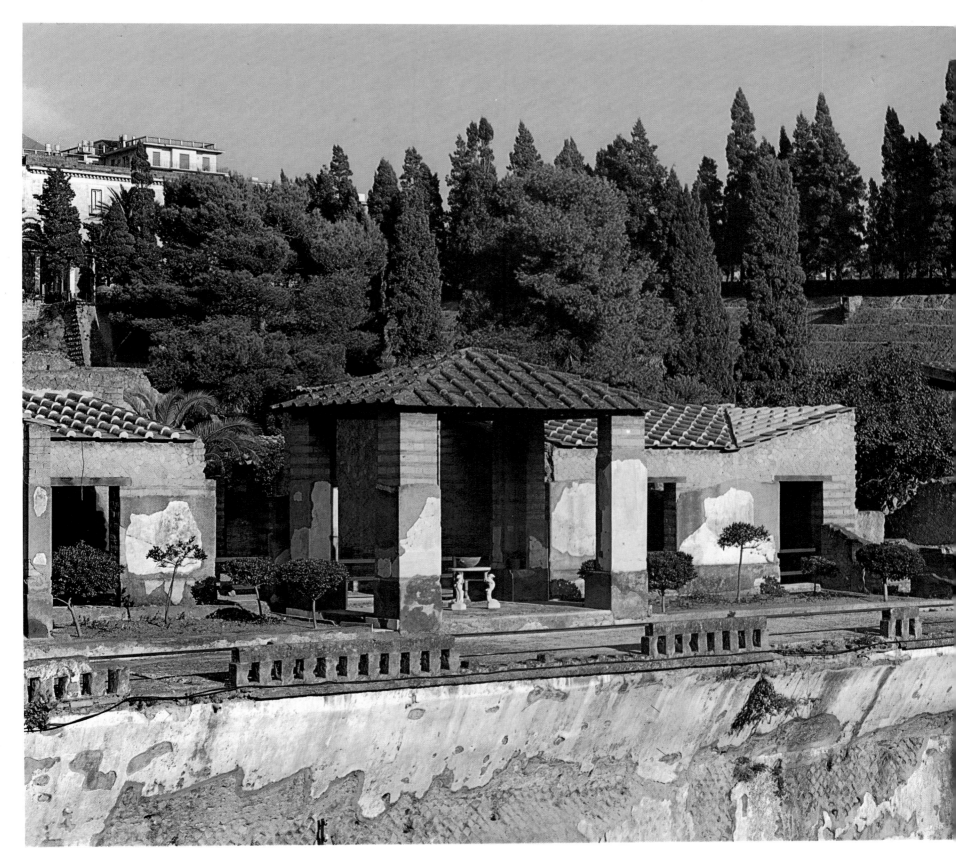

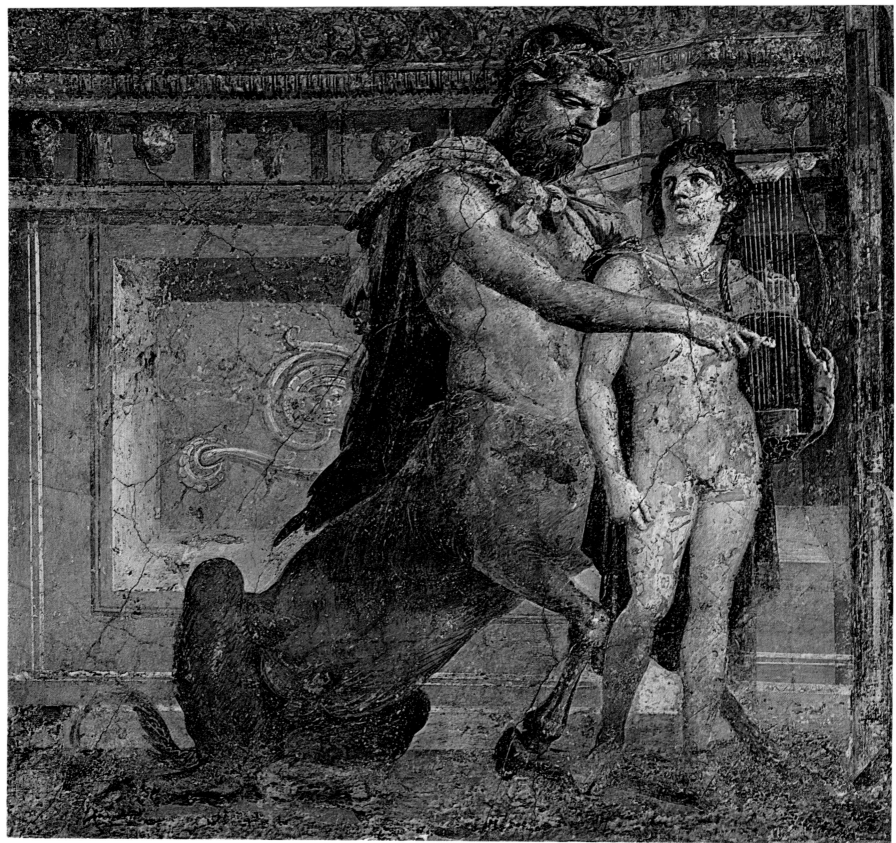

159

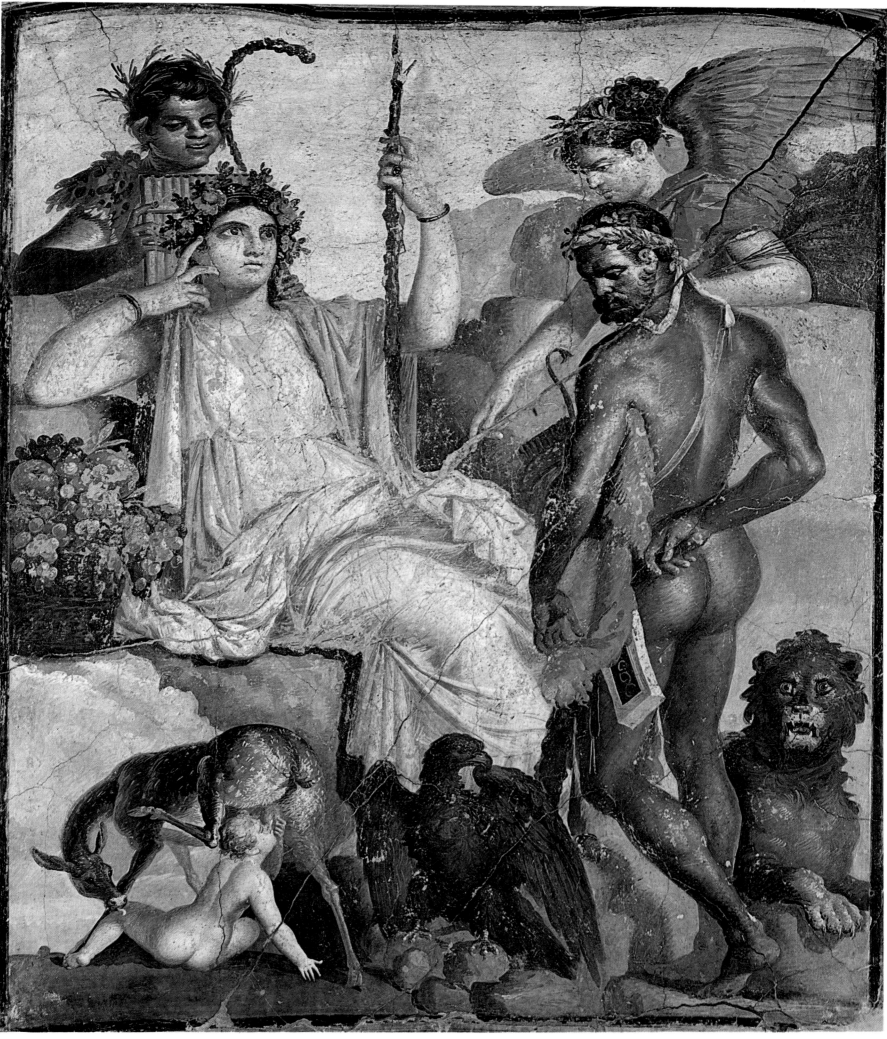

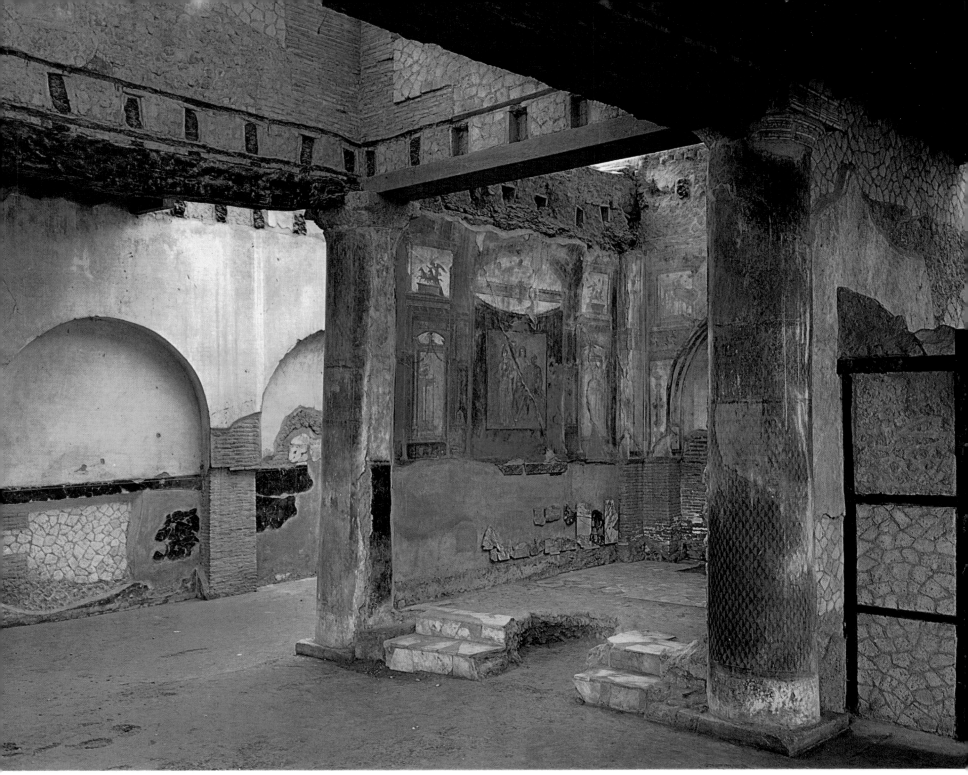

161

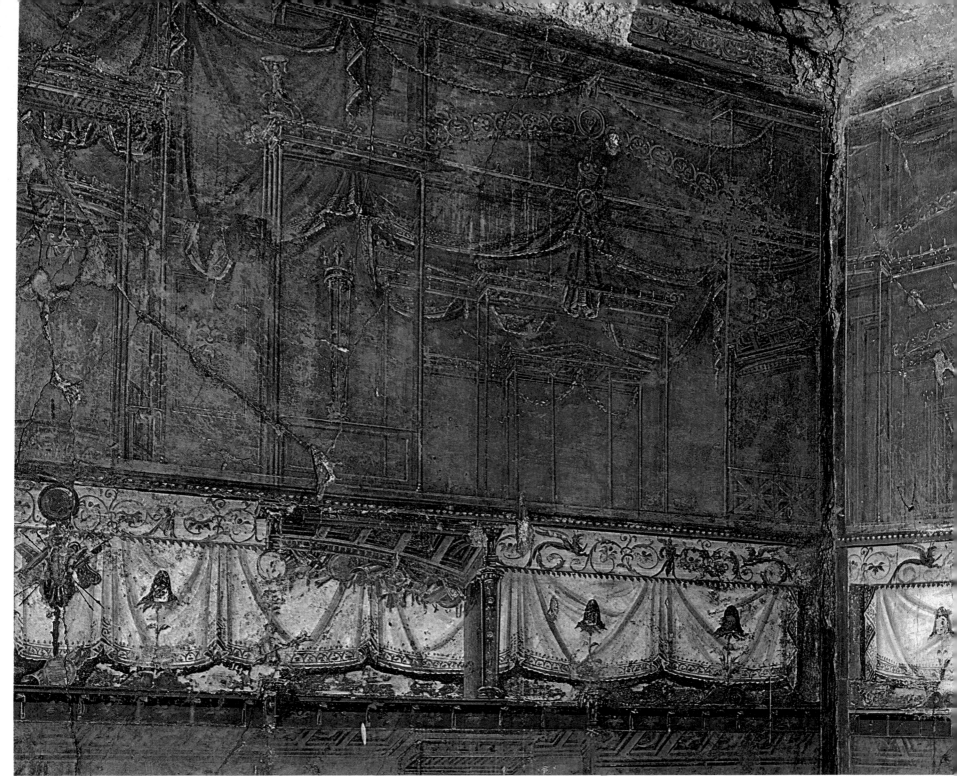

162

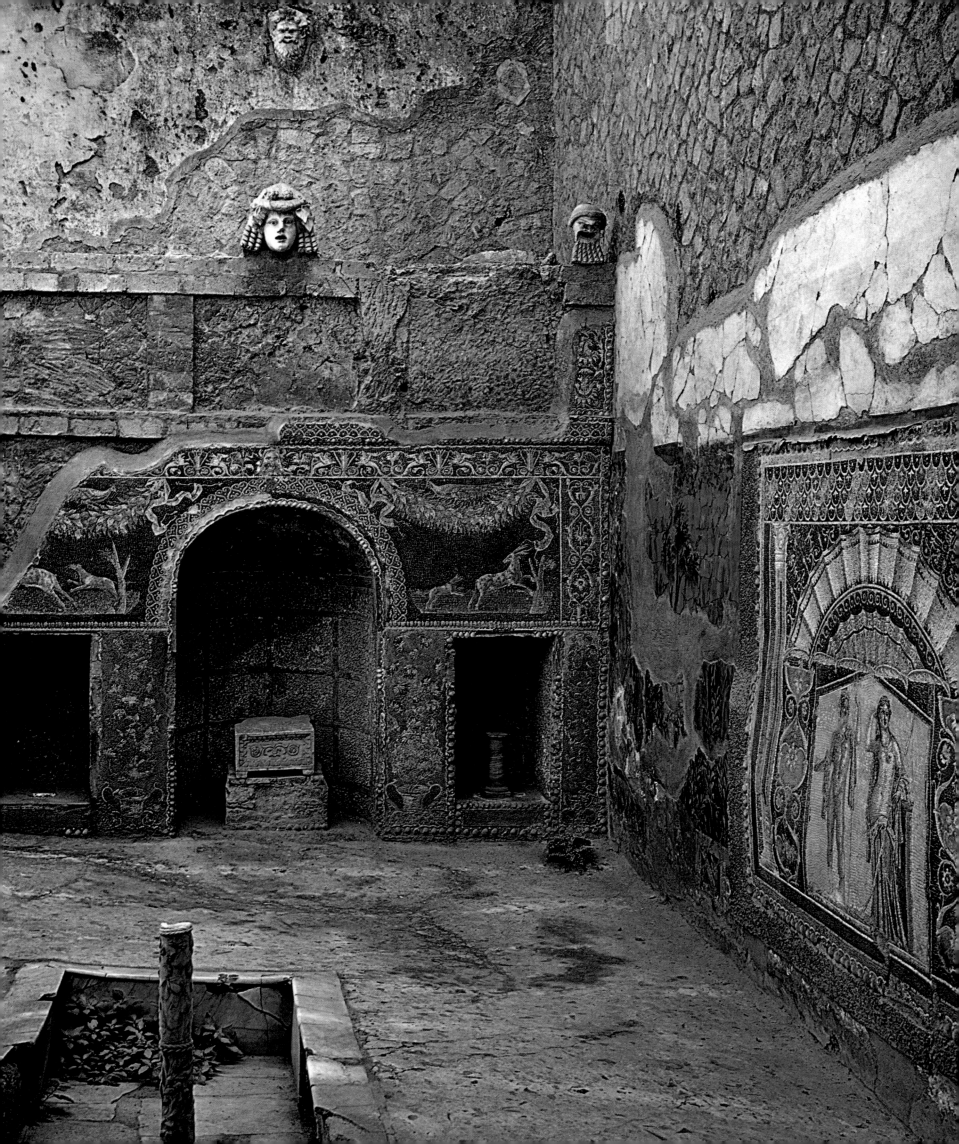

163 SUMMER TRICLINIUM, *House of the Mosaic of Neptune and Amphitrite* (v, 6–7). *Height to the level of the masks, 8' 10 1/4".* The small court of this house (plate 142: *XLIII*) was arranged to be both triclinium and nymphaeum. In the middle of the long wall at the right is a large mosaic with figures of Neptune and Amphitrite framed by highly ornate columns and surmounted by a shell, as if in a niche. Apparently the last owner of the house had this mosaic set into the wall, which originally was decorated with a painted garden landscape, vestiges of which remain at the sides. The rear wall was faced with mosaic to resemble the facade of a nymphaeum with three niches. Hunting scenes extend to either side of the crown of the central niche, and marble masks peer out of the upper wall. Sunken into the floor in the foreground,

marble-faced dining couches surround a small fountain which must have brought a breath of freshness to the company on hot nights.

164 ATRIUM FLOOR, *House of the Mosaic Atrium* (IV, 2). The house faces the sea front (plate 142: *XXV*) and takes its name from the splendid mosaic which has remained largely intact, though the ground beneath it is now anything but level, being first disrupted by the violent earth tremors accompanying the eruption of Vesuvius, then by the great weight of the mass under which it was buried for so long. Exceptionally, the marble-faced impluvium was not set rigorously in the middle of the room and aligned on the main axis. Since the mosaic itself with its checkerboard pattern did obey that rule, the mosaicist had to

make the necessary adjustment and so introduced a vine-tendril border, which noticeably decreases in width from right to left.

Following page:

165 WOODEN LARARIUM. *Living quarters over a tavern on Decumanus Maximus* (v, 17). Within the ensemble of buildings making up the so-called House of the Bicentenary, there was some sort of tavern (plate 142: *LII*) separated from the large dwelling by a wall. Its upper story had living quarters whose wooden shrine to the Lares has wonderfully survived the centuries. It takes the form of a small aedicule with two carved columns and a door much like the portal of any real house, and undoubtedly it held bronze statuettes of the household genius and Lares.

164

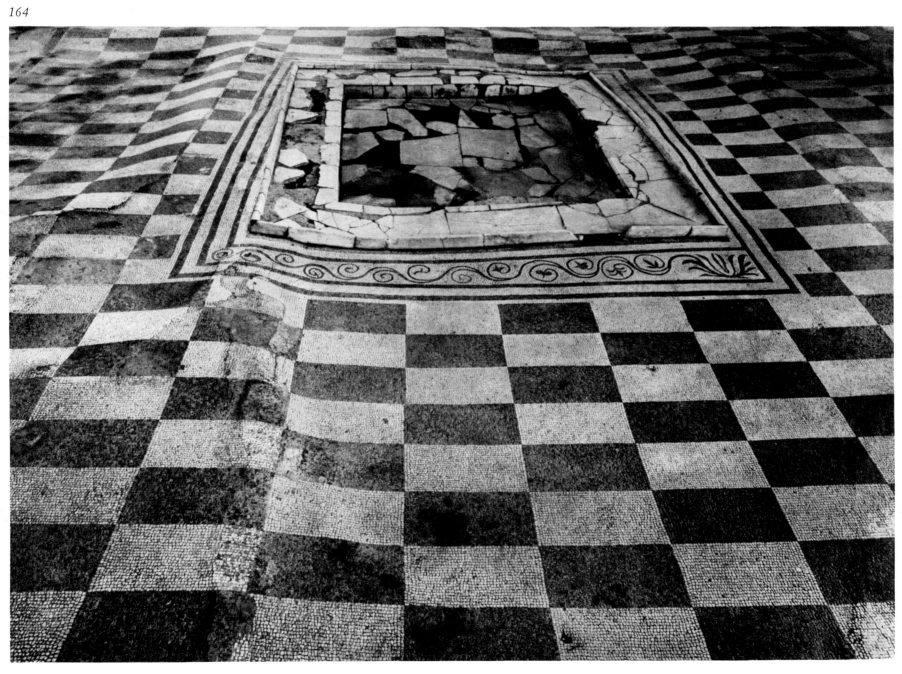

165

166

altar flanked by cornucopia and serpents and surmounted by two tiny figures of the Lares beneath a garland.

169 LEAD CISTA. *House of the Mosaic Atrium* (IV, 2) To the right of the fauces in this elegant house is a room which was undoubtedly once a cubiculum but, in the last years of the city, had been converted into a kitchen. Nothing of the kitchen equipment survives except this *cista*, a round container made of lead. Its relief decoration is laid out in horizontal zones alternating between geometric patterns and figurative medallions. Such lead vats and sarcophagi with relief decoration were more common in Asia Minor and Syria, and motifs like this lozenge pattern were native there.

170 ATRIUM, *Samnite House* (V, 1–2). The atrium in ▷ this house from the early years of Herculaneum (plate 142: *XL*) is viewed here from its northeast corner, looking across into the fauces, which is framed by two tall pilasters. The walls are treated in the First Style, and the atrium is still laid out in Hellenistic fashion with a blind gallery running around the upper wall, its engaged half columns echoing the full columns of the open loggia gallery on the east wall. Despite this, there are paintings on the walls that could only have been done after A.D. 62, and these make an odd contrast to the austere architecture and to the flooring in *opus signinum* (amalgamated, powdered red brick inlaid with white cubes of stone), which likewise goes back to the Hellenistic era. One other "modern" note: the impluvium was quite certainly not faced with marble until after the earthquake.

Following page:
171 ENTRANCE, *House with the Large Portal* (V, 35). The portal of this elegant small house (plate 142: *XLVI*) was built in molded bricks, though in ancient times they were not exposed as they are now. From vestiges of paint we know that the two half columns were stuccoed over and painted red. The travertine capitals each have a relief of a winged Victory on the front. Nothing like this portal, dating from after the earthquake, exists elsewhere in Herculaneum, and it has only a rare rival in Pompeii in something like the doorway of the Villa of Julia Felix, the fact being that in the Vesuvian cities such forms were generally reserved for tombs (compare plate 132).

166 LARARIUM. *House with the Carbonized Furniture* (V, 5). More wooden than stone or brick household shrines have been found so far in Herculaneum, even in the wealthy houses, though one of the handsomest in stucco is in a house on Cardo IV (plate 142: *XLII*), where a good deal of the wooden furnishings were found burnt, something more unusual in Herculaneum than in Pompeii. Set against the rear wall of the small garden behind the tablinum, the aedicule of the shrine sits on a semicircular podium, and its half-shell niche housing the venerated statuettes was quite obviously influenced by fountain architecture.

167 STREET FRONT, *House with the Latticework Masonry* (III, 13–15). The walls of the small, two-storied house on Cardo IV (plate 142: *XXXVI*) were constructed with the technique of *opus craticum* in which a latticework skeleton of wooden lathes or even wickerwork was filled in with mortar. Vitruvius (*De Architectura* ii. 8, 72) agreed that that technique was a great timesaver for the builder but counseled against it as a fire hazard. Brick columns set into the public sidewalk support an upstairs balcony and projecting loggia. The house is one of the most interesting in Herculaneum because of its radical rejection of the standard plan of the Pompeian domus: it has neither atrium nor peristyle but, on the other hand, provides for two entirely independent dwellings on separate floors.

168 PAINTED LARARIUM. *Upper story, House of the Bicentenary* (V, 15–16). On the upper floor of this wealthy house with its entrance on the Decumanus Maximus (plate 142: *LII*) there is, besides the modest dwelling above the tavern (see plate 165), another apartment reached by stairs from a room to the left of the fauces of the main house. On the rear wall of a room between two cubicula there is a painted lararium which, now that there is no floor (the charred remains of the wooden beams can still be seen in the holes in the wall), can be viewed from below. Painted in a brisk and dashing manner, it shows the

167

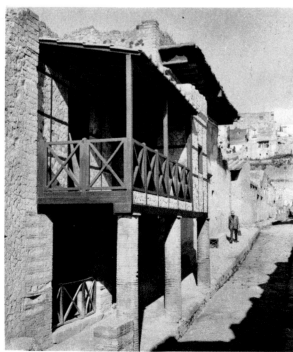

168

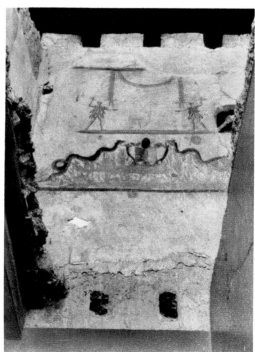

169

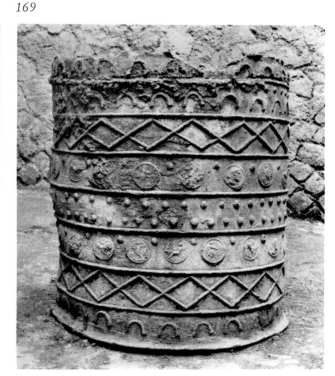

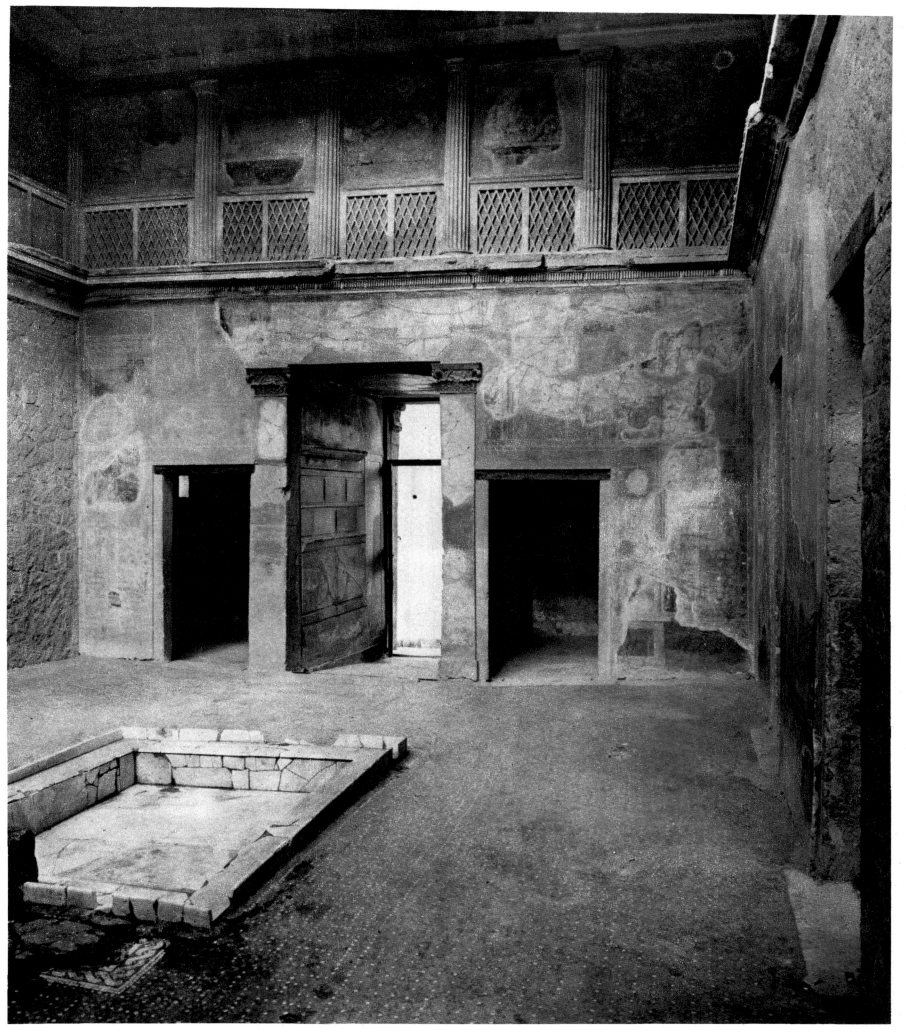

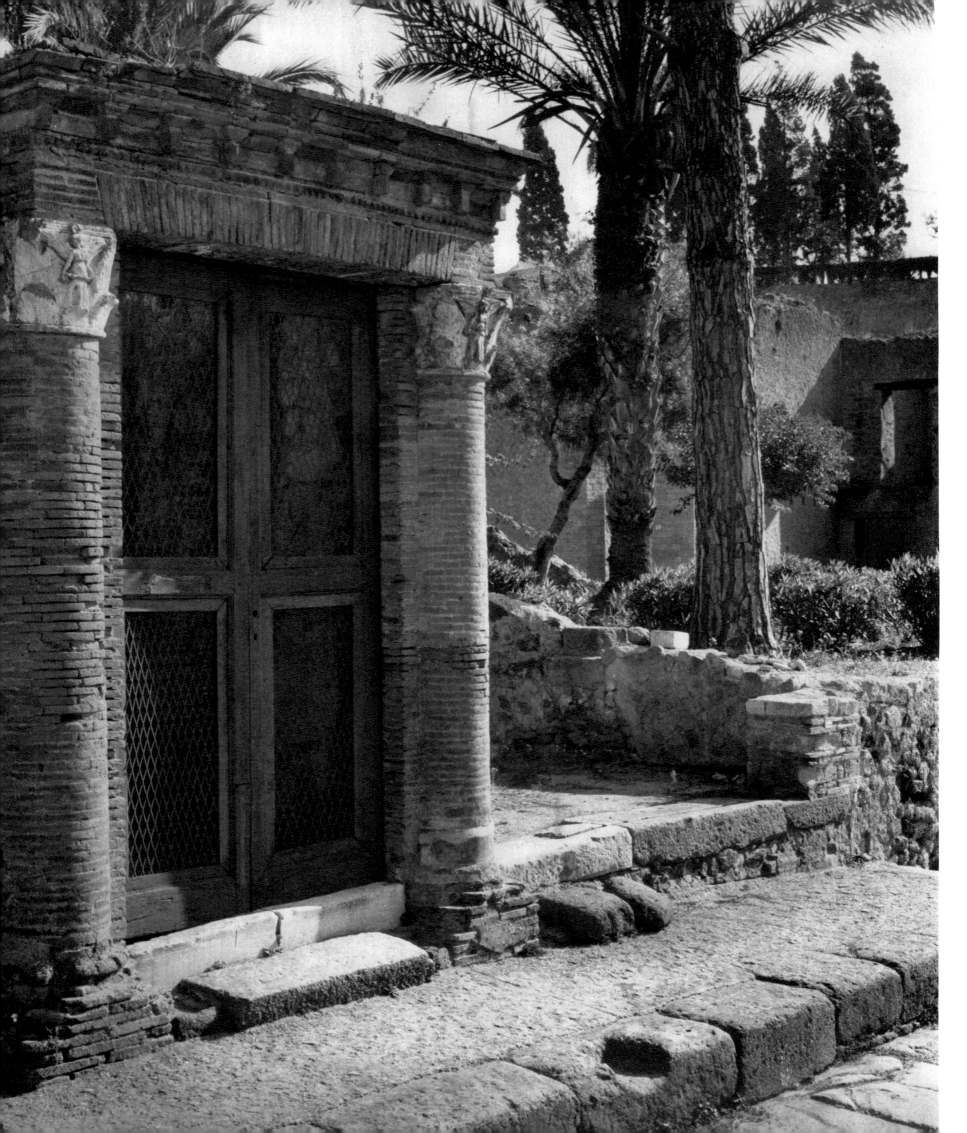

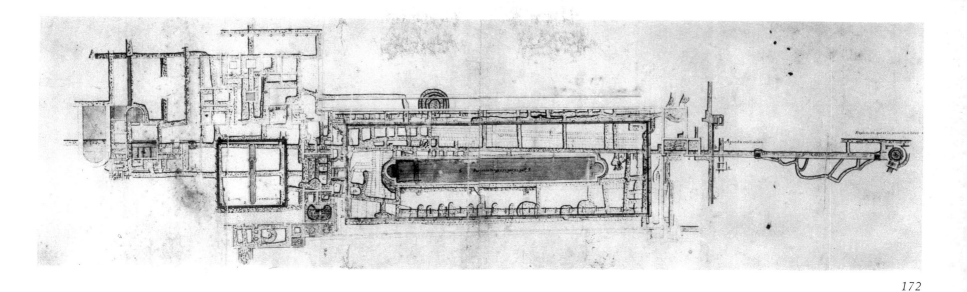

172 PLAN OF THE EXCAVATIONS, *Villa of the Papyri. Museo Nazionale, Naples.* Although unsigned, there is no doubt that the author of this plan was Karl Weber and that the marginal notes are his also. The explanatory text (*explicaciones*) written in Spanish runs from July 20, 1750, to the same day in 1754, but the drawing includes all the excavations that were carried through. The plan is oriented with the southwest to the top, and all the main parts of the villa can be plainly read. At the left are the living quarters around the atrium (at the top) and the small peristyle. Adjoining these is the large peristyle with a long euripus, and at the extreme right the round belvedere with a long entrance leading to it. The numbers and annotations written on the plan refer to the *explicaciones.*

173 PAPYRUS 1008, *from the Villa of the Papyri. Biblioteca Nazionale, Naples.* The fragment comprises columns xvi–xix of Book X of Περὶ χαχιων (*Concerning the Vices*) by Philodemus, a work in which the philosopher contrasts each vice with its respective virtue. Book X, of which unfortunately only twenty-four columns survive and then only with numerous lacunae as can be seen here, deals with Arrogance, and parts of other books of the same treatise were found in the library of the villa.

174 Bust of an Amazon, *from the Villa of the Papyri. Bronze, height 20 7/8". Museo Nazionale, Naples.* The bust was set up at the north corner of the small peristyle in the villa as a pendant to that of the *Doryphorus* (plate 177), both of them in the form of herms. For all their similarities in style, it is less likely that both came from the same workshop than that their respective authors deliberately strove to conform to the same style, that of Apollonius. The prototype itself is ascribed to no less than Phidias.

175 Head of a Youth, *from the Villa of the Papyri. Bronze, height 17 1/8". Museo Nazionale, Naples.* In all probability set on a herm base like the others, this head belonged to the series disposed in front of the southeast colonnade of the large peristyle. It represents a classicistic reworking of prototypes which were no longer Archaic but already part of the early Classical style. Similar hairdresses are found in sculpture from Aegina and especially from southern Italy and Sicily. It is difficult to say if the carefully conceived and executed head represents an athlete or a youthful god like Apollo. Like all these sculptures (plates 174–81) it belongs to the third quarter of the first century B.C.

176 Bust of Hercules, *from the Villa of the Papyri. Bronze, height 18 7/8". Museo Nazionale, Naples.* The head stood in the same row as that of the youth in plate 175. It is a free version of the so-called Landsdowne type of Hercules, going back to a statue by Scopas of Paros which was probably set up in the gymnasium at Sicyon (Pausanias, *Description of Greece* ii. 10, 1) and must have been done about 360 B.C. Despite its venerable ancestry, this head was obviously influenced also by Hellenistic portraits of statesmen.

177 Bust of the Doryphorus, *from the Villa of the Papyri. Bronze, height 21 1/4". Museo Nazionale, Naples.* The bust was displayed at the west corner of the small peristyle, and to judge by its straight-cut sides and squared-off front and back, it was another of the herms. Signed by Apollonius, son of Archias, from Athens, it is among the best copies of the *Doryphorus* by Polycleitus, a marble replica of which was found in the Samnite Palaestra in Pompeii (plate 67).

174

178 Bust of the so-called Pseudo-Seneca, *from the Villa of the Papyri. Bronze, height 13". Museo Nazionale, Naples.* The head was set up on the northwest end of the large peristyle and is the best replica of a portrait which for a long time was thought to be Seneca. While that identification is now abandoned, no other convincing suggestion has been made, although it does seem that the subject must have been a philosopher or poet. The often copied prototype came from the late third century B.C. and, no doubt, from one of the great centers of Hellenistic art, perhaps Alexandria itself.

Following page:
179 Resting Hermes, *from the Villa of the Papyri. Bronze, height 45 1/4". Museo Nazionale, Naples.* The rock on

which the god sits is a modern reconstruction, as is that of the *Drunken Satyr* (plate 181) grouped with it at the northwest end of the piscina in the large peristyle. Exact copies of the statue are known, and while its inspiration must have been drawn from the circle around the Late Classical Greek sculptor Lysippus, the work itself is doubtless an eclectic product of a workshop in Campania.

180 Statue of a Maiden, *from the Villa of the Papyri. Bronze, height 59 7/8". Museo Nazionale, Naples.* Five statues of maidens, customarily thought of as dancers, stood in the southwest portico of the large peristyle. Their significance is not clear, but most likely they represent nymphs. The one shown here is fastening on her right shoulder the *peplos,* a Greek garment falling in loose, full

drapery over the upper body. With traits dating back to the first half of the fifth century B.C., combined with others from about 400 B.C., the statue is a deliberately classicizing work most likely done in a Campanian workshop.

181 Drunken Satyr (detail), *from the Villa of the Papyri. Bronze. Museo Nazionale, Naples.* The satyr sprawls drunkenly on a wineskin (the rock on which he now lies is modern), snapping the fingers of his raised right hand. The statue stood back to back with the resting Hermes (plate 179), and again the prototype was Hellenistic, from the late third century B.C., and most likely from one of the large cities of Asia Minor.

175

176

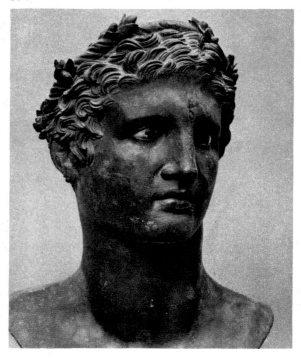

177

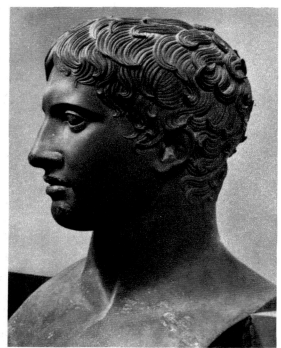

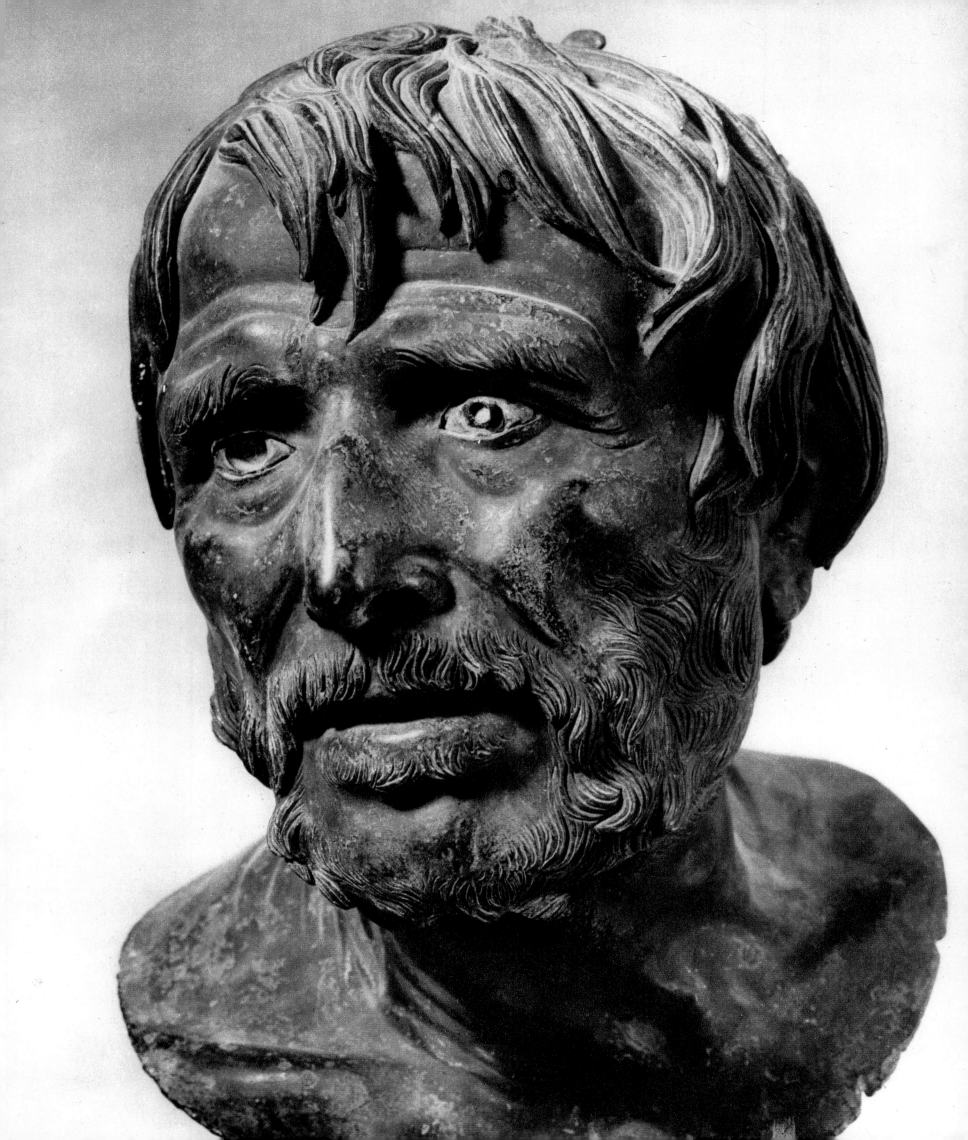

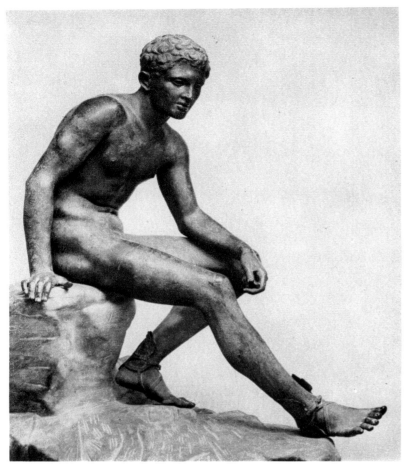

179

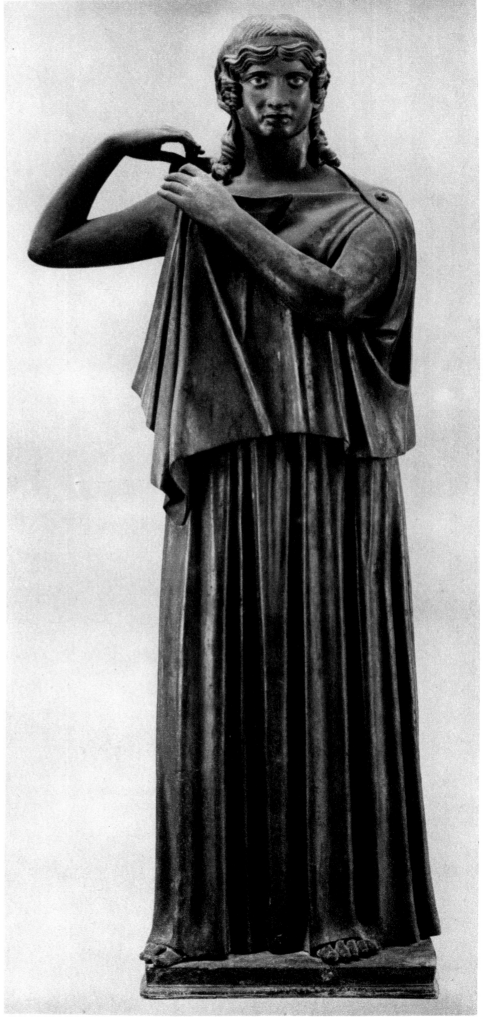

180 ▷

181

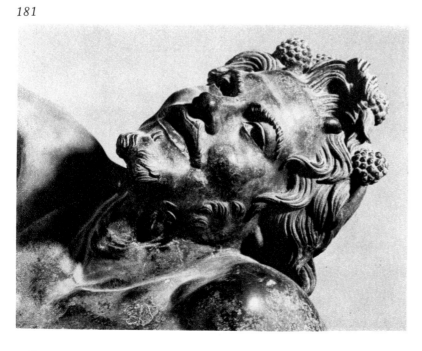

against his implacable opponent Lucius Calpurnius Piso Caesoninus, the father-in-law of Julius Caesar, Cicero expressly states that Philodemus and Piso met when the latter was still young and that the philosopher and the consul lived together and were inseparable. From this it was easy to conclude that Calpurnius himself built the villa and installed his friend there, complete with library.

Despite the arguments of Theodor Mommsen, this has remained the generally held opinion and it seems highly likely if one remembers that the nearby city of Naples appears to have played an important role under the Republic as a center of Epicurean thought, and that Calpurnius Piso belonged to the same *tribus* or class of citizenry to which the citizens of Herculaneum were assigned, namely the Memenia. Be that as it may, it is still not possible to draw an irrefutable conclusion about the ownership of the villa, and for that reason we have avoided referring to it by the name it generally goes under, that of the Villa of the Pisos. Despite all the evidence we have, it is not impossible that someone else—who would have to have been the equal of Piso in rank and fortune—built the villa and collected the works of Philodemus for his own interest.

In any case, the library had been preserved apparently intact and yet, to judge by its character, was not likely to have been assembled later than the middle of the first century B.C. This fact is crucial in any consideration of when the villa received its sculptural decoration. Were the sculptures assembled and set up at that same time, as the majority opinion holds? This would mean that they were part of the original furnishings of the villa and would date from the first century B.C. Or, as is occasionally claimed, were they only gradually brought together in the course of more than a century and continually added to right up to the end? The question is not unimportant. If the second of these views is correct, the most extensive ensemble of finds ever brought to light from a private dwelling loses much of its value as evidence of taste, style, and personality, since it would no longer represent a unified program of decoration that one particular owner of the villa attempted to carry through.

There is no better evidence to decide the question than the style of the eighty-odd sculptures themselves, yet even that is not always easy to define. The small bronze statuettes of animals and the like are often harder to date than the lifesize marble or bronze statues and busts or the over-lifesize, full-length figures. While allowing for a certain margin of uncertainty, it is nevertheless clear enough that the majority of the pieces were done in the same period. A few are undoubtedly more recent, such as a woman's head with hair dressed in the manner of Agrippina, and one or another of the more decorative works may have been a later acquisition. But just as the library remained much the same right up to the end, so, too, the later owners of the villa obviously retained the original sculptural decoration with no significant changes, and indeed a few pieces seem to have been restored at some later date. Only a family tradition of unswerving filial piety seems adequate to explain this conservative attitude.

High as the average quality of the sculpture is, the owner did not collect statues on the basis of their artistic value. Only a few are what are called *opera nobilia*, works of the great classical Greek masters that someone coveted and had copied for his own collection. The number of these is so small that one can only conclude that they were selected for their subject rather than their intrinsic value. Thus, at the corners of the northwest portico of the small peristyle there stood a bronze herm reproducing the

Bust of the Doryphorus by Polycleitus (plate 177) and another with the head of Phidias's *Amazon* (plate 174), but they were probably chosen not because they are copies of the two famous statues but rather because they depict the tragic pair Achilles and Penthesilea.

The greater share of the sculptures are portrait busts. The fact that among them are effigies of Epicurus and Hermarchus, his disciple and successor, and that these were in a room off the small peristyle and set up opposite busts of Zeno and Demosthenes, is entirely in keeping with the contents of the library. In any case, portraits of poets and philosophers play a large role in general, often as counterparts to those of rulers or athletes, as if to express the antithesis of political power and intellectual force.

This antithetical principle operates throughout the villa and most notably sets the character of the large peristyle in the garden. The long pool was bordered by marble pairs of herms portraying Hellenistic princes as against men of intellect. These were counterposed in chiastic, rhythmic alternation, and in one case a portrait presumed to be of King Pyrrhus of Epirus was immediately juxtaposed to a head of an unidentified philosopher. The series of marble or bronze portraits of rulers dispersed in other rooms of the villa is especially interesting in that it includes such rarities as portraits of the very early King Archidamus III of Sparta and of Philetaerus, who made himself first king of Pergamum. Famous Romans are strikingly absent from this portrait gallery, and everything suggests that it could only have been assembled by a steadfast Philhellene. This admiration for Hellenistic monarchs appeared also in a villa in Boscoreale when, about 40 B.C., and therefore more or less contemporary with the statues in Herculaneum, the owner had the largest room in his house painted with an entire cycle of portraits of Macedonian princes (plate 295).

The marble herms were not the only sculptural adornment to the large peristyle. At the northwest end of the euripus were bronze figures of a finger-snapping drunken satyr (plate 181) and of Hermes resting (plate 179). These stood in front of two statues of wrestlers and were flanked by bronze herms, the same sort of assemblage as framed another satyr and two deer at the other end of the pool. Thus a world of bucolic idyll was counterposed to the world of historical fact, a contrast found elsewhere in the villa: in the southeast hall there were three over-lifesize marble statues of poets and orators, while in the long southwest hall there were five bronze figures of nymphs or maidens (plate 180).

All in all, there is a truly effective disposition of the various types of statues. However, one should not lose sight of their artistic qualities. It was typical of the years about 50–30 B.C. that Classical and Hellenistic styles were freely mingled. The Archaic was resorted to only in the stylized archaizing form favored since Late Classical times, represented here by the marble Athena Promachos, which was very effectively placed between the columns of the passage between the small and the large peristyles and was visible from both of the courts.

The statues certainly came from various workshops. The *Bust of the Doryphoros* (plate 177) was signed by the Athenian Apollonius, and a number of painstakingly executed pieces of a similar kind are likely to have been imported from the East. Others must have been produced in Campania itself, among them the marble herms of the large peristyle and the five figures of maidens (plate 180), which are free contemporary variations of an Early Classical prototype of a female figure wearing the peplos. But in this field, too, there remain many still unsolved questions.

MEN

THE INDIVIDUAL AND SOCIETY IN THE CITIES NEAR VESUVIUS

Even if we were to study individually all the public buildings and private homes and the art that adorned them, we would still not do justice to Pompeii. It is true that we know the city street by street and door by door, and thus we have the opportunity, rarely accorded archaeologists, to grasp tangibly every single aspect of human cohabitation, even the most intimate and secret. Herculaneum can offer nothing comparable, not only because so much less has been excavated but also because with only a few exceptions we do not even know the names of the owners of its houses, shops, inns, and workshops. So our discussion here must be mostly of Pompeii, and by now it should be obvious that Pompeii differed in a great many respects from Herculaneum.

Conversely, one must also beware of applying to the whole vast Roman Empire what we glean from Pompeii. The broad framework may be the same, with Roman law and Roman culture dominant everywhere, but within those limits there was such endless diversity that Pompeii had best be allowed to speak for itself alone: it owed its appearance and its character to entirely specific and local historical, economic, sociological, and ethnic conditions.

The Population

Very early on in these pages we spoke of the two large groups that made up the population of Pompeii. The ancient, long-established native element and the Roman newcomers who migrated into the colony continued to set the character of the city to the end. Yet each group was itself the product of various ethnic strains. The Samnites may have become masters of the city, but before them it had lived under Greeks and Etruscans. It is not surprising to come across such Etruscan family names as Veii or Stlaborii, but in most cases it is scarcely possible to say if these offspring of the Etruscans were already residents in Samnite times or if they came only with the Roman colonists, which would mean that they had already been assimilated into that group. The Greeks present an even more difficult problem. Certainly there were Greek merchants in Pompeii as early as about 500 B.C., and in a place so flourishing in Hellenistic times there must certainly have been Greek merchants who settled there in the second century B.C. But it is not always possible to learn with any degree of clarity how far back the bearers of the many Greek names found there joined the community. Very often, too, the names were borne by freedmen, and in that case it is not even possible to know if the individual was himself Greek because it was a widespread and common custom to give slaves, whatever their origin, Greek names.

Of the peoples of the East, the presence of Jews is confirmed by a number of inscriptions and graffiti. Certainly much of what is claimed to be the evidence for this is open to challenge, especially because, in contrast to Ostia, as yet no synagogue has been found in Pompeii. Those individuals who can be identified unequivocally as Jews did not all belong to the upper social stratum: there was a Maria among the workers in a cloth factory, a Martha among the slaves in the House of the Centenary. Added to these were others who were ex-slaves and who, as freedmen, busied themselves with trade. It is precisely among the slaves and freedmen in fact, that individuals of Eastern origin were most numerous. Be that as

it may, it is often very difficult to say if a trader with an Eastern name who commemorated himself in an inscription was a resident of Pompeii or was there for no more than a few days' business. So much the more cause for satisfaction, then, to find something like the marble base in the Temple of Jupiter where, written in Greek and with a date corresponding to 3 B.C., C. Julius Hephaistion identifies himself as "priest of the congregation of Phrygians."

Our examination of the private homes has already told us something about the class structure in the city. The upper stratum was composed of the wealthy Samnite and Roman landed proprietors who had their estates outside the town and lived from the sale of their farm products, wine in particular. Likewise the large industries, such as the production of the widely exported fish sauce, garum, were by and large in their hands. So it was they who determined the economic character and fortunes of the city. It has long been recognized and often repeated that no social revolution ever took place in Pompeii, not even at that decisive turn in its fate when it became a Roman colony.

Nothing prevented freedmen from rising to wealth. Insofar as the non-Roman population was influential in trade and commerce they played a very considerable role in the city. However, they could never have access to official positions and government careers, though such institutions as the college of priests of the Augustales were open to them. In the middle class, comprising shopkeepers and craftsmen, there were both freedmen and free citizens. It is enough to stroll the streets of Pompeii and glance at the many modest shops, workshops, and eating places to realize what a large proportion of the total population belonged to that industrious middle class. Finally, at the bottom, came the great army of slaves, the indispensable working force.

Industry and Foreign Trade

Unfortunately we know little of the role that Strabo attributed to Pompeii as distribution center for goods to be sent on, up the Sarno River, to Nola, Nuceria, and Acerrae (Geography v. 4, 8), but such maritime trade must have accounted for a good part of the city's economy. The bankers (plates 184–89) made their living from it, and the large exchange, the basilica on the Forum, offered facilities for all sorts of financial transactions. Shipowners dispatched their vessels to remote provinces of the Roman Empire, and public houses and inns fed and lodged merchants from abroad. Nor was trade confined to long-distance export. Much buying and selling went on with the towns and districts in the immediate vicinity, and the bargaining and trafficking must have made the Forum a noisy, lively center. Painters have passed on to us some notion of the bustling activities centered on the chief plaza of Pompeii, where stands of all sorts were set up for the day, peddlers cajoled the crowds, scribes plied their trade, and citizens came to read the decrees and announcements of the public administrations (plate 182).

Pompeii had only a few products to export. Particularly important was the wine made on the slopes of Vesuvius, where thirty farms possessed such necessary equipment as a wine press (torcularium) and a cella vinaria, a place to store the wine while it seasoned. The producers were not all from the great families but included a number of freedmen. Pompeii seems to have opened up a very considerable territory in Roman Gaul as an outlet for its goods. Amphora seals with the name of M. Porcius, generally

identified as the man responsible for building the small theater and the Amphitheater, have been found from the southern French coast to Narbonne and as far as Bordeaux, and a ship that went down off Anthéor on the Côte d'Azur carried wine jars with the mark of C. and M. Lassius written in Oscan.

The garum of Pompeii was praised by Pliny (*Naturalis Historia* xxxi. 94) according to whom the sauce was made "from the entrails of fish and other parts usually thrown away, which were left to dissolve in salt." With competition from Cartagena in Spain, Clazomenae in Asia Minor, and Leptis in North Africa, Pliny nevertheless held the garum of Pompeii to be the best in quality, and as commander of the fleet stationed in the waters of Misenum he must have been very familiar with the piquant Pompeian fish sauce. Garum is known to have been manufactured in a house south of the Via dell'Abbondanza (I, 12, 7,8), but that was certainly not the only factory. Special equipment was needed to produce the sauce. The fish offal was put to cure in large vats, then left to decompose in the sun, and finally the resultant liquid was filtered off through special baskets.

It is less certain that the textile industry also produced for export. However, it did have its central seat in the Building of Eumachia on the Forum (plate 29) and disposed of a number of large and small fulling mills (*fullonicae*; plate 199) and dye works (*tinctoria*). Most of these were in the new part of the city, especially on the large arteries open to traffic such as the Via dell'Abbondanza, the Via di Mercurio, and the Strada Stabiana. These neighborhoods were advantageous also because their streets were the main arteries of access to the Amphitheater used by the crowds of local inhabitants but also by out-of-towners, among whom there must have been many with coins to spend. Often the workshop had its own salesroom, as in the factory of M. Vecilius Verecundus, whose wool combers (*coactiliarii*) immortalized themselves in an election appeal and shop sign on the front of the house (plate 200). The various procedures followed in cloth manufacture are known from classical literary sources and pictures. The cloth was first fulled, then placed in large containers with warm water and grease-dissolving liquids and trod on by the workers. For this process human and animal urine was used as well as fuller's earth (*creta fullonia*). Then, after all traces of these substances were cleaned off, the cloth was beaten with sticks to mat the threads together, after which it was roughed into a nap by brushes or thistles. Finally, after bleaching, it was dressed and given a finish.

Other than the fish sauce and textiles, Pompeii does not seem to have manufactured any other products specifically for export. As for imports, then as now ships conveying export goods abroad profited from the chance to load up on the return journey with other goods to be sold in the home port and country.

Among the imports was, strangely enough, wine. Exportation of the native wine reached its high point in the first century B.C., but local production seems to have receded in Imperial times. Whatever the explanation, wines were brought in not only from elsewhere in Italy but also from Spain, Asia Minor, the Aegean islands, and Crete, and there can be no doubt that other food products for ordinary consumption were imported from far places. Then, too, there were luxury articles: the virtual treasure of costly chased silver drinking vessels found in the House of Menander (plates 205–7) and the Villa of Boscoreale were no more made in Pompeii than was the priceless cameo-glass amphora brought to light in a tomb on the Via dei Sepolcri (plate 208). Likewise, certain types of finer ceramics came from outside. Objects in the lustrous red *terra sigillata*, an earthenware first fabricated in Italy, notably in **Arretium** (Arezzo) and **Puteoli** (Puzzuoli), but then produced virtually exclusively by workshops in southern Gaul, have been found in Pompeii.

If nothing else, the coins turned up in the excavations are vivid evidence that the city had commercial dealings with centers from Asia Minor to the Baleares and even Mauretania. Unfortunately, a thorough-going scholarly investigation of all things to be learned from and about the circulation of money in Pompeii remains to be done.

Production for Domestic Use

Clothing and household utensils were for the most part produced in the city itself. Food was sold not only in the central market, the Macellum (plates 15:5, 28, 242), but also in the Forum, where stands were set up on market days (plate 235). In addition, there were many small shops that sold all sorts of wares. In a harbor city in one of the most fruitful areas of southern Italy one did not have to look far to find a fishmonger (*piscator*) or greengrocer (*pomarius*), and one went to the *pigmentarius* for spices, the *lupinarius* for peas, beans, and the like, and the *gallinarius* for poultry.

Considerably more numerous than all other kinds of food dealers were the bakers (*pistores*). Thirty bakeries divided up the various neighborhoods among themselves, and besides these there were pastry shops (*pistores dulciarii*). Many of the shops congregated on the main business arteries: no less than eight on the stretch of street connecting the Vesuvius Gate and the Stabiae Gate, six on the Strada di Nola and its prolongation toward the west.

Most bakeries milled their own flour, and each had its own hour-glass-shaped upper millstone that revolved over a round nether millstone (plates 233, 234). The oven (plate 233) was usually in another room or a courtyard, and there was often yet another room where the dough was prepared and kneaded. Many bakeries worked on a large scale and had numerous employees. The owners, or at least those we know, were for the most part free citizens, some even highly regarded and influential personalities like P. Paquius Proculus, who in the last years of the city stood as candidate for the duumvirate.

Olive oil, as indispensable in Antiquity as it is in Italy today, was produced on the farms and estates in the vicinity and sold in the city, often by the producer personally. However, oil presses have been found in the city itself (plate 237). In early times oil was extracted by grinding the olives with an upright shaft or arbor which was revolved from one end and low-ered on the fruit like a simple lever, but according to Pliny the screw press was invented about A.D. 50. Since, in this modern type, the arbor was poised directly over the center of the vat, it required much less room and so was particularly adapted to pressing oil in a city workshop. With the invention of this new apparatus, the entire press could be made in wood, stone being needed only for the base with its circular gutter and spout, and this was the form used throughout the Roman Empire.

The press was used only after an initial process in which the olives were pounded and the flesh separated from the pit. Afterwards the crushed fruit was laid out in vats (*lacus, lacusculi*) to filter off watery residues. The slow, careful process aimed at oil of the highest quality, and indeed the oil of Campania was as widely famed as its wine.

The slopes of Vesuvius made a fertile terrain. Olives were produced so abundantly that there were plenty for eating as well as for oil. Thanks

to the exceptional conditions of preservation of normally impermanent substances, olives have been found in charred state in Pompeii and Herculaneum along with other fruits such as figs, dates, almonds, and nuts (plate 236). Campanian farms and orchards produced no end of fruits and vegetables, and Pompeii could never have lacked for them. The favorite fruits were apples and pears, and such legumes as beans (*faba*), lentils (*lenticula*), peas (*pisum*), and chick-peas (*cicer*) were staple food in the homes of the poor as well as the rich. The herbs needed in their preparation were often grown in the family's own kitchen garden, an indispensable adjunct to even modest houses.

Like wine and oil, meat—pork, beef, mutton—came mostly from the villae rusticae in the nearby countryside. Fish was a major part of the diet in Herculaneum, and in Pompeii the great heap of fish scales found in the Macellum is ample evidence that it was sold there.

With food in good supply, the next concern was with clothing. In a city which had such a thriving textile industry this was no problem. Clothes and shoes were sold in the Forum on market days, as witness the paintings in the Villa of Julia Felix, where such scenes were depicted with the vivid animation characteristic of folk painting. Pompeii had its share of shoemakers and other artisans involved in the working and producing of leather goods. A tanner (*coriarius*) had his workplace on a lot in the neighborhood of the theater (I, 5, *2*). In a shoemaker's shop (VII, 1, *41–42*) which, according to an election notice, belonged to individuals named Menecrates and Vesbinus, the tools of the trade were found: two halfmoon-shaped knifes (*scalpra*), an awl (*subula*), tongs, nails, and so on.

Jewelry and gold ornaments were much worn and were also made locally. If nothing else, there is the fact that the *aurifices universi*, an association or guild of all the goldsmiths, signed an election manifesto as a group. Their collegium seems to have had its headquarters in the House of L. Coelius Caldus. Engravers of precious metals and stones (*caelatores*) likewise are known, and there were also gem cutters (*gemmarii*). In the House of Pinarius Cerealis (III, 4), famous for a room with splendid decorations in the Fourth Style ostensibly inspired by theatrical scenes (plate 251), were found no fewer than 114 stones of all sorts, shapes, and sizes to be used for rings, and along with them the tools for working them.

For utensils of all kinds there was a wide range of workshops, from heavy-duty blacksmiths to craftsmen specializing in precision items such as surgical instruments (plates 191, 192) or surveyors' tools. There was a smithy on the street leading from the Herculaneum Gate to the Forum (VI, 3, *14–15*), an excellent position for serving horsemen and waggoners entering the city from the north. On another main artery, the Strada Stabiana, the smithy of L. Livius Firmus (IX, 1, *5*) had as a shop sign a phallus between two ironwork tools (plate 201).

The ordinary pots and pans used in Pompeian kitchens (plates 203) were for the most part made in local bronze workshops, though the city was not one of the major centers for bronzework in Campania, the chief purveyor being Capua, which exported its wares even outside of Italy. It is difficult to imagine that richly ornamented objects such as hanging lamps (plate 279) or scales (plate 245) could have been made in Pompeii itself.

A number of potteries have been located in Pompeii, easily identified by kilns built much like those in use nowadays. The shop sign of a potter shows a worker at the wheel (plate 196) and is particularly interesting because the picture also gives us an idea of the types of vessels turned out there. Another pottery seems to have specialized in making lamps. Nevertheless, in pottery as in other craft products, local enterprises would certainly not have been able to satisfy all the needs of the population.

Fine and Applied Art

An examination of all the trades and professions known to have been exercised in Pompeii would far exceed the pages of this book. One, however, demands our special attention, that of the figurative arts. In a range extending from the great honorific statues on the Forum to the decorative reliefs in the porticoes of private houses, Pompeii and Herculaneum possessed a full treasure of marble and bronze sculpture. While excavations have brought a good deal of it to light in more or less satisfactory condition, much has been lost forever.

For the archaeologist as for the art historian there remains the troubling question of whether, and to what extent, these works were products of local artists. Certainly there were workshops for marble sculpture in Pompeii, the best identified of them being the house near the Temple of Zeus Meilichios (VIII, 7, *24*) where, according to the reports of the early excavators, not only unfinished statues were found but also hammers, chisels, compasses, and a stone saw. Other places are less clearly identified. In one (VII, 11, *3*), unfinished marble work and sculptor's tools were dug up, but it would seem more of a storehouse since the same rooms were, at a later time, used for a fullonica. In another house (I, 10, 7) tools were found which could have been used by a sculptor but also, and with more likelihood, by a carpenter (*faber tignarius*).

So all in all the excavations have not provided many answers. On the other hand, it is not at all surprising that Pompeii was never a center for the sculptor's art. If the problem is investigated only on the basis of the surviving works, it is funerary sculpture that provides the surest base. Its style is frequently so provincial and mechanical, and its quality so insignificant that it seems entirely out of the question that any Pompeian would have ordered such work to be done by some out-of-town workshop. However, it is not impossible that even such carefully executed marble reliefs as those on the tombs of Calventius Quietus and Naevoleia Tyche (plate 131) could have been produced in Pompeii itself, and this is true for ornamental pieces like sculptured table bases and fountain statues. Works of folk art, like the reliefs with scenes of the earthquake found in the House of Caecilius Jucundus (plate 9) are not likely to have been carved anywhere but in Pompeii, whose misfortunes they depict. As for architectural sculpture, unfinished capitals and other such ornamental elements prove that the work was done on the spot, though this does not rule out the possibility that entire workshops may have been brought in from outside.

If a few *marmorarii* have been found, the same is not true for bronze foundries. Not a single one has been identified with any certainty, though we must assume they existed. If nothing else, there must have been workshops able to restore or modify existing bronze statues, since these would have been urgently needed after the earthquake in the effort to save whatever seemed salvageable.

Painters and stuccoists must have found themselves swamped with work after that disaster. Whatever workshops or studios existed in the city could scarcely have satisfied all the demands, and outsiders must have been called in. The final catastrophe put such a sudden end to this industrious campaign of restoration and renewal that it left us a permanent record of all the working steps and procedures such artists and artisans had to carry through. Raw materials were piled up waiting for use (plate 241) along with pigments not yet bound into paint (plate 238). It goes without saying that there were shops dealing in artists' supplies, and a few have been excavated. Stucco decoration became particularly favored

in that final period, not only in houses (plate 240) and tombs but also in public buildings (plates 61, 239), and its practitioners were certainly among the craftsmen with more than enough to do after the year 62.

With the exception of one example, there are no signatures of painters or sculptors. True, a certain Lucius boldly signed two pictures in the House of Loreius Tiburtinus, apparently not embarrassed by the decidedly poor quality of his work (plate 258), but his is the only name we know. The same is true for the mosaicists, though at least we have five names incorporated into mosaics which are likely to be signatures: M. Spurius Mensor, Festus, Torquatus, Felix, and one which is only fragmentary, beginning with Hellen . . . Diggings have produced evidence of the existence of mosaic workshops. In one house (I, 12, *4*) was found a large terra-cotta plate with raised edges of the sort used in assembling the small bits to be inlaid.

We do not know, though, if the mosaic workers also did the colored marble inlaid floors (*opus sectile*) and other such pavements, but in any case there must have been a good many such craftsmen in Pompeii itself, since the work had to be done on the spot. It was only the special mosaic emblems that would have been brought in already assembled from the chief centers of the mosaic art in Italy and Greece. In summary, then, even if Pompeii was no match for the important metropolitan centers, it had at its service a virtual galaxy of artists and fine craftsmen who left their personal imprint on the city.

Inns and Hostels

A trading center like Pompeii could not do without accommodations for visitors. Even if many businessmen could depend for hospitality on their local associates or clients, others must have had to put up at an inn. There were, in fact, a good many public houses (*hospitia*) nicely situated for the convenience of merchants arriving from other places, most particularly at the main entrances to the city, the gates to Stabiae and to Nola. Directly behind the gate to Herculaneum there were two spacious inns, one to either side of the street, each with driveways wide enough to accommodate chariots and wagons. On the same thoroughfare leading to the Forum, the Via Consolare, there were four more inns. If the visitor preferred, there were facilities in the center as well, in the neighborhood of the Forum or the Stabian baths.

Generally the *hospitia* also had dining rooms, and their signs specified what they had to offer. An inn in the vicinity of the Stabian Thermae announced on its inscription: *hospitium hic locatur, triclinium cum tribus lectis* (here lodgings are provided, and there is a dining room with three couches). The furnishings were much as in private homes, with the couches either movable or adhering to the wall. The activities in such triclinia were frequently depicted in Pompeian wall paintings, sometimes even with all-out carousals or amorous episodes (plates 216, 226).

Taverns (*cauponae*) were so numerous throughout the city that almost every district had at least one. Often they were located at street corners so that they could be entered from either side. In them the custom was to sit down to one's drinks, and what went on is vividly illustrated in a series of wall paintings from the caupona at the intersection of the Via di Mercurio and the Vico del Lupanare (plates 223–25). The eatables, cheeses, and sausages were hung from the ceiling in the taproom, just as in Italian trattorias nowadays. At one table a weary traveler might be repairing his spirits with food and drink, at another the locals might be throwing dice or playing a board game like chess or checkers. The dice-throwers (*aleari*) and gameboard players (*latrunculari*) were even known to team up for election propaganda, and there were pubs in which the attraction was certainly gaming more than drinking. An evening's fun, then as now, was often not complete without a brawl (plates 222, 224). Certain cauponae were houses of ill repute, and there must have been a good number of these little hangouts.

At least some inns and taverns were brothels on the side. In a port and trading center like Pompeii prostitution was inevitable, and a great many bordellos (*lupanaria*) have been more or less rightly identified. To present-day tourists the best known is the lupanar of Victor and Africanus (VII, 12, *18*), whose identification can scarcely be doubted thanks to its furnishings and its obscene inscriptions and paintings (plates 217–19). The girls, who as a rule were non-Roman, were mostly slaves owned by the proprietor or keeper of a lupanar, and in the inns and hostels the help were often available for a bit of a paid fling. Moral qualms about the pictures and graffiti in these places are entirely unjustified and decidedly misinterpret the customs and attitudes of the ancient Romans, who took such matters in their stride with no great fuss about it.

For hot food and drink to take home, Pompeians could turn to numerous *thermopolia*, a name referring specifically to the favorite drink of wine mixed with hot water, something like our mulled wine, though hot food also was sold. These public kitchens, not unlike modern Italian *tavole calde*, are easily recognized by their furnishings, chiefly a counter, most often L-shaped, into which terra-cotta containers could be fitted (plates 228, 229). Some of these counters or hot tables were elegantly faced with marble. Such cookshops often had a dining room as well, where one could consume on the spot the ready-prepared hot dishes and drinks. As with inns and cauponae, the favorite location for the thermopolia was on the much frequented main arteries. Often the keepers of lodging houses and eating places did not own the premises themselves but merely rented them, and for the most part they belonged to the lower social strata, not infrequently being freedmen.

Thus Pompeii afforded quite adequate accommodations for its visitors, with the pleasures of the table matched by those of the bed. To judge by what has been excavated at Herculaneum, that city, as one would expect from its very different character, appears to have been much less well provided with inns, hostels, taverns, pubs, gambling dens, and brothels.

GODS

CULT AND MYTH

For ancient man, religion was taken for granted as a part of life, and one's relation to it was troubled by neither reflection nor doubts. Sacrifices to the gods were not only solemn public rites but were also accomplished in the intimacy of one's home. Images of the divinities adorned temples, thermae, theaters, and private dwellings, and the myths of gods and heroes were thought of by the Romans as the ideal subjects with which to decorate one's four walls.

Art works of religious content appeared everywhere in Pompeii and Herculaneum and were indeed the most numerous. However, the distinction must be made between those having to do strictly with religion and those belonging to other spheres, these latter being chiefly wall paintings where the mythological content had nothing like the same significance.

Veneration of the Gods

Naturally the temples constituted the most important manifestation of religion, and the sites where they rose are of great significance. When the Romans took over the city, their state religion appropriated to its purpose the Forum where, since remote times, the Temple of Apollo had stood. Soon the plaza came to be dominated by the towering bulk of a temple to the Roman Jupiter (plate 16). Then, in the last period of the city, a temple dedicated to the cult of the emperor was built on the east side of the Forum and, alongside it, another which is thought to have been consecrated to the *Lares publici*. When, in the years around the birth of Christ the duovir and augur Marcus Tullius saw to the building of yet another temple, this one to Fortuna Augusta (plate 27), he chose as the site a piece of land he himself owned which lay only a few yards from the north entrance to the Forum, at the intersection of the Via del Foro and the Strada di Nola. So this temple, too, is to be considered part of the Forum, and apparently the cult practiced there was a concern of the community as such, since the inscriptions state that the *ministri Fortunae Augustae*, a college of priests of more lowly birth, were empowered to carry out their functions by order (*iussu*) of the *duoviri iure dicundo*.

A second group of temples was concentrated in the vicinity of the Doric temple inside the Triangular Forum alongside the large theater (plates 3, 4). There, as early as the second century B.C., the devotees of the cult of Isis had erected a temple north of the theater, joined eventually, in the neighboring block of buildings toward the Strada Stabiana, by the small Temple of Zeus Meilichios (plate 10). Was it by chance that all the gods venerated in this neighborhood were non-Roman? True, we are not certain to whom the Doric temple was dedicated. Some say it was to Hercules who, according to ancient sources, was considered the mythical founder of Pompeii, but others argue for Athena, the goddess who corresponded to the Italic Minerva. An Oscan inscription found south of the Via dell'Abbondanza appears to tell the way to a temple of Minerva which, it happens, could scarcely be anything other than the Greek temple in question. Further, there is a tripartite altar in front of the temple, which suggests that a trinity was worshipped there, but no other clues to their identity survive.

A special site was reserved to the divine patroness of the city, Venus Pompeiana. The large precinct enclosing her temple lay on the farthest southwest spur of the hill on which the city is built. In its commanding position it welcomed from afar all who approached the city by sea. Had the new building begun after the earthquake been completed, Venus would have had the largest and most sumptuous temple in all Pompeii.

Whether other temples exist in districts not yet excavated is an open question, though judging by the way the city is built up and by the character of those outlying neighborhoods we know, it is not very likely. On the other hand, there were sanctuaries outside the city walls. One of them rose on the hill of Sant'Abbondio in the vicinity of the present railway station for Pompeii. In 1947 a pediment relief was found there showing Dionysus (Liber in Italic) and Ariadne in the center flanked by Eros and Silenus, and in addition there was an altar which, according to the Oscan epitaph, was dedicated by the aedile Maras Atiniis. The temple must have been of very modest dimensions and is thought to date back to the early second century B.C. Then, too, although Ceres had her own *sacerdos publica*, a civic priestess, in Pompeii itself, the precinct sacred to her appears to have been located outside the city as prescribed by Vitruvius: *Item Cereri extra urbem . . .* (*De Architectura* i. 7). Mars was another of the gods to be worshipped outside the walls, and Neptune is thought to have had his temple in the vicinity of the harbor.

The existence side by side of the official Roman state religion and of Eastern cults (which in Herculaneum more conspicuously than in Pompeii also included that of Cybele) was typical of a time in which the austere rites of the official, traditional, ancient Roman religion could no longer satisfy the religious aspirations of the individual. Those who hoped for an afterlife, or were attracted by mystery cults with their strange beliefs, turned to gods more apt to gratify such longings. Not the least of these was the Egyptian Isis. Outlawed and persecuted by the state repeatedly even during the reign of Tiberius (A.D. 14–37), her cult nonetheless spread triumphantly throughout the Empire. In Pompeii her image is found together with that of Serapis and other Alexandrian gods even in house chapels, most notably in the Villa of Julia Felix and the House of the Golden Cupids.

Two paintings from Herculaneum depict rites of the cult of Isis. One (plate 256) portrays the exposure of a sacred vessel by the high priest along with a sacrifice, the other shows a ritual dance. The exotic officiants and liturgical music and the embellishment of the sanctuary with sphinxes, Egyptian altars, and the like, as shown in these paintings, surely exercised a profound fascination over the faithful. The legend of the goddess who, bewailing the dead Osiris dismembered by Seth, roamed the world to reassemble the members, which then came together in a total resurrection—a parable of death and rebirth—had a direct impact on human feelings of grief, compassion, and jubilation.

The religion of Dionysus-Bacchus with its mystery rites also implanted itself in Pompeii. Its figures and symbols are so superabundantly represented in wall paintings that they cannot be dismissed as mere decorative motifs drained of significance. It has been stressed with good reason that the decoration of Pompeian gardens is redolent of a Dionysiac atmosphere and overtly symbolic of the presence of the god. No wonder then that Dionysus made his way even into house altars, as in the painting from the lararium in the House of the Centenary, where he was depicted on the slopes of Vesuvius (plate 11).

Private piety was expressed in the images of gods painted on house fronts, who were there as divine protectors of the inhabitant's house and business. Nowhere are these often quite modest but also often well-executed paintings better preserved and more in evidence than on the Via dell'Abbondanza. Over and over there is Mercury, god of trade and

money dealings, alone or with other gods, sometimes Minerva, sometimes Hercules, or Bacchus. Entire congresses of gods are not infrequent, right up to the Twelve, the *Di Consentes*. Nor, naturally, is the tutelary divinity of the city, Venus Pompeiana, absent: again and again she appears in all her solemn majesty (plates 267, 268). Non-Roman gods, too, turn up here and there. Even Cybele, an import from Asia Minor, has been thought to appear on a picture of a religious procession.

Among the domestic cults the chief one undoubtedly was that of the Lares (plates 288–91). In earliest times they were the protectors not just of the house but also of the peasants' farms and holdings. It is no longer doubted that they came from the nature cults of the earliest Roman farmers, which explains why the festival in their honor (*Compitalia*) was celebrated where the limits of two plots of ground met, and it was there that chapels were erected and sacrifices offered. Together with the Lares there was usually the genius, the tutelary spirit of the head of the house, and often, too, there were all sorts of Roman and non-Roman divinities, according to the personal beliefs of the family. What remains true is that every house in Pompeii must have had its lararium, and that their fresh and lively paintings still convey to us a wonderfully animated and manifold picture of the religious life of the Pompeians.

Myths and Tales

In both of the destroyed cities the great majority of figurative wall paintings are mythological in content. The central sections of the wall decorations in private homes are so often devoted to representations of myths as to surprise and puzzle the modern viewer, the more so since they depict almost exclusively Greek gods and heroes. Roman myths are entirely inconspicuous, and only now and again does one find some scene from the *Aeneid*, the great epic of the founding of Rome.

In this, Pompeian painting does not, however, stand alone. In Roman reliefs likewise, Roman myths are less frequent than Greek. When Roman sarcophagus art began to develop ever more richly from the second century A.D. on, the themes were again chosen from the Greek sagas, especially those embodying laments over the dead and a belief in the afterlife. For mosaics also, Greek heroic motifs continued to be used well into late Antiquity.

The phenomenon becomes more comprehensible as soon as one inquires into the sources of the imagery. One of them was certainly Greek literature, as familiar to Romans in colonies like Pompeii as it was to residents of the capital itself. We do not know if the theater in Pompeii presented the classical tragedies, but they were still very much alive and were a major source of iconographic themes for painters. As for the Homeric epics, they were represented in several cycles of paintings in Pompeii (plate 240). Finally, the Roman authors themselves in early Imperial times repeatedly had recourse to Greek myths, and no one more than Ovid, whose *Metamorphoses* has been taken to be the source of a number of Pompeian paintings (plates 257, 258).

Literature, however, constitutes more an intellectual background than a direct influence. For the images themselves the artists turned to Greek prototypes. These, unfortunately, were known most often only in the poorest and most undistinguished copies, which had all too plainly become contaminated with Roman variants. It is not unusual to find the same model used in pictures from entirely different epochs and of great disparity in quality. Because of this, not the least of the merits of Pom-

peian painting in terms of the history of art is that it hands on to us at least an echo of Greek painting which otherwise would remain forever beyond our knowledge.

If copies were made, it was because people longed to own the highly valued Greek paintings. If they could not have an original, they would content themselves with an imitation. An attitude typical of the Roman educated classes, it was responsible also for the innumerable Roman copies and versions of Greek statues and reliefs. As a member of a cultured society, it was *de rigueur* to surround oneself with the paraphernalia of one's class. But precisely because this was the aim, Pompeian painting cannot be explained only in purely aesthetic and art-historical terms.

That these paintings were not mere wall decoration was recognized long ago to be so self-evident as not to admit dispute. Today, however, attention is directed to probing much more deeply into the overall conception underlying all the principal images in a room and uniting them into a coherent and meaningful ensemble. The attempt is not always successful but is easiest when there is a cycle in which all the subjects come from the same body of myth, which often means from the same geographical area. Thus the three large murals in the vaulted large oecus of the Villa Imperiale (plate 130)—*Theseus Abandoning Ariadne*, *Theseus Triumphant over the Minotaur* (plate 286), and *The Fall of Icarus* (plates 128, 129)—all belong to the corpus of Cretan legends. The paintings in the so-called Pentheus Room in the House of the Vettii (plate 112) include *Hercules Strangling the Serpents* (plate 261), *The Death of Pentheus*, and *The Punishment of Dirce*. These are all Theban tales. In other cases subjects were combined either because of some similarity of content or as a contrast, and these counterparts were often composed in such a way as to relate them in both form and content.

Especially favored were the deeds of heroes like Hercules (plates 261–64), Theseus (plates 283, 286), or Perseus (plate 250). Over and over the love of some divine couple is celebrated (plates 265, 269) or the beneficent, or sometimes calamitous, relation between gods and mortals. Sacrilege against divinity followed by atonement and eventual deification is often counterpoised to the tales of a victorious hero. But where such tragic events are depicted one must beware of reading into them an inappropriate religious morality, if for no other reason than that when subjects of this sort appeared in triclinia or garden rooms, where people gathered to refresh themselves, dine, or even carouse, they certainly were not intended to be an eternal finger of warning, recalling the banqueters to piety and temperance.

Nor should the choice of mythological scenes be read as an avowal of faith in one god or another on the part of the householder. At the most this can be presumed where the entire wall decoration is related to a single divinity. The Villa of the Mysteries is an example of this as concerns the Dionysus cult (plates 114, 119–25), and it may apply, too, where Isis and her devotees are pictured (plate 256). But even with these one should be cautious. Modern interpretations must take care not to load down with an entirely disproportionate significance every motif with anything Egyptian about it, presuming them all to be sure signs of the cult of Isis. The fact is that after Egypt fell to the Romans everything connected with it became popular, and there can be no doubt that a good many of its motifs and designs were adopted simply because they made for handsome decoration. With this understood, and even after discounting a large part of the painting, there still remains enough to justify reading certain murals as allusions to the Isis cult which, demonstrably, had a considerable following in Pompeii.

Myths as subject matter were not confined to painting. They appear also in statues and reliefs, though relatively much less often. In reliefs they were exploited particularly in the so-called Neo-Attic style practiced by certain workshops which originated in Attica but then spread also to Italy and, beginning with the second century B.C., worked in a deliberately classicizing manner. All too often their sculptors repeated classical prototypes in a purely decorative fashion with no regard for any ulterior significance, even combining quite unrelated models for no better reason than a pleasant effect. Happily, thanks to just this arbitrary approach, they occasionally handed on certain rarely depicted myths which might otherwise never have been represented in art (plate 287).

ART

WALL PAINTINGS: STYLES AND SCHEMES

Whatever strange, wonderful, and tragic curiosities have been unearthed at Pompeii and Herculaneum, the buried cities owe their special fame to their wall paintings. With the very first excavations these works of art were greeted with delighted amazement, and even today nothing can equal the experience of visiting one of the houses where room after room retains its ancient decoration almost intact. Nowhere else in all the Empire has such an inexhaustible treasure of Roman mural art survived, no other excavated place can rival this or show anything as almost perfectly preserved as these paintings. Precisely because they were so hermetically sealed by hardened lava and slime from all destructive atmospheric influences, they have come down to us in astonishingly good state, and that is why present-day excavators working in the two towns and their environs can and still do discover additional fully painted interiors in such places as Stabiae or Torre Annunziata. On the other hand, the sheer wealth of finds has brought along with it the danger of overestimating their worth. Since almost no pictures painted on wooden panels have survived from ancient times, and all the Greek paintings that classical authors wrote about with such admiration are forever lost and unknown, it is only through mural decorations that we can still get any idea of the pictorial arts of Antiquity and deduce something at least of the principles of composition, style, and technique that once held sway. No wonder, then, that what has been found on the slopes of Vesuvius has often been rated too highly. The plain fact is that a large part of the wall paintings in question never rises above the level of simple artisan work, with all the weaknesses which so often lend a special charm to the products of simple craftsmen. This does not alter the fact that a few houses and villas do contain paintings of the highest quality, masterworks in the truest sense of the word, which hold their ground in any comparison and under any stylistic analysis.

The excavators in Bourbon times had a predilection for full-figured paintings along with small isolated personages, heads, or masks, and these were what they considered worth the effort of cutting out of the walls and sending off to the museum. The result is that the Naples museum has hundreds of bits and pieces, fragments ripped out of their original context and forced into modern wooden frames like so many easel pictures. This is not entirely unfortunate, because in the final analysis the figurative scenes painted on the walls were a substitute for, and were by and large inspired by, the panel paintings they took as models. Nonetheless, a wall painting makes its true effect only as one element within the overall decorative scheme of a room, with a precisely assigned place and role of its own. With this in mind, and as the only means of grasping their true character, the enlightened modern viewer often finds himself compelled to imagine these museum exhibits back in their original setting. But this is not always easy, because in so many cases we simply do not know where a particular painting came from. Since 1957 the task has been made somewhat easier by the publication of *Die Wände Pompejis* by the Basel archaeologist Karl Schefold. This is an immense, indispensable catalogue of all wall decoration in Pompeii, house by house, room by room, in which the author achieved the extraordinary feat of reconstituting the long disrupted ensembles by relating the pieces in the museum to what remained on the walls, complementing and supplementing the paintings that exist with others disappeared or destroyed and known about only from old reports and publications he so doggedly tracked down.

The technique used in these ancient wall paintings differed considerably from that used in Renaissance frescoes. Before the artist could begin his work, the ground on which he was to paint had to be prepared in the way described by Vitruvius (*De Architectura* vii. 3, 5–10). To start with, the rough wall had to be covered with three successive coats of fine lime mortar, followed by three further coats of a mortar using powdered marble, the first fairly coarse in texture, the other two progressively finer. In the process of preparation, the mortars were beaten or, more accurately, whipped with sticks until thoroughly mixed and completely smooth. When the wall surface was ready, it was polished with marble dust and the colors laid on at the same time ("*coloribus cum politionibus inductis*"). By this method, the walls were guaranteed against future cracking and took on a brilliant surface gleam like that of marble itself.

Modern researchers have repeatedly interpreted and reinterpreted what Vitruvius said here and even put his instructions to the test in actual experiment. According to one of them, Walter Klinkert (in *Römische Mitteilungen*, 64, 1957, pp. 111 ff.), the decorations were painted with limewater-based paints on the still-damp coat of plaster and were then subjected to the polishing operation described by Vitruvius, this being the only way, he claims, to achieve the characteristic Pompeian sheen. Of the various arguments pro and con, that of Klinkert, backed by empirical evidence, is the most convincing. This is not, then, a fresco technique, and it is quite inappropriate to speak of "Pompeian frescoes," as is so often done. The technique as practiced in Pompeii and Herculaneum has the great advantage that the beaten stucco, each layer of which could be applied throughout the room in a single operation, dried slowly and therefore did not restrict the painter to the usual "day's work," that is, to the amount of surface that can be covered in one session before the plaster dries on the wall, which is the special difficulty in working in the *al fresco* technique used so notably in the Italian Renaissance.

The mirror-like glaze over the surface involved not only polishing with marble dust but also going over the surface with small rollers. The whole process, it is clear, was so elaborate and expensive that it was of necessity confined to the paintings in the "best" rooms of the house, the others being much more simply decorated. There was also the possibility of doing certain parts of a wall in matte colors as an effective contrast to the polished areas, and this was especially frequent in the Fourth Style. The contrast was further heightened by the fact that polishing made all colors darker.

182 SCENE IN THE FORUM, *from the Villa of Julia Felix, Pompeii (II, 4, 3). Wall painting transferred to panel. Museo Nazionale, Naples.* Like so many others, this wall painting was arbitrarily removed from its setting by the Bourbon excavators. Simply and almost naively it shows three equestrian statues in front of a garland-bedecked colonnade on the Forum. Across the pedestals of the statues a public notice has been fixed to a long board and is being attentively studied by various individuals.

183 PUBLIC NOTICES. *Front of the House of Aulus Trebius Valens, Pompeii (III, 2, 1).* The inscription at the left has not survived intact, but enough remains to tell us that D. Lucretius Satrius Valens, *flamen* (priest) of Nero, and his son D. Lucretius Valens have arranged to have, respectively, twenty and ten pairs of gladiators fight publicly on April 8 and that, as an added attraction, there will be animal baiting, besides which an awning will be drawn to protect the public from the sun. The right-hand notice advises that on June 13, on the occasion of the dedication of the city archives (*dedicatione operis tabularum*), Cn. Alleius Nigidius Maius is organizing games which will include a festal procession, animal combats, and athletic contests (*pompa, venatio, athletae*). The sign painter Ocella immortalized himself by writing his name within the o of *dedicatione*. Between these two lengthy notices there is an election appeal: *Satrium quinq(uennalem) o(ro) v(os) f(aciatis)*—I urge you, make Satrius duovir quinquennalis. As is already obvious from the title borne by Lucretius Satrius Valens, the inscriptions date at the earliest from the reign of Nero, and from other documentary evidence we know that the public career of Nigidius Maius took place under Nero and Vespasian.

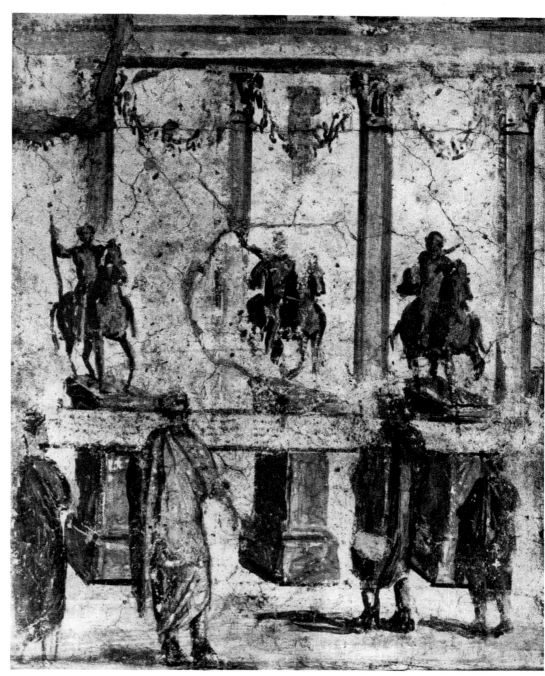

183

184

185

184 MONEY CHEST, *from Pompeii. Iron with bronze fittings, 36 × 40 1/8 × 23 1/4". Museo Nazionale, Naples.* Pompeians kept their money in their houses, in large heavy chests usually firmly anchored to the floor of the atrium, as can still be seen in the House of the Vettii. The Latin name for such a strongbox is *arca,* and the term was used also for the public treasury and the funds of collegiums and other such sodalities. The *arcarius* functioned as treasury official or financial administrator for a wealthy private citizen and could be a slave or freedman. Among the handsomest *arcae* in Pompeii is the one seen here, found in 1867 in a house near the Stabian Thermae. Its iron body is decorated with bronze fittings, and frames outlined in studs or nailheads set off small busts while, in the upper middle, there is a boar's head.

185 TABLETS, *from the House of Lucius Caecilius Jucundus, Pompeii (v, 1, 26). Wax, 4 3/4 × 5 1/4". Museo Nazionale, Naples.* Wax tablets (*tabulae ceratae*), bound so as to be folded together, as in this diptych, were the usual account books. A considerable store of them was found in the house of the banker Lucius Caecilius Jucundus (see plate 189). Mostly they consisted of receipts for transactions carried through by the financier for other parties, or quittances from the city itself for communal lands leased in his own name.

186–88 ROMAN GOLD COINS. Although none of these came from the Vesuvian towns, they are representative of coins circulating in the years before the eruption. The *aureus* was the highest Roman coin and was worth twenty-five silver denarii or a hundred sesterces. According to Pliny (*Naturalis Historia* xxxiii. 47), under Nero its weight was fixed as the equivalent of 1/45 of a pound, roughly 7.28 grams, which was something of a devaluation with respect to early Imperial times when it was still 1/40 of a pound. From left to right we have here a minting weighing 7.74 grams from the reign of Claudius, about A.D. 41 or 42, then an *aureus* of 7.35 grams from the very last years of the reign of Nero, sometime between A.D. 64 and 68, and finally a gold coin from the first year of the reign of Vespasian, A.D. 69 or 70, which weighs 7.38 grams.

189 PORTRAIT HEAD OF THE BANKER LUCIUS CAECILIUS ▷ JUCUNDUS, *from his house in Pompeii. Bronze, height 13 3/4". Museo Nazionale, Naples.* The head, mounted on a herm shaft, formerly stood together with a companion piece, now lost, in the atrium of the house, just in front of the entrance to the tablinum. The inscription on the herm reads: *Genio L(uci) nostri | Felix L(ibertus)*—to the Genius of our Lucius from the freedman Felix. The absence of the cognomen has given rise to some uncertainty as to whether it does not perhaps portray the banker's father L. Caecilius Felix, which would mean that it goes back to the reign of Augustus. The style, however, is much more that of the middle of the century. The facial traits are rendered with pithy sharpness—protruding ears, a somewhat self-conscious, forced smile, a wart on the left cheek—and it is safe to assume that the sculptor was faithful in rendering the true character of a crafty and hard-dealing businessman.

186

187

188

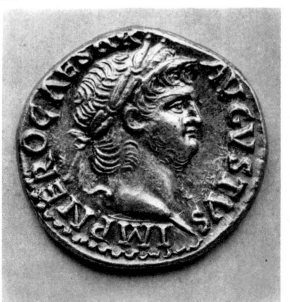

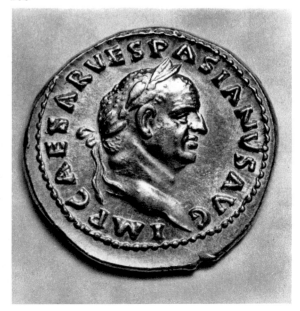

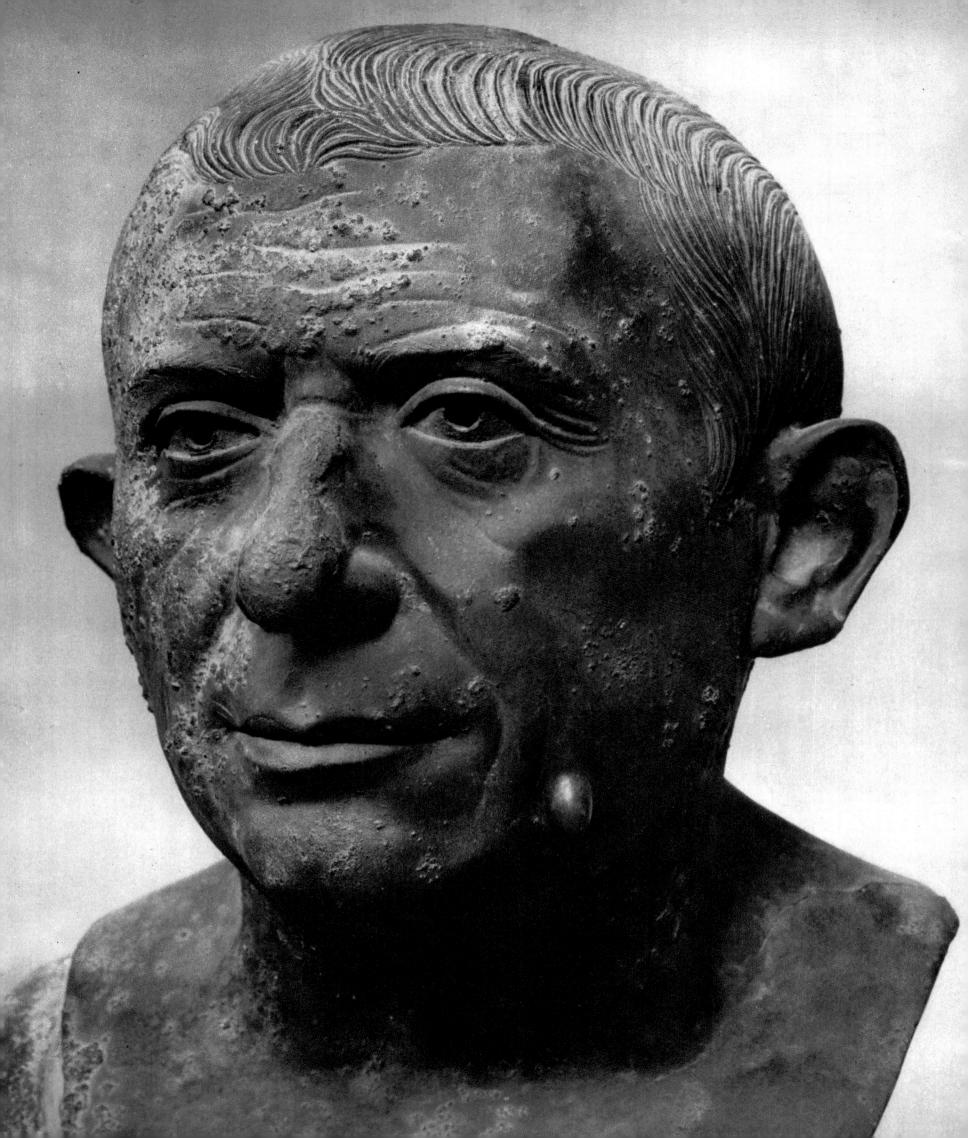

190

190 HOUSE OF THE SURGEON, *Pompeii* (VI, 1, *10*). The profession of the last owner of the house was obvious from the many surgical tools found there (plates 191, 192). The house itself, however, dates very far back. One of the rare examples of the limestone houses that preceded the Tufa Period, it must have been built before 200 B.C. Despite additions and alterations, it retained to the end its old-fashioned arrangement of rooms. Here we are looking from the tablinum toward the street entrance (at the left margin). To the right of the street door is another door leading into a taberna fronting on the street, and then there are two cubicula. The wall in the right foreground separated the tablinum from the adjoining triclinium.

191, 192 SURGICAL TOOLS, *from Pompeii. Museo Nazionale, Naples.* Some of these instruments were found in a wooden case in the House of the Surgeon. The tools are in bronze, the knife blades in iron. Along with spatulas, scalpels, clamps, and scissors there is an ingenious forceps for removing bone splinters or arrowheads (at the right in plate 191, left of center in plate 192) as well as a *speculum vaginae* (plate 191, center), which is opened and closed by turning a screw fitted out with a handle. Dating probably from between A.D. 62 and 79, the instruments are evidence of the advanced state of medicine in the latter half of the first century of our era.

193 GLASS VESSELS, *from Pompeii. Museo Nazionale, Naples.* Glass, metal, and pottery were commonly used for drinking vessels. These examples are all from early Imperial times. The beaker at the left is decorated with diagonal striping, the small amphora next to it has a vertical pattern. In all four the glass itself is colorless. Quite probably none of them was made in Pompeii itself, and the beaker may have been imported from Syria.

191

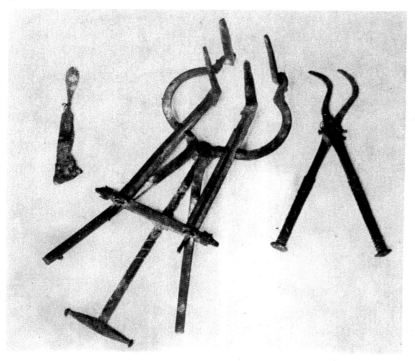

192

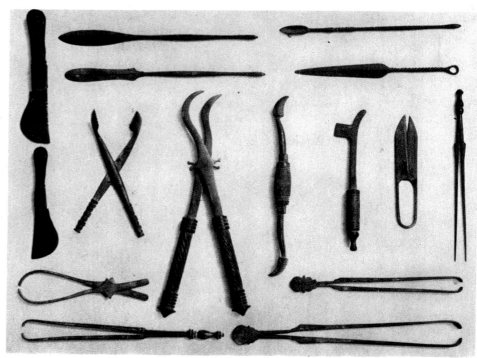

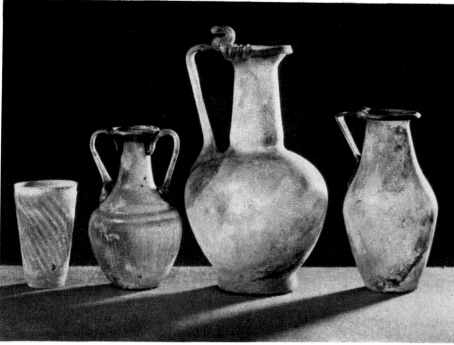

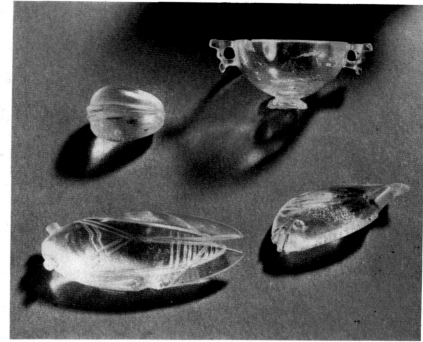

193

194

194 OBJECTS IN ROCK CRYSTAL, *from Pompeii. Museo Nazionale, Naples.* Rock crystal was a highly prized and most valuable material, the best of which, we are told by Pliny (*Naturalis Historia* xxxvii. 23), came from India though it was found also in Asia Minor and the Alps. There are references in Roman literature to *crystalla*, beakers in rock crystal. The miniature vessel seen here has the form of a skyphos, and there are also a nut, cicada, and fish. In the present state of research it is still difficult to be sure where such objects were made.

195 OIL SHOP, *Via degli Augustali, Pompeii* (VII, 12, *9*). In a small shop on a much-frequented street in the older part of the city, four large terra-cotta vats were found sunken into the floor, two in the wide entrance (seen

here), two along the left wall. They were used to store the oil sold retail here. Oil was one of the major items of agricultural production in the region, primarily for consumption in Pompeii itself. Alongside the shop another room opened on the street and had a staircase leading to living quarters upstairs.

196 POTTER AT WORK (*detail of a shop sign*), *from a pottery in the vicinity of the Amphitheater, Pompeii* (II, 6). *Antiquarium, Pompeii.* The picture shows the god Vulcan as tutelary patron of craftsmen, and in this detail a lappet of his garment can be seen in the upper left corner. The potter himself is a young man in short workman's tunic who sits on a low, rectangular stool and turns a tall, slender vase on his wheel, which he operates by treading a

lever with his left foot. On the ground are vessels he has already completed: a bowl and small pitchers with handles. The sign is clear evidence that ordinary pottery for domestic use was produced in Pompeii itself.

197 HOLLOW BRICKS USED IN HEATING THE WALLS OF THE SUBURBAN THERMAE, *Herculaneum.* In the baths outside the walls of Herculaneum (plates 142:*XX*, 154), a stock cf hollow bricks of the sort used in Imperial times for warming bathrooms was found together with a supply of slaked lime in a room to the right of the entrance. This room had obviously been set aside to store building materials. The hollow bricks were no doubt manufactured locally.

195

196

197

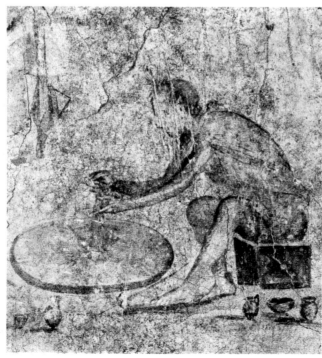

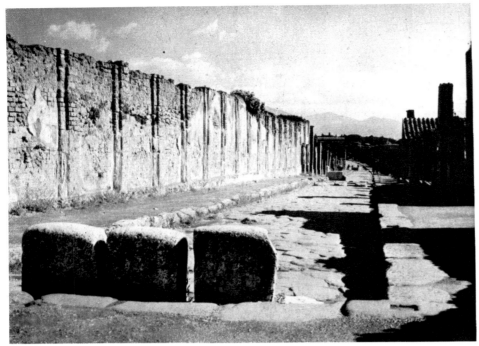

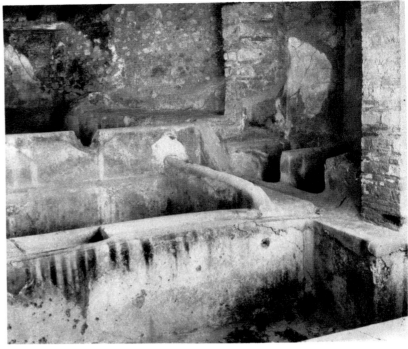

198

199

198 POMPEII, *the beginning of the Via dell'Abbondanza with the exterior of the Building of Eumachia.* As we have seen, a statue of the priestess Eumachia was set up by the *fullones*—the cloth fullers—in the large building erected at her expense which seems to have served as their guild hall. Certainly it was the most conspicuous of all the buildings in Pompeii concerned with trade or indutry,s with a choice site right on the Forum at the beginning of the Via dell'Abbondanza. The stones in the foreground are roadblocks to stop traffic from entering the Forum from the street.

199 FULLONICA OF STEPHANUS, *Pompeii* (I, 6, 7). On the Via dell'Abbondanza, the leading commercial street in Pompeii, there was a *fullonica*—a workshop for cloth

fulling and dyeing—behind the viridarium in the back part of a large house. From an election appeal on the house front the owner would seem to be one Stephanus, most likely a freedman. The cloth was washed in these large masonry basins and then fulled by first being trampled with bare feet and then beaten with sticks, which not only cleaned but also matted and thickened it. The workshop and equipment, as we see them now, must date from the last years of Pompeii.

200 SHOP SIGN OF THE CLOTH FACTORY AND SALESROOM OF M. VECILIUS VERECUNDUS, *Pompeii* (IX, 7, 7). The business sign of this clothmaker adorned the front of his premises just below a large painting of Venus Pompeiana on a chariot drawn by four elephants (plate 267). The

owner appears in person at the right holding up a finished garment, the end product of the operations pictured on his sign. In the center, four workers knead the material for fulling in two large wooden troughs to either side of a wood-burning oven. Three others, seated at low tables, prepare strips of cloth. In addition to being a shop sign, this plaque served another purpose: across the top was written *Vettium Firmum aed(ilem) quactiliari rog(ant)*—the feltworkers want Vettius Firmus as aedile. The original sign and election appeal dated from the last years of the city, though what we see now is a modern reconstruction.

201 SHOP SIGN ON THE SMITHY OF L. LIVIUS FIRMUS, *Pompeii* (IX, 1, 5). *Tufa stone, 16 1/8 × 13".* Set into the

200

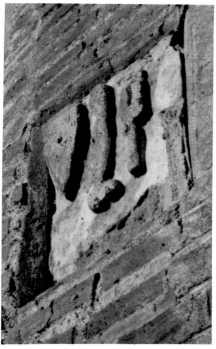

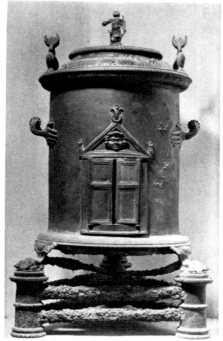

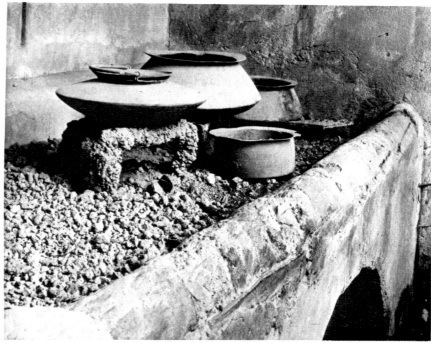

201 202 203

wall to the right of the entrance is a plaque picturing, in crude relief, a phallus to ward off evil and bring good fortune flanked by a sledge hammer and a pair of tongs. Painted red, they stand out vividly against a white ground. Here an election appeal on the shop front tells us the name of its owner.

202 WATER HEATER (?). *Bronze, height 37 3/8″. Antiquarium, Pompeii.* Round receptacles have been found in Pompeii which consist of a boiler set above a fire feedbox with a door, and these were more likely water heaters than stoves. This one is elaborately decorated, with a fire door in the shape of a temple whose pediment is adorned with masks and, at the apex and either end, flower-shaped acroteria. The handles appear as human hands.

Although there were bronze foundries in Pompeii, an ornate piece like this was probably imported from some more industrialized center in Campania.

203 BRONZE KITCHENWARE. *House of the Vettii, Pompeii* (VI, 15, *1*). A good many simple cooking utensils were found in the House of the Vettii (see plates 109–12) and have been put back on the hearth just as they were when the family cook was at her tasks: charcoal for the fire, a pot sitting on an iron tripod, other pots being kept warm at the side. The opening at the lower right was for storing firewood. Simple and plain in form, the utensils were most likely turned out locally.

204 CUPIDS AS GOLDSMITHS (*detail*). *Wall decoration, House*

of the Vettii, Pompeii. This charming picture and others like it enliven the upper band of the base of the wall in the large garden room of the house (see plate 110). Here cupids take over the goldsmith's tasks. At the left, one uses tongs to hold a piece on the anvil while another hammers it, at the right a cupid works on a gold dish, another holds some object in the oven, while yet another hunches over some task that evidently requires the utmost concentration. On a counter the finished products are set out for sale. The shopowner, an Eros like his workers, weighs a gold ornament on a hand scale in the way jewelers the world over still do, while his client, a winged psyche, looks on. There is every reason to take this as reliable evidence of the activities in a Pompeian goldsmith's shop.

204

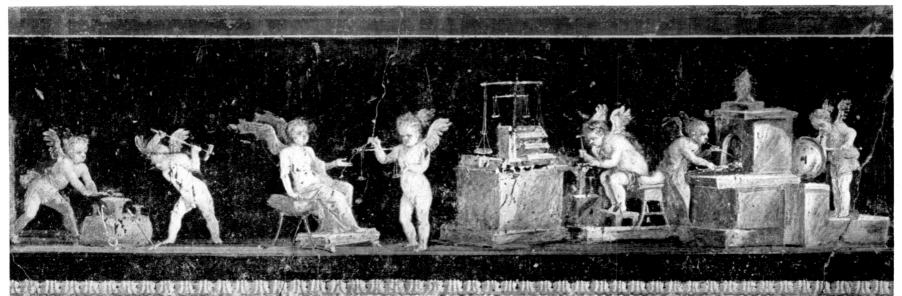

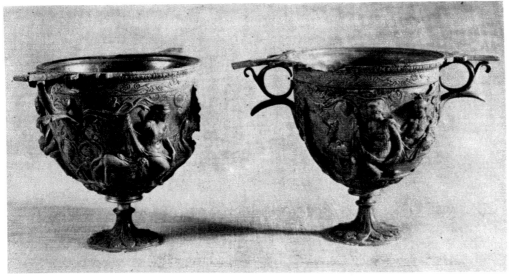

205

205-7 SILVER VESSELS, *from the House of Menander, Pompeii (I, 10, 4)*. In the so-called House of Menander belonging to the Poppaeus Sabinus family, a veritable treasure of silver objects was brought to light in 1930. No less than 118 fine vessels and utensils for eating and drinking had been carefully wrapped in cloth and laid away in a wooden chest in a cellar storeroom reached from the housekeeping rooms in the west tract of the house. Everything suggests that in A.D. 79 the house was still being renovated, so it may be that it was occupied only by the family's procurator or steward, who was there to oversee the work. This would explain why the priceless silver service was hidden away in an underground chamber. As so often with family silver, the pieces came from many different periods, and the older items show signs of use or repair.

205 TWO KANTHAROI, *with reliefs of Venus and Mars. Silver, height 4 7/8" each. Museo Nazionale, Naples*. The drinking vessels in this luxurious dinner service were often in pairs, as in these high-stemmed, two-handled goblets. With a rich foliage frieze around the rim and the bottom of the bowl, the main surface of both is filled by depictions of Mars and Venus. The amorous gods loll on a kline, she gowned and wearing a crown, the war god sprawled in front of her. The splendidly worked goblets must date from about the middle of the first century B.C.

206, 207 TWO SKYPHOI, *with scenes of country life. Silver, height 3 3/8 × 4 7/8" and diameter 3 1/4 × 4 7/8". Museo Nazionale, Naples*. The figurative scenes on these steep-sided, two-handled cups are directly in the tradition of Hellenistic reliefs of rustic life. In the first of them, a wanderer has laid down his traveling gear and sits sipping a refreshing drink in the presence of a female soothsayer. Behind her an old man squats on a low stool, in his left hand a plate for sacrificial offerings and in his right a drinking vessel. At the far right a female servant holding a bowl in her left hand busies herself at the hearth on which stands a pot. On the other cup, an oarsman steers his skiff between two rocks.

The name Apelles is written on the underside of both cups, but it would seem to belong to the dealer rather than to the artisan who made them. They have been dated in the middle of the first century B.C., and Amedeo Maiuri, who found them, attributed them to an insular Asia Minor workshop.

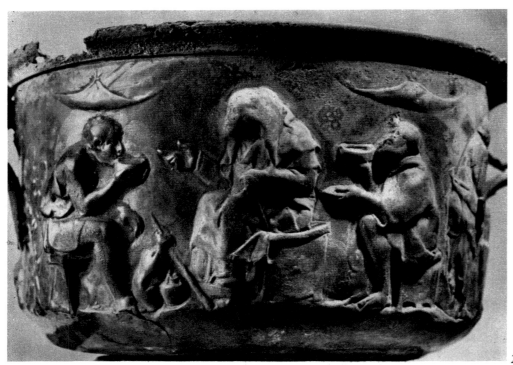

206

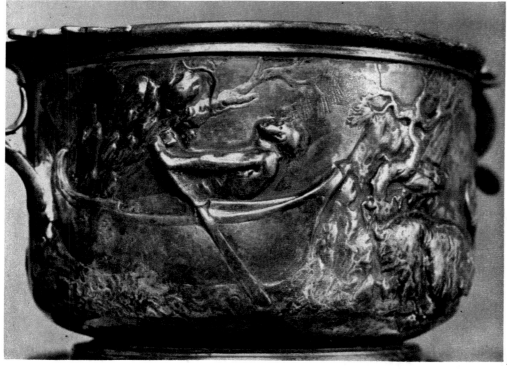

207

The enormous task of establishing a chronological order for all of the Pompeian painting from Samnite times to the year 79 was undertaken by the outstanding German scholar August Mau. In his basic study published in 1882, *Geschichte der decorativen Wandmalerei in Pompeji*, he began by investigating just how the walls themselves were constructed and found that specific decorative schemes went hand in hand with specific constructional methods which could be assigned to particular periods in time. With this as a basis he was able to identify four styles which, since his epoch-making work, have been generally accepted as fundamental to Pompeian painting.

Certainly there was opposition to his theory, beginning with his basic concept of "style." But considering that art historians commonly speak of a style as linked to an entire epoch, and that architectural historians are perfectly clear about what they mean by, say, a Doric, a Romanesque, or a Gothic style, there can be no really serious objection to the approach of Mau, in which by "style" he means the decorative system applied to an entire wall. The concept is still the most useful ever proposed and so will be retained here.

However, when it came to chronology Mau's conclusions were rather more open to dispute. Ludwig Curtius, in particular, attempted to show that the Fourth Style not only derived from the Second in stylistic traits—Mau had already pointed this out—but also succeeded it chronologically and therefore was contemporary with the Third Style. This thesis did not go unchallenged, most notably by the Dutchman H. G. Beyen, whose premature death nevertheless left him time for numerous studies which brilliantly countered and invalidated the point of view of Curtius. Not only were the categories established by Mau revived, but in the course of time they have become increasingly sharpened and refined, most notably in reference to how the Fourth Style developed in the years after the earthquake. Karl Schefold took on the task of distinguishing a Neronian style from a Vespasian style, and his conclusions have been by and large accepted by scholars, thereby leaving them free to seek out the answers to other still pending questions.

The First Style

The history of wall decoration in Pompeii and Herculaneum begins for us with the Tufa Period or, in other words, the mature and Late Hellenistic periods of the Samnite epoch. Nothing is known about the decoration of the older limestone houses, and it is futile to speculate if it involved yet another wall system, something perhaps based on broader zones such as has been found in southern Russian tombs of the fourth century B.C. When the First Style of wall decoration appeared in Pompeii—the commonly accepted date is about 200 B.C.—it was current throughout the Hellenistic world. In the Greek East it appears to have held on longer even than in Pompeii. It was still used on the island of Delos in the sixties of the first century B.C. There are examples from Attica, notably in the so-called Tower of the Winds in Athens, as well as in the cities of Asia Minor and the Greek islands and, indeed, even in the colonies on the Black Sea.

Unlike the systems of wall decoration that followed it, the First Style is not painterly but plastic. Though it utilizes color, and often with very dramatic contrasts, the chief element is stucco relief used in such a way as to imitate blocks of stone. The fields thus delineated stand out boldly on the wall surface, which consequently is articulated not only by color but by delicate lights and shadows. The aim in using stucco was to imitate the texture of a wall composed of hewn stones, while the use of color, on the contrary, derived from the incrustation technique utilized in facing interior walls with fine marble slabs.

The beginnings of this sumptuous manner of decoration are unknown, but it had great success from Roman Imperial times well into late Antiquity. If we can trust Pliny (*Naturalis Historia* xxxvi. 47) the first to make use of it was Mausolus, King of Caria in the fourth century B.C. In any case, its initial steps must be looked for in the Greek East, in those regions in constant contact with Oriental lavishness. If one does not accept Pliny's reference to the Mausoleum of Halicarnassus, then the most likely source would be the courts of the Diadochi, the successors to Alexander the Great, though we have only an inadequate idea of their fabled splendor. As early as Hellenistic times certain of the colored varieties of marble were mined and used which were to enjoy even greater favor among the Romans.

Obviously incrustation was a process of decoration so costly as to be beyond the reach of any but the most powerful and wealthiest of lords. Nevertheless, the new fashion caught on, but in the simpler and less expensive medium of painted stucco. The result was the Hellenistic style of wall decoration which spread to southern Italy and Campania and was the only system used in Pompeii up to the time Samnite independence was finally crushed.

The elevation of the wall in this system is clear and rigorous. A base zone rises from the floor level and can often reach a considerable height. Above it, and usually separated from it by a projecting stucco band, are the so-called *orthostates*, a term borrowed from Greek stone architecture and referring to the lowest zone of high, often vertically disposed blocks of stone, something the First Style imitated in paint and stucco. In painted wall decoration these pseudo-blocks are more often horizontal than vertical, as for instance in the House of the Centaur in Pompeii (plate 8) or the entrance of the Samnite House in Herculaneum (plate 170). In what must surely have been the late phase of the style, as evidenced in the House of Sallust in Pompeii (plate 292), the individual fields were once again enclosed in a real three-dimensional framework of stucco rather than relying only on illusionistic painting.

Crowned by a friezelike strip contrasting in color with the orthostates, the lower portion of the wall was closed off by a first cornice, as a rule in the same tight sawtooth pattern used in architecture of the time. Above this level are the illusionistic blocks, lined up in such a way that the middle of each block lies over the butt joint of the two blocks below it, exactly as in stone masonry but probably also as in Hellenistic wall facings using fine marble slabs. It is for this zone that the First Style usually reserved its richest colors. Often the contrasts between immediately neighboring fields are so violent that modern viewers may find the total effect somewhat gaudy. Intense red and yellow were special favorites, along with a lifelike marbling which imitated specific varieties of stone. Then, above another friezelike strip, there is a second tooth-edged cornice which is much more markedly profiled than the one above the lower zone, and it emphatically closes off the wall at the top.

In this style there is no place for either figuration or ornamental motifs. If at all present in such rooms figuration is restricted to the floor, to the richly colored mosaic emblems which reached their high point in precisely this period. Nevertheless, now and then ornamental motifs do introduce a timid note of relaxation into this severe Hellenistic system, but only in the narrow frieze bands. There are a number of examples of this in the later houses on Delos, and in this, too, Pompeii simply followed

208 AMPHORA WITH PUTTI, *from a tomb, Pompeii. Blue glass, height 12 5/8". Museo Nazionale, Naples.* This vase, one of the most sumptuous examples of the so-called cameo-glass technique, was found in a tomb on the Via dei Sepolcri outside the Herculaneum Gate (see plates 117:8, 139). The technique, in which an opaque white glass is laid over a blue glass vessel and then carved away as in cameos, was originally native to Egypt but was then taken up in Italy, though its workshops there have not yet been localized. The most one can say is that work of such high skill certainly did not originate in Pompeii itself.

Below the handles (not seen here) putti pluck clusters of grapes to either side of a kline, where one of their companions lies listening to a lyre player. On the other side of the jar, putti press grapes, and on both sides the intervening surfaces are filled with exuberant vines and fruit. The lower part of the bowl is decorated with animals under trees. The narrow-necked amphora was made in the second quarter of the first century A.D.

Following pages:

209 APHRODITE. *Marble with gold ornaments, height 12 1/4". Museo Nazionale, Naples.* The small statuette, whose surface is not well preserved, represents Aphrodite as she steps out of her bath and wrings out her hair with both hands. This type of Aphrodite-Venus is called Anadyomene because the pose first appeared in images showing the "foam-born" goddess emerging from the sea. The statue was originally nude, the drapery being a Hellenistic innovation. Beyond its intrinsic value, the statuette is a noteworthy illustration of how Roman women wore their gold ornaments on neck, arms, and wrists.

210 GOLD COSTUME JEWELRY. *Museo Nazionale, Naples.* Some of these pieces—the lower of the two double-strand, beaded armbands, the pearl earrings, and the gold circlet—came from the skeleton of a girl dug up in May, 1905, in the commune of Scafati on the opposite bank of the Sarno beyond the modern town of Pompeii. Undoubtedly a Pompeian, the girl must have fled the city at the start of the eruption only to meet her death in the open countryside: her skeleton was buried under six and one-half feet of ash. Gold-beaded armbands and pearl earrings have often been found in the excavations, so they are likely to have been produced in Campania itself. The two serpent rings come from Pompeii, and this type of hemispherical earrings in all sorts of variants has been discovered in such numbers in the Vesuvian towns that the Naples museum has more than eighty examples.

211 GOLD INTAGLIO RINGS, *from Pompeii. Museo Nazionale, Naples.* Although Pompeii had its quota of goldsmiths and gem cutters, none of these rings can be proved to be a local product. The one at the left is about one inch in diameter and its stone is inscribed CAS SIA to either side of a male figure in profile with left arm raised. It was one of a number of pieces of jewelry on the body of a woman found in the House of the Faun and has led to the supposition that the last mistress of the house was named Cassia. The next ring to the right has an early Imperial portrait, while the one next to it has a steersman's rudder, cornucopia, anchor, and what may be a thyrsus. The one at the right shows a youth alongside a horse facing right.

212 OIL LAMP, *from Pompeii. Gold, height 5 7/8", length 9 1/8". Museo Nazionale, Naples.* The large, double-flame lamp of quite remarkable length is in solid gold and is the most valuable ever found in Pompeii. The body is ornamented with a row of lotus leaves, a typical pattern on Hellenistic vessels in precious metals or their terracotta imitations. The handle has a palmetto in relief, and the lid must certainly have had similar relief decoration but it has never been found. This most luxurious lamp was made in the early years of the Empire.

213 PORTRAIT OF A YOUNG WOMAN, *from Pompeii. Wall painting transferred to panel, diameter 11 3/8". Museo Nazionale, Naples.* The portrait in a round medallion on a white ground was quite early given the name "Sappho" but has nothing whatsoever to do with the great Greek poetess. Instead, its subject is merely a young woman of Pompeii portrayed in the same gesture as the wife of Terentius Neo (plate 214). The way the hair is dressed, parted down the middle and with a hairnet to hold in the tight curls, places this charming portrait in the reign of Claudius. In execution and artistic expression it is far superior to the double portrait of Neo and his wife.

214 DOUBLE PORTRAIT OF TERENTIUS NEO AND HIS WIFE, *from a house, Pompeii* (VII, 2, 6). *Wall painting transferred to panel, 22 7/8 × 20 1/2". Museo Nazionale, Naples.* The house from which this painting was removed appears to have belonged to the brothers Terentius Proculus and Terentius Neo, the former a baker, the latter a *studiosus* (probably an attorney), as he himself states in an election appeal. It is most likely the man of learning who had himself portrayed holding a scroll—the marriage contract?—together with his wife, who holds wax tablets and a writing stylus, in all probability merely her housekeeping notes and shopping list. It is pure fantasy to imagine, as some have done, that the couple were calling attention to their literary ambitions! The picture was part of a wall decoration in Vespasian style.

215 THE SO-CALLED PLATONIC ACADEMY, *from a villa near Pompeii. Mosaic emblem, 33 7/8 × 33 1/2". Museo Nazionale, Naples.* The mosaic was found on May 31, 1897, in what was most likely a *villa suburbana* in a locality called Civita some 426 feet outside the third tower of the city wall counting from the Herculaneum Gate. A frame of masks and garlands (not included here) is characteristic of the Hellenistic tradition (see plate 103), but the emblem seems rather to date from as late as the first century A.D. In the upper right background a city wall surrounds an acropolis. In the foreground, in front of a sundial, tree, and two-columned monument with vases, seven bearded, Greek-garmented men gather on or around a semicircular bench (an *exedra* or *schola*). Three of them hold scrolls, and the third from the left seems to be drawing or writing in the sand with a staff. A globe with the courses of heavenly bodies marked on it lies in a box in the immediate foreground, and to the left there is another such box, this one half open. Repeatedly the group has been identified as the Academy of Plato, and it is a fact that the third man from the left does resemble the known portrait of the philosopher, which means that the city in the background would be Athens. The interpretation, however, is easily refuted. This could just as well be a gathering of scholars active at one of the Diadochian courts. The prototype, rather clumsily copied in this mosaic, was no doubt a Hellenistic painting. In any case, the mosaic does seem to testify to the literary and cultural interests which, at the time, were beginning to assume new prominence in Pompeii.

216 TWO COUPLES IN A SUMMER TRICLINIUM, *from a house, Pompeii* (I, 3, 8). *Wall painting transferred to panel, 17 3/8 × 18 7/8". Museo Nazionale, Naples.* A wall in the background closes off a garden where two couples sporting wreaths stretch out on klinai with drinks at hand to be taken in just such elegant silver goblets as were found in the House of Menander (plates 205–7). But while the pair to the left is lost to the world in an endless kiss, the other girl, beaker in hand, reclines on her man's breast in a state of amorous exhaustion or, it may be that she is a little tipsy. Her companion signals to a serving girl who has tactfully withdrawn from the goings-on. She has been biding her time off to one side in a grove of trees, in the company of an aulos player likewise indulging in a spot of drinking but discreet enough to turn his back on the ladies and gentlemen on the couches. A scene such as this, which could certainly not have been painted before A.D. 70, must obviously allude to a day in the life of a hetaera.

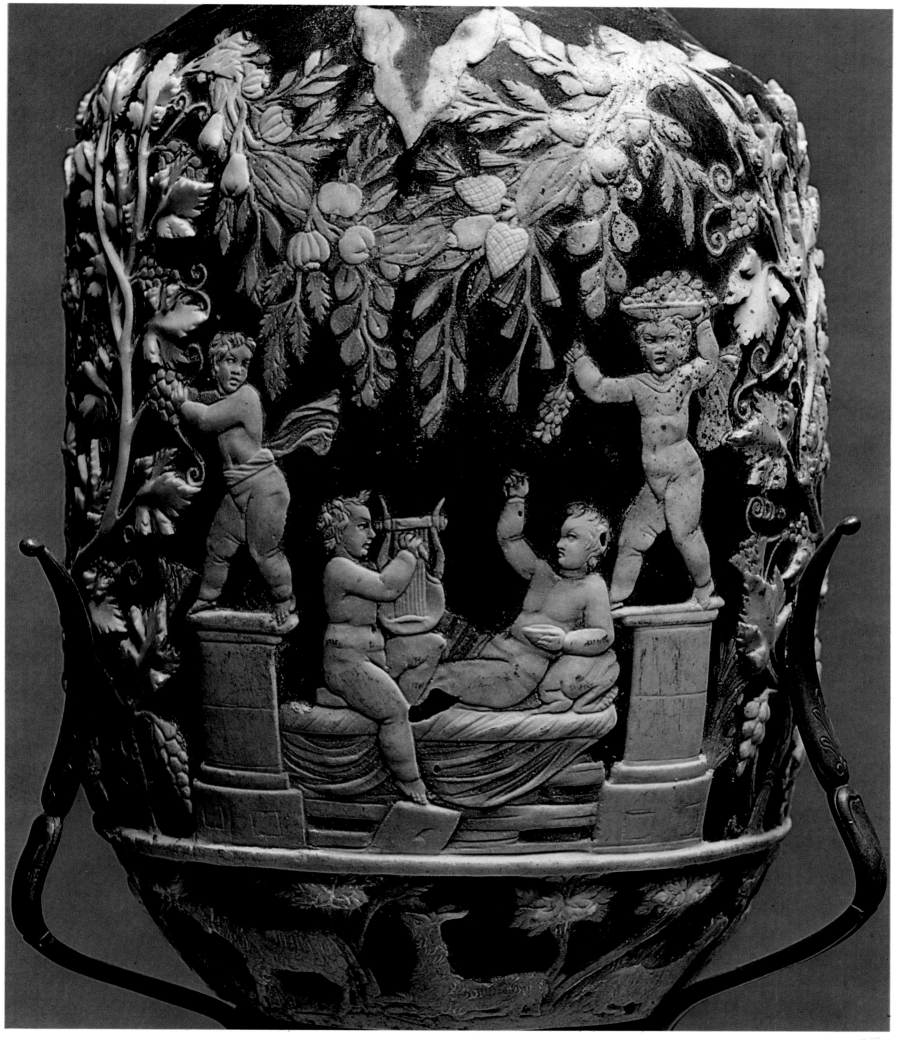

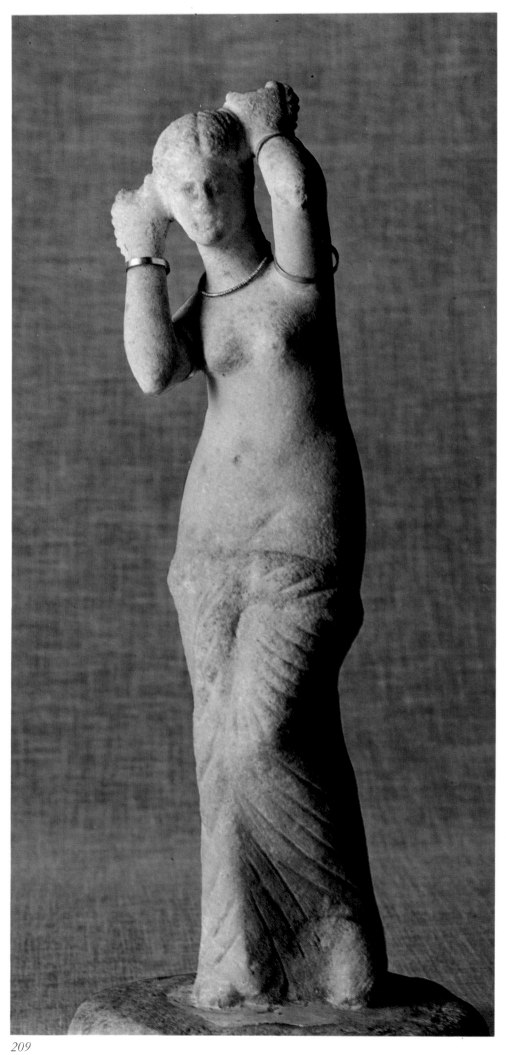

209

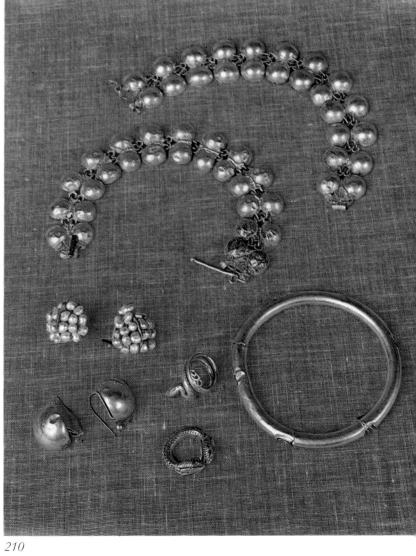

210

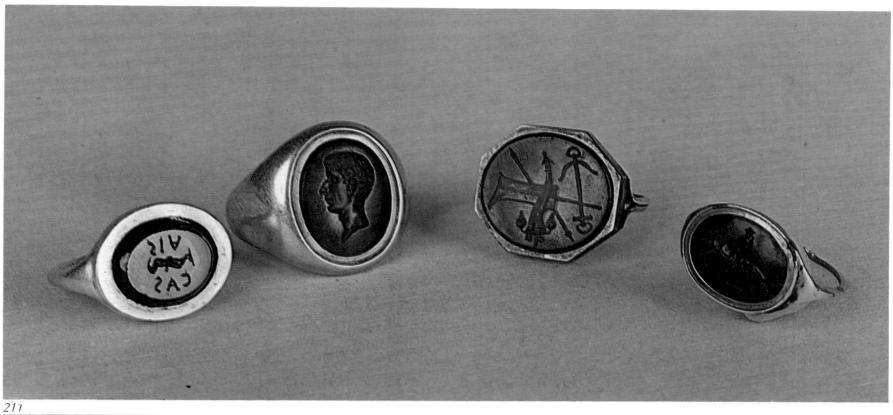

211

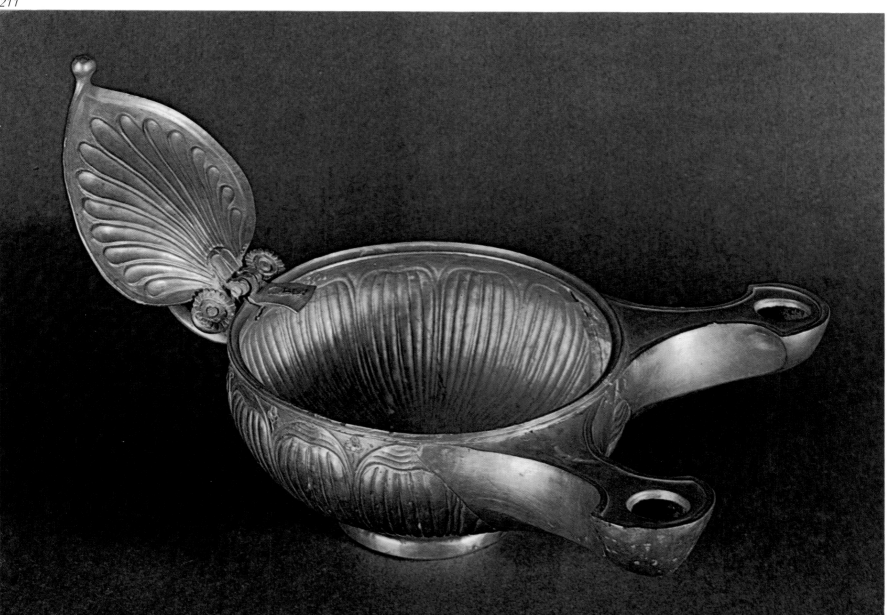

212

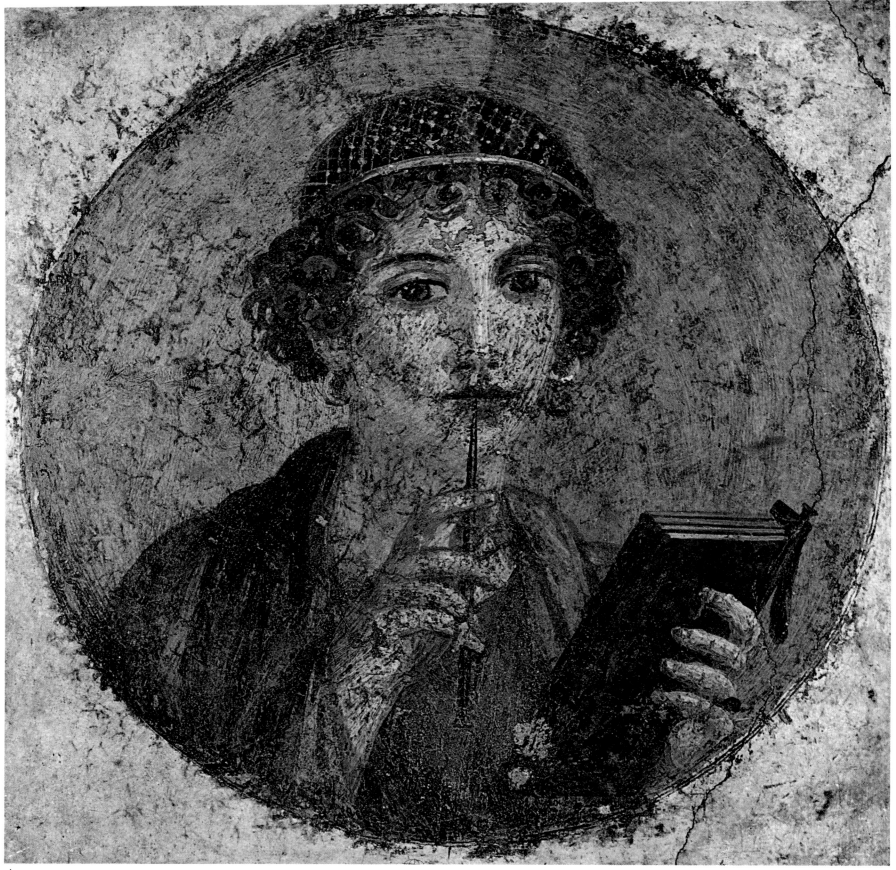

213

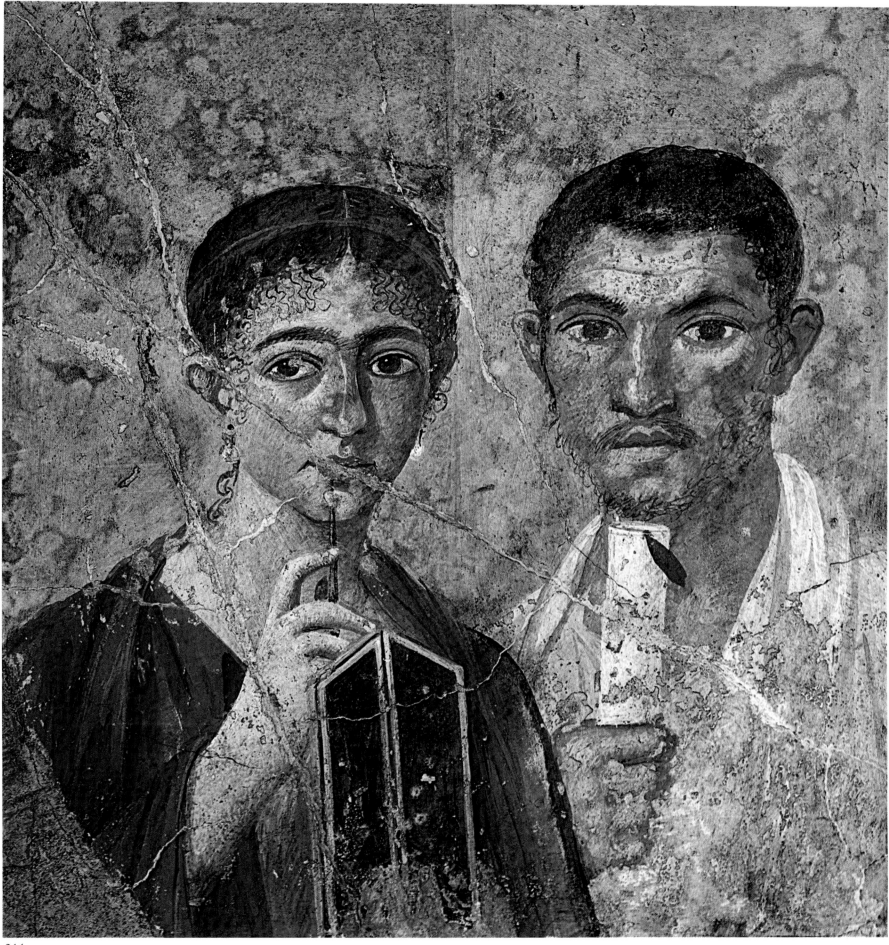

214

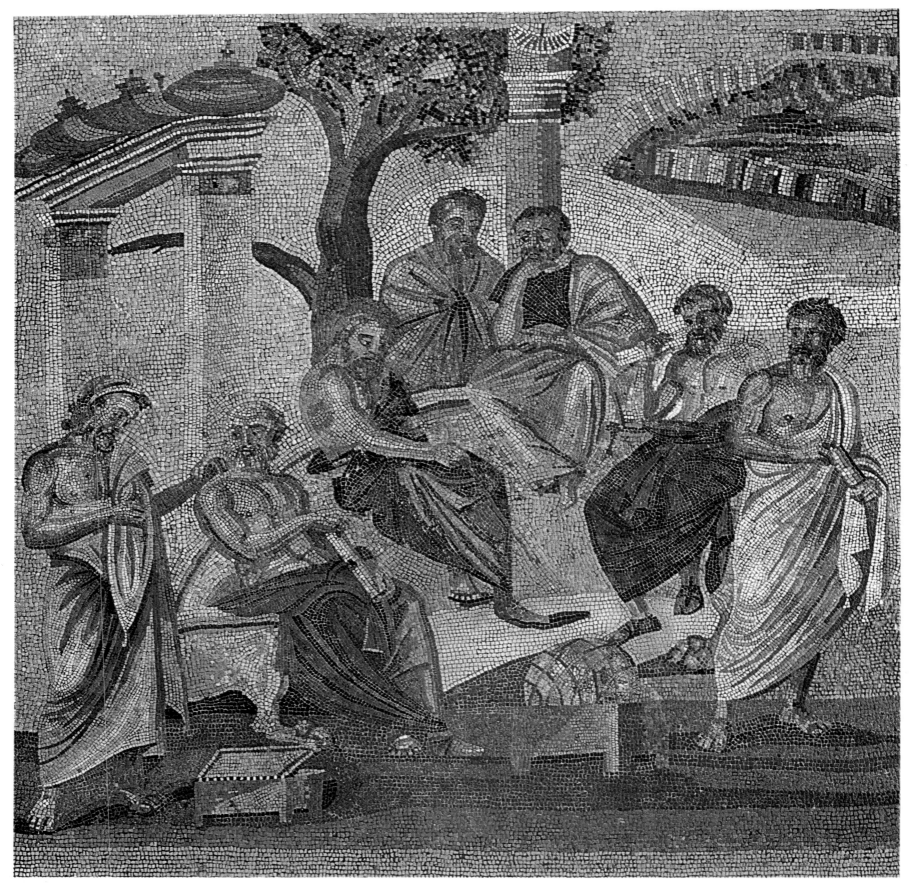

215

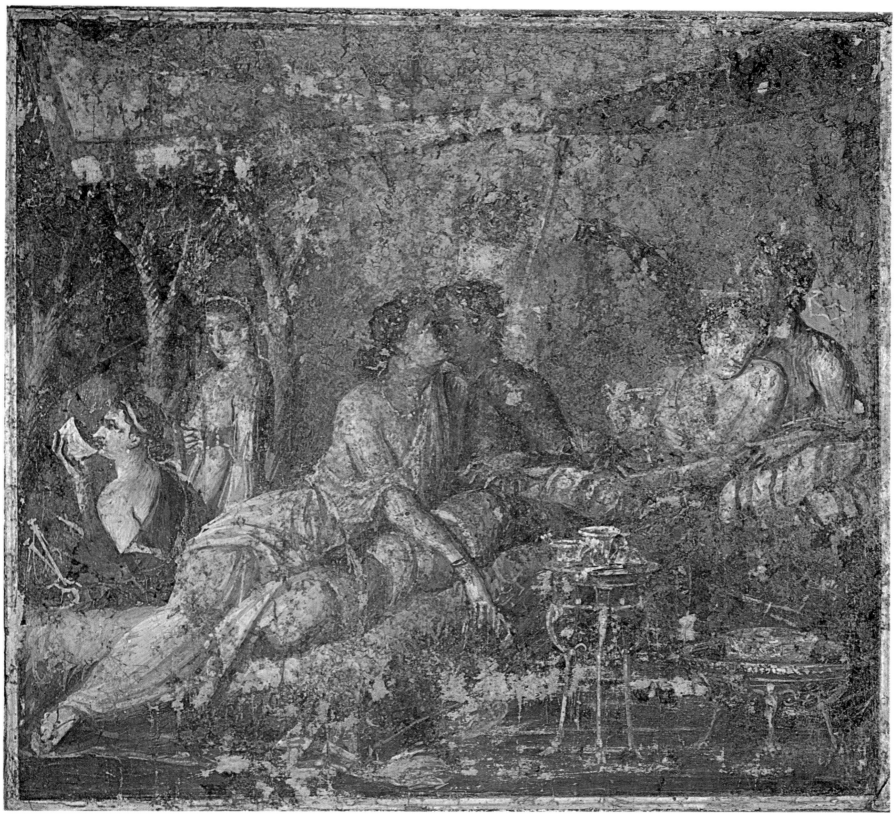

216

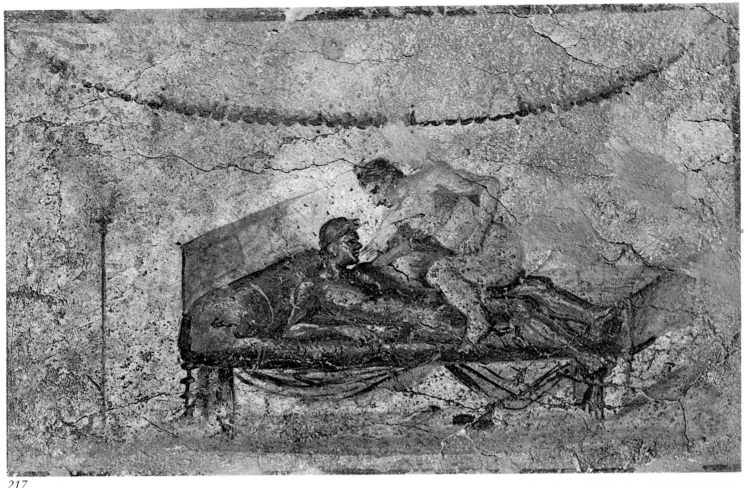

217

218

217, 218 Two erotic scenes. *Wall paintings in a lupanar, Pompeii.* Public houses and commercial sex were a normal part of living in all Roman cities, especially in ports or busy trading centers like Pompeii, which, in fact, had a number of such establishments (see also plates 223–25). The best known is the lupanar in the old part of town at the corner of the Vico del Lupanare and the Vico del Balcone Pensile (plate 219). Pictures like these were painted over the doors to the girls' cubicles, the one in plate 217 over the entrance to the first room to the left in the house, the other at the end of the corridor on the ground floor.

219 Lupanar, *Pompeii* (VII, 12, *18*). The brothel is seen here from the Vico del Lupanare. A balcony (*maenianum*) serves as a corridor for the five rooms on the upper story, and there are also five rooms on the ground floor, all of them with built-in masonry beds. The walls were decorated with the kind of paintings we have seen, and there are a great many—more than 120—obscene graffiti. From election appeals similarly gracing the walls it appears that at the time of the eruption the house was being run by two individuals named Victor and Africanus.

220

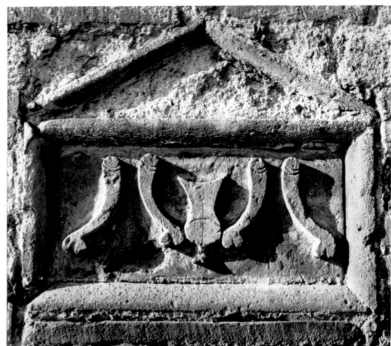

221

222

220 PHALLUS. *Relief on the wall of a house, Pompeii (VI, 5, 16).* In Antiquity the phallus appeared everywhere as a kind of totem to ward off evil and guarantee good fortune, even on the outside wall of such a modest house as this, the property of one Faventius.

221 FOUR PHALLI AND A DICE CUP. *Stone shop sign, 11 × 18 1/4" (with frame but without gable). Gambling house (taberna lusoria), Pompeii (VI, 14, 28).* The sign sums up nicely the functions of a *caupona,* a tavern with gambling downstairs and rooms for assignations on the upper story. That the house speciality was dicing is clear from an election appeal there: *aliari rog(ant),* the first word of which has often been read as *alliari*—garlic sellers (!)—but is much more likely to have been, as Matteo Della Corte argues, *aleari,* dice players. The relief was painted, and the red phalli and gray beaker make a nice effect against the dark background.

222 ARGUMENT OVER A DICE GAME, *from a caupona, Pompeii (VI, 14, 36). Wall painting transferred to panel. Museo Nazionale, Naples.* Two players face each other across a table. The one at the left raises his dice cup and calls: *"exsi"* ("I am out," meaning "I have won"). His opponent, however, contradicts him: *"non tria, duas est"* ("that's not three but only a two!"). The tavern from which the picture came was run by a man named Salvius, who apparently rented it from the Poppaeus family since the adjoining entrance leads to a workplace of Politus Poppaei Sabini. His name tells us that he was a tenant (or freedman) of a Poppaeus, and, the fact is the fine house next door belonged to C. Poppaeus Firmus.

223–25 TAVERN SCENES, *from a gambling house, Pompeii (VI, 10, 1). Wall paintings transferred to panel. Museo Na-*

223

224

225

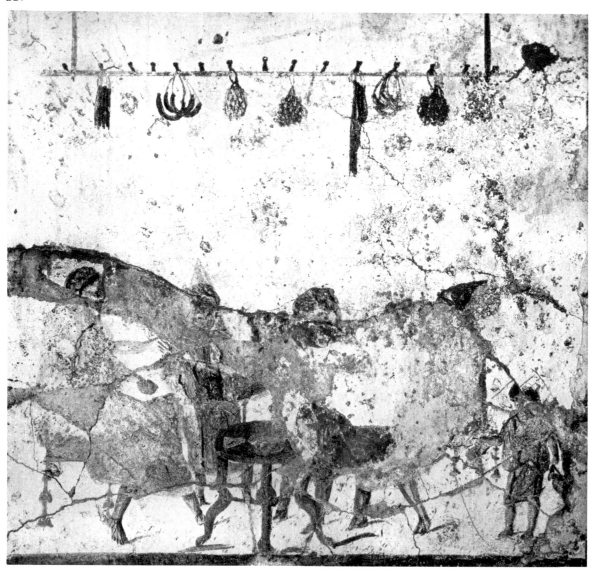

zionale, Naples. As in every Roman port or commercial center, there was no shortage of inns in Pompeii. The caupona from which these paintings came was located in a busy part of town, not far from the Forum at the intersection of the Via di Mercurio and the Vico del Lupanare. A room used as thermopolium opened out on the Via di Mercurio, and off it was a sleeping room with its own door on the less busy side street, and this was decorated with scenes from the daily—or nightly—life of a public house. A side corridor to the right led past the food counter of the thermopolium to a small bedroom whose erotic paintings leave no doubt as to its purpose.

223 A guest seated on a bench holds up a glass beaker while a waiter whispers something in his ear—a tip on a business deal? an assignation?

224 Four men sit or stand around a three-legged table. The third man from the right appears to have just jumped up in agitation, his outburst obviously directed against his opponent at the other end of the table, who holds a glass in his left hand and a smaller vessel in his right. The waiter at the left and a man at the right intervene to calm the uproar. It is hard to say if the men are merely drunk or are squabbling over their dice game.

225 Though the picture is badly damaged in the center, one can make out four men, two of them wearing hoods (cuculli), who are eating and drinking around a table with the same type of curved legs as in the preceding picture. The man on the right raises his glass to his mouth, his neighbor reaches into a pot. At the right margin a tiny waiter or serving boy looks on. Sausages and cheeses and other foods hang on the walls, as they still do in Italian eating places.

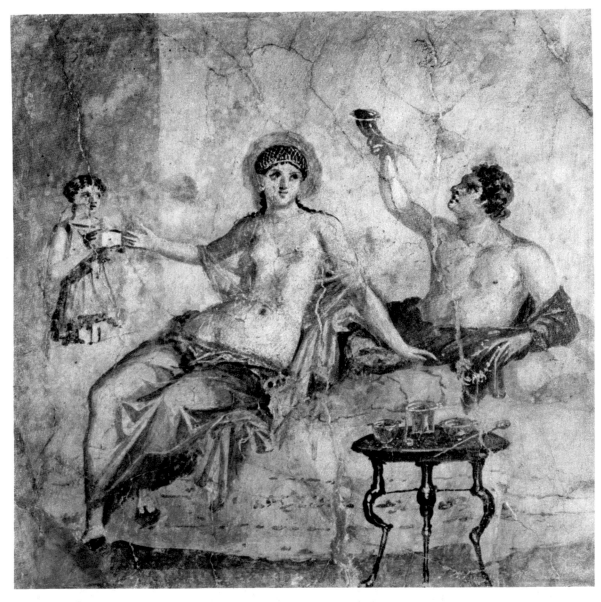

226 CAROUSING COUPLE, *from Herculaneum. Wall painting transferred to panel, 23 1/4 × 20 7/8″. Museo Nazionale, Naples.* In this picture, painted about A.D. 70, a half-naked young man stretches out on a kline and lifts a drinking horn (*rhyton*) to his lips. In front of him sits a girl whose upper body is more displayed than concealed under her see-through garment and who wears a close-fitting net over her tight curls. Within handy reach of the couch, a three-legged table holds everything necessary for mixing drinks. There is no doubt about what is going on here, nor about what the young lady does for a living.

226

227

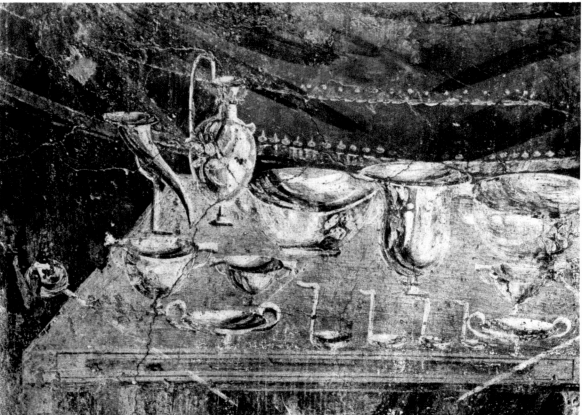

227 SILVER DRINKING VESSELS (*detail of a painting*). *Tomb of C. Vestorius Priscus outside the Vesuvius Gate, Pompeii.* In a painting on the rear wall of the east ambulatory of this tomb (see plate 138) one sees a table on which silver drinking vessels are disposed: at the back of the table two *rhyta,* two pitchers, and two skyphoi frame a tall goblet; in the foreground, kantharoi and *kylikes* (bowls on tall stems) surround four *simpula* (ladles). Below (not seen here) are a high-handled pitcher and a bowl with a long handle. The depiction of drinking vessels in tombs already had a rich tradition in Italic regions before the Roman conquest, and probably had to do with libations or banquets for the dead.

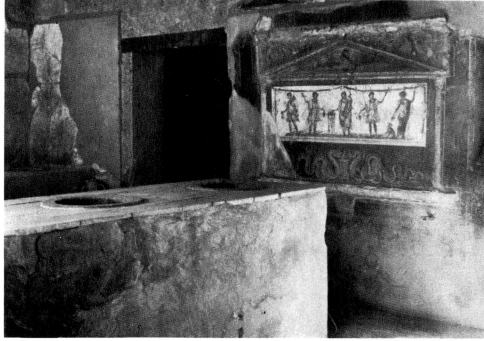

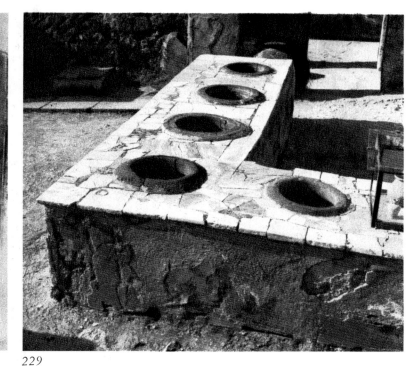

228

229

228 THERMOPOLIUM ON VIA DELL'ABBONDANZA, *Pompeii* (I, 8, *8*). *Thermopolia* were shops selling warm food and drink to be consumed on the premises or taken out, something still existing everywhere in the Mediterranean regions today. Food was kept warm in pots set into round openings in the counter. On the right here is the shrine of the Lares: the usual motif of an altar flanked by serpents is surmounted by a painting of the household genius and the Lares offering a sacrifice. At the left is Mercury, god of commerce, and at the right Bacchus, god of wine: a perfectly logical allusion to the nature of the shop which must have enjoyed a lively business, situated as it was on the most frequented street in the city.

229 THERMOPOLIUM, *Herculaneum* (IV, *15–16*). This "ready-to-eat" shop likewise had an excellent location, on the southwest corner of Cardo V and Decumanus Inferior (see plate 142). The counter was faced with marble, the vats for food were, as usual, in terra-cotta. At the right

can be seen a few small vessels found there. In the background, left of the door, is a bin for provisions. The taberna was directly connected with a dwelling, which suggests that they had the same owner. This is unlike most such thermopolia which had, at the most, very modest living quarters on the upper story.

230 AMPHORA BEARERS. *Tufa stone relief, height c. 15 3/4".* *Wine shop, Pompeii* (VII, 4, *16*). On a plaque set into a brick wall two men are shown carrying a wine amphora slung by its handles from a pole they support on their shoulders. Both men have sticks or staves. Of fairly crude artisanal quality, the relief served as a sign for a wineseller at the corner of Via degli Augustali and Via del Foro. It was painted, with the men reddish brown and the amphora yellow, with traces of blue in the background.

231 AMPHORAS. *Tavern on the Via dell'Abbondanza, Pompeii* (I, 12, *3*). In ancient times wine was stored and transported in large two-handled amphoras. The

export trade flourished, as can be seen from the seals and addresses on the vessels, and a much-prized wine was produced in Pompeii itself and shipped out in quantity. One of the most used forms of amphoras was pointed at the bottom and ended in a kind of spike so that the jar could be made to stand upright in sand or earth. Though we think of them as works of art, empty amphoras were piled up as casually as modern bottles, as here in a tavern courtyard.

232 WINE RACK. *House of the Mosaic of Neptune and Amphitrite, Herculaneum* (V, *6–7*). The house, whose garden triclinium we have seen (plates 142: *XLIII,* 163), included a tavern to the right of its entrance which connected directly with the living quarters. Enough of the charred wood remained to make it possible to reconstruct a rack providing two rows of semicircular supports for amphoras, where the wine could be properly cradled in the manner still in use today. Above the rack there is a glimpse of an upper story whose floor no longer exists.

230

231

232

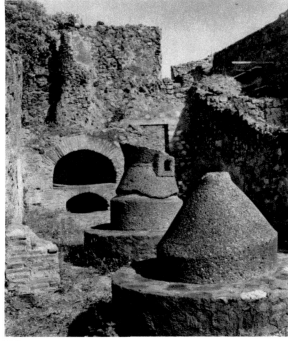

233

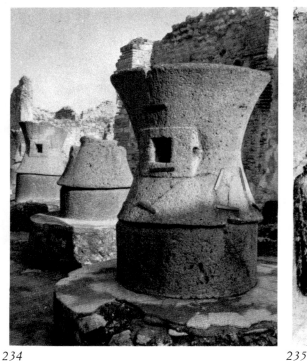

234

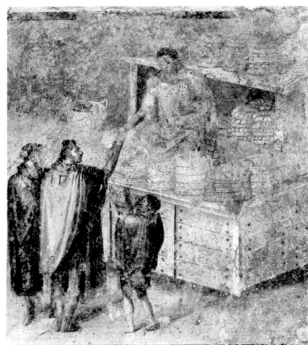

235

233 BAKERY ADJOINING THE HOUSE OF SALLUST, *Pompeii* (VI, 2, 6). The entrance at the left end of the street front of this distinguished house opened on a bakery (*pistrinum*) whose premises were not otherwise connected with the house and were obviously merely rented from its last owner, A. Cossius Libanus. First came the mill room with its three mills (*molae*). The conical nether millstone (*meta*) sits on a base, and over it is fitted an hourglass-shaped upper millstone known as the runner (*catillus*). An iron pivot in the apex of the *meta* keeps the *catillus* just far enough above it to permit it to revolve freely (if it sat directly on the nether stone this would be impossible) and yet grind out a fine flour. Two rectangular openings opposite each other held the wooden beam which turned the millstone and was generally operated by slaves or a beast of burden. The grain was poured into the funnel at the top and then, when ground, ran out over the base, which presumably had some sort of wooden receptacle to catch it, though some mills had grooved base stones with high rims. In the background here is the oven. Its

lower opening served for the fire, its upper and larger opening extends on a rectangular gullet leading into the oven chamber. Smoke was drawn off through a chimney. By and large, the pizza ovens, so much a feature of Naples today, are not much different. The door in the background led to a room where the dough was prepared and kneaded. Beyond the low wall at the right there was a kitchen, and there were living quarters upstairs.

234 BAKERY, *Strada Stabiana, Pompeii* (IX, 1, 3). This was a larger bakery on one of the principal arteries of the city, and it had a shop where its flour was sold.

235 BREADSELLER IN A PUBLIC SQUARE, *from the House of the Baker, Pompeii* (VII, 3, 30). *Wall painting transferred to panel, 22 × 19 5/8". Museo Nazionale, Naples.* The painting, part of the Fourth-Style wall decoration in the tablinum of the baker's house, shows him selling the typical Roman bread (see plate 236) from a wooden stand set up on the Forum or some other public square rather

than across the counter in his own shop. Without having to stand up, he hands his customers—a man accompanied by another man and a boy—a bread of the sort piled up on a ledge behind him. In the left background there is the wicker basket he must have used to carry the bread to the market.

236 FOOD FOUND IN THE EXCAVATIONS AT POMPEII. *Museo Nazionale, Naples, and Antiquarium, Pompeii.* At the upper right is the typical Roman round bread, notched to make it easier to break off chunks. There was quite an assortment of breads: wheat, barley, millet, or oat. Here, too, from upper left to lower right, are eggs, hazelnuts, almonds, and dates.

237 OIL PRESS. *Via degli Augustali, Pompeii* (VII, 4, 24–25). The shop belonged to the Numisii, and the citizens we know by that name—Jucundus, Secundus, and Victor— no doubt all belonged to the same family. Numisius Jucundus and Secundus both turn up in an inscription in

236

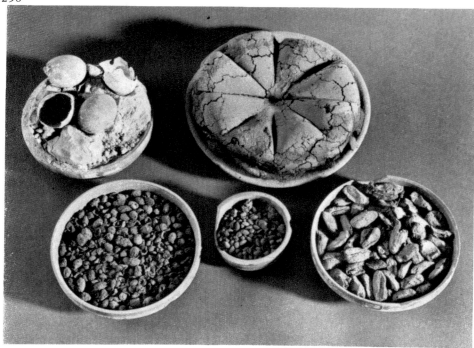

237

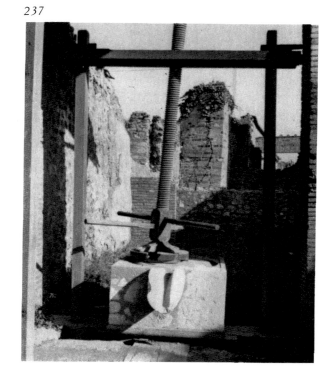

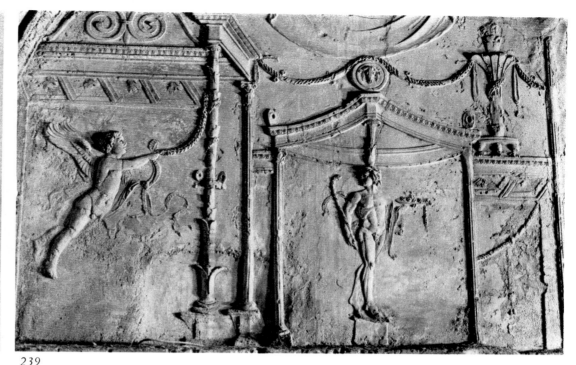

238

239

Rome from A.D. 80 which says they moved there soon after the earthquake and so were spared the eruption of Vesuvius. The oil press, as reconstructed, has the usual form, with a vertical screw set into a crossbeam and turned by a horizontal winder. Four levers lowered it on the olives whose oil ran out into a circular channel in the base stone and thence, through a lip, into a vessel.

238 PAINTER'S SUPPLIES, *from Pompeii. Museo Nazionale, Naples.* After the earthquake there was a great demand for painters and stuccoists to repair the extensive damage to public buildings and private houses. Although not entirely unique, such a store of ancient paints as was found in Pompeii is certainly a great rarity. Before being applied to the still moist plaster on the wall (see p. 156) the pigments had to be mixed with limewater as a binding agent to give them their durability and vitality.

239 STUCCO WALL DECORATION, *Men's apodyterium,*

Stabian Thermae, Pompeii. The delicately traced fantasy architecture unquestionably points to Flavian times, and the motifs are those of Fourth-Style wall painting. Nevertheless, in something like the two delicate supports for the entablature at the left, one realizes that stucco is not the ideal medium for rendering perspective, and even the three-cornered pavilion where a satyr substitutes for a column does not succeed in conveying the illusion of space. The soaring Eros is a good example of the full-bodied treatment of the human figure in those years.

240 HOMERIC SANCTUARY, *House of the Sacello Iliaco, Pompeii* (I, 6, 4). The house, which gets its name from the small chapel (*sacellum*) with scenes from the *Iliad,* is actually part of the larger House of the Cryptoporticus. The small room to the right of the tablinum may have been a household shrine. When disaster struck in A.D. 79, only its barrel vault and the stucco frieze below it had been redone, and the walls had not yet been plastered. The

lovely decoration of the vault, with its centerpiece of Ganymede and the eagle, is an ingenious combination of Fourth-Style architectural stuccoes and painting. The small frieze depicts the combat and death of Hector as recounted in the *Iliad.* In the portion seen here, the Trojan hero's body is dragged by a horse and, at the right, his father Priam enters Achilles' tent to ransom the body for proper burial. Where the stucco has fallen away we can see how the preparatory drawing was incised into the surface to guide the painter.

241 CHALK FOR PLASTER. *House of the Sacello Iliaco, Pompeii.* In the courtyard of the house, where renovation was still going on, there were piles of chalk waiting to be ground into plaster. At the time of the eruption, entire rooms and courts in many houses were still uninhabitable, cluttered as they were with building and decorating materials.

240

241

242

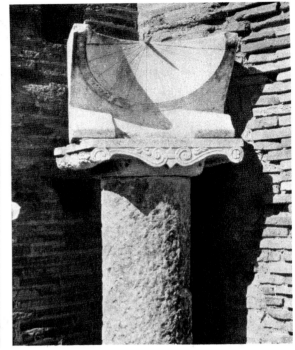

243

242 COURT OF THE MACELLUM, *Pompeii.* The Macellum was the central market of Pompeii. Here, in its courtyard, the circle of pillar bases marks the round pavilion where fish was sold. Behind it was a chapel presumably dedicated to the Imperial cult. The market was under municipal authority, and prices and weights were rigorously controlled. On the opposite side of the Forum stood the *mensa ponderaria* (plate 244), where weights and measures were checked against official standards.

243 SUNDIAL ON THE STONE DEPOSITORY AT THE FORUM, *Pompeii.* The earliest instruments used by the Romans for measuring time were sundials (*solaria*), and they were set up everywhere, in private homes as well as on public squares. The construction was simple: a convex half circle cut from a block of marble was fitted with a metal indicator (*gnomon*) whose shadow, changing with the position of the sun, fell on lines drawn on the face of the dial, which were calibrated to mark the divisions of time. Obviously it was not a precision instrument, but then neither are those on medieval or even modern church towers.

244 MENSA PONDERARIA ON THE FORUM, *Pompeii.* The *mensa ponderaria* served for the control of weights and measures by the public authorities (see p. 27). The grain or other substance to be checked was put into the receptacles seen here which, originally, were calibrated according to Samnite standards but were adapted to Roman measures in the late first century B.C. by the duoviri A. Clodius Flaccus and N. Arcaeus Arellianus Caledus, as the inscription on the front of the table states.

245 SCALE. *Bronze, length of beam 11". Museo Nazionale, Naples.* Among the various hand scales for weighing smaller quantities there were either precision instruments for tiny amounts of precious metals (see plate 204) or rough but fairly accurate devices like the one seen here for use in markets and shops. On Roman scales the weight that was moved along the calibrated horizontal beam generally took the form of a bust. Here it is a Minerva in armor with a winged Gorgon's head on the breastplate. The crest of her helmet hooks on a loop suspended from the scale arm. This well-made piece must date from early Imperial times.

246 STONE WEIGHTS IN THE STONE DEPOSITORY ON THE FORUM, *Pompeii.* Heavy-duty weighing generally called for stone counterweights like these. In the form of thick discs, they could obviously only be used on a large apparatus. The basic Roman unit of weight was the *libra*, equivalent to 327.45 grams, something like 12 ounces and,

244

245

246

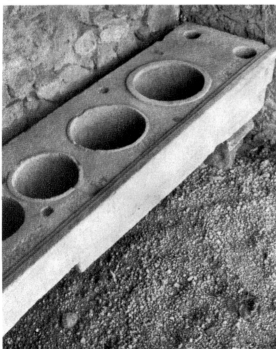

in fact, divided into just that number of *unciae*. The weight it represented was incised into each stone. Here the one at the left in the second tier from the bottom still bears the number XXX.

247 JUPITER, *from the Temple of Zeus Meilichios, Pompeii. Terra-cotta, height 6′7/8″. Museo Nazionale, Naples.* The statue was found in 1766, together with a terra-cotta statue of Juno and a bust of Minerva, in the cella of the Temple of Zeus Meilichios (plate 10). It was still standing in place on the podium. The damage these statues showed—a hand and the left foot of the Jupiter were broken—could therefore only have occurred during the eruption of Vesuvius. From this fact it was deduced that the Capitoline trinity was moved to this much smaller temple after the earthquake because the large Temple of Jupiter had been hard hit. This statue is a free reworking of a Greek prototype.

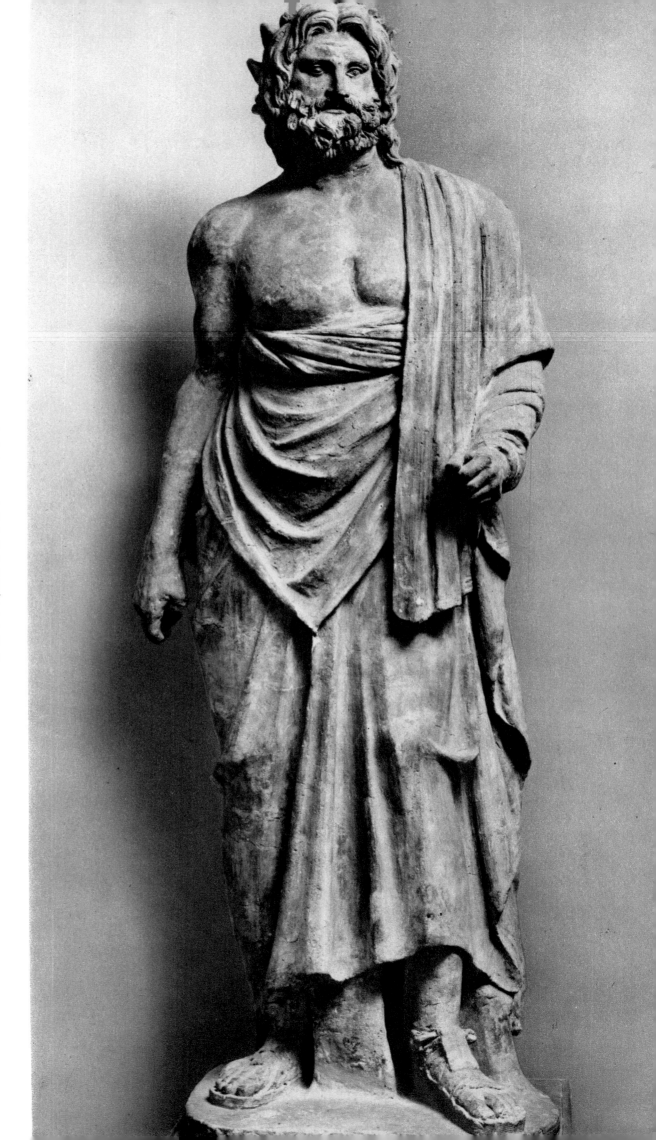

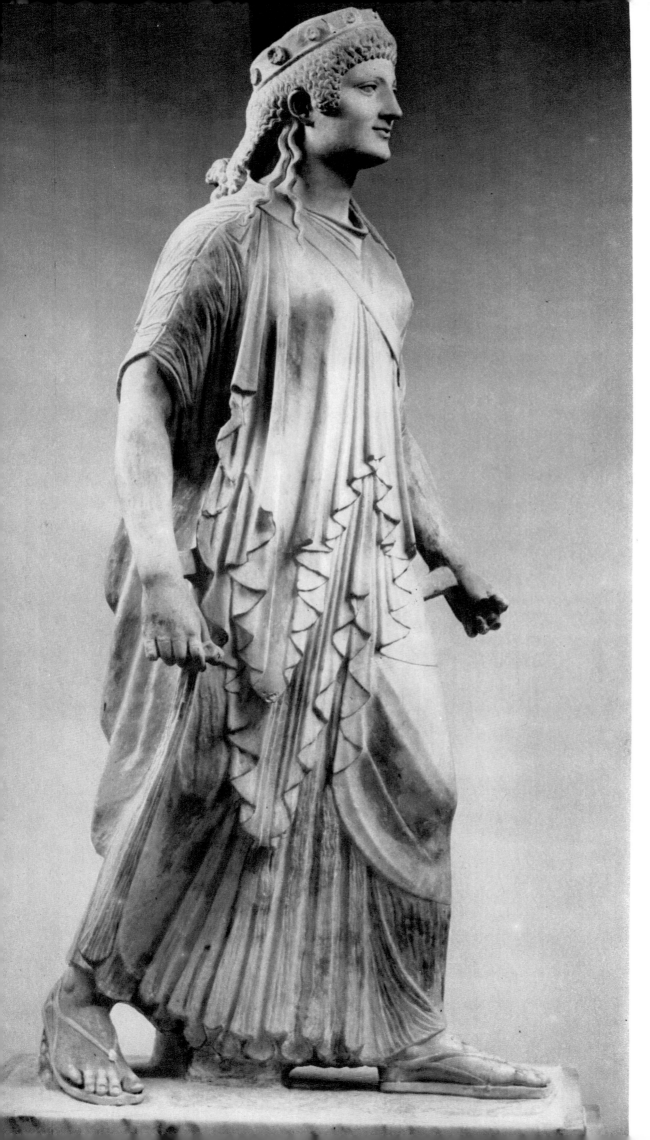

248 ARTEMIS, *from the House of Marcus Holconius Rufus, Pompeii* (VIII, 4, 4). *Marble, height 45 5/8". Museo Nazionale, Naples.* Artemis appears here with bow and arrow as goddess of the hunt. Her quiver hangs from a broad shoulder strap, and she wears a diadem. The prototype is thought to have been a statue of Artemis from sometime between 500 and 480 B.C. which was looted from Segesta in Sicily by the tyrannical praetor Verres and brought to Rome, where it was reproduced on various coins during the reign of Augustus. The Pompeian statue, of which other marble replicas are known, was sculpted toward the middle of the first century B.C. in a deliberately archaistic style.

249 APOLLO CITHAROEDUS (detail), *from the House of the* ▷ *Citharist, Pompeii* (I, 4, 5). *Bronze. Museo Nazionale, Naples.* Holding in his lowered right hand the plectrum used in playing the cithara (the Greek *kithara*), the nude god raises his left arm—suggesting that the statue was utilized as a *lychnouchos*—to hold a candle or torch. Composed in the classical rhythm of the fifth century B.C., the soft modeling of the slender nude body would seem much more to place it in the fourth century, as does the head, despite the archaizing corkscrew curled hair. The fact is, however, that the work is an eclectic creation by a southern Italian master of about 30 B.C.

Following pages:
250 PERSEUS LIBERATING ANDROMEDA. *Wall painting, 53 1/8 × 35 5/8". West wall of the triclinium, House of the Sacerdos Amandus, Pompeii* (I, 7, 7). Andromeda was the daughter of King Cepheus of Ethiopia and of Cassiopea. When her mother boasted that Andromeda was more beautiful than even the nereids, Poseidon in rage unleashed on the city a sea monster which devoured beasts and men alike. The oracle advised Cepheus that his land could be saved only by delivering up his daughter to the foul creature. Chained to a rock in the sea, Andromeda would surely have perished had not Perseus slain the monster and liberated her, receiving her hand in marriage as reward. The painter of this Third-Style work combined two scenes: in the foreground Perseus swoops down to slay the monster while Andromeda waits chained to her rock, in the right background Cepheus welcomes the triumphant hero.

251 ATYS AND A NYMPH (detail of a wall painting). *House of Pinarius Cerealis, Pompeii* (III, 4, 4). The shepherd Atys was beloved by the goddess Cybele but betrayed her for a mere nymph. Punished with madness he emasculated himself and was metamorphosed into a fir tree. Here the myth seems acted out as if on a stage, in front of an imposing *scaenae frons* in the Fourth Style. Atys, dressed in Eastern garments (he was Phrygian) and with shepherd's crook and the castrating sickle in his hands, has his attention directed by a small love god to a half-nude young woman below, identified as a water nymph by the amphora lying by her side. Two other nymphs on the left (not seen here) complete the scene, whose composition very much suggests a theatrical presentation.

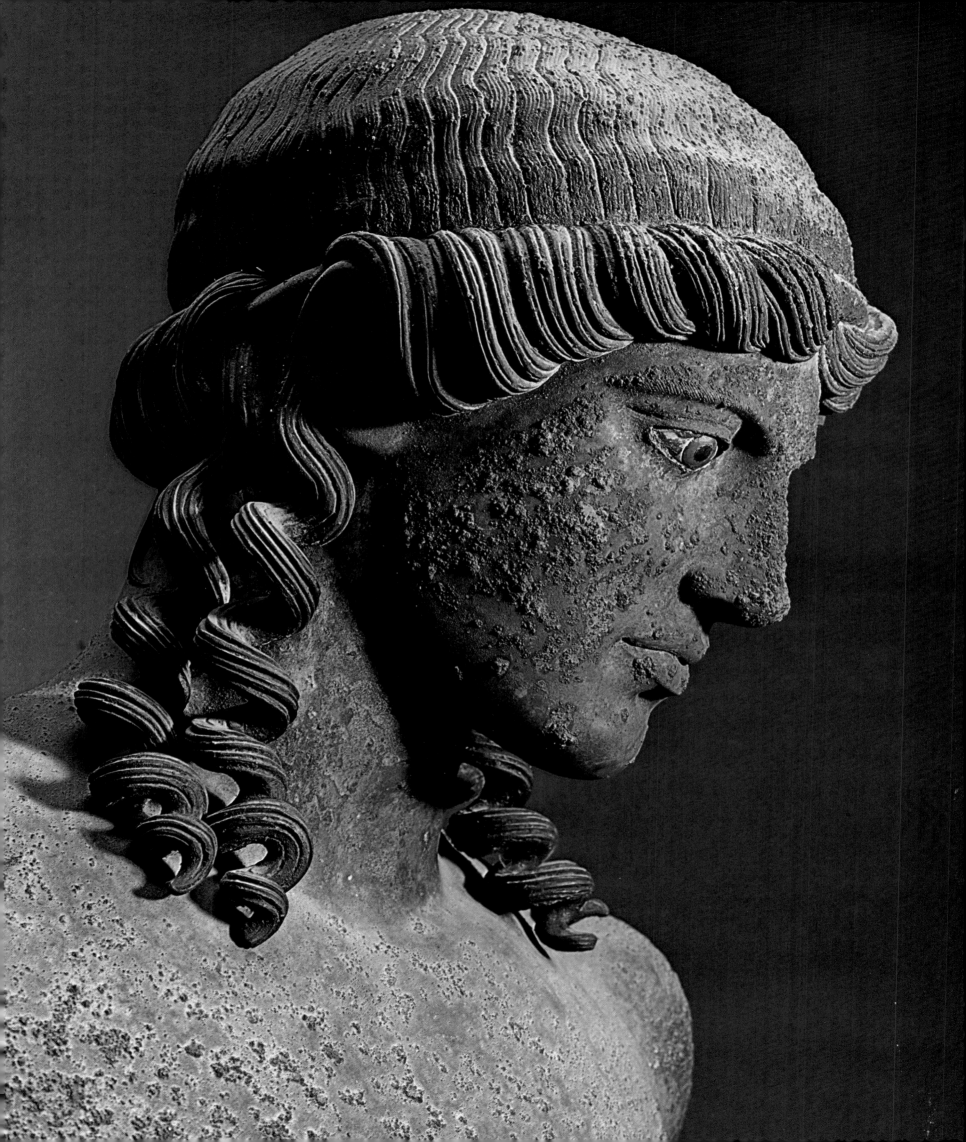

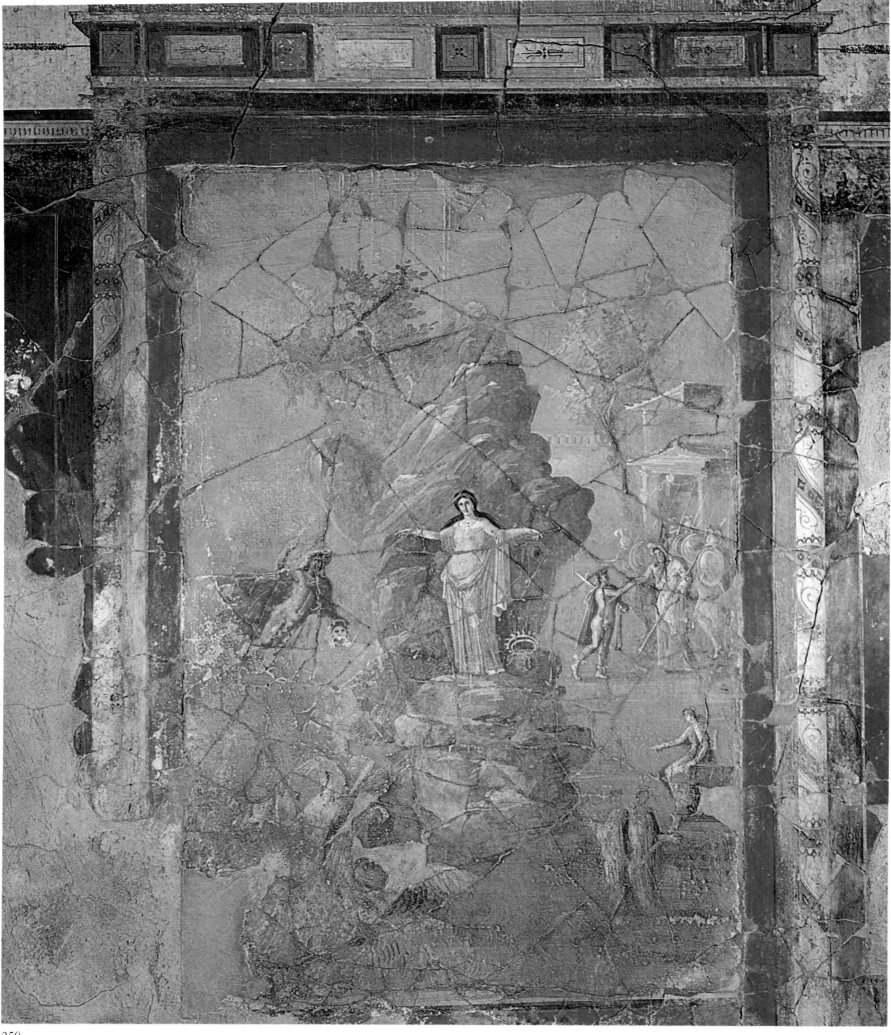

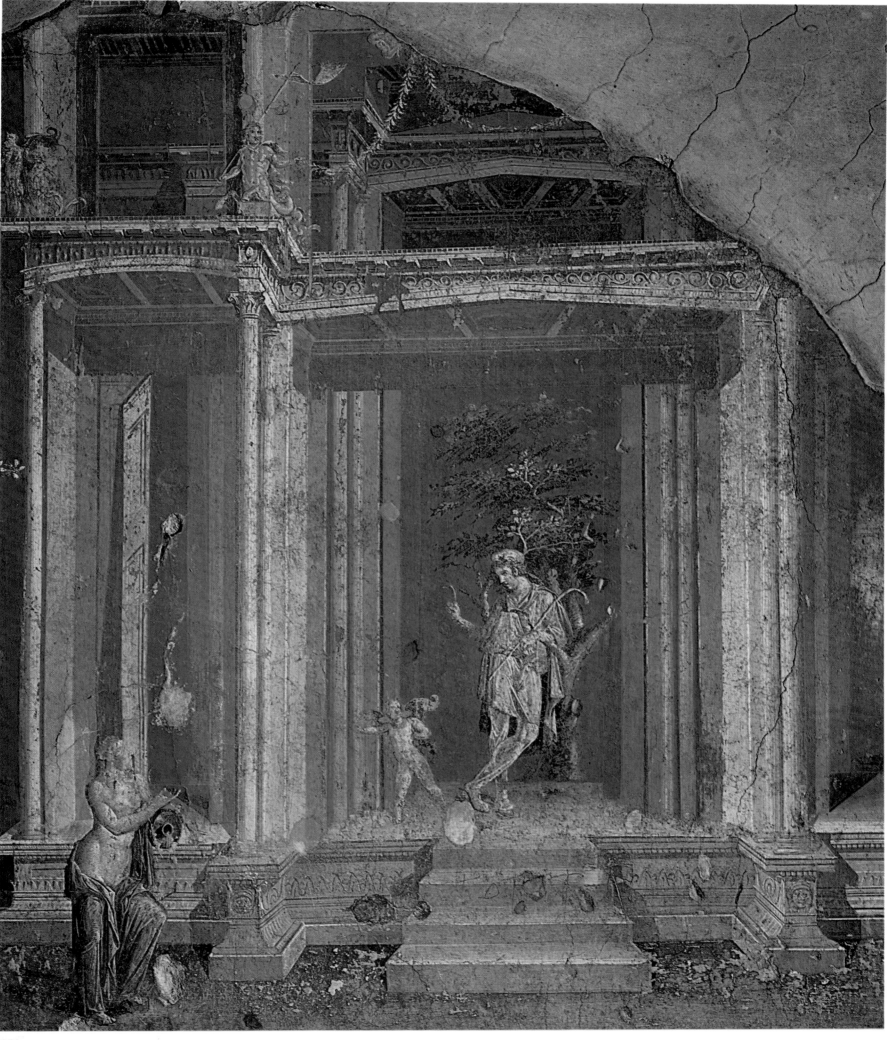

251

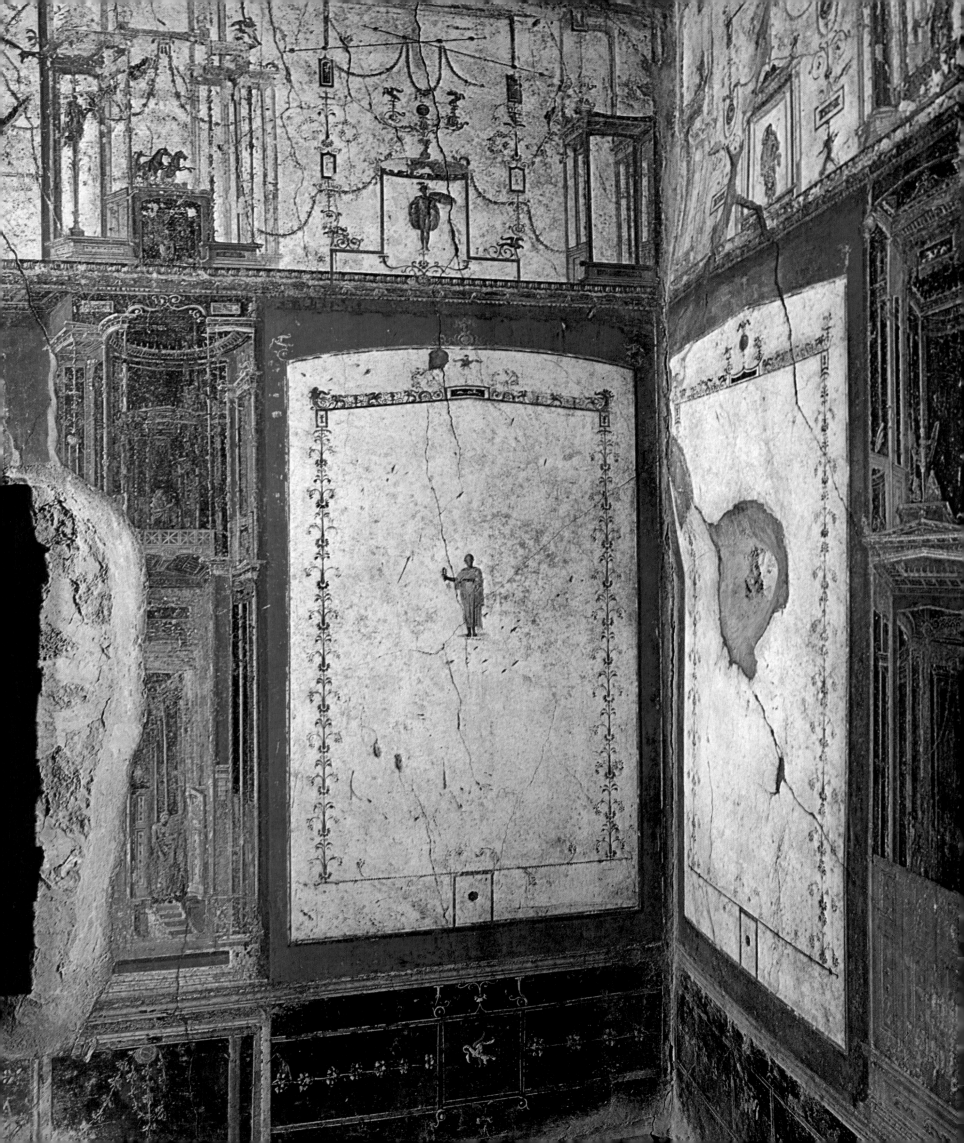

252 SACELLUM, *House of Loreius Tiburtinus, Pompeii*
(II, 2, 2). At the west end of the transverse terrace
beyond the euripus (see plate 89) there is a room whose
front resembles that of a small temple. Decorated in the
Fourth Style of the time of Nero, the room has a niche
in the west wall which once held a statuette of Isis. In the
right field of the south wall, seen·here, there is a priest of
Isis in the prescribed long white garment and with shaved
head (compare plate 256) who holds a *sistrum*—the rattle
used in the worship of Isis—while a *situla*, the bucket used
for ritual lustrations, hangs from his left arm. The two
lines of the inscription beneath his feet are generally read
as *amplus alumnus Tiburs,* the highly regarded disciple of
Isis from Tibur (Tivoli).

253 FEMALE HEAD, *from the Temple of Isis, Pompeii.
Marble, height 11 5/8″. Museo Nazionale, Naples.* The
head was found along with two others in a kind of chest
or shrine in the lararium on the east side of the Temple of
Isis (plate 254). Originally set into a full-length statue,
the delicate face, despite its Aphrodite-like character, has
much in common with a Ptolemaic portrait. The lovely
head dates from the early Empire and is probably a vestige
of the decoration in the earlier Temple of Isis destroyed in
the earthquake.

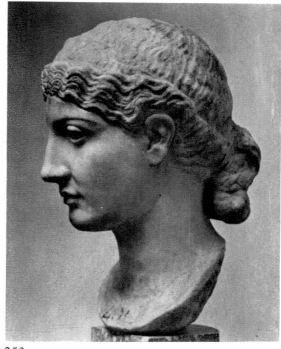

253

254 TEMPLE OF ISIS, *Pompeii.* Rebuilt after A.D. 62
by the freedman Numerius Popidius Celsinus in the name
of his six-year-old son, the Temple of Isis was one of the
first sanctuaries to be restored to function after the earth-
quake. It is set in a precinct surrounded by porticoes and
rises from a podium crowned by an Egyptian-style hollow
molding. In the niches to either side of its front (only the
one to the left is visible here) there were no doubt orig-
inally statues, though they have never been found and
were perhaps removed by the priests when Vesuvius
showed signs of becoming dangerous. The altar stands
crosswise at the foot of the stairs, and behind it is a small
but richly stuccoed building in which perhaps the sacred
water from the Nile was kept.

255 THE COMING OF IO INTO EGYPT, *from the Ecclesiaster-*
*ion, Temple of Isis, Pompeii. Wall painting transferred to panel,
54 3/4 × 53 7/8″. Museo Nazionale, Naples.* Because
Zeus loved her, Io was metamorphosed into a cow by
Hera and driven from land to land until she at last found
rest in Egypt, where she gave birth to Epaphus, her son
by Zeus who was to become king of Egypt and founder
of Memphis. The painting comes from the large assembly
room to the rear of the Temple of Isis and shows Io borne
across the sea on the shoulders of a water god. The two
horns symbolize her metamorphosis. She is made wel-
come here by Isis herself who sits enthroned on a rock, the
Uraeus snake in her left hand, her foot on a crocodile, and
her small son Harpocrates alongside her. The woman with
the sistrum and the man with sistrum, staff of Mercury,
and situla in the background are probably the Egyptian
gods Nephtys and Hermanubis.

254

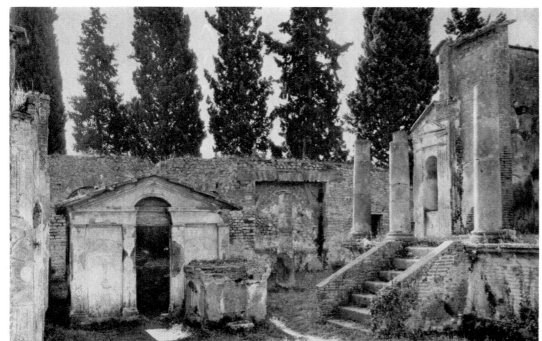

255

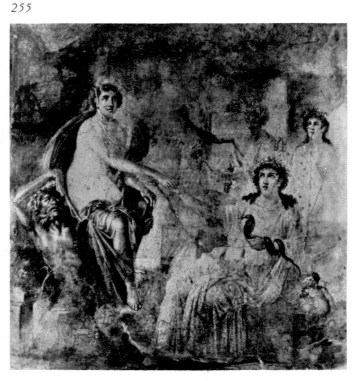

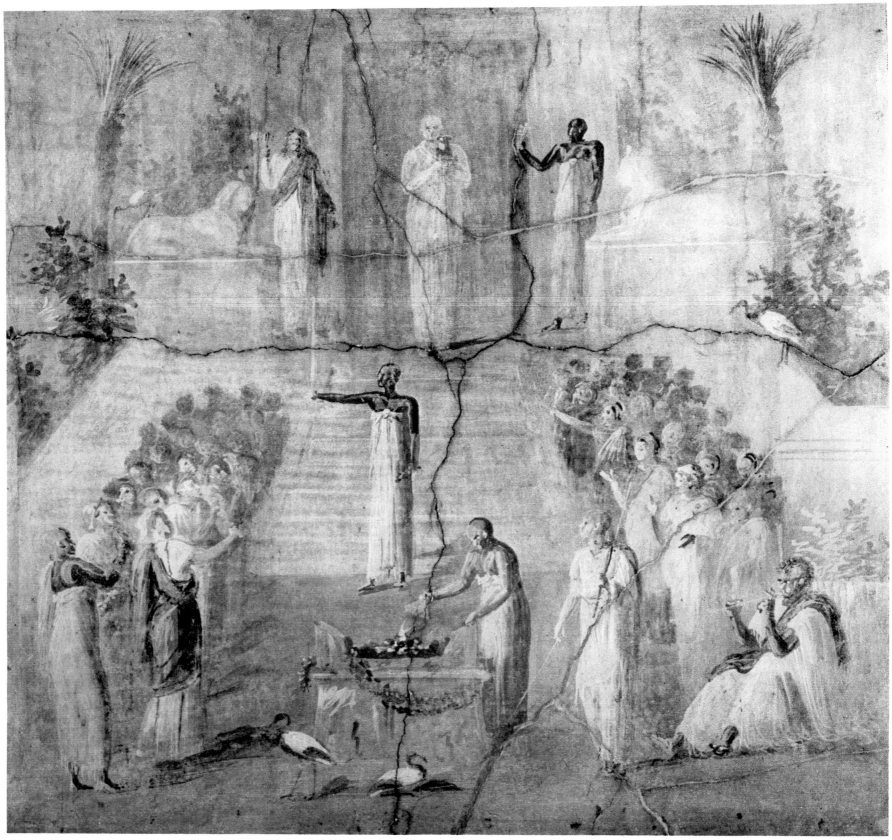

256

256 CEREMONY OF THE ISIS CULT, *from Herculaneum. Wall painting transferred to panel, 31 7/8 × 32 1/4". Museo Nazionale, Naples.* This picture and a companion piece testify to the existence of an Isis cult in Herculaneum, though no temple has as yet been found there. In front of a sanctuary door a priest in white garment and with shaved head holds up a vessel in his veiled hands. A priestess and a dark-skinned priest, apparently of lower rank than the high priest, accompany the act with their sistrums. The faithful line the stairs at the foot of which an attendant fans the fire on a traditional Egyptian altar. Palms, ibises, and statues of sphinxes all help to establish the local color for this solemn ceremony.

257 NARCISSUS. *Wall painting, 17 3/4 × 18 7/8". House of Marcus Lucretius Fronto, Pompeii (v, 4, 11).* Punished by Nemesis for his indifference to the nymph Echo, Narcissus fell in love with his own reflection, glimpsed when he knelt to drink from a fountain. Unable ever to embrace the object of his affections, the foolish youth pined away until he was metamorphosed into the flower we call by his name. The tale as recounted by Ovid was especially popular in Roman painting. Dating from the reign of Vespasian, the small picture in the cubiculum to the right of the tablinum in this elegant house (see also plates 265, 298) vividly conveys the dreamily longing look of the handsome narcissist.

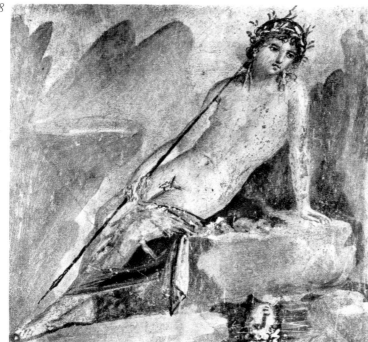

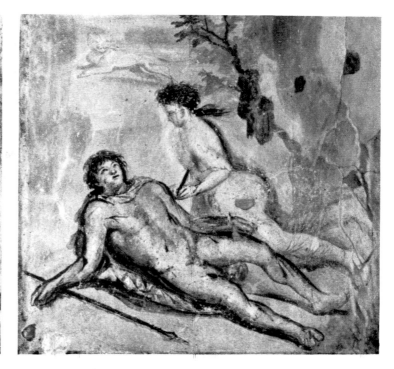

258 Pyramus and Thisbe. *Wall painting. Biclinium of the garden terrace, House of Loreius Tiburtinus, Pompeii* (II, 2, 2). Likewise immortalized by Ovid, the tale of Pyramus and Thisbe was oddly enough rarely depicted in Pompeii. Here, in this Fourth-Style painting, it is rendered quite crudely, with more than a touch of folk art. Pyramus lies dying in the sand after stabbing himself in despair over Thisbe's presumed death. Alongside, the equally despairing Thisbe runs herself through with his sword. Behind them is the lioness responsible for all this tragedy. Thisbe came early to her rendezvous with Pyramus, fled at the sight of the lioness, dropped her veil which the beast smeared with blood from its last meal, and Pyramus found what he had no reason to doubt was documentary proof of her premature demise. On the upper side of one of the two klinae in front of this picture and its counterpart, a *Narcissus at the Well*, is the signature,

Lucius pinxit. This signature doubtless applies to both paintings which, therefore, are unique among the paintings in Pompeii in being signed.

259 Endymion and Selene. *Wall painting. Triclinium, House of the Ara Maxima, Pompeii* (VI, 16, 15). This picture and the next belong to the same Fourth-Style ensemble (see plate 76). The handsome hunter Endymion lies sleeping on a rock, his lance by his side, and what few clothes he wears have slipped down below the point where they would be of any use. It is in that dishabille state that the moon goddess Selene catches her first glimpse of him and, standing on tiptoe, stretches out her arms in passionate admiration. Only the watchful hound of Endymion beholds the divine presence. All night the goddess will lie at the hunter's side and embrace him in his sleep, and to keep things that way she will get Zeus to

grant her unwary lover eternal sleep and unfading youth.

260 Ariadne on Naxos. *Wall painting, 17 3/8 × 16 1/2". Triclinium, House of the Ara Maxima, Pompeii.* Closely related in composition and even subject, this is the companion piece to the *Endymion and Selene* we have just seen. Ariadne, daughter of King Minos of Crete, helped Theseus slay the minotaur and find his way out of the labyrinth by following a long thread she gave him. On the voyage back to Athens the ungrateful hero abandoned her while she was asleep on the isle of Naxos and went his merry way to new loves. This was no great loss, as the god Dionysus found her there and took her for his wife. Here she sleeps on Naxos's rocks, wearing not much more than a pair of gold armbands. A passing maenad, struck by her beauty, rushes off to summon her godly master to share the lovely sight.

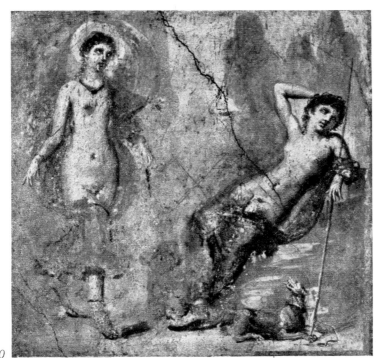

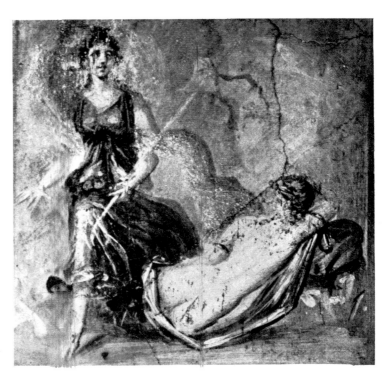

191

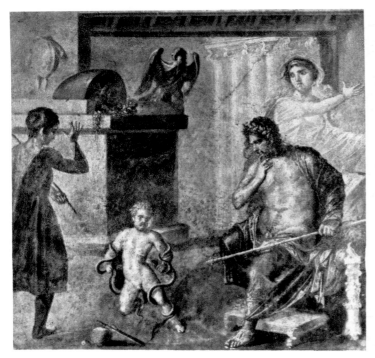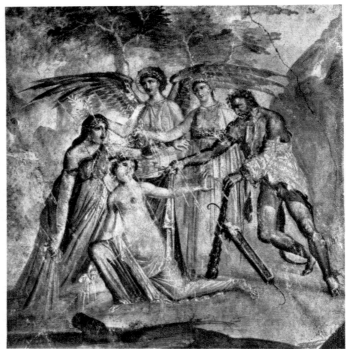

261 HERCULES STRANGLING THE SERPENTS. *Wall painting. Pentheus Room, House of the Vettii, Pompeii* (VI, 15, *1*). Furious with jealousy, Hera sent serpents to kill the newborn son fathered by Zeus with the mortal Alcmene, but the infant climbed out of his crib and promptly strangled them with his own hands. Here, in a room looking out on a colonnade, the crowned and sceptered Amphitryon, husband of Alcmene and as far as he knows progenitor of the mighty tot, looks on at the combat with amazement and terror. Behind him his faithless wife recoils in horror while a servant rushes in from the left. But there is no need to worry: the eagle of Zeus has swooped down on the altar in the background, ready to intervene should it be necessary. The painting is part of the Fourth-Style decoration on the north wall of the south triclinium, the so-called Pentheus Room (plate 112), in this splendid house.

262 HERCULES VIOLATES AUGE. *Wall painting. Triclin-ium off the small peristyle, House of the Vettii, Pompeii.* Hercules, drunk as he often was, stumbles on Auge, the daughter of King Aleus of Tegea, as she does her washing at a stream with only a handmaiden as company. She falls to her knees, he rips off her clothes, her servant tries to come to her aid but is stopped short by a powerful winged female holding a branch: it is the will of the gods that Hercules shall beget by Auge the future founder of Pergamum, Telephus (see also plates 160, 287). The winged female has also been identified as the star goddess Parthenos, consecrating with her branch the future motherhood of Auge. The other woman, wreathed and pouring a lustration on Auge, may be a priestess of Dionysus. Done in the time of Vespasian, the painting must have had a prototype in Pergamum.

263 HERCULES IN ROME. *Wall painting, 21 1/4 × 20 1/2″. House of the Ara Maxima, Pompeii* (VI, 16, *15*). The giant Cacus lived in a cave on Mount Aventine and was in the habit of killing passersby. He went too far, however, when he stole some of the cattle Hercules had taken from Geryon, so the hero killed him. In gratitude the Romans dedicated to their deliverer the Ara Maxima on the Forum Boarium, and that altar, from which the house gets its name, is seen here at the right margin. Hercules is shown taking leave of King Evander, his host in Rome, and the man with white chlamys and lance is probably a grateful citizen.

264 HERCULES AND NESSUS, *from the tablinum, House of the Centaur, Pompeii* (VI, 9, *3–5*). *Wall painting transferred to panel. Museo Nazionale, Naples.* At the River Evenus, Hercules paid the centaur Nessus to carry Deianira to the opposite bank, but the creature attempted to ravish her and Hercules slew him. In this fine Third-Style painting from about A.D. 40 or 50, Nessus approaches the hero on his knees to offer his service. While Hercules greets him with a look and gesture of distrust, Deianira, carrying

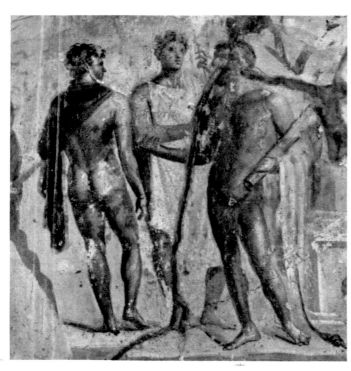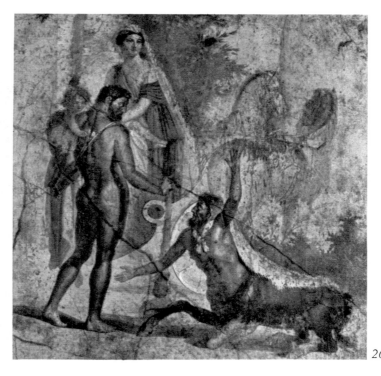

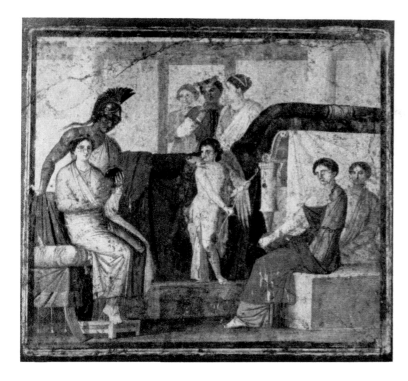

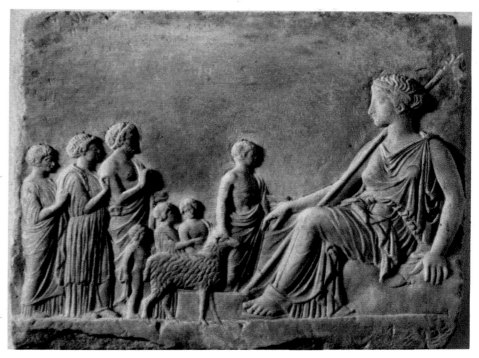

265

266

their small son Hyllus out of a two-horse chariot, seems quite unaware of any danger. A wall and a tree close off the scene at the back, and the river is suggested at the lower left.

265 MARS AND VENUS. *Wall painting, height 17 3/4".* *Tablinum, House of Marcus Lucretius Fronto, Pompeii (v, 4, 11).* A huge bed occupies the center of the picture. Modestly attired for once, Venus sits in front of the helmeted war god, who runs his hand over her left breast. Eros readies his bow and arrow. Two women, detached from it all, are seated at the right. At the rear, between two maidens, is a man with wings on his head; perhaps he is Hypnos, god of sleep, attempting to lure the couple into bed. The picture was painted about A.D. 50 as part of a room lavishly decorated in the late Third Style (see plate 298). Its Greek model did not include the figures functioning here only as onlookers.

266 SACRIFICE TO APHRODITE, *from a house in Pompeii*

(v, 3, 10). *Marble relief, 17 3/4 × 24 3/8". Museo Nazionale, Naples.* The relief was found leaning against a wall in the small garden of the house, perhaps waiting to be set into the wall, as was usually done with such works (see also plate 287). Enthroned on a rock the goddess—most likely Aphrodite, in classical peplos and with a lotus-crowned scepter resting on her right shoulder—receives a cortège of the faithful: an altar servant leading a sacrificial ram, three children, a man, and two women. The forms are typical of the style about 400 B.C.

267 VENUS POMPEIANA. *Painting. Front of the workshop of M. Vecilius Verecundus, Pompeii (ix, 7, 7).* The divine patroness of the city stands on a chariot which has a prow like that of a ship and is drawn by four elephants. In festive attire and crowned with a diadem, she holds a scepter in her left hand and leans on a ship's tiller. The small Eros, standing on a high pedestal immediately alongside her, holds a mirror, while two others approach through the air with palm and wreath, the signs of victory.

In the foreground, on one side Fortuna with cornucopia and tiller balances on her globe, on the other side is the genius of the colony with cornucopia and libation bowl. The triumphant and beneficent protectress of Pompeii was never depicted more majestically than in this picture, painted after A.D. 62, which sits above the business sign of a clothmaker's shop (see plate 200).

268 VENUS POMPEIANA. *Painting. Front of a workshop, Via dell'Abbondanza, Pompeii (ix, 7, 1).* This Venus is rather similar to the one in plate 267 and likewise appears on the front of a feltworker's shop, with much the same ornaments, festal clothing, attributes, flying cupids, and even a small Eros holding up a mirror. The Eros stands on a high pedestal, and Venus herself is on a low base like a religious statue of the sort that, on certain festivals, the faithful solemnly dressed in new garments and lavish ornaments. The words in the lower left belong to an election appeal and have nothing to do with the picture. The work doubtless dates from after A.D. 62.

267

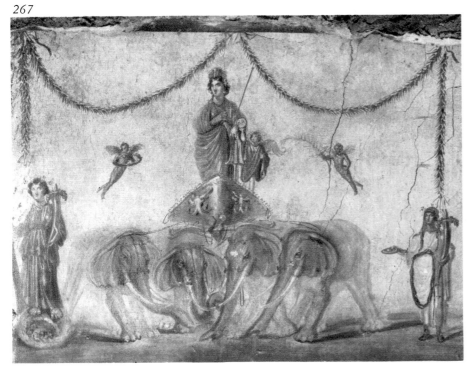

268

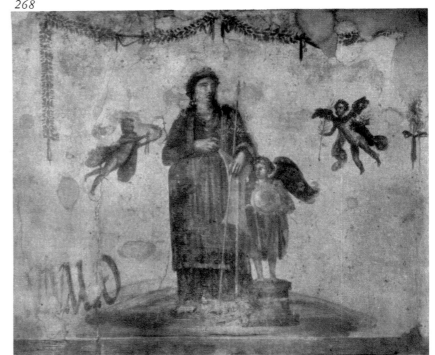

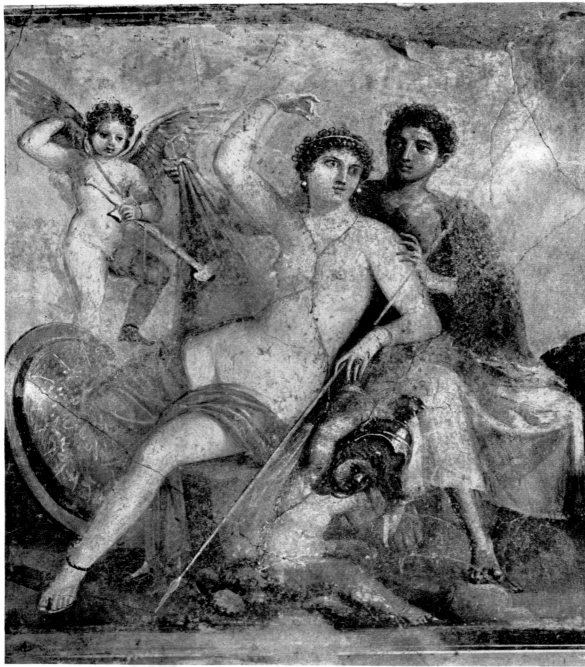

269

269 MARS AND VENUS, *from the tablinum, House of Mars and Venus, Pompeii (VII, 9, 47). Wall painting transferred to panel, 35 × 32 1/4". Museo Nazionale, Naples.* Mars, busily seducing the beautiful wife of Vulcan, draws the last veil off her body, leaving her with nothing but the long chain crossing between her breasts that is so often associated with the goddess of love (see plates 270, 271). Two cupids amuse themselves with the helmet and weapons of the war god. This pair of divinities was a favorite motif of Hellenistic and Roman art (compare plates 205, 265), and it has been suggested that here they are nothing else than a vehicle for a double portrait. The painting is in the Fourth Style and had as model a Greek panel picture from about 300 B.C.

270, 271 VENUS REMOVING HER SANDALS, *from a house, Pompeii (II, 11, 6). Marble statuette, height 24 3/4". Antiquarium, Pompeii.* The goddess supports herself on a statuette of Priapus while removing the sandal from her leftfoot, beneath which squats a tiny Eros. The breast band, armlets, necklace, sandal straps, chain around the midriff, and hair were all gilded, as was her pubic hair and that of

Priapus. The group goes back to a famous statue probably executed in Asia Minor about 200 B.C. of which more than 180 copies in various materials are known. While the Pompeian statuette dates from the time of Nero and the Flavians, it is thought to be an Alexandrian importation.

Following pages:
272, 273 TWO DIONYSIAC SCENES, *from the House of the Colored Capitals, Pompeii (VII, 4, 31, 51). Marble intarsia (opus sectile), each 9 × 26 3/8". Museo Nazionale, Naples.* Both of these bacchanales with colored marble figures inlaid on a black ground were found in the tablinum close to the Via degli Augustali in this exceptionally large house (see plate 75). In one, a maenad with torch and tympanon and a satyr with thyrsus and animal pelt dance ecstatically in front of a small sanctuary. In the other, a maenad with sling and patera approaches a priapic herm behind which stands a statue, while on the right the young Dionysus— if it is really he—dances in front of a tree and a religious monument. The figures recall those of Neo-Attic reliefs, and according to Pliny (*Naturalis Historia* XXXV. 3) this inlay technique was introduced during the reign of Claudius (A.D. 41–54).

274 SACRIFICE BEFORE A HERM OF PRIAPUS. *Wall painting. Cubiculum next to the oecus with the great frieze, Villa of the Mysteries, Pompeii.* The small picture, designed to look like a panel painting, sits on the painted cornice above a picture of the intoxicated Dionysus propped up by a satyr. Using a loosely brushed technique it depicts a grotto with a herm of Priapus on an outcropping of rock on which lie fruits and flowers, as on an altar. A bearded, half-naked man with billowing mantle rushes toward it flourishing a torch. He is accompanied by a cupid who brings as sacrifice a pig adorned with a band around its middle.

275 POLYPHEMUS AND GALATEA, *from the House of the Hunt, Pompeii (VII, 4, 48). Wall painting transferred to panel, 30 1/4 × 26". Museo Nazionale, Naples.* The love of the cyclops Polyphemus for the lovely nereid Galatea was a frequent subject in Roman wall painting. In this Fourth-Style version, the colossus sits on a panther skin spread across a rock, alongside him a beribboned staff and panpipe and in the foreground, to round out the bucolic atmosphere, a ram. He embraces the nymph who, still clutching a fan in her left hand, seems by no means reluctant to give herself to the brute. In the right background there is a patch of sea.

276 HERMAPHRODITUS AND PAN, *from the atrium, House of Castor and Pollux, Pompeii (VI, 9, 6–7). Wall painting transferred to panel, 29 1/2 × 49 1/4". Museo Nazionale, Naples.* The hermaphrodite—female above, male below—was a favorite theme in both painting and sculpture as early as Hellenistic times. The ambiguous creature reclines on an animal hide in a rocky place near a herm of Priapus, with a building, perhaps a temple, at the upper left. Pan, who took the sleeper for a nymph, has stolen up and ripped off the cover but recoils in horror, indifferent to the hermaphrodite's longing gesture. Painted after A.D. 62, the picture certainly goes back to a Hellenistic invention.

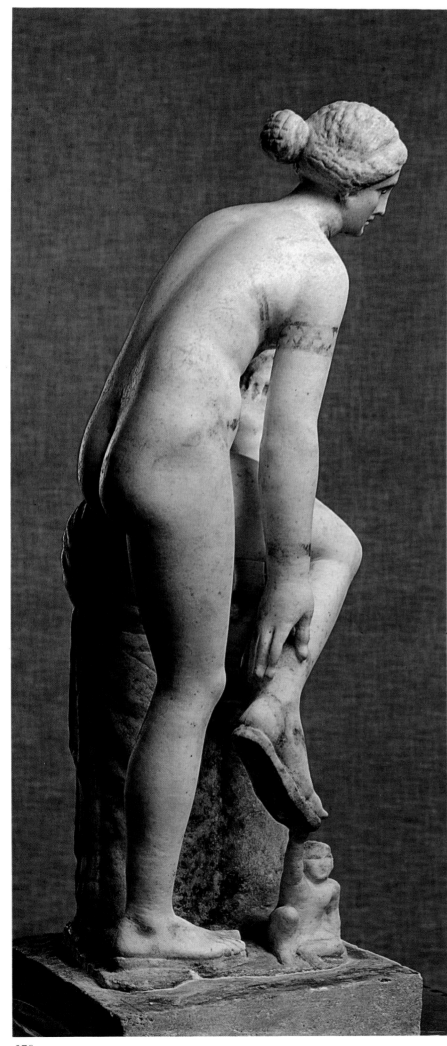

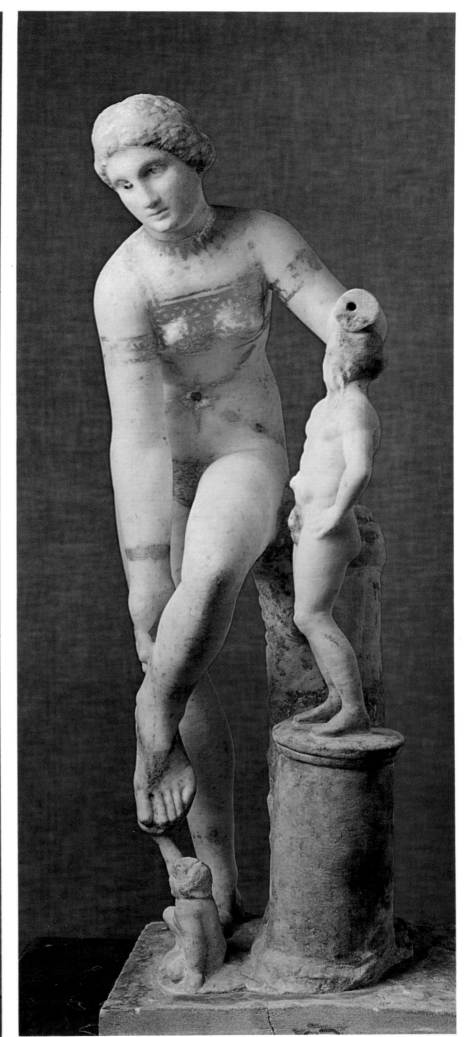

270

271

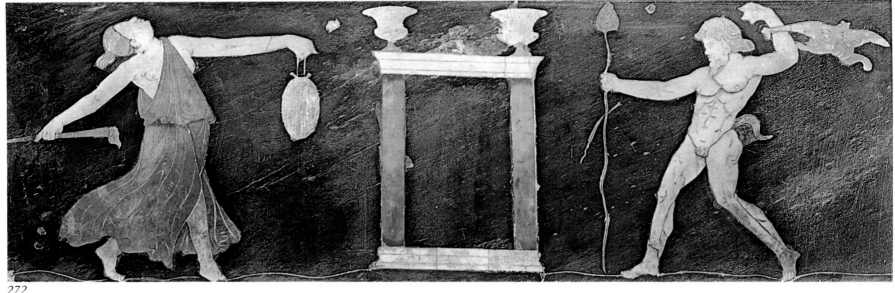

272

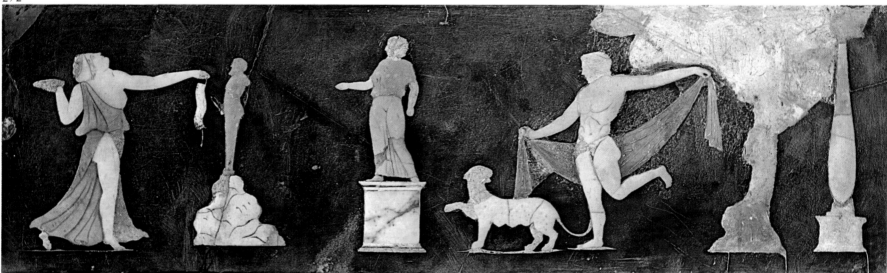

273

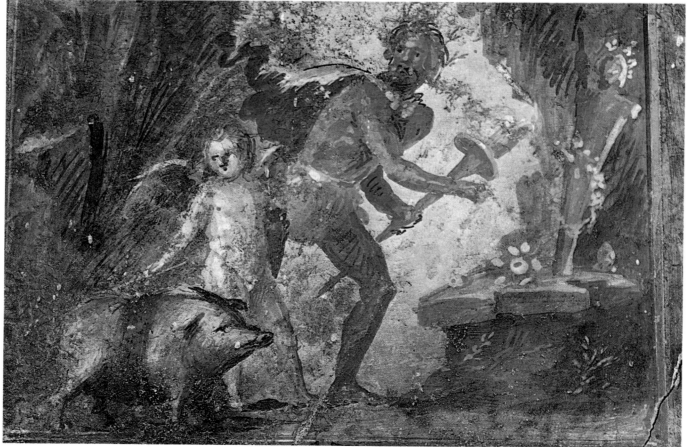

274

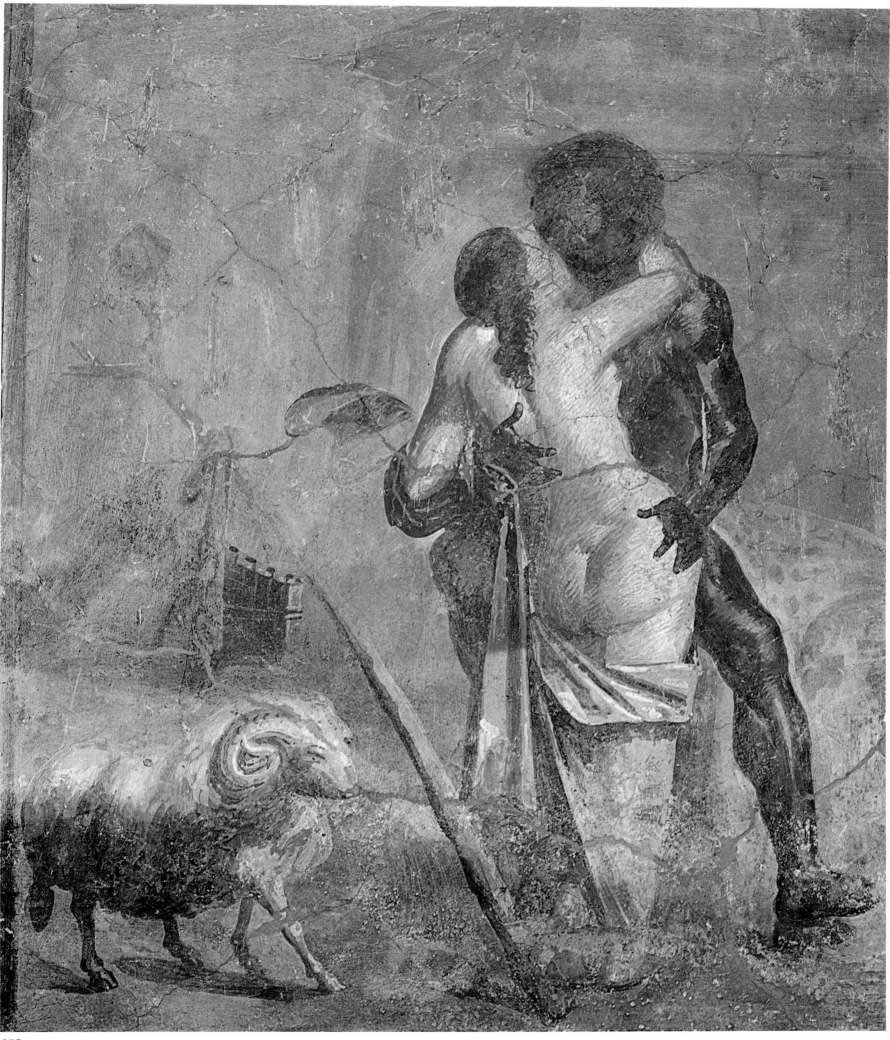

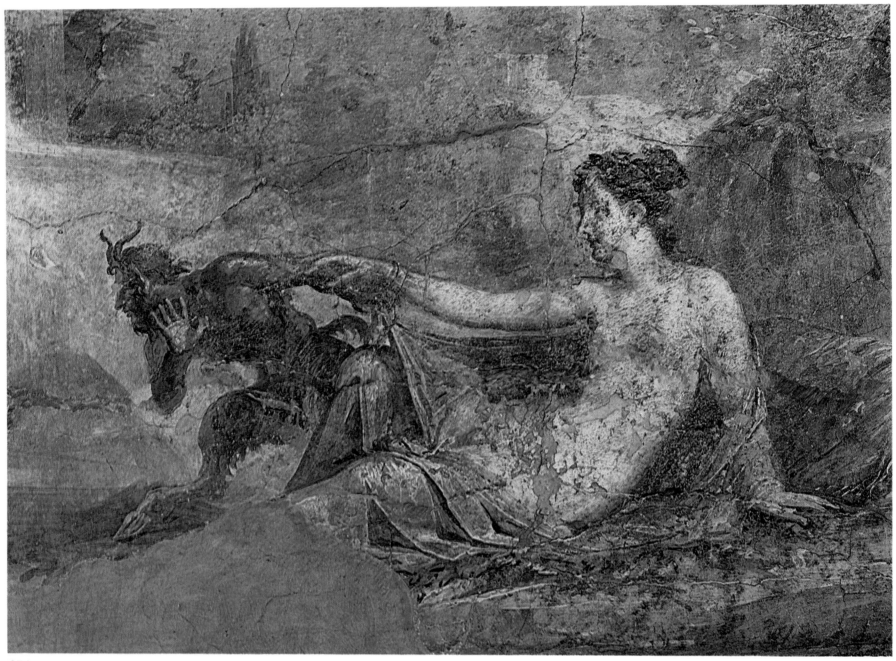

276

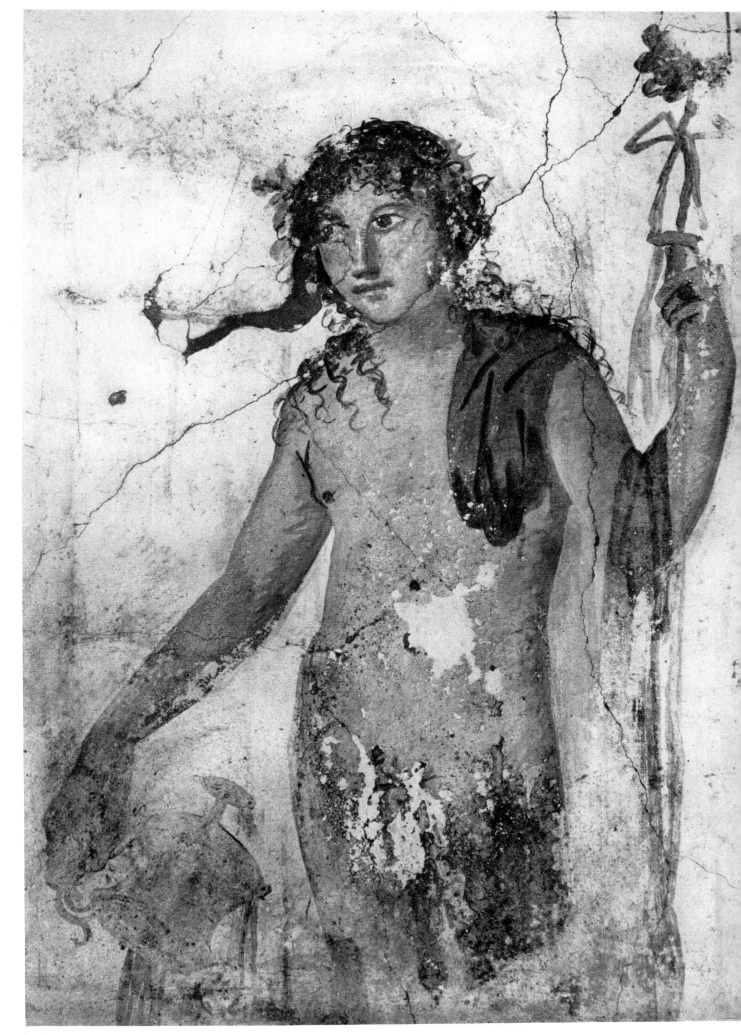

277 BACCHUS (*detail of a wall painting*). *Summer triclinium, House of the Prince of Naples, Pompeii* (VI, 15, 7–8). The youthful god, naked except for the mantle thrown over his left shoulder, holds the thyrsus in one hand and with the other pours a drink from a kantharos for his panther. In this room, decorated during the reign of Vespasian, the god of wine appears on the main wall while Venus graces the right-hand side wall and her faithful cupids are on the wall facing her. Everything in this room, whether figures or objects, is related to these two gods, who were often associated in Pompeii.

277

278　　　　　　　　　　　*279*

278 TRIPOD SUPPORTED BY THREE FIGURES OF PAN *(detail)*. *Bronze. Museo Nazionale, Naples.*　　Among the finest depictions of Pan is this tripod found in Pompeii, where the goat-hoofed god appears as a triad of youthful, slender figures, their tails intertwined, who support a basket-like receptacle. Each figure with elongated hooves and tiny horns on his head has the right arm akimbo and the left hand raised as if in astonishment at his own aroused virility. The elegant tripod dates from early Imperial times.

279 PHALLIC HANGING LAMP. *Bronze. Antiquarium, Pompeii.*　　One of a number of such objects, the lamp consists of a figure suspended by his hair and endowed with an exaggerated phallus from which dangle little bells of the sort dancers wore on their arms and legs. The

ancients made much less fuss about such things, and these fertility symbols, believed to ward off evil and bring good luck, were as common in Pompeii as everywhere else in the Roman world (see plates 220, 221, 282).

280 DANCING SATYR. *Wall painting. Cubiculum next to the oecus with the great frieze, Villa of the Mysteries, Pompeii.*　　On the south wall of the room with the picture of the sacrifice to Priapus (plate 274), a young, naked satyr, left leg raised as if dancing, is painted in the middle zone of the wall of the alcove behind the foot end of the bed. With his right arm akimbo and the back of his hand resting on his hip, he lays his left hand on his head, palm upward, in a mischievous gesture matched by the grin with which he faces the viewer: a marvelous evocation of the half-animal character which his pointed ears confirm.

281 SILENUS AND SATYR. *Wall painting. Cubiculum, Villa of the Mysteries, Pompeii.*　　On the north wall, facing the dancing satyr, an old Silenus is portrayed in a drunken state, with one hand propping himself up on a staff, and with the fingers of the other snapping merrily away in the air. His tunic has slipped down to expose a veritable wine tub of a belly. A young satyr hastens to lift up the tunic and conceal the old man's nakedness. Like the other figures in this room, these are associated with Dionysus.

282 PRIAPUS. *Wall painting. Entrance, House of the Vettii, Pompeii* (VI, 15, *1*).　　The fertility god Priapus appears not only in the form of a herm, as in garden statues or depictions of the Dionysiac celebration (*thiasos*; plate 273), but also upon occasion full length. Here, as protector of the well-being of the household, he is fully

280　　　　　　　　　　　*281*　　　　　　　　　　　*282*

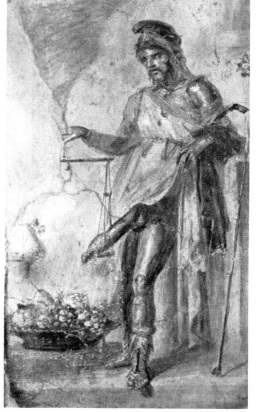

283 284

clothed and wears the Phrygian bonnet. Leaning on a pillar, he weighs his gargantuan phallus, symbol of good fortune. To one side there is a basket of fruit, to the other a thyrsus. Although now denied to public view, the painting was not obscene in intention.

283 BATTLE OF THE CENTAURS AND LAPITHS, *from Herculaneum. Painting on marble, 13 3/4 × 19 1/4". Museo Nazionale, Naples.* At the marriage feast of Pirithoüs and Hippodamia, the drunken centaurs attempted to ravish the lapith women. In the battle that ensued they were defeated by the lapithae led by their king Pirithoüs together with Theseus, a guest at the wedding. One of these heroes is seen here attacking a centaur, who is forced to let his lovely prey escape. The painting, in an unusual medium, copies a prototype from the first half of the fourth century B.C.

284 THE KNUCKLEBONE PLAYERS, *from Herculaneum. Painting on marble, 16 1/2 × 15 3/4". Museo Nazionale, Naples.* At the upper left is the signature *ΑΛΕΞΑΝ-*

ΔΡΟΣ ΑΘΗΝΑΙΟΣ ΕΓΡΑΦΕΝ—Alexandros from Athens painted this. In the foreground two girls, Hilaeira and Aglaia, concentrate on their game of knucklebones (which could be real bones or, quite often, terra-cotta). From the right, Phoebe and Niobe approach Leto, who seems withdrawn and melancholy. It is difficult to say if there is some connection with the myth of Niobe and her children. On the basis of its style, the picture must go back to a prototype of the late fifth century B.C.

285 DAEDALUS AND PASIPHAË. *Wall painting. Ixion Room, House of the Vettii, Pompeii* (VI, 15, 1). Pasiphaë, queen of Crete and wife of Minos, visits the workshop of Daedalus to see the wooden cow he has devised at her order. She intends to conceal herself inside it so as to couple with the bull with which Poseidon has caused her to become infatuated. The inventor demonstrates the ingenious flap he has contrived in the rump of the beast and praises his work with eloquent gestures. Behind the queen stand her nurse and a handmaiden, and in the foreground a workshop helper is busy with his carpenter-

ing. The painting dates from after A.D. 70 and is part of the wall decoration in the Ixion Room of the House of the Vettii (see plate 109).

286 THESEUS TRIUMPHANT OVER THE MINOTAUR. *Wall painting, 68 7/8 × 46 1/8". Villa Imperiale, Pompeii.* Theseus poses triumphantly over the dead monster while two boys crowned with wreaths kiss his hands and legs. As a model for the composition there must have been a famous early Hellenistic picture, which was also used for a painting formerly in the Herculaneum Basilica. The painter of this early Third-Style work seems to have enriched the prototype with two female observers seated at the feet of a statue of Athena Promachos and with a silhouette of the city of Athens in the background.

287 THE HEALING OF TELEPHUS, *from the House of the Relief of Telephus, Herculaneum. Marble relief. Museo Nazionale, Naples.* In this further episode from the life of Telephus (see plates 160, 262), he has been wounded by Achilles and counseled by an oracle that only he who

285

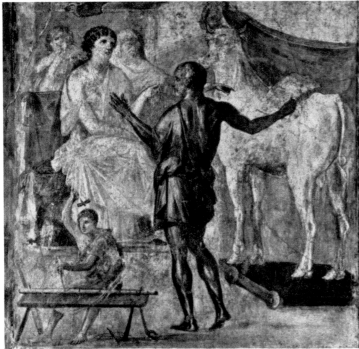

286

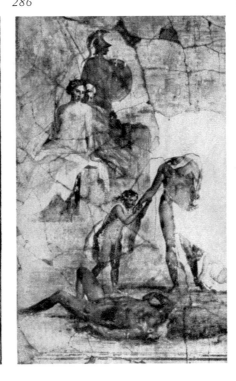

287

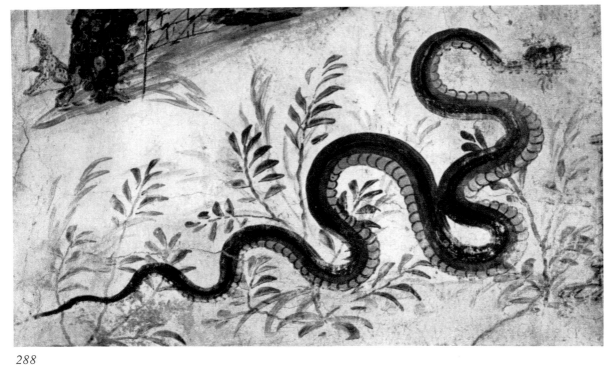

288

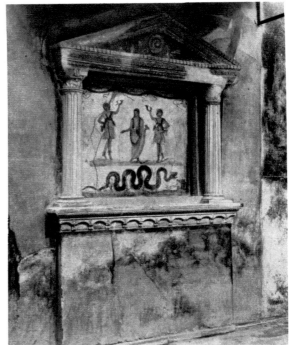

289

made the wound can cure it. Therefore he has journeyed to Argos to find Achilles, who does indeed heal him by rubbing the wound with rust from the lance that caused it. The relief was set into the wall of a cubiculum.

288 SERPENT AND ALTAR (*detail*), *from the Lararium, House of the Centenary, Pompeii* (IX, 8, *3, 6*). *Wall painting transferred to panel. Museo Nazionale, Naples.* As was usual in household shrines to the Lares, a serpent close by an altar represented the tutelary spirit of the house. This splendid specimen coils across the lower part of a unique painting of Bacchus at Mount Vesuvius (plate 11).

289 LARARIUM. *House of the Vettii, Pompeii* (VI, 15, *1*). In Pompeii, household shrines were most often set in stucco aedicules (see plate 291). Here, painted on the rear

wall of the shrine, is the usual serpent in front of an altar, and above it the Lares are represented as dancing youths flourishing drinking horns. The image in this form was probably associated with the festival of the Compitalia, which was celebrated in honor of the household gods with a ceremony at the edge of the family property. Generally the Lares were accompanied by the genius of the house in the guise of a priest holding a libation bowl. Public festivals of the Lares also included veneration of the personal genius of the emperor, which may explain how that spirit came to be associated with the household gods.

290 STATUETTES OF THE LARES. *Bronze. Museo Nazionale, Naples.* Often the painting in a shrine was replaced by sculptured effigies, mostly small bronze statuettes of the

Lares represented in the same way as in the paintings, dancing on the balls of their toes and pouring libations from a rhyton into a patera. The mannered treatment of the drapery here, notably the swinging skirts, must derive from the archaizing current which appeared alongside a more freely developing style of Greek sculpture in the early fourth century B.C. and won new favor in the Hellenistic world.

291 LARARIUM. *House of Castor and Pollux, Pompeii* (VI, 9, *6–7*). The shrine to the Lares could be located anywhere in the Pompeian house: in the entrance, atrium, housekeeping rooms, or, often enough, in the garden, as here, where it took the form of an aedicule with arch and pediment resting on columns.

290

291

a general trend. In the House of Sallust and the House of the Faun there are bands of a dark background on which are painted light-colored vines, and in both cases this must represent a late form of the First Style.

Although the developments of the Second, Third, and Fourth styles have been explored, the same is not true for the First Style, which stretched over at least a full century. If nothing else, its virtually unflagging architectonic rigor makes such an attempt more difficult. But an undertaking along these lines would make it possible to set up some kind of chronological framework within the First Style. Such a study is all the more needed because there are simply no fixed chronological points of reference one way or the other for it, so that, without such a study, we cannot even be sure when it began and when it was superseded.

In any case, in the late phase there seem to have been variations on the First Style which, as far as is known, were unique to Campania. The wall, with its superimposed continuous horizontal zones, came to be articulated vertically as well as horizontally, mostly by half columns set against the surface. This could be done on a small scale, as in a cubiculum in the House of Sallust, but when such projecting elements reached the entire height of the wall, the effect was that of a porticus projected in relief. While this proved to be one of the most important sources of the Second Style, in the First Style the wall remained intact, a closed field, and to achieve an illusionistic effect of depth and extension was beyond both the possibilities and the aim of Hellenistic wall decoration, its means continuing to be entirely plastic and architectonic.

The Second Style

Our first evidence of something new is in a house on the Palatine Hill in Rome, beneath the Flavian Imperial palace, which, because of a stucco lunette in one room, has been called the House of the Griffins. Columns are painted on its walls, and their plastic effect is further enhanced by bases painted in illusionistic perspective. Here, then, in this very earliest example, the aim was to make the room look larger. The optical effect is much stronger than in the stucco half columns found in the late phase of the First Style mentioned above. All elements which, if real, would project into the room—beams, the surfaces of the wall fields, and the like—are merely painted. Even in this first manifestation of the Second Style the elevation of the wall is divided horizontally into three areas, as it was to be throughout the course of the style's development: first a base around the foot of the wall, then a middle zone of alternating broad and narrow large fields, and finally a narrow upper zone.

The dating proposed for the House of the Griffins in Rome varies between 110 and 80 B.C., the criterion being the technique used in building the walls. It is only natural to assume that the new art of decoration arose where one finds its earliest manifestation, which means in Rome itself. However, this does not change the fact that the new style, like its predecessor, was rooted in Hellenistic painting and is inconceivable without it, if for no other reason than that, in that particular period, the painters in what was becoming the capital of a world empire were mostly Greek. But where the members of the workshop who painted the House of the Griffins came from, and what they may have brought with them of the artistic traditions of their homeland, remains an open question despite all efforts to resolve it.

The new manner of decoration reached Pompeii when the city became a Roman colony. Its early phase there is found in full-blown form in the Villa of the Mysteries. Even the decorative background for the great frieze belongs to the Second Style (plates 114, 119–25), though its illusionistic perspective is restricted to the narrow stage on which the figures move. But pure architectural painting has its finest manifestations in other rooms in the same villa, and chiefly with a simple system with painted columns (plate 293) already utilized in the House of the Griffins in Rome. The columns rise from a continuous narrow ledge and acquire convincing plasticity from the ingenious lights and shadows deployed in their fluting. Since the eye takes this lowest zone of the wall to be the one which projects farthest into the room, the middle zone strikes one as set back somewhat so that the room appears deeper than it really is, and it is only at the top, with the entablature resting on the capitals, that the plane appears to return to where it is at the base.

The principal zone of the wall consists of vertical, rectangular fields imitating wall paneling and ends above with a cornice whose perspective treatment plays an important part in the overall spatial effect. The fine lines framing the fields are painted partly dark, partly light, and are intended to aid in the illusion of surfaces that project only very slightly from the wall, thereby doing with paint what the First Style had contrived with stucco. The same effect recurs in the pseudo-blocks of the upper part of the wall. Still very reminiscent of the First Style, their proportions are nevertheless changed, and they are longer and less high. What is carried over into the new style, however, is the marbling of these smaller fields as well as of the dado around the walls and the strip that runs immediately above the bases of the illusionistic columns. In a wall like this it becomes perfectly clear what the Second Style owed to its predecessor.

But there are much bolder forms of the new idiom in the same villa. In a cubiculum with two alcoves in the west part of the house (plate 294), the niche for the bed is clearly distinguished by a change in the painting, something which was to become the rule in the Second Style in particular. While the system of wall decoration used in the room is perfectly simple and does not aim at spatial effects except in the cornices, there is a wonderfully imaginative play of architectonic forms behind the pseudo-pilasters. The rear wall of each of the alcoves is divided into three fields in its width and laid out with scrupulous axial symmetry. The approach defined in this early Second Style remained the norm for all Pompeian painting, and the alignment of the decoration on a dominant central motif, along with an insistence on rigorous symmetry, was to continue in force in the Third and Fourth Styles.

An architrave, supported by pseudo-columns at the corners of the wall and by two pseudo-columns in the center, is interrupted in the middle and replaced by a high arch. But there, beneath the arch, the eye is carried beyond the wall itself. Though at the sides there are merely painted blocks, here there is a painted curtain in the middle above which is seen, as if outdoors, the upper portion of a round temple. Thus, for the very first time, the surface of the wall is broken through, as it were, to afford what purports to be a view of other buildings outside the house. The large panels surmounted by a zone of painted blocks become reduced in size and importance alike. What is more, the eye reads the rear architrave with its two foreshortened wings as lying in a plane very much deeper in the wall than that of the painting outside the niche. But that is not all. To either side the eye is likewise seemingly carried outdoors, with a glimpse of portico fronts in the upper corners which act as architectonic framing for the round building in the center. Thus the wall gives the effect of a kind of half-height divider or partition above which one has a view of the outdoors. Here, then, is the start of a new development in the course of

which such illusionistic views of a distant prospect would play an increasingly important part in wall decoration.

Elements involving perspective and the semblance of depth become much more emphasized. In this room the strong accent created by the pairs of columns seen in foreshortening pushes the wall optically even farther back than do the half columns and horizontal bands in the other room in the same villa, which is a more conservative, less advanced version of this new Second Style (plate 293). True, not everything is laid out in central perspective with a single viewing point, and the spatial relationship is much less clear in the zone of the column bases than in the architrave. Nonetheless, the architecture is set out with rigorous logicality and could easily be translated into a real three-dimensional construction. This is true in the overwhelming majority of cases in this "Architectural Style," Mau's name for the Second Style.

Faced with such wall paintings, it is only natural to ask if and how this painted architecture was related to actual past and contemporary architecture. The only answer, however, is that in no real building or fragment of a building that has survived from Republican times—the period in which this style flourished—is there an example of undercut molding in either architrave or column base such as we see here (plate 126), nor are there arches like these (plate 294). In the second alcove of this same cubiculum (plate 126) there is a gable lacking a horizontal architrave to support it, and this is a form which turned up in real architecture only very much later.

From all this it is natural to conclude that the fantasy of the painters was decidedly ahead of its time. True, when they painted such daring constructions these artists did not have to worry about static relationships nor conform to any traditional types and forms. And certainly the phenomenon is not without parallels in later epochs of European painting. But before coming to any definitive conclusions it must be kept in mind that we know only a fragment of ancient and, above all, Hellenistic architecture. One variety is forever lost: the theater scenery, festive pavilions, and similar ephemeral structures built in perishable materials. One need only think of the banqueting pavilion of Ptolemy II as described in the literary sources, or the Nile barge of Ptolemy Philopator. Even small-scale decorative architecture obeyed other laws than large buildings, and this decorative architecture must be kept in mind as a possible stylistic source, no matter how monumental the edifices depicted on the walls of Pompeii would seem to be. So, in the final analysis, one must exercise due caution in deciding, just because we do not know the precedents of this architecture, that it must not have existed.

The wall paintings in the Villa of the Mysteries were executed about 60 B.C. Some twenty years later, paintings were done in the Villa of P. Fannius Sinistor in Boscoreale which constitute a second outstanding example of the large-figured cycle (plate 295). But while in the Pompeian villa the figures are disposed in a continuous friezelike composition with nothing to interrupt their flow (plates 114, 119–25), in Boscoreale the groups of figures are separated by powerful columns, and the architectonic framework within which the action takes place has gained in volume and importance. The personages move in front of a kind of half-height wall culminating at its top in a markedly projecting Doric architrave above which there is a vista of colonnaded architecture which now takes in the entire breadth of a field. Much more space is conceded here to the open sky and the outdoors than in the cubiculum in the Villa of the Mysteries. In addition, there are signs of a more ornamental treatment of the columns. If in the villa at the gates of Pompeii they were still a reason-able facsimile of what could be seen in real buildings, in Boscoreale there are right-angled bosses projecting from the unfluted shafts and casting long sideways shadows which enhance the impression of depth (plate 295). In another room in the same villa the painted columns are overgrown with delicate vines. As time went on, such illusionistic columns lost more and more of their architectonic character, their proportions became altered, and they began to incorporate elements not to be found in real architecture.

With time, too, the solid opaqueness of the wall was more boldly disregarded. Then a countermovement set in which emphasized it even more strongly, in an unmistakable reaction against the baroque polyphony of the open architectural prospects which had been such an essential part of the previous approach. By no means an isolated phenomenon, this was part of a general trend in all the arts during the principate of Augustus, when a new and distinctly Roman classicism grew up and broke with the Hellenistic exuberance of forms.

This late phase of the Second Style is most clearly grasped in Rome, where its finest examples are to be found. In Pompeii we can look at something like a room in the House of Marcus Obellius Firmus, whose decoration can be dated about 25–20 B.C. (plate 81). Even at a glance one recognizes the extent to which the architectural forms had become invaded by purely ornamental elements in the fifteen to twenty years since the villa at Boscoreale was painted. Here the two columns of the central aedicule are entirely covered with scales, and their bases have lost every trace of architectonic character, assuming no more than a playful, decorative note. If the other columns exhibit the same rectangular bosses seen in Boscoreale, here there are figures in relief on the alternate drums of each column. Nor are the proportions those of real architecture: the shafts are so exaggeratedly slender as scarcely to deserve the term column.

These columns, supports, or whatever one wishes to call them stand on a base which dispenses entirely with beveled moldings in favor of herms, winged griffons, and spirals. Here architecture has made way for the sort of pictorial and ornamental decorative motifs that were thenceforth to become the dominant feature. Though the columns still bear markedly projecting moldings, and spatial depth is still emphasized by painted shadows on the rear wall, the wall itself, painted in a strong red, makes a solid, smooth surface. It is interrupted only to either side at the top of the central aedicule where there is a view of two porticoes stretching away in diminishing perspective, and only above these is there a patch of blue sky.

By the time of this phase of the Second Style, the human figure had long been accepted as an element of decoration. Ever since the step taken in the Villa of the Mysteries there were not only lifesize and over-lifesize figurative cycles but also single figures and groups which took their place on the panels in the middle zone of walls. Even earlier than this example in the House of Obellius Firmus, there had been figures framed in an aedicule in the center of a wall. There has been much discussion as to whether these were meant to represent a panel painting hung on the wall or something outdoors glimpsed *through* the wall. In favor of the latter is the fact that the point of departure leading to the further development of the Second Style was precisely the illusionistic opening up of the wall.

Virtually no other innovation was more fraught with consequences. Right up to the end of Pompeii, the central figurative picture continued to be the main feature of Pompeian wall decoration, regardless of the considerable stylistic changes that took place. What is more, figures began to appear fairly early in other positions on the walls, as in the *trompe*

l'oeil panel or folding pictures of the sort found standing on painted cornices in the Villa of the Mysteries (plate 274). Then, too, small panel paintings were set into a wall, as in the House of Obellius Firmus, where they were placed alongside the masks in the lateral wall fields.

The Second Style did not survive long beyond the stage represented in that latter house. The last examples that can be dated with some certainty are in Rome. It is almost certain that the ancient house beneath the Villa Farnesina, whose wall paintings and ceiling stuccoes are now in the Museo Nazionale in Rome, belonged to M. Vipsanius Agrippa and Julia, the son-in-law and daughter of Augustus, and was decorated about 19 B.C. Thus we have a house built and decorated for the Imperial family which developed still further the characteristics of the Second Style in one of those late phases which bear within themselves the seed of a new style.

Undoubtedly the artisanal workshop tradition of the Second Style lived on for a while, but about 12 B.C. the Third Style was already well implanted in Rome, and in no less a monument than the Pyramid of Cestius, a private tomb for which the new manner was certainly not invented. By the end of the first century B.C. at the latest, the Second Style must have been a thing of the past.

The Third Style

In 1902, when the construction crews of the Circumvesuviana, the railway built to provide direct service between Naples and the gulf of Sorrento, dug a deep trench in the vicinity of Boscotrecase to get the soil needed to fill in the uneven terrain, they came upon the southeast corner of a large villa rustica, which was promptly excavated by the proper authorities. Then, a mere four years later, the building so recently unearthed was covered over again when Vesuvius erupted on April 8, 1906. It was a stroke of luck, in this case, that considerable portions of its wall paintings had been removed and can still be seen in the Museo Nazionale in Naples and the Metropolitan Museum of Art in New York. Those paintings, from rooms on the north side of the large peristyle, are especially important as the earliest examples of the Third Style ever found in the buried cities.

It is now taken as certain that the splendid villa rising above the gulf belonged to Agrippa Postumus, the son of Marcus Vipsanius Agrippa and Augustus's daughter, Julia. His name appears on a tile with a date corresponding to 11 B.C., but since he was born only one year before then and orphaned in the same year, he must have inherited the villa from his father. This means that the last paintings in the Second Style in Rome and the first in the Third Style in the Vesuvian region were done by order of the same members of the Imperial family—an extraordinary coincidence of inestimable importance for scholars.

The red wall now in the Naples museum (plate 296) rises above a black dado decorated with linear motifs and fruits. What at first glance seem to be only light-colored ornamental strips, on closer examination contain tiny bases and miniature capitals, so that what could be taken for entirely unarchitectonic forms are, in fact, derived from columns and pilasters. Here, then, the ultimate consequences are drawn from the development of the Second Style, and in such a manner that further progress along the same line would seem impossible.

All spatial illusion is abandoned. Even the central aedicule has been transformed into a hairbreadth baldachin, which strikes one as no more than a delicate and finely worked frame for the picture it encloses. The wall is conceived as a closed solid surface across which the decoration is stretched like a fine net. On the horizontal ornamental bands are poised slender candelabra spun around with blossoming vines and linked, one to the other, by the narrowest of garlands. Small pictures of masks sit on the candelabra—soar in front of them, one is tempted to say. Two minuscule ibises bend their long necks from the upper corners of the central baldachin.

The ibises are not the only Egyptianizing elements in this villa. Small pictures with Egyptian divinities appear in the black background decoration of another cubiculum, and in what remains of a third they recur in the bands across the central portion of the wall. Thus, from the start, one of the traits of this new style was the use of motifs from the land of the Nile, though these were already present in the late Second Style. As we have seen, Egypt and things Egyptian came to enjoy an unprecedented popularity when Octavian triumphed over Antony and Cleopatra at Actium in 31 B.C. and then, a year later, when the land of the Pharoahs became a Roman province. Here again we must repeat our warning against looking for esoteric significance when Egyptian elements are found in Pompeian painting. The walls of the villa in Boscotrecase use these exotic forms in a purely decorative context and for purely ornamental purposes.

With their white grounds, the principal pictures in the red bedroom stand out most effectively against the red walls. In themselves white backgrounds were no novelty, having been used in the Second Style, specifically in the house beneath the Villa Farnesina. The real innovation was that now, for the first time, these illusionistic framed pictures depicted landscapes in and for themselves, with the human figure no longer a center of interest but a mere accessory. These views of rustic temples and sanctuaries are painted in delicate pastel-like colors and float against a neutral ground completely lacking in spatial depth. Indeed, they do not even aim at such an illusion of depth. The smooth surfaces against which they are set have much the same relationship to the painted image as a marble plaque does to the relief mounted on it. By nature without spatial definition, it is only by being set in this fashion that the image becomes defined as in an unlimited space. This quality is emphasized even more in the black cubiculum, where small landscape paintings are placed directly against the dark wall surfaces.

It is consistent with the trend of the early Third Style that it often dispenses entirely with a large central picture in favor of delicate small still-life or even figurative motifs. In such instances everything is tuned to the effect of the uniform fields of color, especially the two favorites, glowing red and burnished black. Even the very finest photographs, such as those in this book, can at best suggest the cool, restrained, highly cultivated elegance of such walls. To comprehend their full fascination one needs to experience them in person, in something like the tablinum of the Villa of the Mysteries.

The filigree-like, delicate ornamentation drawn over the columns and pilasters and the buttressing elements between them make up a playful, fantastic new repertory of forms. The individual elements are quite arbitrarily juxtaposed and are removed from natural prototypes such as leafy vines and garlands, tending instead to the abstract. Peter H. von Blanckenhagen very convincingly argues that the leading master of the work at Boscotrecase belonged to the workshop that decorated the house beneath the Villa Farnesina in Rome, though the detailed evidence is too extensive to be repeated here.

Naturally this is a very important clue to where the Third Style

originated. Earlier writers occasionally held out for Alexandria, adducing the Egyptian motifs as proof, but, as we have seen, there was good reason for this sort of motif to be taken up in Italy itself at that time. Moreover, it is precisely when one follows through the logical development of the Third Style out of the late Second Style, and when one sees how consistently the one exploited and carried further the implications already present in the other, that it becomes clear that the only possible birthplace must be Rome. To which can be added the fact that the changeover took place in the immediate milieu of Augustus himself, which is sufficient to explain why the new style spread so far and so rapidly.

Thanks to its fortunate preservation, in Pompeii there is yet another example of the early Third Style which, like the Boscotrecase villa, is of the highest excellence in execution and reveals innumerable connections with the style practiced by the Farnesina workshop. This is the Villa Imperiale (plates 128–30). While there is still a good deal of the Second Style in its decoration, the paintings were in fact done later than those at Boscotrecase. But unlike the latter, in the Villa Imperiale the columns of the aedicules framing the pictures rest on undercut moldings (plate 129) which, on the long walls in particular, make for a stronger accent. Then, too, the paired columns, at the summit of which stand tiny figures of maidens, still have rather more real substance. Here an entirely different artistic temperament was at work, transforming the older style in a totally diverse manner. Thus, for example, to either side of the central pictures the wall becomes a kind of half-height partition on which stand delicate pavilions and from which small panel paintings—paintings-within-paintings—seem to be hanging from vertical supports. But this half-height wall is a solid, smooth, delimiting surface like other walls in the early Third Style, and the zone above it is neutralized by a white ground with nothing of the suggestion of open air and sky found in similar circumstances in the Second Style. So even if the figure plays a decidedly greater role in these paintings, the tendency toward a suppression of space remains nevertheless the same. Besides which it is only fair to ask if the system used in the red cubiculum at Boscotrecase, which measures only 15 feet by 17 feet 9 inches, was appropriate to this hall of 19 feet 8 inches by almost 29 feet, one of the largest in all Pompeii.

Just as Roman art between Augustus and Nero trod new paths, with its classicism transformed into newly revived baroque forms, so, too, the Third Style grew away from the early phase described here. It lost more and more of its rather studied elegance and emphasis on closed surfaces. Comparing the system used in Boscotrecase (plate 296) with the late wall decoration in the House of Marcus Lucretius Fronto in Pompeii (plate 298), it becomes clear just how far the style changed over the years. If at first glance one notices only the difference, their connection is none the less evident.

The walls in the Fronto house, painted in the last decade before the earthquake, no longer have a uniform, overall ground color. Black fields flank the central red panel which itself is set off within a wide black frame, while above and alongside the black lateral panels there are small fields of red. Besides these, slender, elongated aedicules with a red ground are intercalated between the central and side panels, and above them the opaque wall opens up to reveal gently curving colonnades. Thus the motif of the architectonic vista is brought back in the central zone of this wall system, with a difference, however: the dark background precludes any impression of a real outdoors beyond the wall, so that what we have here is very unlike the spatial illusionism of the Second Style and the deeply recessed fantasy architecture of the mature Fourth Style.

The ornamentation becomes broader and fuller. In many places—above the central panel and the side fields, or below the entire middle zone of the wall—its forms betray their derivation from the early Third Style. But now the architecture seen through the imaginary apertures is framed by plantlike decoration which, in the rather frayed borders, combines with purely objective abstract motifs. So rich and full is this exuberantly flowering ornamentation that it almost overwhelms the excessively slender columns flanking the central field. Virtually without substance, those columns as well as the metallic, thin, architectural structures of the upper wall are still unquestionably in the tradition of the earlier forms, though on the other hand the candelabrum in the right-hand side field has just as surely increased in volume and three-dimensionality.

One of the most significant innovations of the late Third Style concerns the central picture of each wall. It no longer fills the large vertical oblong field. Instead, almost square and of moderate dimensions, it sits in the middle of the broad red field and has become nothing more nor less than an imitation of a picture painted on a panel which might, in actual fact, be hung in exactly this spot. The aim is obviously to suggest just that. Any reminiscence of a vista through the wall has been eliminated. This new approach was destined to have a great future in the Fourth Style, where indeed it was to become the rule. Likewise the small landscapes with villas and harbors that, as here, hang or float in front of the candelabra played an important part in decoration done after the earthquake.

Just as the overall wall system quite clearly differed between the early and the late phase of the Third Style (even though they continued to have enough in common to distinguish them from the styles that preceded and followed them), so, too, figurative painting went through a development which set it as much apart from that of pre-Augustan times as from that of the Fourth Style which eventually replaced it. This is evident even in the single most important factor in painting: color. The basis for the change was already present in the delicate atmospheric coloring of the landscapes in the villa at Boscotrecase (plate 296). Favoring broken tones and rejecting strong accents, the early Third Style conspicuously preferred and frequently combined a cool green somewhat on the blue side and a gentle and rather unusual violet. They were used together as early as the paintings in the Villa Imperiale (plates 128, 129, 286) and continued in favor until about the middle of the century. Along with this went a preference for light backgrounds regardless of the setting called for by the subject, be it landscape, mountain view, interior, or architecture.

Hand in hand with that transparent coloring went clarity in the drawing of the figures. Never before and never again did contour play a greater part in Pompeian painting. Even the modeling of the bodies and garments was achieved more by drawing than by painterly means. All in all, then, in figurative painting there was the same coolly remote classicism as manifested itself in the organization of the wall decoration as a whole.

Broad, open space came to play a decisive role in the composition. Often the personages appear small and isolated in a vast landscape (plate 250), and even in scenes with several figures there is always much air around them, a thin, cool, transparent atmosphere (plates 129, 286). It is characteristic of the late phase of the Third Style that the action depicted began to fill the space available in very much the same way as in the best mythological scenes of the Fourth Style. All things considered, not too much separates the picture of a Dionysiac procession found in the House

of Lucretius Fronto (plate 298) from figurative scenes in the succeeding style.

Then, too, a new compositional principle comes into play. The mythological action takes place in the presence of spectators who are in no way directly connected with what is happening and are entirely unnecessary to it. Look, for instance, at the two maidens in the *Theseus Triumphant* in the Villa Imperiale (plate 286) or the women in the *Mars and Venus* in the House of Lucretius Fronto (plate 265). Obviously this is not always the case, but when it is, it is almost exclusively in Third-Style paintings. Indeed, it is carried to such lengths that the modern viewer involuntarily finds himself wondering if they are perhaps not mythical personages but mere humans. It is by no means infrequent in pictures of this period that an elegantly dressed woman simply wanders into some scene from an ancient saga. In any event, such a blending of two spheres—the divine and the mortal—is quite certainly to be attributed to the fact that it was a court circle that stood godfather to this Third Style.

The Fourth Style

Here again, as for the Third Style, the only fixed point in time that can be determined is the date of its earliest appearance. Right up to the destruction of Pompeii there is not a single date concerning the Fourth Style that is based on anything more than stylistic analysis. All that is certain is that its beginnings were in the years after the earthquake. In none of the Vesuvian towns has there been found, up to the present at least, a single painting in the Fourth Style on a wall that survived intact the disaster of A.D. 62.

Among the earliest examples are the decorations in the red garden room in the House of the Vettii (plates 110, 111). Various writers did their best to date this ensemble before A.D. 62 until Maiuri investigated the structural condition of the building and demonstrated that this was simply not possible. In any event, conclusions arrived at by stylistic analysis alone are perfectly comprehensible, if for no other reason than that a good deal here strikes one as brilliant variations on the Third Style.

Whatever the central pictures may have looked like—and it is more likely that they were removed in some earlier excavation we do not know about than that they had not yet been set into the wall when the final disaster struck—the overall character of the walls is still determined by the large red surfaces between which narrow black fields are interposed in much the same way as the illusionistic vistas to either side of the main panel in the Fronto house (plate 298). Indeed, in the latter one has much more the feeling of looking at something genuinely architectural than the hairbreadth candelabra entwined in vine runners found in the House of the Vettii, which one hesitates even to refer to as candelabra, so little do such fantastic creations have to do with anything real.

But even the pairs of gods floating aloft undeniably have their origin in the Third Style, though they are no longer subtle miniatures and now occupy considerably more area. They have become something halfway between freely soaring figures and a circumscribed pictorial composition, and although they are painted directly on the red background which continues uninterrupted all around them, they are none the less encompassed within framing lines drawn in perspective. In any case, the wall is still opaque in effect as in the Third Style, and the thin strutlike bands in the black portions give no impression whatsoever of three-dimensionality.

What is really different is the dado around the base of the walls: it now has figurative scenes in all three bands. While figures had already been introduced into the base zone in the late Third Style (plate 298), it was still done only very sparingly. What we see in the House of the Vettii is strikingly new, especially in the black pictorial fields set into the red band of the dado (plate 111) which, as the style developed, were transformed into illusionistic niches drawn in perspective.

Above the stucco cornice that crowns the middle zone, the wall surface is opened up in an entirely new way. The pavilion-like architecture of this upper zone is not a new motif. It was already present in the Third Style, but the buildings rendered there in clear, linear draftsmanship are quite unlike these airy, open summerhouses or kiosks, where the feeling of depth is conveyed by delicate colors that fade away gradually into the background. What is more, this upper zone is brought to life by mythological figures so interwoven into the architecture as to play an essential part in the effect of perspective. Here there can be no doubt that the aim was spatial illusion, and in some ways this recalls the Second Style, though the degree of reality, of believability, in this architecture is basically very different. The later period had no concern with realistic depiction of real buildings but instead, in a wonderfully imaginative and fantastic manner, played with light and shadow, space and atmosphere.

This, then, was an entirely new artistic conception. Whatever its similarities, it was not a further development of the Third Style but, on the contrary, was as distinctly different from its predecessor as the wall paintings in Boscotrecase differ from those in the house under the Farnesina in Rome. The new traits are even more evident in the somewhat later room in the House of Loreius Tiburtinus, where a priest of Isis is pictured on one wall (plate 252). There the architectural motifs of the upper zone, enlivened with figures and fabulous beasts, are even more interwoven with fantasy forms and assimilated into something purely ornamental. In the middle zone, the narrower fields between the main panels are opened up to provide vistas through the wall, and in these the artist made use of more pronounced perspective—note the figure in the open door at the head of a small flight of stairs—without, however, weakening the character of unreality but, if anything, giving it added intensity. Sumptuous in overall effect and subtle in their details, these paintings are exquisite evidence of the richness of the late Neronian style of Pompeian art in the years between A.D. 62 and 68.

The Fourth Style did not originate in Pompeii. It is found fully developed in Rome in the Domus Aurea, the Golden House that Nero built after the great fire of A.D. 64. One is tempted to regard the artists who worked under Fabullus on the decoration of that splendid residence as the real creators of the Fourth Style. But even if they were not, theirs must have been a very important workshop, and they must have considered this to be a most important undertaking. Whatever the case, for Rome as for Pompeii, all attempts to identify examples of the Fourth Style before the time of Nero, or indeed before A.D. 60, have been fruitless.

As was already the case in the early examples, the renewed emphasis on breaking through the solid opaqueness of the wall focused on the tall, narrow fields between the central and side panels. In these the pavilion-like architectural fantasies stand out in bolder perspective and are sometimes piled one on the other so high as to invade the upper zone (plate 302), which often consists of nothing but such architectural prospects. Here the virtuosity of the painter is at its richest. The eye penetrates spatial layers lying farther and farther back and becoming ever lighter and paler until they disappear into the background.

The high point of this approach was reached during the reign of Nero himself. Entire walls were covered with painted imaginary architecture, nowhere more impressively than in a room in the House of Pinarius Cerealis (plate 251), where the figures move within and in front of aedicules as if on a theater stage. That the stimuli for this sort of wall painting came from the *scaenae frontes* of the contemporary theater is beyond dispute, but the gorgeous, imaginary facades in the paintings make no attempt to copy real architecture. Not only are the colors unrealistic to start with, but their irreality is further emphasized by the fabulous creatures frisking about on their cornices and by the way the architectural forms have become no more and no less important than the daringly disposed vine tendrils, garlands, and plantlike candelabra. Furthermore, in their deeply graduated spatiality these wall paintings are entirely unlike the stage settings of the time, in which aedicules were simply set in front of a solid rear wall.

Often, too, the solid wall fields themselves break into movement and are transformed into curtains that seem to hang in front of architectural structures (plate 304). Even more characteristically, something of the texture of a clearly circumscribed painted wall surface is often retained, so that one cannot be sure if the forms are meant to be hangings or solid wall. Similarly arbitrary is the way the eye suddenly finds itself blocked where it has every reason to expect an open vista, seeing instead a patch of wall holding a simulacrum of a small panel picture (plates 109, 304). While this would seem to make the wall appear more solid and to run counter to the process of opening it up, it often works the other way, introducing a further note of instability and restlessness and giving the overall impression of a certain baroque excess often associated with the Fourth Style.

To pin down the development of this style, to grasp its changes in the course of the years, proves far more difficult than for all the Pompeian painting that preceded it. When it comes to dates, here more than elsewhere, one hesitates to propose even a round number, so it must be understood that anything suggested here is at best conjecture. In a series of studies, Karl Schefold came to the conclusion that the illusionism favored during the reign of Nero was followed during that of the first Flavian emperor, Vespasian (A.D. 69–79), by a reaction in which the wall acquired a new solidity and the motifs suggesting spatial depth were once again more firmly anchored to the surface. Even if one subscribes to this theory, the stylistic classification of a great number of forms continues to involve no end of problems. In this, naturally enough, the individual workshops and their specific artistic traditions played a part that should not be undervalued. In the years after the earthquake, alongside the Fourth Style, there continued to be imitations of all three earlier systems of decoration, obviously at the insistence of patrons of conservative taste. Among these were exquisite ornamental paintings that could compete with the best in the Third Style (plate 309). However, there was a good deal that simply would not fit into the decorative scheme of the Fourth Style, notably the large landscapes and garden pictures with which it became fashionable to cover entire walls in viridaria and peristyles.

As secure exemplars of wall decoration in Vespasian times we can single out the so-called Ixion and Pentheus Rooms in the House of the Vettii, already discussed in connection with the house itself (plates 109, 112). Likewise the House of the Ara Maxima (plate 76) is a good representative of the solid but also more sober way of treating the wall in that same period. In its triclinium (at the left on our illustration) much less space and emphasis were given to the open vista, and the curtain motif is at the most a reminiscence, reduced to a fine, white, ornamental border inscribing a hexagon against the red ground.

The Fourth Style was defined on the basis of what was found in Pompeii. If in that one city there are a number of divergent trends within the style, it is understandable that in Herculaneum the basic tendency should be the same, but with a number of forms not found in the same overall arrangement in Pompeii and differing even to some extent in treatment and detail. Herculaneum has, in fact, several examples of the Fourth Style which can match the best in Pompeii (plate 162). Especially favored there, it would seem, was the architectural prospect rendered in something like monochrome grisaille against a uniform dark ground.

In the period of the Fourth Style the way of using stucco was intimately related to what was being done in painting. Architectonic elements were occasionally done in actual relief (plate 303), giving the impression that the painted architecture literally projects from the surface, a device used again sixteen centuries later in the Baroque. That touch of realism, however, was enough to nweake the illusion. The actual contours of what was done in stucco relief became excessively prominent, spatial depth was much harder to obtain by this method than by painting, often there were distortions in perspective, and the capital of a column may appear to exist in a spatial plane different from that of its base.

As for figurative painting, its palette was more forceful than in the Third Style and its means more truly painterly than ever before. Convincingly three-dimensional in its treatment of the human body, the male nude in particular became more anatomically articulated and more powerful than ever before (plate 160). It is not without significance that, in this "baroque" reaction to the classicism of the preceding period, the Fourth Style paralleled the development in sculpture of the time.

Scenes with figures now filled the surface so fully that landscape, architecture, and interiors were pushed into the background and became no more than a simple frame for a central action. Mythological episodes tended to concentrate on essentials and to reject all the secondary matter to which the Third Style was so partial. The number of persons in any scene was generally restricted to those indispensable to the action.

To cap it all, a new note of pathos entered into pictorial narration. The Greek period in which such an attitude was most prevalent was the Hellenistic, and it is interesting that the Fourth Style often achieved its finest results precisely when it dealt with prototypes from that period, as in something like the scene in which Hercules discovers the infant Telephus (plate 160). Although frequently there was no attempt to arrive at a faithful copy, painting in the time of Nero and the Flavians came infinitely closer to Hellenistic art in spirit and feeling than it did under the Julians and Claudians, and it is not inconsistent with this that the final stage of painting in the cities so tragically buried by Vesuvius should have been the most pictorial and the most painterly in the history of Roman art.

Following pages:

292 FIRST-STYLE DECORATION, *North wall of the tablinum, House of Sallust, Pompeii* (VI, 2, 4). Despite various later alterations and additions, the nucleus of this house—the rooms around the atrium—retained to the end the simple dignity of a dwelling of the Tufa Period. The First-Style decoration of the tablinum has a band along the base of the wall (what can be called a dado), which is surmounted by painted and stuccoed imitations of a stratum of large stone blocks (the stone course architectural historians call *orthostates*). These blocks are outlined in projecting stucco borders to enhance the illusion. The imitation blocks above them give a good idea of the colorfulness typical of the First Style. At the left is one of two stucco pilasters framing the broad door opening.

293 SECOND-STYLE DECORATION, *Room 15, Villa of the Mysteries, Pompeii.* Besides its great frieze, the Villa of the Mysteries has preserved a veritable repertory of Second-Style forms from about 60 B.C. Those seen here are among the simplest and earliest. The only spatial elements are the illusionistic narrow ledge above the plinth, the columns rising from it, and the cornice running beneath the three upper strata with their oblong blocks. There is no figurative decoration, nor does the wall open into a vista of architecture in perspective.

294 SECOND-STYLE DECORATION, *Cubiculum 16, Villa of the Mysteries, Pompeii.* The lavish decoration exploits two different aspects of the Second Style. The middle zone of the wall at the right, beyond the pilaster, dispenses with anything like three-dimensionality, simply repeating the system of broad and narrow fields used in the room with the great frieze. In the alcoves, however, there is a richly illusionistic perspective of painted architecture with undercut projecting moldings on the colonnades and a deep vista beneath the arch. The rear wall is laid out with rigorous axial symmetry.

295 PHILOSOPHER, *from the Villa of P. Fannius Sinistor, Boscoreale. Wall painting transferred to panel, height c. 80".*

Museo Nazionale, Naples. The largest room in this Roman villa was decorated about 40 B.C. with a figurative cycle which, along with that in the Villa of the Mysteries, constitutes the most significant example known of large-figure painting in the Second Style. The subject of this cycle seems to concern the Macedonian royal house, and the bearded philosopher here is usually identified as Menedemus of Eretria. The figures are set in an elaborate architectural arrangement.

296 THIRD-STYLE DECORATION, *North wall of the red cubiculum, from the Villa of Boscotrecase. Museo Nazionale, Naples.* The villa, owned by Agrippa Postumus and decorated about 11 B.C., marks the beginning of the Third Style in the Vesuvian towns. The solidity and enclosing effect of the wall are emphasized, and the architectonic articulation of the earlier styles is transformed into incorporeal decorative elements. Here, in the middle of the wall is a landscape of a sacred precinct dominated by a statue of a seated goddess.

297 GARDEN LANDSCAPE. *Third-Style decoration, Cubiculum, House of the Fruit Orchard, Pompeii* (I, 9, 5). The motifs around the base belong to the Third Style, but all the rest is true garden landscape painting. Above the wall of an ornamental garden with trellises, vases, and fountains are seen the upper parts of trees between the extremely slender columns typical of the Third Style. Despite a certain disparity between the broadly painted upper wall and the delicate treatment of the lower zone, this decoration seems to date from the first quarter of the first century A.D.

298 LATE THIRD-STYLE DECORATION, *North wall of the tablinum, House of Marcus Lucretius Fronto, Pompeii* (V, 4, 11). Done sometime between A.D. 50 and 60, this decoration typifies the late phase of the Third Style in which what had been merely miniature-like, delicate, ornamental motifs came virtually to overrun the architectural elements supporting them. At the same time, the

solid opaque wall surface once again was opened up into architectural vistas. In the small picture in the center, Bacchus and Ariadne ride in triumph in a cart drawn by bulls, accompanied by Silenus, a satyr, and two maenads (see also plate 265).

299 THE PUNISHMENT OF CUPID, *from the House of the Punishment of Cupid, Pompeii* (VII, 2, 23). *Wall painting transferred to panel, 45 5/8 × 34 1/4". Museo Nazionale, Naples.* The picture, painted about A.D. 20, came from the north wall of a tablinum and depicts a winged boy, his legs chained, wiping his tears as he is led toward his mother, Venus, who is already gripping the hoe with which, as punishment for misusing his powers, he will be condemned to toil. The setting is an airy landscape, rather small in proportion to the very large, cleanly contoured, linearly drawn figures. The cool tonalities are characteristic of the earlier Third Style.

300 NYMPH WITH LYRE (*detail*), *from the House of Jason, Pompeii* (IX, 5, 18). *Wall painting transferred to panel. Museo Nazionale, Naples.* In the full picture, Pan and two nymphs listen to this third nymph playing the lyre in a richly landscaped setting. The delicately colored painting from about A.D. 10 exemplifies the elegant classicistic Third Style of the Augustan age at its high point.

301 EARLY FOURTH-STYLE DECORATION, *Small oecus off the atrium, House of the Vettii, Pompeii* (VI, 15, 1). The white-ground decoration here was done earlier than that in the Pentheus and Ixion Rooms in the same house (plates 109, 112). Illusionistic architecture is used only very sparingly in the middle zone of the wall, and only in the upper zone does it fill the entire surface. Figures, animals, and vessels lend a note of animation, together with strange hybrid creatures balancing on the projecting cornices at the top. A special role is played by the delicate ornamentation, which is dotted with fantastic figures of animals. The main picture, on the left here, depicts Cyparissus and his stag, and on the opposite wall there is Danaë.

209

302 FOURTH-STYLE DECORATION, *Large hall, House of Fabius Rufus, Pompeii (insula occidentalis)*. The house, situated on the southwest edge of the city in a site affording a splendid view of the sea, was still being renovated in A.D. 79, but the largest room had already received its black-ground, Fourth-Style decoration. Above a dado enlivened with animals, vases, musical instruments, and other such motifs, pavilions rise to the ceiling with an extraordinarily three-dimensional effect, helped by figures in and on them (the woman on the balcony at the left, for example). Apollo, Bacchus, and Venus appear in the main picture on the rear wall, in the upper zone above them is Leda with her swan, and small personifications of the muses stand isolated in the side fields. The sumptuous decoration, whose dark ground makes the figures and ornamental elements stand out with particular prominence, was done only nine or so years before the catastrophe.

303 PAINTED STUCCO WALL, *from Pompeii. Museo Nazionale, Naples*. Executed about A.D. 70, this wall is one of the finest examples of the combined use of paint and stucco. All architectonic elements were done in low stucco relief, as were the woman on the balcony and the figures in the red middle zone at the right. The spatial effect of the wall is enhanced by these plastic means, though it remains true that perspective, and the consequent illusion of a larger space, is best achieved with painting. Least successful is the entablature running sharply at an oblique angle to the right of the large open door.

304 FOURTH-STYLE DECORATION, *North wall of the peristyle, House of Castor and Pollux, Pompeii (VI, 9, 6–7)*. The large colonnaded court of the house, the property of Nigidius Vacula, was rebuilt after the earthquake and decorated in the Fourth Style. Above a simple dado, the principal zone has large fields which seem to be hung with curtains or carpets on or against which soar isolated figures. These fields alternate with much narrower intermediate fields in which airy pavilions rise above still-life pictures. Delicate, almost incorporeal architecture fills the topmost zone. In the large fields seen here, to the left there is a youth carrying sword and spear and dressed in a short mantle called a *chlamys*. To the right is a maenad with tympanon and thyrsus. This highly fantastic decoration is dated in the reign of Nero.

305 THE JUDGMENT OF SOLOMON, *from the House of the Physician, Pompeii (VIII, 5, 24). Wall painting transferred to panel, 17 3/4 × 61". Museo Nazionale, Naples*. Originally the picture was on the inner side of the podium on the east side of the peristyle in a house presumably owned by a physician. The action is sufficiently explicit to warrant the title, and the picture is interesting evidence that the Jewish Biblical tradition was not unknown in Pompeii. As so often in the time of Nero, the personages are represented as pygmies with what would seem to be an attempt at parody.

306 NILE LANDSCAPE WITH PYGMIES *(detail), from the House of the Physician, Pompeii. Wall painting transferred to panel. Museo Nazionale, Naples*. On the west side of the same peristyle there was this Nile landscape in the manner fashionable at the time of the Fourth Style. The lively and amusing depiction—pygmies attacking a hippopotamus which is making a meal of one of them, others capturing a crocodile which one of the hunters mounts like a horse—belongs to the same phase as the *Judgment of Solomon* from the same house.

307, 308 MAENAD ON A BOUND CENTAUR *and* BOY WITH CYMBALS TRANSPORTED BY A FEMALE CENTAUR PLAYING A LYRE, *from the Villa of Cicero, Pompeii. Wall paintings transferred to panel, height of each 11 3/4". Museo Nazionale, Naples*. These two fragments have been laid end to end with two others to make a kind of frieze, though originally they were isolated on the walls in much the same way as, in the Third Style, small figures were poised against a neutral background, a device exploited occasionally in the succeeding style as well. Just how the individual pictures were related, and in what context, is not known. Other painted decoration found in the same room bears out the conclusion that these charming groups, with their highly painterly and ebullient approach, belong to the late phase of the Third Style as practiced about the middle of the first century A.D.

309 FOURTH-STYLE DECORATION *(detail of a wall), Triclinium, House of the Centenary, Pompeii (IX, 8, 3, 6)*. Under Vespasian there were still decorations of such exquisite subtlety that they could be mistaken for Third Style, were it not that details in the plan of the wall elevation point so clearly to the later approach. Among the loveliest of these ensembles with delicate ornamental motifs is the white-ground triclinium on the north side of the peristyle in the House of the Centenary. In this small portion of the west wall of that room, hairbreadth vines holding birds of all sorts twine around narrow candelabra stretched tautly vertical across the surface like fine cords. Such a composition was possible only in a period which could draw its repertory of forms not only from the Third Style but also from the early Fourth Style, as we find it in the large garden oecus in the House of the Vettii (plates 110, 111).

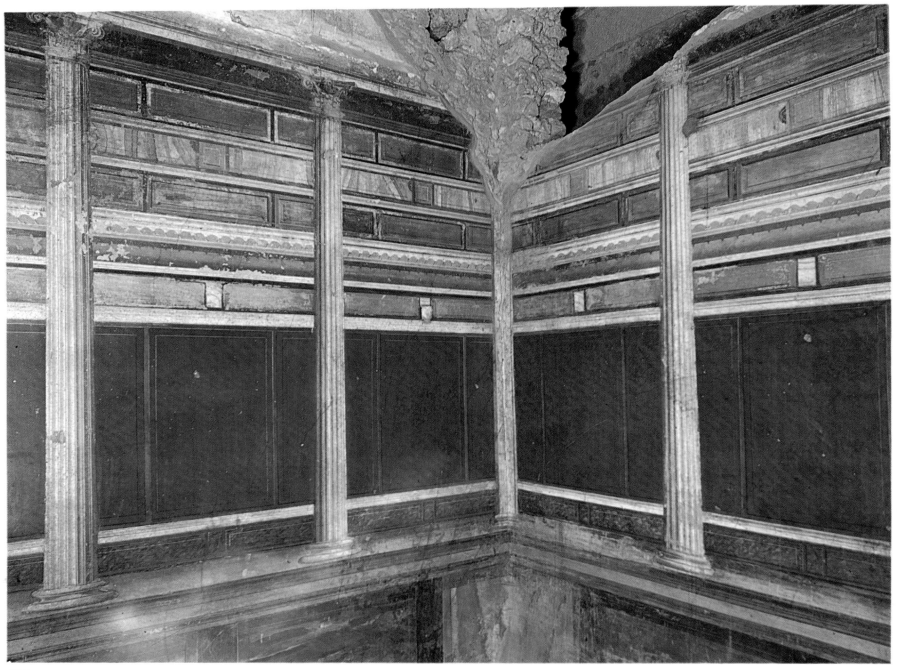

293

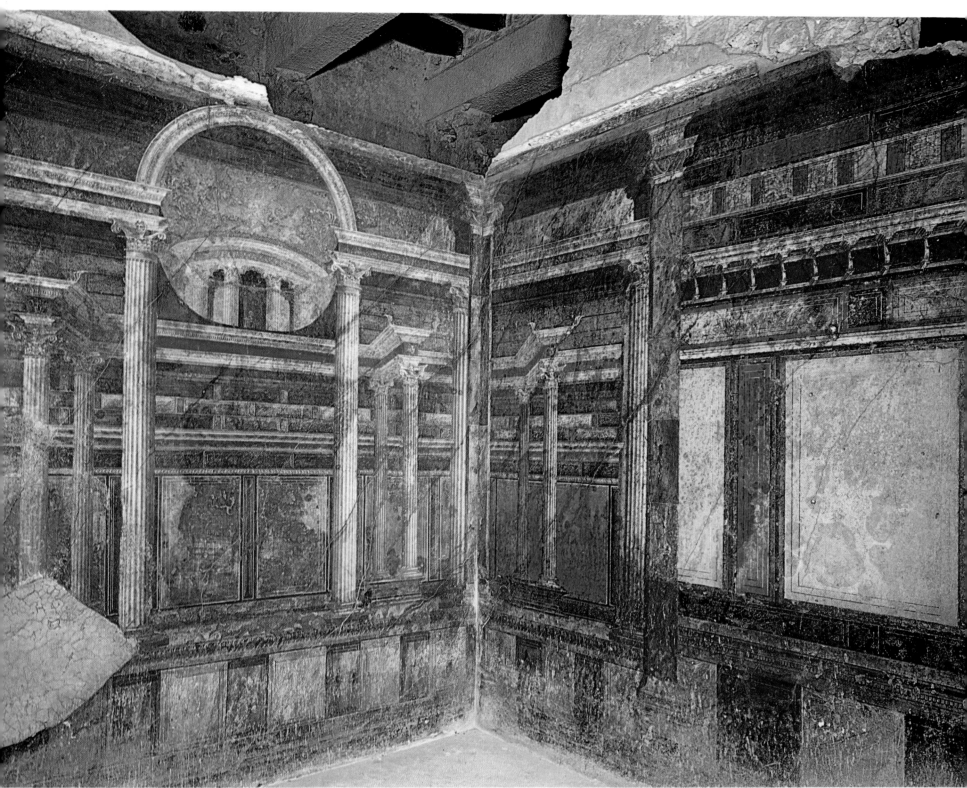

294

296

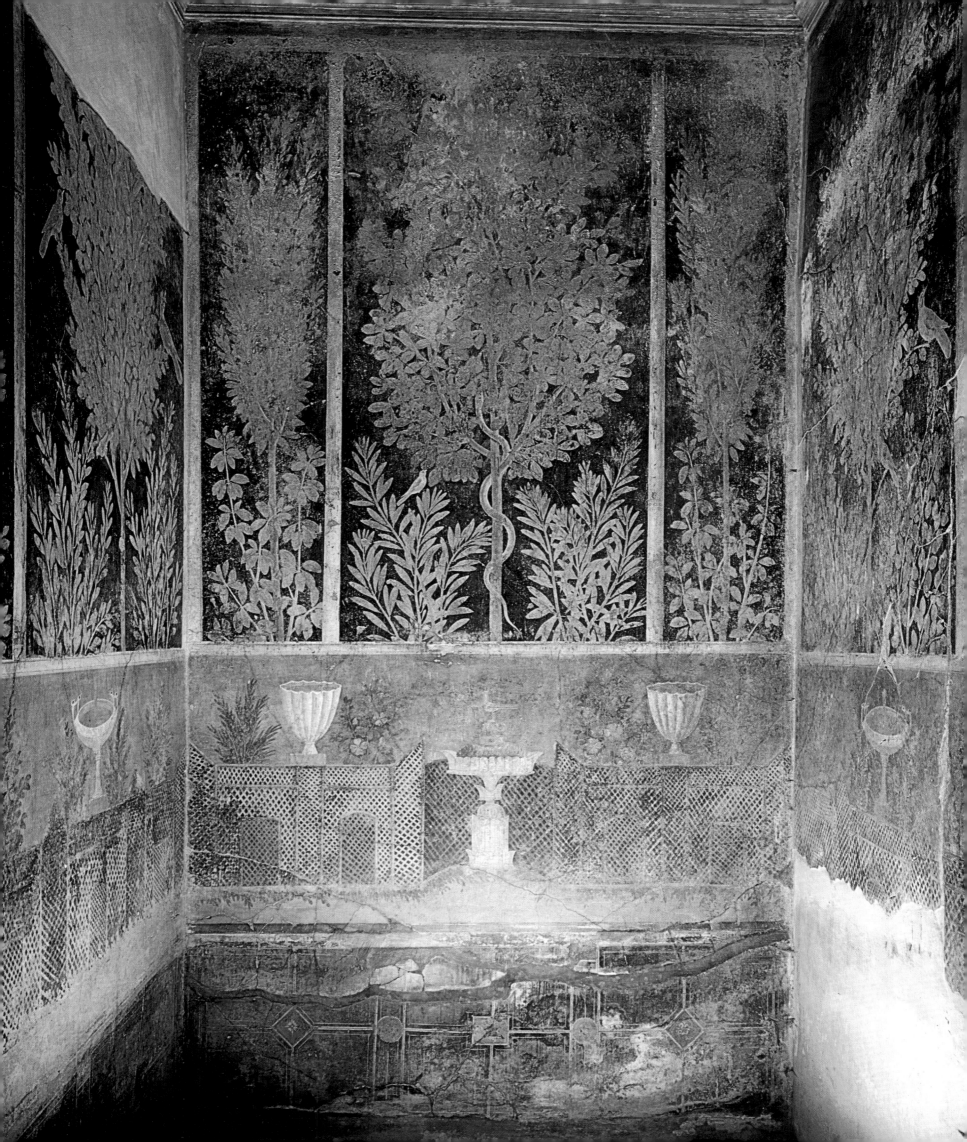

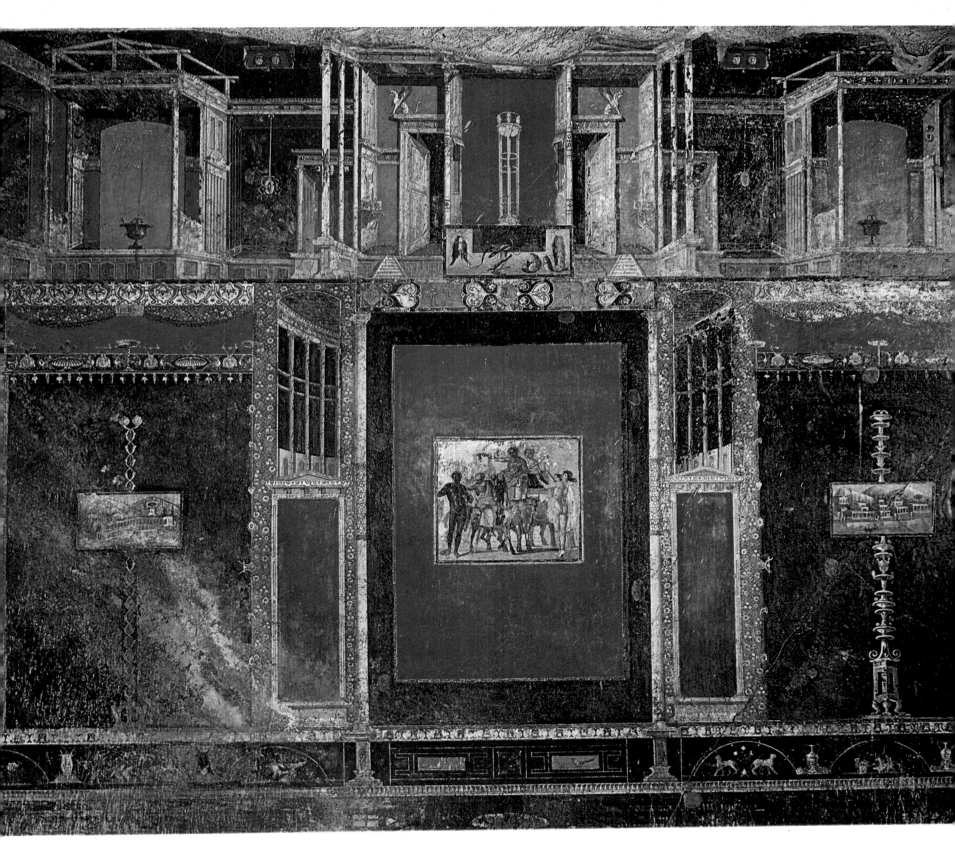

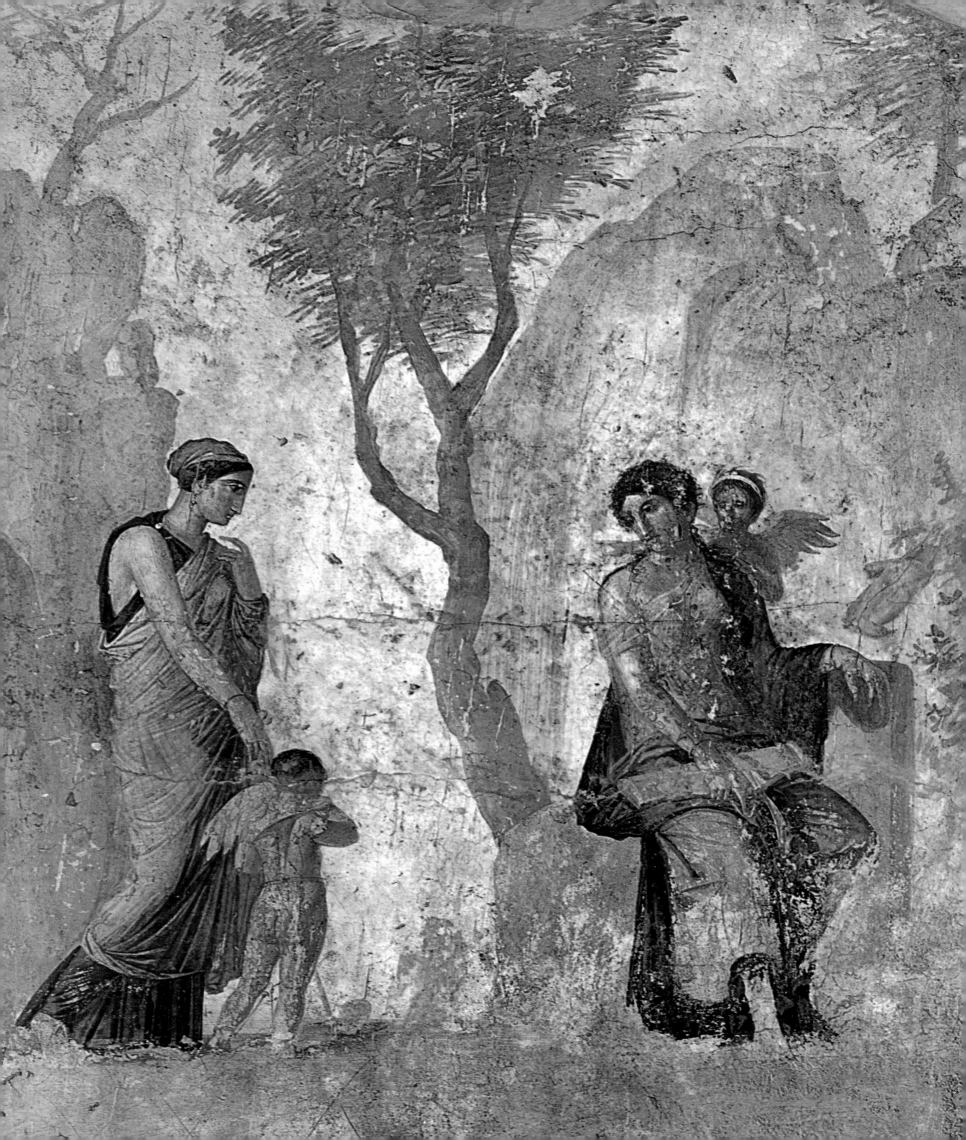

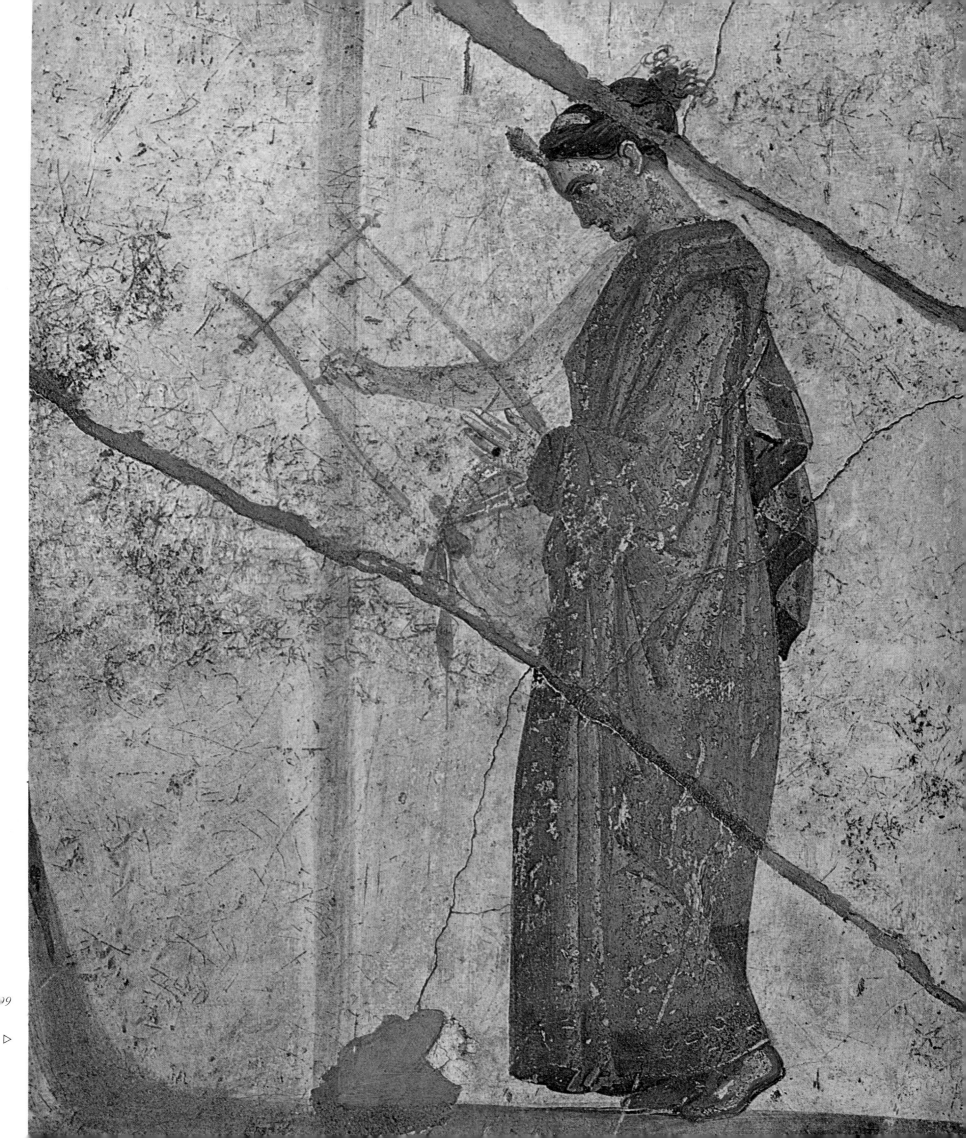

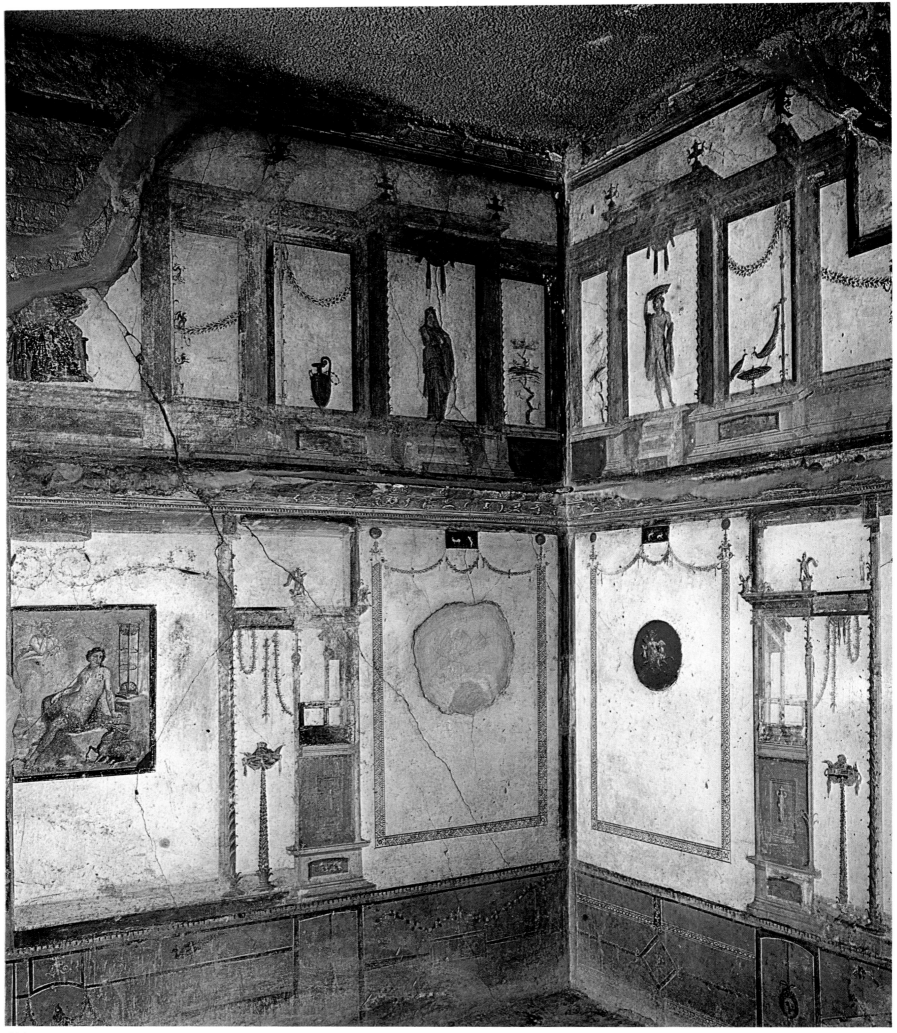

301

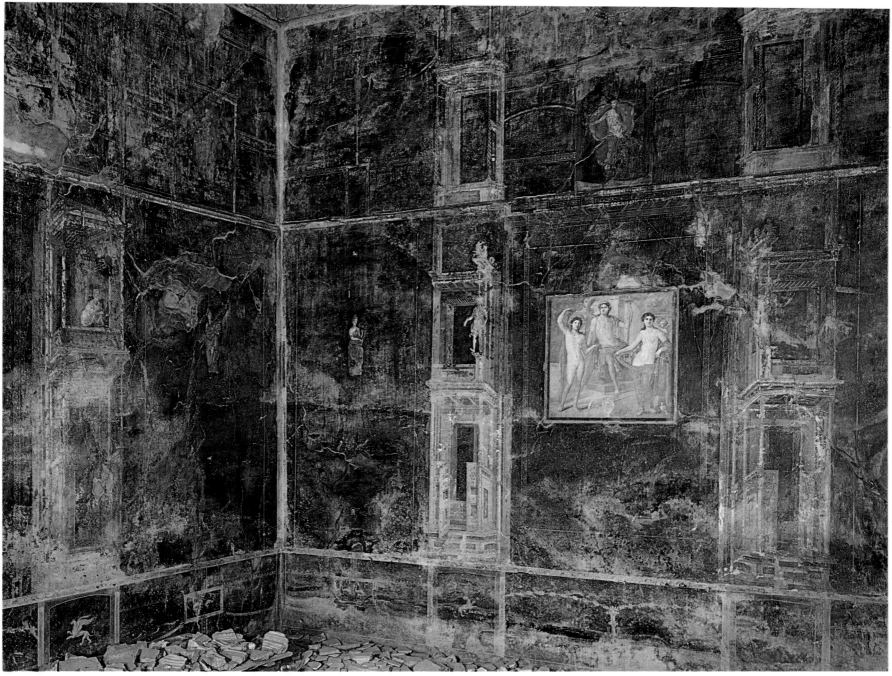

302

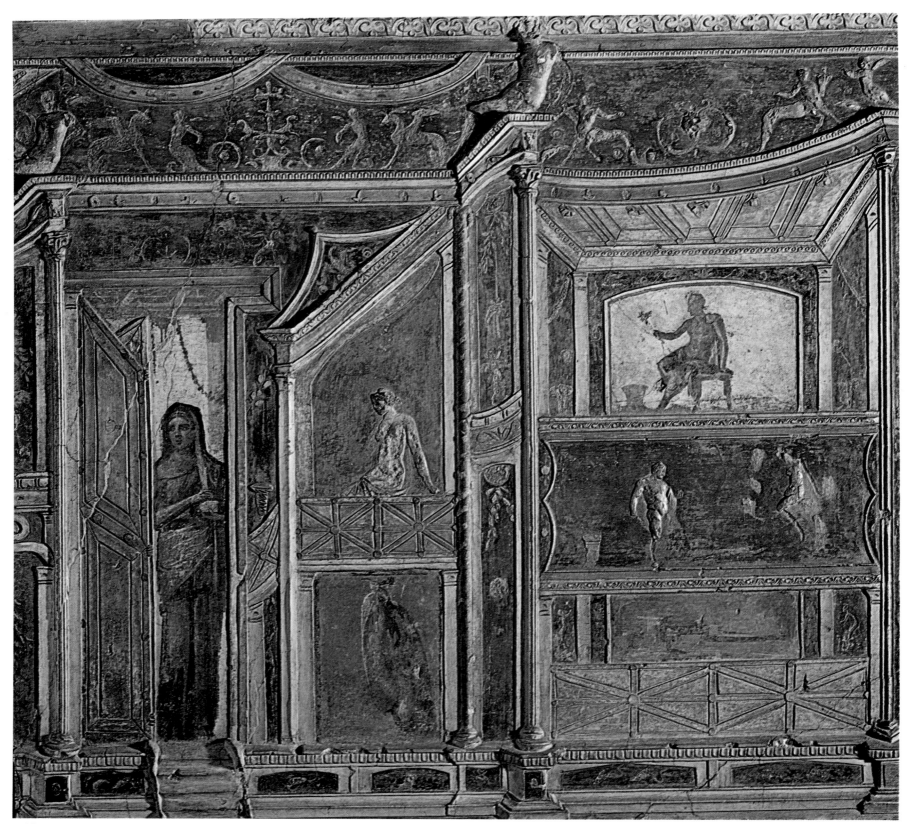

303

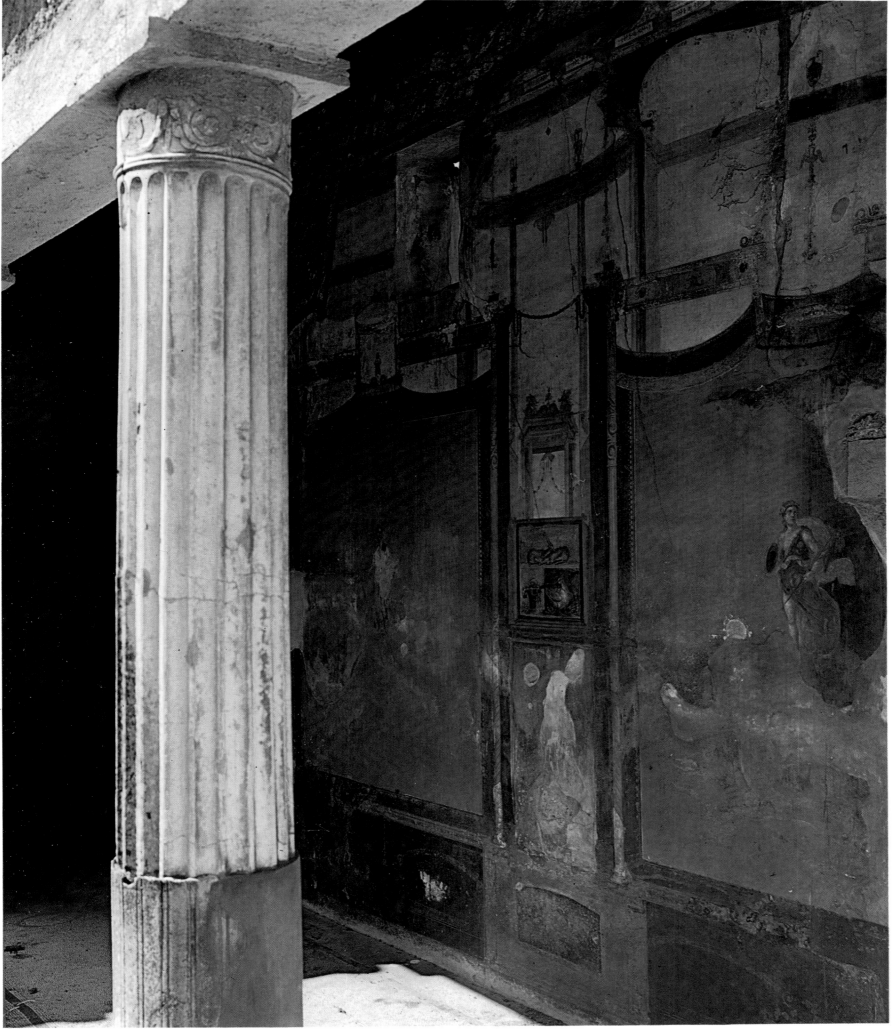

304

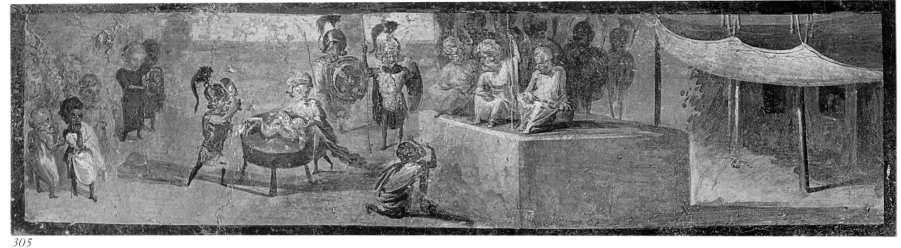

305

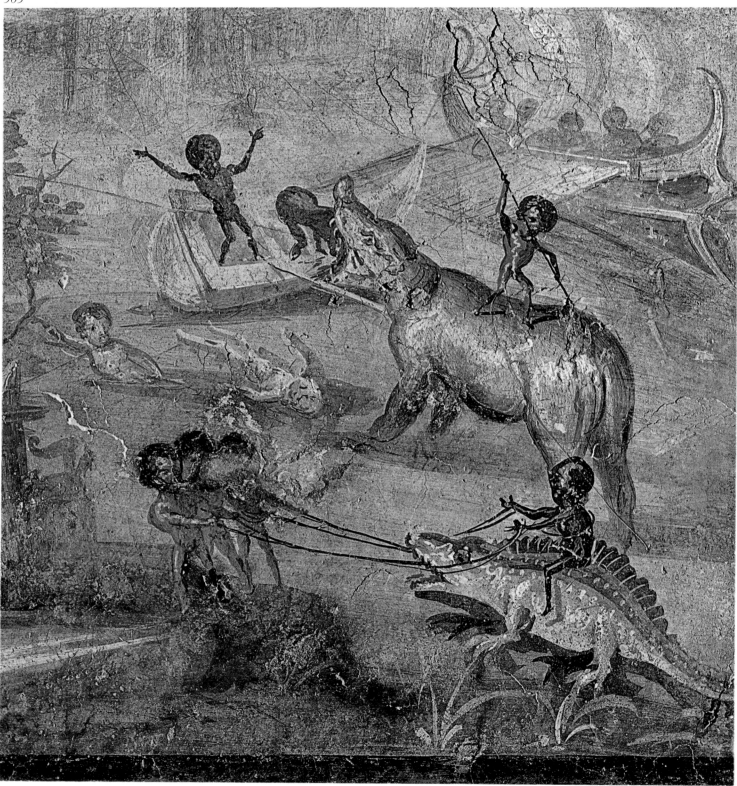

306

307

308

BIBLIOGRAPHY

1 Adriani, A. *Repertorio d'arte dell'Egitto greco-romano.* 2 vols. Palermo: Fondazione "Ignazio Mormino" del Banco di Sicilia, 1961.

2 Andreae, B. *Das Alexandermosaik.* Bremen: W. Dorn, 1959.

3 ———. "Römische Malerei," in T. Kraus, *Das römische Weltreich* (Propyläen Kunstgeschichte, vol. 2), Berlin, 1967, pp. 201 ff.

4 ———. "Römische Stuckdekoration," in T. Kraus, *Das römische Weltreich* (Propyläen Kunstgeschichte, vol. 2), Berlin, 1967, pp. 215 ff.

5 Bastet, F. L. "Wann fingt der vierte Stil an?" *Bulletin van de Vereeniging tot Bevordering der Kennis van de Antieke Beschaving te 's-Gravenhage* (Leiden), 39, 1964, pp. 149 ff.

6 Bauchhenss-Thüriedl, C. *Der Mythos von Telephos in der antiken Bildkunst.* Würzburg, 1971.

7 Becatti, G. *Problemi fidiaci.* Milan: Electa, 1951.

8 Beschi, L. *I bronzetti romani di Montorio Veronese.* Venice: Istituto Veneto di Scienze, Lettere ed Arti, 1962.

9 Beyen, H. G. "A propos of the 'Villa Suburbana' (Villa Imperiale) near the Porta Marina at Pompeii." *Bulletin van de Vereeniging tot Bevordering der Kennis van de Antieke Beschaving te 's-Gravenhage* (Leiden), 31, 1956, pp. 54 ff.

10 ———. *Die Pompejanische Wanddekoration vom zweiten bis zum vierten Stil.* 2 vols. The Hague: M. Nijhoff, 1938–60.

11 ———. "The Workshops of the 'Fourth Style' at Pompeii and its Neighbourhood," in *Studia archaeologica G. van Hoorn oblata,* Leiden, 1951, pp. 43 ff.

12 Bianchi-Bandinelli, R. "Dioskourides," in *Enciclopedia dell'arte antica, classica ed orientale,* vol. 3, Rome, 1960, pp. 132 ff.

13 Bieber, M. *Die Denkmäler zum Theaterwesen im Altertum.* Berlin-Leipzig: Vereinigung Wissenschaftlicher Verleger, 1920.

14 ———. *The History of the Greek and Roman Theater.* 2nd ed. Princeton: Princeton University Press, 1961.

15 ———. *The Sculpture of the Hellenistic Age.* 2nd enl. ed. New York: Columbia University Press, 1961.

16 ———. "Wurden die Tragödien des Seneca in Rom aufgeführt?" *Mitteilungen des Deutschen Archäologischen Instituts, Römische Abteilung* (Rome), 60–61, 1953–54, pp. 100 ff.

17 Blake, M. E. "The Pavements of the Roman Buildings of the Republic and Early Empire." *Memoirs of the American Academy in Rome* (Rome), 8, 1930, pp. 7 ff.

18 Blanckenhagen, P. H. von. "Daedalus and Icarus on Pompeian Walls." *Mitteilungen des Deutschen Archäologischen Instituts, Römische Abteilung* (Rome), 75, 1968, pp. 106 ff.

19 ———, and C. Alexander, with an appendix by G. Papadopulos. *The Paintings from Boscotrecase* (Mitteilungen des Deutschen Archäologischen Instituts, Römische Abteilung, Ergänzungsheft 6). Heidelberg: F.H. Kerle, 1962.

20 Blümner, H. *Die römischen Privataltertümer* (Handbuch der Altertumswissenschaft, vol. 4, sec. 2, fasc. 2). Munich: C. H. Beck, 1911.

21 ———. *Technologie und Terminologie der Gewerbe und Künste bei Griechen und Römern.* 2nd ed. Leipzig: B. G. Teubner, 1912.

22 Boyce, G. K. *Corpus of the Lararia of Pompeii* (Memoirs of the American Academy in Rome, 14). Rome: American Academy in Rome, 1937.

23 Breglia, L. *Catalogo delle oreficerie del Museo Nazionale di Napoli.* Rome: La Libreria dello Stato, 1941.

24 Brendel, O. "Der grosse Fries in der Villa dei Misteri." *Jahrbuch des Deutschen Archäologischen Instituts* (Berlin), 81, 1966, pp. 206 ff.

25 ———. "Immolatio Boum." *Mitteilungen des Deutschen Archäologischen Instituts, Römische Abteilung* (Rome), 45–46, 1930, pp. 196 ff.

26 Briegleb, J. "Pseudo-Seneca," in *Enciclopedia dell'arte antica, classica ed orientale,* vol. 6, Rome, 1965, pp. 531 ff.

27 Byvanck-Quarles van Ufford, L. "Le 'Canthare' d'Alésia." *Bulletin van de Vereeniging tot Bevordering der Kennis van de Antieke Beschaving te 's-Gravenhage* (Leiden), 35, 1960, pp. 80 ff.

28 Cerulli Irelli, G. *Ercolano.* Naples: Di Mauro, 1969.

29 Coarelli, F. "Il Monumento Teatino di C. Lusius Storax al Museo di Chieti: Il rilievo con scene gladiatorie." *Studi miscellanei* (University of Rome), 10, 1963–64, pp. 85 ff.

30 Comparetti, D., and G. de Petra. *La villa ercolanese dei Pisoni, i suoi monumenti e la sua biblioteca.* Turin: E. Loescher, 1883.

31 Confalonieri, L. *Pompeii and its Tragedy.* Milan: A. Martello, 1959.

32 *Corpus Inscriptionum Latinarum IV: Inscriptiones parietiae Pompejanae,* ed. K. Zangemeister. Berlin: G. Reimerum, 1871.

33 Curtius, L. *Die Wandmalerie Pompejis: Eine Einführung in ihr Verständnis.* Leipzig: E. A. Seemann, 1929.

34 Dawson, C. M. *Romano-Campanian Mythological Landscape Painting* (Yale Classical Studies, 9). New Haven: Yale University Press, 1944.

35 De Franciscis, A. *Il ritratto romano a Pompei* (Accademia di Archeologia, Lettere e Belle Arti di Napoli, Memorie I). Naples: G. Macchiaroli, 1951.

36 ———. *Pompei.* 2nd ed. Novara: Istituto Geografico de Agostini, 1968.

37 ———, and R. Pane. *Mausolei romani in Campania.* Naples: Edizione Scientifiche Italiane, 1957.

38 Della Corte, M. *Case ed abitanti di Pompei.* 3rd ed. Pompeii-Rome: Presso l'Autore, 1965.

39 ———. "Ercole e l'Ara Massima in un dipinto pompeiano." *Memorie della Real Accademia di Archeologia, Lettere e Belle Arti di Napoli* (Naples), 1, pt. 2, 1911, pp. 167 ff.

40 ———. "L'Educazione di Alessandro Magno nell'enciclopedia aristotelica." *Mitteilungen des Deutschen Archäologischen Instituts, Römische Abteilung* (Rome), 57, 1942, pp. 31 ff.

41 Dentzer, J. M. "La Tombe de C. Vestorius dans la tradition de la peinture italique." *Mélanges d'archéologie et d'histoire* (Paris), 74, 1962, pp. 533 ff.

42 De Petra, G. "Le tavolette cerate di Pompei rinvenute a 3 e 5 luglio 1875." *Atti della Real Accademia dei Lincei* (Rome), 3, ser. 3, 1876.

43 Dohrn, T. "Crustae." *Mitteilungen des Deutschen Archäologischen Instituts, Römische Abteilung* (Rome), 72, 1965, pp. 127 ff.

44 Drerup, H. "Bildraum und Realraum in der römischen Architektur." *Mitteilungen des Deutschen Archäologischen Instituts, Römische Abteilung* (Rome), 66, 1959, pp. 147 ff.

45 ———. "Die römische Villa," in *Marburger Winckelmann-Programm,* Marburg, 1959, pp. 1 ff.

46 Eisen, G., and F. Kouchakji. *Glass: Its Origin, History, Chronology, Technic and Classification to the Sixteenth Century.* 2 vols. New York: W. E. Rudge, 1927.

47 Elia, O. "Di due pannelli decorativi pompeiani con figure in 'opus sectile' ad intarsio." *Bollettino d'arte* (Rome), 9, ser. 1, fasc. 6, 1929, pp. 265 ff.

48 ———. *Le pitture del tempio d'Iside* (Monumenti della pittura antica scoperti in Italia, sec. 3. fasc. 3–4). Rome: La Libreria dello Stato, 1941.

49 ———. "Lo stibadio dionisiaco in pitture pompeiane." *Mitteilungen des Deutschen Archäologischen Instituts, Römische Abteilung* (Rome), 69, 1962, pp. 118 ff.

50 ———. *Pitture murali e mosaici nel Museo Nazionale di Napoli.* Rome: La Libreria dello Stato, 1932.

51 ———. "Testa isiaca e ritratti ellenistico-romani di Pompei." *Rivista dell'Istituto nazionale d'archeologia e storia dell'arte* (Rome), 8, fasc. 2–3, 1941, pp. 89 ff.

52 Engemann, J. *Architekturdarstellungen des frühen zweiten Stils* (Mitteilungen des Deutschen Archäologischen Instituts, Römische Abteilung, Ergänzungsheft 12). Heidelberg: F. H. Kerle, 1967.

53 Eschebach, H. *Die Städtebauliche Entwicklung des antiken Pompeji* (Mitteilungen des Deutschen Archäologischen Instituts, Römische Abteilung, Ergänzungsheft 17). Heidelberg: F. H. Kerle, 1970.

54 Étienne, R. *La Vie quotidienne à Pompéi.* Paris: Hachette, 1966.

55 Forti, L. *Le danzatrici di Ercolano.* Naples: L'Arte Tipografica, 1959.

56 Fremersdorf, F. "Ein Bergkristall-Becher der frühesten Kaiserzeit in Köln," in *Festschrift Andreas Rumpf,* Krefeld, 1952, pp. 76 ff.

57 Fuchs, W. *Die Skulptur der Griechen.* Munich: Hirmer Verlag, 1969.

58 Gabriel, M. M. *Masters of Campanian Painting.* New York: Bittner, 1952.

59 Ghali-Kahil, L. B. *Les Enlèvements et le retour d'Hélène dans les textes et les documents figurés.* 2 vols. Paris: E. de Boccard, 1955.

60 Giordano, C., and I. Kahn. *Gli Ebrei in Pompei, in Ercolano e nelle città della Campania felix.* Pompeii, 1966.

61 Giuliano, A. "Fuit apud Segestanos ex aere Dianae simulacrum." *Archeologia classica* (Rome), 5, 1953, pp. 48 ff.

62 Goethert, F. W. "Studien zur Kopienforschung I: Die Stil und Trachtgeschichtliche Entwicklung der Togastatuen in den beiden ersten Jahrhunderten der Kaiserzeit." *Mitteilungen des Deutschen Archäologischen Instituts, Römische Abteilung* (Rome), 54, 1939, pp. 176 ff.

63 Grant, M. *Cities of Vesuvius.* London: Macmillan, 1971.

64 Guttmann, J. "A Reexamination of the 'Judgement of Solomon' Fresco at Pompeii." *Bulletin of the Israel Exploration Society,* 18, 1954, pp. 176 ff.

65 Heintze, H. von. *Römische Kunst.* Stuttgart: Belser, 1969.

66 Hekler, A. *Greek and Roman Portraits.* New York: G. P. Putnam, 1912.

67 Helbig, W. *Die Wandgemälde der vom Vesuv verschütteten Städte Campaniens.* Leipzig: 1868.

68 ———. "Scavi di Pompei." *Bullettino dell'Instituto di corrispondenza archeologica,* 2, 1865, pp. 228 ff.

69 Herbig, R. *Neue Beobachtungen am Fries der Mysterien-villa in Pompeji.* Baden-Baden: B. Grimm, 1958.

70 ———. *Pan.* Frankfurt: V. Klostermann, 1949.

71 ———. "'Schön wie von der Hand der Gratien.' Der III. Stil in der pompejanischen Wandmalerei." *Mitteilungen des Deutschen Archäologischen Instituts, Römische Abteilung* (Rome), 69, 1962, pp. 172 ff.

72 ———. "Zwei Strömungen Späthellenistischer Malerei." *Antike* (Berlin), 7, 1931, pp. 135 ff.

73 Hermann, P., R. Herbig, and F. Bruckmann. *Denkmäler der Malerei des Altertums.* Munich: F. Bruckmann, 1906–.

74 Hermann, W. *Römische Götteraltäre.* Kallmünz: Lassleben, 1961.

75 Hess, A. Auction catalogue, Lucerne, March 23, 1961.

76 Heydemann, H. *Iliupersis.* Berlin: Enslin, 1866.

77 Ibel, T. "Die Wage im Altertume und Mittelalter." Ph.D. dissertation, University of Erlangen, 1908.

78 *I Papiri Ercolanesi I* (I Quaderni della Biblioteca Nazionale di Napoli, ser. 3, no. 5), ed. E. F. Giannoni. Naples, 1954.

79 Jashemski, W. F. "The Caupona of Euxinus at Pompeii." *Archaeology* (Cambridge, Mass.), 20, no. 1, 1967, pp. 37 ff.

80 Joly, D. "Quelques aspects de la mosaique pariétale au premier siècle de notre ère d'après trois documents pompéiens," in *La Mosaique Gréco-romaine* (Colloques internationaux du centre national de la recherche scientifique), Paris, 1965, pp. 57 ff.

81 Kähler, H. *Rom und sein Imperium.* Baden-Baden: Holle, 1962.

82 Klein, W. "Pompejanische Bilderstudien III." *Jahreshefte des Österreichischen Archäologischen Instituts in Wien* (Vienna), 23, no. 2, 1926, pp. 71 ff.

83 Klinkert, W. "Bemerkungen zur Technik der pompejanischen Wanddekoration." *Mitteilungen des Deutschen Archäologischen Instituts, Römische Abteilung* (Rome), 64, 1957, pp. 111 ff.

84 Kluge, K., and K. Lehmann-Hartleben. *Die antiken Grossbronzen.* 3 vols. Berlin: W. de Gruyter, 1927.

85 Koldewey, R., and O. Puchstein. *Die griechischen Tempel in Unteritalien und Sicilien.* 2 vols. Berlin: A. Asher, 1899.

86 Kraiker, W. "Das Stuckgemälde aus Herculaneum 'Schmückung einer Priesterin.'" *Mitteilungen des Deutschen Archäologischen Instituts, Römische Abteilung* (Rome), 60–61, 1953–54, pp. 133 ff.

87 Kraus, T. *Das römische Weltreich* (Propyläen Kunstgeschichte, vol. 2). Berlin: Propyläen Verlag, 1967.

88 ———. "Die jüngsten Entdeckungen in Pompeji, Herculaneum und Stabiae," in E. C. Conti Corti, *Untergang und Auferstehung von Pompeji und Herculaneum,* ed. T. Kraus, 8th ed., Munich, 1964.

89 ———. "Zum Neapeler Relief mit Paris und Helen." *Mitteilungen des Deutschen Archäologischen Instituts* (Rome), 5, 1952, pp. 141 ff.

90 Kretzschmer, F., and E. Heinsius. "Über einige Darstellungen altrömischer Rechenbretter." *Trierer Zeitschrift* (Trier), 20, 1951, pp. 96 ff.

91 Künzl, E. "Venus vor dem Bade—ein Neufund der Colonia Ulpia Traiana und Bemerkungen zum Typus der 'sandalenlösenden Aphrodite.'" *Bonner Jahrbücher* (Bonn), 170, 1970, pp. 102 ff.

92 Küthmann, H. *Untersuchungen zur Toreutik des zweiten und ersten Jahrhunderts vor Christus.* Kallmünz: Opf, 1959.

93 La Baume, P. *Römisches Kunstgewerbe zwischen Christi Geburt und 400* (Bibliothek für Kunst- und Antiquitätenfreunde, 18). Braunschweig: Klinkhardt und Biermann, 1964.

94 Lauter, H. "Zur Chronologie römischer Kopien nach Originalen des 5. Jahrhunderts." Ph.D. dissertation, Bonn, 1966.

95 Lawrence, A. W. *Later Greek Sculpture and its Influence on East and West.* New York: Hacker Art Books, 1969.

96 Lehmann, P. W. *Roman Wall Paintings from Boscoreale in the Metropolitan Museum of Art* (Monographs on Archaeology and Fine Arts, 5). Cambridge, Mass.: Harvard University Press, 1953.

97 Licht, H. *Die Erotik in der griechischen Kunst* (Sittengeschichte Griechenlands, suppl. 3). Zurich: P. Aretz, 1928.

98 Lippold, G. *Die griechische Plastik* (Handbuch der Archäologie, vol. 3, pt. 1). Munich: F. Bruckmann, 1950.

99 ———. *Kopien und Umbildungen griechischer Statuen.* Munich: F. Bruckmann, 1923.

100 Longpérier, H. de. "Recherches sur les insignes de la questure et sur les récipients monétaires." *Revue archéologique* (Paris), n.s. 18, 1868, pp. 58 ff.

101 L'Orange, H.P., and P. J. Nordhagen. *Mosaik von der Antike bis zum Mittelalter.* Munich: F. Bruckmann, 1960.

102 Lorenz, T. *Polyklet. Doryphoros.* Stuttgart: Reclam, 1966.

103 Maiuri, A. *Ercolano* (Itinerari dei musei, gallerie e monumenti d'Italia). 7th ed. Rome: La Libreria dello Stato, 1970.

104 ———. *Ercolano: I nuovi scavi (1927–1958).* 2 vols. Rome: La Libreria dello Stato, 1958.

105 ———. *La Casa del Menandro e il suo tesoro di argenteria.* 2 vols. Rome: La Libreria dello Stato, 1933.

106 ———. *La Villa dei Misteri.* 2 vols. Rome: La Libreria dello Stato, 1931.

107 ———. "L'Efebo di Via dell'Abbondanza a Pompei." *Bollettino d'arte* (Rome), 5, ser. 2, no. 8, 1926.

108 ———. *Le pitture della Casa di M. Fabius Amandio, del Sacerdos Amandus e di P. Cornelius Teges* (Monumenti della pittura antica scoperti in Italia, sec. 3, fasc. 2). Rome: Istituto Poligrafico dello Stato, 1938.

109 ————. *L'ultima fase di edilizia di Pompei* (Istituto di studi romani, sezione campana, Campania romana 2). Rome: Istituto di Studi Romani, 1942.

110 ————. "Nuove pitture di giardino a Pompei." *Bollettino d'arte* (Rome), 37, ser. 4, fasc. 1, 1952, pp. 5 ff.

111 ————. *Pompei* (Itinerari dei musei, gallerie e monumenti d'Italia). 14th ed. Rome: La Libreria dello Stato, 1967.

112 ————. *Pompei ed Ercolano: Fra case e abitanti.* 2nd ed. Padua: Le Tre Venezie, 1959.

113 ————. *Pompei, Ercolano, e Stabia, le città sepolte dal Vesuvio* (Musei e monumenti). Novara: Istituto Geografico de Agostini, 1961.

114 ————. "Ritratto di Marcello a Pompei." *Le Arti* (Milan), 2, fasc. 3, 1940, pp. 146 ff.

115 ————. *Roman Painting.* Geneva: Skira, 1953.

116 ————. "Saggi e ricerche intorno alla Basilica [II Pompei]." *Notizie degli scavi di antichità* (Atti della Accademia Nazionale dei Lincei, Rome), 5, fasc. 7–12, 1951, pp. 225 ff.

117 ————. "Saggi nella cavea del 'Teatro grande' [XIX Pompei]." *Notizie degli scavi di antichità* (Atti della Accademia Nazionale dei Lincei, Rome), 5, fasc. 1–6, 1951, pp. 126 ff.

118 ————. "Scavo della 'Grande Palaestra' nel quartiere dell'Anfiteatro (a. 1935–1939) [I Pompei]." *Notizie degli scavi di antichità* (Atti della Accademia Nazionale dei Lincei, Rome), fasc. 8, 9, 1939, pp. 165 ff.

119 ————, and B. Maiuri. *Museo Nazionale di Napoli.* Novara: Istituto Geografico de Agostini, 1957.

120 ————, and R. Pane. *La Casa di Loreio Tiburtino e la Villa di Diomede in Pompei* (Monumenti italiani, ser. 2, fasc. 1, no. 4). Rome: La Libreria dello Stato, 1947.

121 Maiuri, B. *Museo Nazionale, Napoli* (Conoscere: Grandi Musei). Novara: Istituto Geografico de Agostini, 1971.

122 ————. "Relievo gladiatorio di Pompei." *Rendiconti della Accademia Nazionale dei Lincei* (Rome), 2, fasc. 11–12, 1947, pp. 491 ff.

123 Marconi, P. *La Pittura dei Romani.* Rome: Biblioteca d'Arte Editrice, 1929.

124 Matz, F. "Zum Telephosbilde aus Herculaneum." *Mitteilungen des Deutschen Archäologischen Instituts, Athenische Abteilung* (Athens), 39, 1914, pp. 65 ff.

125 Mau, A. *Geschichte der decorativen Wandmalerei in Pompeji.* Berlin: G. Reimer, 1882.

126 ————. *Pompeji in Leben und Kunst.* 2nd ed. Leipzig: W. Engelmann, 1908.

127 ————. "Scavi di Pompei nell'inverno 1876–77, R. VI. is. 14." *Bullettino dell'Instituto di corrispondenza archeologica,* 1878, pp. 86 ff.

128 ————. "Scavi di Pompei 1894–95." *Mitteilungen des Deutschen Archäologischen Instituts, Römische Abteilung* (Rome), 11, 1896, pp. 3 ff.

129 Mercklin, E. von. *Antike Figuralkapitelle.* Berlin: W. de Gruyter, 1962.

130 Milne, J. S. *Surgical Instruments in Greek and Roman Times.* Aberdeen, 1907.

131 Napoli, M. "Il capitello ionico a quattro facce a Pompei," in *Pompeiana: Raccolta di studi per il 2° centenario degli scavi di Pompei,* Naples, 1950, pp. 230 ff.

132 Onorato, G. O. *Iscrizioni pompeiane: La vita pubblica.* Florence: Edizione Fussi, 1957.

133 Overbeck, J. *Pompeji in seinem Gebäuden, Alterthümern und Kunstwerken.* 4th ed. Leipzig: W. Engelmann, 1884.

134 Pandermalis, D. "Zum Programm der Statuenausstattung in der Villa dei Papiri." *Mitteilungen des Deutschen Archäologischen Instituts, Athenische Abteilung* (Athens), 86, 1971, pp. 173 ff.

135 Pernice, E. *Gefässe und Geräte aus Bronze* (Die hellenistische Kunst in Pompeji, 4). Berlin: W. de Gruyter, 1925.

136 ————. *Pavimente und figürliche Mosaiken* (Die hellenistische Kunst in Pompeji, 6). Berlin: W. de Gruyter, 1938.

137 Petersen, E. "Über zwei Mosaiks und ihr Urbild." *Mitteilungen des Deutschen Archäologischen Instituts, Römische Abteilung* (Rome), 12, 1897, pp. 328 ff.

138 Picard, G. *Roman Painting.* Greenwich, Conn.: New York Graphic Society, 1970.

139 Pliny the Elder. *Natural History* (Loeb Classical Library), trans. H. Rackham. 10 vols. Cambridge, Mass.: Harvard University Press, 1938–62.

140 Rakob, F. "Ein Grottentriklinium in Pompeji." *Mitteilungen des Deutschen Archäologischen Instituts, Römische Abteilung* (Rome), 71, 1964, pp. 182 ff.

141 ————. "Römische Architektur," in T. Kraus, *Die römische Weltreich* (Propyläen Kunstgeschichte, vol. 2), Berlin, 1967, pp. 153 ff.

142 Reuterswärd, P. *Studien zur Polychromie der Plastik: Griechenland und Rom; Untersuchungen uber die Farbwirkung der Marmor- und Bronzeskulpturen.* Bonniers: Svenska Bokforlaget, 1960.

143 Richardson, L. *The Casa dei Dioscuri and its Painters* (Memoirs of the American Academy in Rome, 13). Rome: American Academy in Rome, 1955.

144 Richter, G. M. A. *The Portraits of the Greeks.* 3 vols. London: Phaidon, 1965.

145 Ridgway, B.S. "The Bronze Apollo from Piombino in the Louvre." *Antike Plastik* (Berlin), 7, pt. 2, 1967, pp. 43 ff.

146 Rizzo, G.E. *La pittura ellenistico-romana.* Milan: Fratelli Treves, 1929.

147 Roques de Maumont, H. von. *Antike Reiterstandbilder.* Berlin: W. de Gruyter, 1958.

148 Rohden, H. von. *Die Terracotten von Pompeji.* Stuttgart: W. Spemann, 1880.

149 Ronczewski, K. *Gewölbeschmuck im römischen Altertum.* Berlin: G. Reimer, 1903.

150 Ruesch, A. *Guida illustrata del Museo di Napoli.* Naples: Richter, 1909.

151 Rumpf, A. "Der Idolino." *Critica d'arte* (Florence), 4, no. 1–2, fasc. 19–20, 1939, pp. 17 ff.

152 ————. "Die schönsten Statuen Winckelmanns," in *Miscellanea Accademica Berolinensia,* 3, 1950, pp. 31 ff.

153 ————. "Kyparissos." *Jahrbuch des Deutschen Archäologischen Instituts* (Berlin), 63–64, 1948–49, pp. 83 ff.

154 ————. *Malerei und Zeichnung der klassischen Antike.* (Handbuch der Archäologie, 4, pt. 1). Munich: C.H. Beck, 1953.

155 ————. "Zum Alexandermosaik." *Mitteilungen des Deutschen Archäologischen Instituts, Athenische Abteilung* (Athens), 77, 1962, pp. 229 ff.

156 Saletti, C. "Il Kouros Pisoni." *Athenaeum* (Pavia), n.s. 38, fasc. 3–4, 1960, pp. 310 ff.

157 ————. "L'Apollo citaredo di Pompei." *Arte antica e moderna* (Bologna), 11, 1960, pp. 248 ff.

158 Salomonson, J. W. "Römische Mosaikkunst," in T. Kraus, *Das römische Weltreich* (Propyläen Kunstgeschichte, vol. 2), Berlin, 1967, pp. 266 ff.

159 Schefold, K. *Die Wände Pompejis: Topographisches Verzeichnis der Bildmotive.* Berlin: W. de Gruyter, 1957.

160 ————. *Pompejanische Malerei, Sinn und Ideengeschichte.* Basel: B. Schwabe, 1952.

161 ————. "Pompeji unter Vespasian." *Mitteilungen des Deutschen Archäologischen Instituts, Römische Abteilung* (Rome), 60–61, 1953–54, pp. 107 ff.

162 ————. "Probleme der Pompejanischen Malerei." *Mitteilungen des Deutschen Archäologischen Instituts, Römische Abteilung* (Rome), 72, 1965, pp. 116 ff.

163 ————. *Vergessenes Pompeji: Unveröffentliche Bilder römischer Wanddekoration in geschichtlicher Folge.* Bern: Francke, 1962.

164 ————. "Zur Chronologie der Dekorationen im Haus der Vettier." *Mitteilungen des Deutschen Archäologischen Instituts, Römische Abteilung* (Rome), 64, 1957, pp. 149 ff.

165 Schilling, R. *La Religion romaine de Vénus depuis les origines jusqu'au temps d'Auguste* (Bibliothèque des écoles françaises d'Athènes et de Rome, 178). Paris: E. de Boccard, 1954.

166 Scott-Ryberg, I. *Rites of the State Religion in Roman Art* (Memoirs of the American Academy in Rome, 22). Rome: American Academy in Rome, 1955.

167 Sichtermann, H. "Zur Achill und Chiron-Gruppe." *Mitteilungen des Deutschen Archäologischen Instituts, Römische Abteilung* (Rome), 64, 1957, pp. 98 ff.

168 Simon, E. *Die Fürstenbilder von Boscoreale: Ein Beitrag zur hellenistischen Wandmalerei.* Baden-Baden: B. Grimm, 1958.

169 ————. *Die Portlandvase.* Mainz: Verlag des Römisch-Germanischen Zentralmuseums, 1957.

170 ————. "Zum Fries der Mysterienvilla bei Pompeji." *Jahrbuch des Deutschen Archäologischen Instituts* (Berlin), 76, 1961, pp. 111 ff.

171 Siviero, R. *Jewelry and Amber of Italy: A Collection in the National Museum of Naples.* New York: McGraw-Hill, 1959.

172 Sogliano, A. "La Casa dei Vettii in Pompei." *Monumenti antichi* (Real Accademia dei Lincei, Rome), 8, 1898, pp. 235 ff.

173 ————. Untitled report "[XV Pompei]." *Notizie degli scavi di antichità* (Real Accademia dei Lincei, Rome), January, 1880, pp. 97 ff.

174 ————. Untitled report "[XX Pompei]." *Notizie degli scavi di antichità* (Real Accademia dei Lincei, Rome), June, 1880, pp. 230 ff.

175 ————. "Relazione degli scavi fatti durante il mese di febbraio 1901 [II Pompei]." *Notizie delgi scavi di antichità* (Real Accademia dei Lincei, Rome), February, 1901, pp. 145 ff.

176 ————. "Relazione degli scavi fatti durante il mese di settembre 1901 [III Pompei]." *Notizie degli scavi di antichità* (Real Accademia dei Lincei, Rome), September, 1901, pp. 400 ff.

177 ————. "Relazione degli scavi fatti dal dicembre 1902 a tutto marzo 1905, Casa degli Amorini [VI Pompei]." *Notizie degli scavi di antichità* (Atti della Real Accademia dei Lincei, Rome), fasc. 9, 1907, pp. 549 ff.

178 ————. "Relazione degli scavi eseguiti dal dicembre 1902 a tutto marzo 1905 [IV Pompei]." *Notizie degli scavi di antichità* (Atti della Real Accademia dei Lincei, Rome), fasc. 1, 1908, pp. 53 ff.

179 Spano, G. "La tomba dell'edile C. Vestorio Prisco in Pompei." *Memorie della Accademia Nazionale dei Lincei* (Rome), 3, ser. 7, 1943, pp. 237 ff.

180 ————. "L'Edificio di Eumachia in Pompei." *Real Accademia di Archeologia, Lettere e Belle Arti di Napoli* (Naples), n.s. 36, 1961, pp. 5 ff.

181 ————. "Relazione degli scavi eseguiti negli anni 1908 e 1909 [V Pompei]." *Notizie degli scavi di antichità* (Real Accademia dei Lincei, Rome), fasc. 6, 1910, pp. 377 ff.

182 Spinazzola, V. *Pompei, alla luce degli scavi nuovi di Via dell'Abbondanza (anni 1910–1923).* 3 vols. Rome: La Libreria dello Stato, 1953.

183 Statius. *Silvae* (Loeb Classical Library), trans. J. H. Mozley. Cambridge, Mass.: Harvard University Press, 1947.

184 Strong, D. E. *Greek and Roman Gold and Silver Plate.* Ithaca, N.Y.: Cornell University Press, 1966.

185 Tabanelli, M. *Lo strumento chirurgico e la sua storia dalle epoche greca e romana al secolo decimosesto.* Forlì: Romagna Medico, 1958.

186 Tran Tam Tinh, V. *Essai sur le culte d'Isis à Pompéi.* Paris: E. de Boccard, 1964.

187 Vanderpoel, H. B. "The Frieze of the House o Meleager at Pompei." *Archaeology* (Cambridge, Mass.), 14, 1961, pp. 180 ff.

188 Vermeule, C. "Hellenistic and Roman Cuirassed Statues." *Berytus* (Beirut), 13, 1959–60, pp. 1 ff.

189 Vitruvius. *The Ten Books on Architecture,* trans. M. H. Morgan. New York: Dover, 1960.

190 Webster, T. B. L. *Hellenistic Art.* London: Methuen, 1967.

191 ————. *Monuments Illustrating Tragedy and Satyr Play* (Institute of Classical Studies, bulletin supplement no. 14). London: University of London, 1962.

192 Zevi, F. *La Casa Reg. IX. 5, 18–21 a Pompei e le sue pitture* (Studi miscellanei 5, University of Rome). Rome: Bretschneider, 1960–61.

INDEX OF ILLUSTRATIONS

with references to pertinent items in the Bibliography

229

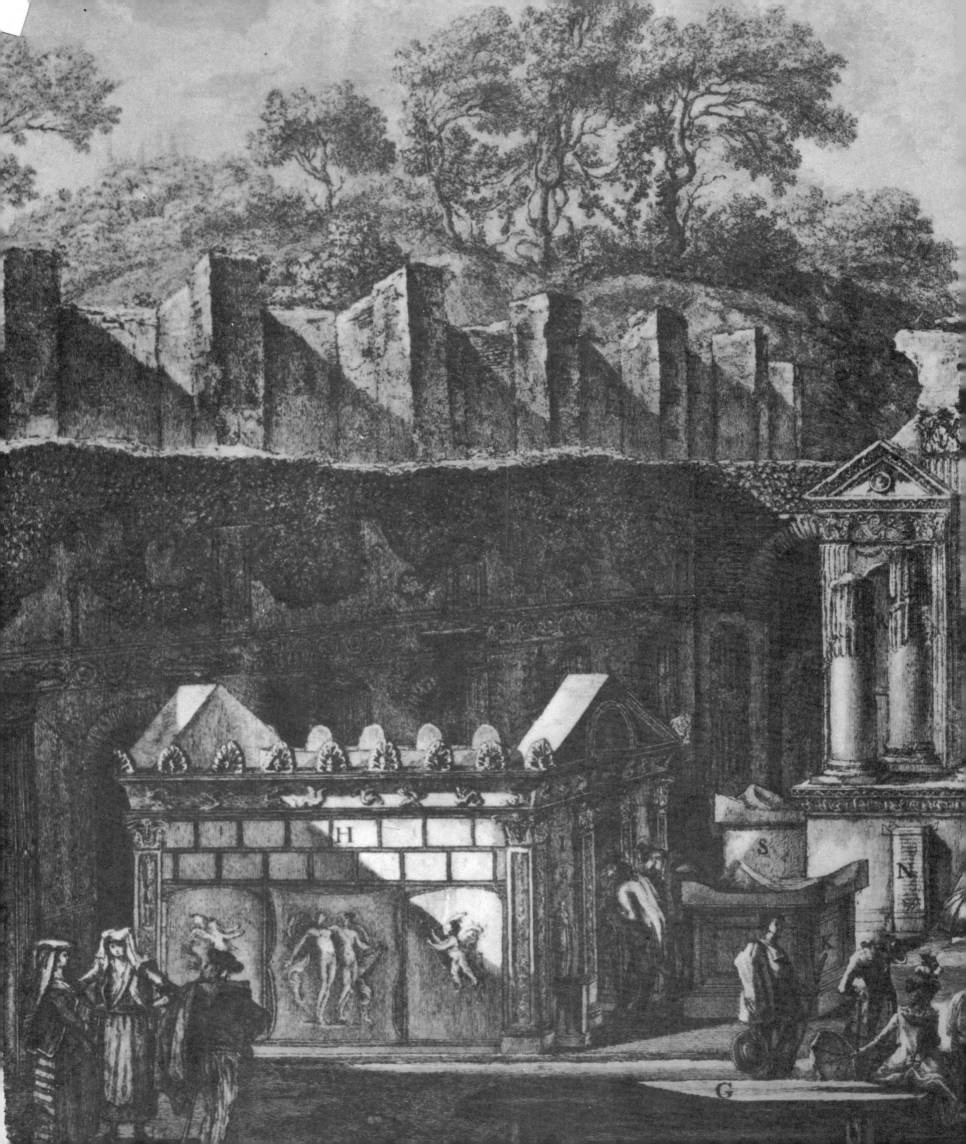